VISUALISING THE NEOLITHIC

Visualising the Neolithic: Abstraction, Figuration, Performance, Representation

Neolithic Studies Group Seminar Papers 13

Edited by

Andrew Cochrane and Andrew Meirion Jones

Oxbow Books
Oxford and Oakville

Neolithic Studies Group Seminar Papers
Series Editor: Timothy Darvill

Published by
Oxbow Books, Oxford, UK

© Oxbow Books and the authors, 2012
ISBN 978-1-84218-477-7

This book is available direct from:

Oxbow Books, Oxford, UK
(Phone: 01865-241249; Fax: 01865-794449)

and

The David Brown Book Company
PO Box 511, Oakville, CT 06779, USA
(Phone: 860-945-9329; Fax: 860-945-9468)

or from our website

www.oxbowbooks.com

A CIP record for this book is available from the British Library

Library of Congress Cataloging-in-Publication Data

Visualising the Neolithic : abstraction, figuration, performance, representation / edited by Andrew Cochrane and Andrew Meirion Jones.
 p. cm. -- (Neolithic studies group seminar papers ; v. 13)
 Includes bibliographical references.
 ISBN 978-1-84217-477-7
 1. Neolithic period--Great Britain. 2. Neolithic period--Europe. 3. Passage Graves culture--Great Britain. 4. Passage Graves culture--Europe. 5. Megalithic monuments--Great Britain. 6. Megalithic monuments--Europe. 7. Rock art--Great Britain. 8. Rock art--Europe. 9. Great Britainx--Antiquities. 10. Europe--Antiquities. I. Cochrane, Andrew. II. Jones, Andrew Meirion.
 GN776.22.G7V57 2012
 936.1--dc23
 2012029362

Printed in Great Britain by
Hobbs the Printers
Totton, Hampshire

Foreword

This book presents the proceedings of a seminar organized by the Neolithic Studies Group (NSG), working in association with the Lithic Studies Society, and forms part of an ongoing series of NSG seminar papers. The NSG is an informal organization comprising archaeologists with an interest in Neolithic archaeology. It was established in 1984 and has a large membership based mainly in the UK and Ireland, but also including workers from the nations of the Atlantic seaboard. The annual programme includes two or three meetings spread throughout the year and includes seminars held in London and field meetings at various locations in north-west Europe.

Membership is open to anyone with an active interest in the Neolithic in Europe. The present membership includes academic staff and students, museums staff, archaeologists from government institutions, units, trusts and amateur organizations. There is no membership procedure or application forms and members are those on the current mailing list. Anyone can be added to the mailing list at any time, the only membership rule being that names of those who do not attend any of four consecutive meetings are removed from the list (in the absence of apologies for absence or requests to remain on the list).

The Group relies on the enthusiasm of its members to organize its annual meetings and the two co-ordinators to maintain mailing lists and finances. Financial support for the group is drawn from a small fee payable for attendance of each meeting.

Anyone wishing to contact the Group and obtain information about forthcoming meetings should contact the co-ordinators at the following addresses:

TIMOTHY DARVILL
School of Applied Sciences
Bournemouth University
Poole
Dorset BH12 5BB

KENNETH BROPHY
Department of Archaeology
University of Glasgow
Glasgow
G12 8QQ

Alternatively visit the NSG website: http://www.neolithic.org.uk/

This book is dedicated to the artist and photographer Ken Williams
whose work is actively forwarding archaeological research
and whose photographs embellish the cover of this book.

To view more of Ken's wonderful photography go to:
www.shadowsandstone.com

Contents

List of Contributors

LARA BACELAR ALVES
larabacelar@sapo.pt

RICHARD BRADLEY
Department of Archaeology
University of Reading
Whiteknights
Reading, RG6 6AH
r.j.bradley@reading.ac.uk

NICK CARD
Orkney Research Centre for Archaeology
Orkney College (UHI)
Kirkwall, KW15 1LX
nick.card@uhi.ac.uk

JOHN CHAPMAN
Durham University
Department of Archaeology
Durham, DH1 3LE
j.c.chapman@dur.ac.uk

ANDREW COCHRANE
Sainsbury Institute for the Study of
 Japanese Arts and Cultures
64 The Close
Norwich, NR1 4DW
cochraneaj@gmail.com

TREVOR COWIE
Department of Archaeology
National Museums Scotland
Chambers Street
Edinburgh, EH1 1JF
t.cowie@nms.ac.uk

BISSERKA GAYDARSKA
Durham University
Department of Archaeology
Durham, DH1 3LE
b_gaydarska@yahoo.co.uk

ROBERT HENSEY
Contact via: Dept. of Archaeology
School of Geography and Archaeology
NUI Galway, Co. Galway
http://independent.academia.edu/
RobertHensey

DANIELA HOFMANN
Cardiff University Centre for Lifelong
 Learning
Senghennydd Road
Cardiff, CF24 4AG
HofmannD@cf.ac.uk

LILIANA JANIK
Department of Archaeology
University of Cambridge
Downing Street
Cambridge, CB2 3DZ
lj102@cam.ac.uk

ANDREW MERION JONES
Archaeology
Faculty of Humanities
University of Southampton
Highfield
Southampton, SO17 1BF
amj@soton.ac.uk

ANTTI LAHELMA
Department of Archaeology
University of Helsinki
Unioninkatu 38F
P.O Box 59
00014 Helsingin yliopisto
Finland
antti.lahelma@helsinki.fi

Guillaume Robin
Università degli Studi di Sassari
Facoltà di Lettere e Filosofia
Piazza Conte di Moriana, 8
07100 Sassari
Italy
guillaume.robin@netcourrier.com

David Robinson
School of Forensic & Investigative Sciences
University of Central Lancashire
Preston, PR1 2HE
DWRobinson@uclan.ac.uk

Stratos Nanoglou
Stratos.Nanoglou@gmail.com

Stuart Needham
Langton Fold
South Harting,
West Sussex, GU31 5NW
sbowman1@waitrose.com

Kate E. Sharpe
Department of Archaeology
Durham University
South Road
Durham, DH1 3LE
kesharpe@live.co.uk

Antonia Thomas
Archaeology Department
University of the Highlands and Islands
Orkney College
East Road
Kirkwall, KW15 1LX
antonia.thomas@orkney.uhi.ac.uk

Elizabeth Twohig
Annestown
Co. Waterford
Ireland
etwohig@archaeology.ucc.ie

Gillian Varndell
Deptartment of Prehistory and Europe
British Museum
Gt. Russell St.
London, WC1B 3DG
GVarndell@thebritishmuseum.ac.uk

Aaron Watson
www.monumental.uk.com
a.watson@monumental.uk.com

Visualising the Neolithic: an introduction

Andrew Cochrane and Andrew Meirion Jones

> *Art does not reproduce the visible; rather, it makes visible*
> Paul Klee

INTRODUCTION

We begin with a quote from the artist Paul Klee's 1919 *Creative Credo* (see Wrathall 2011); it captures many of the interpretative issues we raise in our discussion of Neolithic visuality below. Before commencing with a discussion of how we analyse Neolithic visual expressions we commence with a brief overview of the material from Neolithic Europe.

This volume discusses visual expression across Neolithic Europe; as such it considers a range of media, including rock art, passage tomb art, mortuary costume and figurines. One of the primary aims of the volume is to compare approaches to differing visual media; the volume therefore brings together debates within two archaeological 'special interest' groups: rock art specialists and figurine specialists. We do this for two reasons. First, to reconsider and compare approaches to the study of visuality across these classes of visual media. Secondly, these discussions are introduced, as we believe they have a significant bearing on our wider appreciation of the Neolithic, and should not solely be confined to specialist forums.

The papers in this volume result from a meeting of the Neolithic Studies Group on the topic of '*Neolithic visual culture*' at the British Museum in November 2010. The intention of the meeting was to assess new studies of rock art from across Britain and Ireland, and to compare these with studies of Neolithic visuality from continental Europe. For the published volume the scope of the original meeting was widened, and the editors elicited papers from outside the conference to provide a wider context, and more coherent analysis, of visual expression across Neolithic Europe. The volume is organised so that the rock art and passage tomb art traditions of the Neolithic in Britain and Ireland are compared to the rock art traditions of Northern and Southern Europe, and the mortuary costumes and figurines of Central and South-eastern Europe. Prehistoric art and imagery is a notoriously difficult subject to define, and the reader will notice that we are careful to avoid, where possible, the terms 'art' and 'visual culture' in our discussion of Neolithic visual media. The reasons for this will become clear below.

Starting with a brief overview of approaches to Neolithic visual forms, including rock art and figurines, we then discuss broader theoretical problems associated with the study

of visuality, particularly the issue of representation. We consider how our understanding of Neolithic material forms relates to our broad understanding of the chronology of the period in Europe, and conclude by reconsidering previous discussions of the role of symbolic representation in the process of Neolithisation.

ROCK ART AND FIGURINES: FROM REPRESENTATION TO PERFORMANCE

Representational motifs are common in the rock art traditions of Northern Scandinavia, Neolithic Brittany and Neolithic and Copper Age Alpine France and Italy, and for the Schematic and Levantine art of the Iberian Peninsula. Scholars studying these rock art traditions have focused on the representational significance of form (Bradley 2009; Barfield and Chippindale 1997; Nordbladh 1978; Tilley 1991; Tilley 2006; Tilley and Thomas 1993; Whittle 2000; Diaz-Andreu 1998; Domingo Sanz 2009). The representational nature of these motifs appears to be borne out by images that appear to represent animals, humans and artefacts. This representational approach, however, often provides a narrow account of images. It tends to privilege form over process, overlooks the material properties of images, and as a result can present images as static and unchanging entities. Recent accounts of Scandinavian rock art, while retaining a sense of the image as representation, also acknowledge the material and sensory qualities of images (Hultmann 2010; Goldhahn 2002; 2010; Lahelma 2008; 2010), while some narratives incorporate accounts of representational meaning alongside a subtle analysis of seasonal change (e.g., Helskog 1999; Gjerde 2010); as a result the motifs in these accounts are less static, and acknowledge the changing character of images.

The rock art and passage tomb art traditions of Britain and Ireland, like much rock art on the Atlantic fringe of Europe, contrast with other regions of continental Europe as they are dominated by abstract geometric motifs including cup and rings, spirals and rosettes (Bradley 1997). These visually spectacular motifs – particularly those of the well-documented passage tombs in Ireland– have invited a variety of interpretations over the years, by both scholars and the general public. It is precisely because of the visually spectacular nature of these motifs that interpretation has tended to focus on their form from a representational perspective. Yet these motifs have resisted easy interpretation. We have previously argued that accounts of images that solely focus on representation are misconceived (Cochrane 2005; 2006; 2009; Jones 2005; 2006; 2007), as they overlook the material qualities of the rock on which they are carved, they fail to provide an adequate account of the repetitive character of carving traditions, and are unable to account for the power of images, and their dynamic role. For scholars studying the rock art and passage tomb art traditions of Britain and Ireland the inadequacy of a representational approach is made especially apparent. Rather these rock art traditions require us to ask quite different questions of prehistoric imagery; regarding their materiality, performativity, animacy and potency.

We have discussed contrasting approaches to rock art traditions in different regions of Neolithic Europe. How do these approaches compare with Neolithic figurines? The figurines of Neolithic Europe, being figurative, necessarily invite representational and stylistic analyses. Stylistic analysis involves the empirical measurement and cataloguing

of figurines for the purposes of comparison. While style is an important component of analysis, the definition of figurines by style can also be problematic. For example, Daniela Hofmann (2005) notes problems with the stylistic analyses of Linearbandkeramik figurines, which are often unhelpfully compared with figurines from South-eastern Europe. Like the static representational analysis of rock art motifs the stylistic analysis of figurines tend to isolate or abstract figurines from their individual contexts in order that they can be compared.

The empirical measurement and stylistic analysis of figurines provides the basis for analyses of representational meaning. Questions of meaning are, however, complex as the work of Douglass Bailey (2005) amply demonstrates. Bailey (2005) studies the representational power of figurines in various Neolithic cultures of South-eastern Europe and asks what is it that renders figurines as representations, investigating aspects of representation including processes of abstraction, miniaturisation and three-dimensionality. In doing so, his analysis reveals the *performative* nature of representation. In a similar sense, in a diverse discussion of the deployment of animal skeletal materials and the production of animal imagery in the Greek Neolithic, Stratos Nanoglou (2009) argues for a shift away from thinking about figurines as representations, as resembling animals. Instead, Nanoglou suggests we consider the working together of diverse elements, as a process of 'reassembling' (2009, 187). He argues that the relationship between animals and people is not a given; rather these relationships are produced by performative practice. The representation of animals is then bound up with a process of inhabiting the world in a particular way – of making the world inhabitable (Nanoglou 2009, 185).

Nakamura and Meskell (2009), discussing the rich corpus of figurines from Çatal Hüyük, Turkey likewise focus on the representational choices deployed in the production of anthropomorphic figurines at the site, and furthermore document the casual nature of figurine production and discard (see also Hodder 2010, 15). Significantly, in this context, figurines appear to have been both representations and performances.

To reiterate, we have argued that the analysis of the performative character of British and Irish rock art and passage tomb art motifs offers a fruitful line of enquiry. Notably this approach to images has been discussed for other periods of prehistory. For example, Aldhouse-Green (2004) argues for an approach to Iron Age and Roman images that takes account of their active nature along with an understanding of what they represent: '[images in later European antiquity] *were active, interactive and dynamic, highly evocative of both their cultural context and a more individualized and mutable "objectified" context*' (Aldhouse-Green 2004, 3).

If we are to provide a coherent comparison with the visual media of Central and South-eastern Europe then we need to adopt a similarly performative approach to our analysis of figurines. In both cases then, we have stressed the importance of performative approaches over more traditional stylistic or representational analyses.

Having said this, the contributors to this volume take a variety of approaches to their material, variously emphasizing the representational and/or performative character of Neolithic visual expression. In some cases, as with the attribution of the halberd image from Ri Cruin, Scotland, and the analysis of differing motif traditions in the Iberian Peninsula, the stylistic definition of the image is essential to analysis (Needham and Cowie this volume; Alves this volume), in other cases the desire to comprehend images solely as representations is less helpful.

Why do we especially emphasise performance over representation? We discuss this more generally below.

Representation, performance and materials

We propose that there is a problematic emphasis upon representation in the analysis of Neolithic visual media. We will widen our discussion and consider more general problems with the notion of representation. It is a commonplace assumption that the visual arts are representational. For example, a recent introduction to archaeological art makes the seemingly innocuous claim that: '*visual arts are filled with significance and encode many levels of information about the identity of the artists and their sociocultural context*' (Domingo Sanz *et al.* 2009, 15).

Here we observe a clear expression of the idea that visual arts primarily concern representation. They are associated with visually encoding information, and this visual information is further assumed to encode information about identity. We want to argue that this notion is based upon a false assumption that prehistoric peoples possess an ontology shared with contemporary Euro-Americans. We do not believe this to be the case; below we outline the reasons for this.

What do we mean if we consider the world to consist of representations? We assume that humans have a common capacity to reflect their experiences imaginatively as symbolic representations. Representations, in this account, are expressions of the imaginative capacity of humans visually projected onto a passive material medium. In this account people appear to be able to step outside of the current of daily life in order to reflect their experiences as visual symbols. In such models the material world – as distinct from humans – appears to play little role in the process of representation. Materials appear transparent here; they simply serve as the substrate upon which representations are overlaid. This material substrate is imagined as an inert, stable and unchanging entity awaiting the action of thoughtful human subjects.

We can question the notion of visual art as cultural representation in a number of ways. First, we can reconsider the relationship between people and the world they inhabit. In what sense are people able to abstract their experience and reflect it as a representation? Under what conditions are people able to disengage themselves from the world they live within in order to abstractly represent that world as a representation? The notion of representation assumes that ideas (or representations) exist prior to the world; they are formulated and then imposed upon the world. On the contrary, we argue that people are never distinct or separate from the world that they inhabit, they are always involved in a processes of inhabitation, therefore visual expression is probably better understood as a process of relating to the world. We assert, with the geographers Ben Anderson and Paul Harrisson, that '*thought is placed in action and action is placed in the world*' (Anderson and Harrisson 2010, 11). If we can argue that people are constantly engaged in processes of inhabitation and engagement, we need to entertain the possibility that the material world plays an active role in such processes. Rather than treating the material world as a blank and stable substrate upon which human ideas or representations are imposed we need to instead consider the possibility that humans occupy an active, vibrant and lively world of changing material forms (Bennett 2010, 20–38; Ingold 2011, 67–75). It is through attending to, and interacting with, these changing materials that visual forms are created.

The classical notion of cultural representation offers a very one-sided account of the relationship between people and their world; it assumes that the material world passively receives forms inscribed upon it by the active power of humans. Such an assumption is only possible if we analyse forms as somehow sheared from the processes and relationships that gave rise to them. Rather than thinking of visual expressions as the *outcome* of representational processes, perhaps we are best thinking of the materials of the artwork as *partners* in the process of making representations; for the art theorist Nicolas Bourriaud (2002, 14–18) art is a state of encounter, part of the social interstices that makes up human interactions. Such an argument emphasizes the artwork and the materials of art as significant components in the creation of visual expressions. Importantly we are not arguing that stylistic and semiotic approaches should be abandoned, rather that we understand the conditions that make representations possible.

Our accounts alter considerably from classical notions of cultural representation if we entertain the possibility that the materials of the world also play a significant role in a process of interaction with people. If we assume instead that existence involves active engagement with a changing world, and that it is through interaction with the changeable materials of the environment that visual arts are formed. We therefore shift away from the belief in the primacy of representation and instead consider visual arts as components of different ways of relating with the world. The approach we advocate therefore places emphasis on understanding the processes, performances and relationships bound up with expression. We have shifted in our argument away from an assumption that humans are ontologically distinct from the world that they represent, to arguing that expressions may involve differing ontological engagements with the world.

VISUAL PERSUASION

For the reasons outlined above we remain cautious of the use of the terminology 'visual culture' as it implies a representational distinction between artist and world, although we would agree with Mitchell's (2005) arguments concerning the potency of images. Similarly, we remain suspicious of cross-cultural calls for the term 'art' (see especially Morphy 2007; 2010) as this appears to shear practice from the processes, relationships and materials of its production; here the term 'art' appears as a form of meta-representational term. We build upon Morphy's (2009) assertion that 'art' is a form of action, suggesting instead that visual expression is a mode of action, and vice versa.

Following Mitchell (2005), we will now address the visual power of images (see also Freedberg 1989). For example, when considering passage tomb art, if we consider the visual motifs of passage tombs not from a panoptic-surveillance gaze (as is traditional) but instead from a panoramic or dioramic gaze, we can imagine a spectator looking at an image (such as a decorated kerbstone or orthostat), maybe standing immobile, neither controlling the visual encounter, nor empowering the visual engagement, but rather playing an interactive and creative role. The spectator is ready to participate with the visual reality placed in front of his or her body. Through these interactions – these fluid engagements – the image is able to influence the person's experience.

One of the best modern examples of the power of images is the effect produced by the poster of Kitchener saying, 'Your country needs you'. The image literally enters the viewer's 'life space', with Kitchener's direct gaze creating an interpersonal interaction (Messaris 1997, 21). Images therefore can momentarily destroy one perception of reality and instantaneously replace it with another. As such, the viewer of *any* image, be it a nineteenth century watercolour or passage tomb motif, is temporarily immersed and engaged in a world not present, a simulation of a 'world-as-a-picture'. Moreover, in considering panoramic and dioramic gazes, we can envisage spectators absorbed in the experience of artificially simulated worlds (Brett 1996, 57; Cochrane 2005, 15). These visual experiences are not stable but rather change their relations to a given reality at particular moments in time and place, creating a matrix consisting of realities within realities (Lyotard 1993, 9; Cochrane 2005, 15) or simulations within simulations. Images that assist in simulating or changing a reality are therefore much more than a static 'world-picture'. Instead they are fluid 'visual-events' or 'visual actions' devised by humans as tactics to emplace fresh visual realities within the world of everyday life (Messaris 1997, 7; de Certeau 2002, xix). In sum, '… *the process of vision consists in a never-ending, two-way process of engagement between the perceiver and his or her environment* …' (Ingold 2000, 257–58).

Having discussed visual immersion and interaction we now want to consider various practices associated with visual images. In the interests of space we confine our discussion to the related practices of collage, montage and superimposition, and to processes of erasure.

Collage, montage, erasure and superimposition

We illustrate the practices of superimposition and erasure with contemporary examples before considering prehistoric analogies. Processes of superimposition are wonderfully illustrated by the work of the contemporary artist Idris Khan. In Khan's photographic pieces, we are invited to explore visual palimpsests – nothing is erased, but rather overlaid to the point of illegibility (Dillon 2006). For instance, in his *every… page of the Holy Koran* (2004), texts from the religious book are *repeatedly* pasted upon each other producing a blur of superimposition. In another work by Khan, *every… stave of Federick Chopin's Nocturnes for the piano* (2004), the scores are subjected to similar processes of overlay and produce similar blurs. In both works, overlay masks the material traces that might allow us to interpret the thought processes that went into the 'original' makings, but they are still nevertheless present, and therefore influence the character of the newer image. Yet are we really looking at processes of erasure here? What we can surmise is that more complex pattern recognitions are being created by acts of interference. Or is it something else? Maybe a form of excess and saturation with images being imbued with too much resonance? As Khan demonstrates, this can be a form of erasure in its own right.

So what happens when you attempt to remove a surface or image? In essence, it creates new traces and residues. Examples of this process can be seen in the photographic deletions of political colleagues by particular dictators in the twentieth century, e.g., Joseph Stalin and Mao Tse-tung (Dillon 2006). These erasures can be chilling, in that the erased subject was not only visually airbrushed out of history, but also often physically erased by execution or assassination. In many examples, however, the photographic retoucher has not removed all trace of the victim, while in other instances erasure produces fresh

images (see King 1997; Farid 2006). Indeed it is a commonplace philosophical point that erasures produce presences (Derrida 1994). As with the example of the destruction of the Bāmiyān Buddhas in Afghanistan by the Taliban (Centlivres 2002, 75), motivations for these moments of erasure can be manifold, and can include ideological, political, personal and social reasons.

Acts of image erasure, however, need not always be moments of aggression or resistance. For instance, Robert Rauschenberg attempted to further explore the work of Willem de Kooning (1904–1997) by completely erasing one of his drawings (Katz 2006). This performance created the image *Erased de Kooning Drawing* (1953), and according to Rauschenberg was not inspired by negativity, but rather a desire for ongoing process (Katz 2006, 41). In this sense, and depending upon the spectator's belief system or taste, something negative has the capability to produce positive repercussions.

Considerations of processes of superimposition and erasure have important repercussions for our analyses of Irish passage tomb art and open-air rock art. For example, in considering superimposition Eogan (1997) has noted the way in which the interior of the major passage tombs of the Boyne valley, Ireland receive repeated and overlaid marks, and Jones (2007) has argued that these repetitive marks relate to mnemonic practices and the significance of these monuments in enacting a sense of place. In a similar sense Jones (2005, 2006; Jones *et al.* 2011) notes the importance of processes of superimposition and jutxtaposition in the open-air rock art of the Kilmartin region, Argyll, Scotland. He argues that the repetitive carving of images work interactively with the geological joints and cleavage planes of the rock surface, and with previously carved images, to situate successive images in narratives of place and ancestry. In terms of erasure, Muiris O'Sullivan (1986) has drawn our attention to later phases of pick dressing in Irish passage tomb contexts. With regard to this Cochrane (2009) argues that this is much less a process of removal of prior images, and more a process of *additive subtraction*, in which erasure enhances or draws attention to that which was removed; this practice was very much part of the prescribed process or sequence of interaction with passage tomb imagery.

We hope to have demonstrated that a consideration of performance therefore has a significant impact on our interpretation of prehistoric imagery. A shift towards a consideration of the performance of images has both interpretative and practical consequences. For example, we might consider the recent increase in the number of excavations associated with open-air rock art sites as part of a shift away from the simple representational documentation of motifs to a concern with how these motifs were made, how they were viewed, with how they *performed*. This final point recalls the opening quotation from Paul Klee. Art is less concerned with representing the visible, and more concerned with making the visible.

VISUALISING NEOLITHIC CHRONOLOGIES

There are immediate consequences of the performative approach we have outlined above to the archaeological study of visual media. In a traditional representational approach, the purpose of archaeology is simply to chart, map or document changing visual representations; this is typically undertaken using some form of stylistic analysis. Coupled with this are assumptions that stylistic changes relate to differing identities.

If instead, we assume that visual arts are bound up with processes of engagement and interaction within a changing material environment then the analysis of visual media becomes a process of attending to the changing way in which people relate in the world. It involves appreciating possible ontological differences expressed in these different ways of relating (e.g., Nanoglou 2009). This will of course involve a degree of stylistic documentation and analysis, but it will not divorce these stylistic approaches from their contexts. It does not involve the abandonment of issues such as identity and place, which are especially significant to the study of rock art (Domingo Sanz *et al.* 2009), but these issues are instead understood as ways of relating in the environment.

Here we want to briefly consider how the various media we discuss in this volume relate to our understanding of chronology for Neolithic Europe. Following on from this we will conclude by considering the relationship between visual media and the broader processes of sedentism and agriculture associated with the Neolithic.

Figurines emerge at an early stage in the European Neolithic, in regions such as Thessaly, Greece in *c.* 6700/6500 BC (Andreou *et al.* 1996; Perlès 2001). They continue to be produced in a variety of regions across the Balkans, such as the Pre-Cucuteni and Cucuteni-Tripolye cultures of Romania and the Ukraine beginning *c.* 5050 BC (Lazarovici 2010) – which also produces some of the most spectacular visual media, such as ceramics and house models – the Vinca culture of the central Balkans commencing *c.* 5300 BC (Chapman 1981), and the Hamangia cultures of southeastern Romania and north-eastern Bulgaria beginning *c.* 5500 BC. The production of figurines in materials such as clay, stone and bone appears at an early stage of the South-eastern European Neolithic and figurines continue to be produced throughout the Neolithic sequence of this region, with each culture and region having distinctive figurine forms. We observe a second phase of visual expression in the Varna culture of the Bulgarian Copper Age, beginning *c.* 4600 BC with copper and gold metallurgy deployed in spectacular mortuary costumes. Throughout the Neolithic sequence of South-eastern Europe we also observe the production of visually spectacular objects from shell, especially those of the species *Spondylus gaederopas*. These too, appear in the mortuary costumes of the Copper Age, at sites such as Varna and Durankulak, Bulgaria.

Figurative forms on ceramic vessels and other media appear in the Körös and AVK cultures of the Great Hungarian Plain during the 6th millennium BC (Whittle 2003, 55–60). Figurines also appear in Neolithic contexts in Central Europe, most especially those of the Linearbandkeramik culture, beginning *c.* 5700 BC on the Great Hungarian Plain. The Linearbandkeramik has both an eastern and western zone of expansion, and figurines continue to be produced into Western Europe, in regions such as central and southern Germany (Hofmann 2005; this volume). In other regions of continental Europe figurative statue stelae characterise the Neolithic, in regions such as Alpine Italy and southern France. Concentrations of stelae are known in regions such as Sardinia, Corsica and Iberia, with other examples from southern Italy, Malta, the Paris Basin, Channel Islands, Germany, Hungary and Bulgaria. These figurative stelae date from a wide chronological range *c.* 3500–2000 BC (Robb 2009, 169–70).

The Neolithic of much of Atlantic and North-western Europe differs from South-eastern Europe in terms of its visual media; in regions such as Spain, Portugal, northern Scandinavia and Britain and Ireland traditions of rock art characterise the Neolithic sequence (Cochrane *et al.* forthcoming; Alves this volume).

The date of much of this rock art is equivocal, but we have a clearer date for similar motifs in the passage tomb art tradition, especially with the Schematic art of the Iberian peninsula (Bueno Ramirez and de Balbín Behrmann 1998), with dates for megalithic/schematic art from the dolmen of Carapito, Portugal of the beginning of the 4th millennium BC (5125±70 BP and 5120±40 BP; Bueno Ramirez and de Balbín Behrmann 1998, 57), dates of the mid-4th Millennium BC from Mamoa I, Medorrras, Spain (4790±60 BP, 4420±40 BP, 5280±40 BP, 4540±65 BP, 3500±40 BP; Bueno Ramirez and de Balbín Behrmann 1998, 57). Bueno Ramirez and de Balbín Behrmann (1998, 57) also note a date of 4655±60 BP from painted megalithic art from the Antelas dolmen, north-west Spain. In addition, Manuel Calado (2002, 28–9) notes an important group of decorated standing stones or menhirs dating to the early Neolithic, sometime towards the end of the 5th millennium BC, in the Alentjo region of Portugal.

The sequence in Iberia is likely to parallel that for Brittany, France (Calado 2002). Here the sequence has been studied in detail, and suggests a complex process of Neolithic monumental development commencing in the mid-5th millennium BC with the creation of *tertres tumulaires*, long mounds of earth (Boujot and Cassen 1998). In certain regions decorated menhirs predate monumental construction. For example dates from six of the sockets of the Grand Menhir Brisé alignments are within the broad range 5300–4070 cal BC. As Scarre (2011, 76) notes there is a risk of residuality in the earliest dates, but construction in the second or third quarter of the 5th millennium BC appears to be indicated. At a later date, towards the end of the 5th millennium BC decorated menhirs are broken up and utilised in the construction of passage graves. At this stage we also see episodes of re-carving. There is much regional and chronological variation in the Breton sequence (see Scarre 2011), and not all menhirs were dismantled at the same time.

In other regions of western Europe, such as Ireland, we do not observe an earlier phase of decorated standing stones or menhirs, although some of the most thoroughly excavated sites, such as Knowth and Newgrange, Co. Meath, Ireland exhibit evidence for re-used decorated boulders. There is the potential here for overlap in the chronology and motifs with open-air rock art. The passage tomb art of Ireland is dated to the middle Neolithic to late Neolithic (3600–3100 BC; Cooney 2000; Scarre *et al.* 2003), although the final use of passage tombs may date to a later stage than this; the related passage tombs of Anglesey (see Burrow 2010) date from the middle Neolithic (*c.* 3500–2900 BC). Orcadian passage graves emerge at a slightly later date, around 3300 BC, as does the imagery of the late Neolithic settlements of Orkney (see Card and Thomas this volume).

We have raised the vexed issue of the relationship between open-air rock art and passage tomb art above. In some regions of Western Europe the two are obviously related, as noted by Bueno Ramirez and de Balbín Behrmann (1998) for Iberia (see also Alves this volume). In Britain and Ireland, the relationships are still open to question, and the dating of open-air rock art sites is still in its infancy. Recent dates obtained from sites in the Kilmartin region of Scotland, however, suggest probable 3rd millennium BC dates for rock art production activities (Jones *et al.* 2011; this volume). Other excavations in Northumbria, northern England broadly concur with this picture (Waddington *et al.* 2005). However rock art sites continue to attract attention throughout prehistory and early historic periods, and excavations around rock art sites produce a variety of later prehistoric and historic dates.

The open-air rock art of northern Scandinavia embodies yet another tradition in Neolithic Europe. The Neolithic period of this region differs considerably, as agriculture and sedentism did not impact on the prehistoric societies of this region until much later (Prescott 1996). The rock art of the Neolithic is therefore best understood as part of the continuum of Stone Age, or Northern tradition, rock art (Goldhahn *et al.* 2010; Lahelma this volume). Recent excavations in association with a Northern Tradition painted rock art site at Valkeisaari in Finland suggest dates commencing in the sub-Neolithic period, *c.* 3600 BC, with continued activity into the Early Metal period of the 2nd millennium BC (Lahelma 2008). Excavation in association with the well known rock art site of Nämforsen, Northern Sweden likewise suggests a spread of dates with activities in the Mesolithic, Neolithic and into the Iron Age (Nilsson 2010).

Unsurprisingly, our brief survey of Neolithic visual media suggests that the appearance of visually expressive forms, figurines, rock art and passage tombs conforms to the broad picture for the emergence of the Neolithic in Europe, with the early appearance of figurines in South-eastern Europe and the later appearance of rock art and passage tomb art in Western Europe. This is to be expected if we are simply tracking the progressive appearance and emergence of visual media during the Neolithic. As we argued above, however, we need to start thinking differently about the ontological character of Neolithic visual media. We conclude this survey by considering this.

RE-ENVISIONING THE NEOLITHIC

Over the last two decades it has become orthodoxy in the study of Neolithic Europe to consider the emergence of the Neolithic in terms of an ideational transformation. Ian Hodder (1990) argued that the process of domestication emerged as an idea, or set of structuring principles, prior to, or alongside, the emergence of agriculture and sedentism (see also Hodder 2010). In many ways Hodder's (1990) arguments echo those of Jacques Cauvin (2000), who also argued for a transformation of the mind as an integral component of the emergence of the Neolithic in the Levant (cf. Jaynes 1976). Cauvin (2000, 69–70) argues for the emergence of a new way of thinking related to the appreciation of a personified divinity. The arguments of both Cauvin (2000) and Hodder (1990) place the emphasis on symbolic transformations that occur with the emergence of the Neolithic. It has therefore become commonplace to consider the Neolithic in terms of the creation of new symbolic worlds (Bradley 1993; Hodder 1990; Thomas 1990; Tilley 1994; Whittle 1996). As we outlined above, such an argument rests upon the fundamental assumption that contemporary Euro-American ontology prevailed at the onset of the Neolithic. It assumes that most Neolithic people were disengaged from the environments they inhabited, and were able to abstractly reflect upon these environments in order to represent them symbolically. For example, in Hodder's (1990) terms it assumes, rather paradoxically, that the ideal of domesticity emerged prior to sedentism. On the contrary we propose that concepts are constructed through emerging practices and engagements; concepts do not simply spring to life as *a priori* representations, they must be performed and enacted.

The argument for symbolic change assumes a fundamental distinction between person and world, and overlooks the role played by the materials and environments occupied

by and with people. As we discussed above, if we reconsider this assumed ontological relationship we begin to see that in fact visual media, and indeed much Neolithic material, is not the result of an abstract symbolic process that took place in the mind, but is the result of a process of engagement and interaction with mutable materials in the environment, an ongoing process of creating fresh ontological relationships as opposed to generating symbolic representations.

The differing visual media associated with the European Neolithic might be considered as expressions of differing ontological relationships. The creation of rock art, and potentially passage tombs art, may be considered as a way of relating with place, while the creation of figurines may be considered as a way of working with, and relating with materials. Such a position raises the potential for fresh ways of thinking about the Neolithic transformation not as a process by which people wrested themselves from their hunter-gatherer origins through cognitive and symbolic transformation, but as a process by which new ontological relationships emerged through processes of engagement with the changing materials of the environment; a far less sharp and dramatic, more emergent, process of transformation.

Studies of the Neolithic period tend to emphasize animals and agriculture, materials (pottery and stone tools) or monuments as significant characteristics of the period. There is much less emphasis upon visual media or imagery. One of the aims of this volume is to foreground the significance of visual media during the Neolithic. Indeed, we have argued that visual media offer an important insight into the fresh ontological modes of relating, that were forged during the Neolithic periods; in a sense – to recall our opening quotation from Paul Klee once again – they make the Neolithic visible.

REFERENCES

Aldhouse-Green, M. 2004. *An Archaeology of Images. Iconology and Cosmology in Iron Age and Roman Europe*. London: Routledge.
Anderson, B. and Harrisson, P. 2010. The promise of non-representational theories. In B. Anderson and P. Harrisson (eds) *Taking Place: non-representational theories and geography*, 1–34. Farnham: Ashgate.
Andreou, S., Fotiadis, M. and Kotsakis, K. 1996. Review of Aegean Prehistory V: the Neolithic and Bronze Age of northern Greece. *American Journal of Archaeology* 100, 537–97.
Bailey, D. 2005. *Prehistoric Figurines. Representation and Corporeality in the Neolithic*. London: Routledge.
Barfield, L. and Chippindale, C. 1997. Meaning in the later prehistoric rock engravings of Mont Bégo, Alpes Maritimes, France. *Proceedings of the Prehistoric Society* 63, 103–28.
Bennett, J. 2010. *Vibrant Matter. A Political Ecology of Things*. Durham, NC: Duke University Press.
Boujot, C and Cassen, S. 1998. Tertres armoricains et tumulus carnacéens dans le contexte de la néolithisation de la France occidentale. In J. Guilane (ed.), *Sépultures d'occident et genèses des mégalithismes (9000–3500 avant notre ére)*, 109–126. Paris: Errance.
Bourriaud, N. 2002 *Relational Aesthetics*. Paris: Les Presses du Réel.
Bradley, R. 1993. *Altering the Earth. The Origins of Monuments in Britain and Continental Europe*. Edinburgh: Society of Antiquaries of Scotland Monograph Series 8.
Bradley, R. 1997. *Rock Art and the Prehistory of Atlantic Europe. Signing the Land*. London: Routledge.
Bradley, R. 2009. *Image and Audience. Rethinking Prehistoric Art*. Oxford: Oxford University Press.
Brett, D. 1996. *The Construction of Heritage*. Cork: Cork University Press.

Bueno Ramirez, P. and de Balbín Behrmann, R. 1998. The origin of the megalithic decorative system: graphics versus architecture. *Journal of Iberian Archaeology* 0, 53–67.

Burrow, S. 2010. Bryn Celli Ddu passage tomb, Anglesey: alignment, construction, date and ritual. *Proceedings of the Prehistoric Society* 76, 249–270.

Calado, M. 2002. Standing stones and natural outcrops: the role of ritual monuments in the Neolithic transition of the central Alentjo, in C. Scarre (ed.), *Monuments and Landscape in Atlantic Europe. Perception and Society during the Neolithic and Early Bronze Age*, 17–35. London: Routledge.

Cauvin, J. 2000. *The Birth of Agriculture and the Origin of the Gods*. Cambridge: Cambridge University Press.

Centlivres, P. 2002. Life, death, and eternity of the Buddhas in Afghanistan. In B. Latour and P. Weibel (eds), *Iconoclash: beyond the image wars in science, religion and art*, 75–77. London: The MIT Press.

Chapman, J. 1981. *The Vinca Culture of Eouth-east Europe. Studies in Chronology, Economy and Society, 2 vols*. Oxford: British Archaeological Reports.

Cochrane, A. 2005. A taste of the unexpected: subverting mentalities through the motifs and settings of Irish passage tombs. In D. Hofmann, J. Mills and A. Cochrane (eds), *Elements of Being: mentalities, identities and movements*, 5–19. Oxford: British Archaeological Reports.

Cochrane, A. 2006. *Irish Passage Tombs. Neolithic Images, Contexts and Beliefs*. Unpublished PhD. University of Cardiff.

Cochrane, A. 2009. Additive subtraction: addressing pick-dressing in Irish passage tombs. In J. Thomas and V. Oliveira Jorge (eds), *Archaeology and the Politics of Vision in a Post-modern Context*, 163–85. Cambridge: Cambridge Scholars Publishing.

Cochrane, A., Jones, A. M. and Sognnes, K. forthcoming. Rock art and the rock surface: Neolithic rock art traditions of Britain, Ireland and northernmost Europe. In Fowler, C., Harding, J and Hofmann, D. *Oxford Handbook of Neolithic Europe*. Oxford: Oxford University Press.

Cooney, G. 2000. *Landscapes of Neolithic Ireland*. London: Routledge.

de Certeau, M. 2002. *The Practice of Everyday Life*. Trans. S. T. Rendall. Berkeley: University of California Press.

Derrida, J. 1994 *Specters of Marx*. London: Routledge.

Diaz-Andreu, M. 1998. Iberian post-palaeolithic art and gender: discussing human representations in Levantine art. *Journal of Iberian Archaeology* 0, 33–52.

Dillon, B. 2006. The revelation of erasure. *Tate Etc* 8, 30–37.

Domingo Sanz, I. 2009. From the form to the artists: changing identities in Levantine rock art (Spain). In I. Domingo-Sanz, D. Fiore and S. K. May (eds), *Archaeologies of Art. Time, Place, Identity*, 99–130. Walnut Creek: Left Coast Press.

Domingo Sanz, I., Fiore, D. and May, S. K. 2009 *Archaeologies of Art. Time, Place, Identity*. Walnut Creek: Left Coast Press.

Eogan, G. 1997. Overlays and underlays: aspects of megalithic art succession at Brugh na Boinne, Ireland, *Brigantium* 1997, 10, 217–34.

Farid, H. 2006. Digital doctoring: how to tell the real from the fake. *Significance* 3(4), 162–166.

Freedberg, D. 1989. *The Power of Images: studies in the history and theory of response*. Chicago: University of Chicago Press.

Goldhahn, J. 2002. Roaring rocks: an audio-visual perspective on hunter-gatherer engravings in northern Sweden and Scandinavia. *Norwegian Archaeological Review* 35(1), 29–61.

Goldhahn, J. 2010. Emplacement and the hau of rock art. In J. Goldhahn, I. Fuglesvedt and A. Jones (eds), *Changing Pictures. Rock Art Traditions and Visions in Northern Europe*, 106–26. Oxford: Oxbow Books.

Goldhahn, J., Fuglestvedt, I. and Jones, A. 2010. (eds). *Changing Pictures. Rock Art Traditions and Visions in Northern Europe*. Oxford: Oxbow Books.

Gjerde, J-M. 2010. 'Cracking' landscapes: new documentation – new knowledge. In J. Goldhahn, I. Fuflesvedt and A. Jones (eds) *Changing Pictures. Rock Art Traditions and Visions in Northern Europe*, 170–86. Oxford: Oxbow Books.

Helskog, K. 1999. The shore connection: cognitive landscape and communication with rock carvings in Northernmost Europe. *Norwegian Archaeological Review* 32, 73–94.

Hodder, I. 1990. *The Domestication of Europe*. Oxford: Blackwell.

Hodder, I. 2010. Probing religion at Catal Hoyuk: an interdisciplinary experiment. In I. Hodder (ed.), *Religion in the Emergence of Civilization. Çatalhöyük as Case Study*. Cambridge: Cambridge University press.

Hofmann, D. 2005. Fragments of power: LBK figurines and the mortuary record. In D. Hofmann, J. Mills and A. Cochrane (eds). *Elements of Being: mentalities, identities and movements*, 58–70. Oxford: British Archaeological Reports.

Hultmann, M. 2010. The known yet unknown ringing stones of Sweden. In J. Goldhahn, I. Fuglesvedt and A. Jones (eds), *Changing Pictures. Rock art traditions and visions in Northern Europe*, 60–72. Oxford: Oxbow Books.

Ingold, T. 2000. *The Perception of the Environment: essays in livelihood, dwelling and skill*. London: Routledge.

Ingold, T. 2011. *Being Alive: essays on movement, knowledge and description*. London: Routledge.

Jaynes, J. 1976. *The Origin of Consciousness in the Breakdown of the Bicameral Mind*. Boston: Houghton Mifflin.

Jones, A. 2005. Between a rock and a hard place. Rock art and mimesis in Neolithic and Bronze Age Scotland. In V. Cummings and A. Pannett (eds), *Set in Stone: new approaches to Neolithic monuments in Scotland*, 107–17. Oxford: Oxbow Books.

Jones, A. 2006. Animated images. Images, agency and landscape in Kilmartin, Argyll. *Journal of Material Culture* 11 (1/2), 211–26.

Jones, A. 2007. *Memory and Material Culture*. Cambridge: Cambridge University Press.

Jones, A., Freedman, D., Lamdin-Whymark, H., O'Connor, B., Tipping, R. and Watson, A. 2011. *An Animate Landscape: rock art and the prehistory of Kilmartin, Argyll*. Oxford: Windgather Press.

Katz, V. 2006. A genteel iconoclasm. *Tate Etc* 8, 38–41.

King, D. 1997. *The Commissar Vanishes: falsification of photographs and art in the Soviet Union*. London: Canongate Books.

Lahelma, A. 2008. *A Touch of Red. Archaeological and Ethnographic Approaches to Interpreting Finnish Rock Paintings*. ISKOS 15. Helsinki: Finnish Antiquarian Society.

Lahelma, A. 2010. Hearing and touching Rock art: Finnish rock paintings and the non-visual. In J. Goldhahn, I. Fuflesvedt and A. Jones (eds), *Changing Pictures. Rock Art Traditions and Visions in Northern Europe*, 48–59. Oxford: Oxbow Books.

Lazarovici, C-M. 2010. Cucuteni ceramics: technology, typology, evolution and aesthetics. In D. W. Anthony (ed.), *The Lost World of Old Europe. The Danube Valley 5000–3500 BC*, 128–61. Princeton, NJ: Princeton University Press

Messaris, P. 1997. *Visual Persuasion: the role of images in advertising*. London: SAGE Publications.

Mitchell, W. J. T. 2005. *What do Pictures Want? The Lives and Loves of Images*. Chicago: Chicago University Press.

Morphy, H. 2007. *Becoming Art: exploring cross-cultural categories*. Oxford: Berg.

Morphy, H. 2009. Art as a mode of action: some problems with Gell's art and agency. *Journal of Material Culture* 14(1), 5–27.

Morphy, H. 2010. Art as action, art as evidence. In D. Hicks and M. Beaudry (eds), *The Oxford Handbook of Material Culture*, 265–90. Oxford: Oxford University Press.

Nakamura, C. and Meskell, L. 2009. Articulate bodies: forms and figures at Catalhöyük. *Journal of Archaeological Method and Theory* 16, 205–30.

Nanoglou, S. 2009. Animal bodies and ontological discourse in the Greek Neolithic. *Journal of Archaeological Method and Theory* 16, 184–204.

Nilsson, P. 2010. Reused rock art: Iron Age activities at Bronze Age rock art sites. In J. Goldhahn, I. Fuflesvedt and A. Jones (eds), *Changing Pictures. Rock Art Traditions and Visions in Northern Europe*, 154–69. Oxford: Oxbow Books.

Nordbladh, J. 1978. Images as messages in society. Prologomena to the study of Scandinavian petroglyphs and semiotics. In K. Kristiansen and C. Paludan-Muller (eds), *New Directions in Scandinavian Archaeology*. Studies in Prehistory and Early History I, 63–79. Copenhagen: National Museum Press.

O'Sullivan, M. 1986. Approaches to passage tomb art. *Journal Royal Society of Antiquaries of Ireland*, 116, 68–83.

Perlés, C. 2001. *The Early Neolithic in Greece*. Cambridge: Cambridge University Press.

Prescott, C. 1996. Was there really a Neolithic in Norway? *Antiquity* 70, 77–87.

Robb, J. 2009. People of stone: Stelae, personhood, and society in prehistoric Europe. *Journal of Archaeological Method and Theory* 16, 162–83.

Scarre, C. 2011. *Landscapes of Neolithic Brittany*. Oxford: Oxford University Press.

Scarre, C., Arias, P., Burenhult, G., Fano, M., Oosterbeek, L., Schulting, R., Sheridan, A. and Whittle, A. 2003. Megalithic Chronologies, in G. Burenhult and S. Westergaard (ed.) *Stones and Bones. Formal disposal of the dead in Atlantic Europe during the Mesolithic–Neolithic interface 6000–3000 BC. Archaeological conference in honour of the Late professor Michael J. O'Kelly,* 65–112. Oxford: British Archaeological Reports S1201.

Thomas, J. 1990. *Rethinking the Neolithic*. Cambridge: Cambridge University Press.

Tilley, C. 1991. *Material Culture and Text. The Art of Ambiguity*. London: Routledge.

Tilley, C. 1994. *A Phenomenology of Landscape. Places, Paths and Monuments*. Oxford: Berg.

Tilley, C. 2006. *Body and Image: explorations in landscape phenomenology*. Walnut Creek, CA: Left Coast Press.

Tilley, C. and Thomas, J. 1993. The axe and the torso: symbolic structures in the Neolithic of Brittany. In C. Tilley (ed.) *Interpretative Archaeology*, 225–324. Oxford: Berg.

Waddington, C., Johnson, B. and Mazel, A. 2005. Excavation of a rock art site at Hunterheugh Crag, Northumberland. *Archaeologia Aeliana* 34 (5th Series), 29–54.

Whittle, A. 1996. *Europe in the Neolithic. The Creation of New Worlds*. Cambridge: Cambridge University Press.

Whittle, A. 2000. 'Very like a whale': menhirs, motifs and myths in the Mesolithic–Neolithic transition of northwest Europe, *Cambridge Archaeological Journal* 10, 243–259.

Whittle, A. 2003. *The Archaeology of People. Dimensions of Neolithic life*. London: Routledge.

Wrathall, M. 2011. The phenomenological relevance of art, in J. D. Parry (ed.), *Art and Phenomenology*, 9–30. Routledge: London.

Strange swans and odd ducks: interpreting the ambiguous waterfowl imagery of Lake Onega

Antti Lahelma

INTRODUCTION

On the eastern shore of Lake Onega (Finn. *Ääninen*, Rus. *Онежское озеро*) in Karelia, north-western Russia, waves crash on sandy beaches interspersed by rocky capes. These capes, worn smooth by countless glaciations, are home to one of the largest concentrations of rock art in Northern Europe. Since the initial discovery of the Besov Nos and Peri Nos locales in 1848, more than 1300 carvings have been counted on smooth granite cliffs and a few offshore islets, located roughly between the estuaries of two small rivers (Vodla and Chernaya) along a 20km long stretch of the shoreline (Figure 2.1). The Neolithic date of this art is comparatively well established.[1] Excavations in the vicinity of the carvings have produced a wealth of Neolithic material, and iconographic comparisons with Neolithic rock art of the adjacent regions, as well as with Neolithic pottery decoration and flint figurines, likewise support a date between 5th and 3rd millennia BC (Poikalainen and Ernits 1998, 29–39). Further confirmation was offered by an experimental microerosion study conducted by Robert Bednarik (1992, 151–2), the results of which were well in line with those suggested by traditional archaeological methods.

The number of carvings is likely to grow, as new discoveries are still being made (e.g., Poikalainen and Ernits 1998; Zhulnikov 2010). However, the most remarkable feature of the Lake Onega carvings is not their number but the unusual subject matter. Whereas images of cervids (elk and wild reindeer) dominate most hunter-gatherer rock art sites throughout Northern Eurasia, the Neolithic inhabitants of the Onega region preferred to depict birds and especially waterfowl. According to the data collected by Väino Poikalainen (2004), avian imagery forms 44% of the total number of figures counted at Lake Onega, and exceeds 60% at some locales. There are, of course, other motif types depicted at the Onega sites – such as boats, celestial symbols and even some cervids – and they show a close stylistic affinity with sites like Nämforsen in Sweden (Hallström 1960), Alta in Northern Norway (Helskog 1988) or the rock paintings of the Finnish Lake Region (Lahelma 2008). But whereas images of birds are almost completely absent at Nämforsen, Alta and Finland, the prehistoric inhabitants of Lake Onega seem to have been completely obsessed with them. There is no other area in Northern Europe – possibly even the entire world – where birds play such a dominant role in rock art.

In the majority of cases, it appears that the birds depicted are Whooper Swans (*Cygnus cygnus*), but occasionally some smaller waterfowl – probably members of the duck and goose

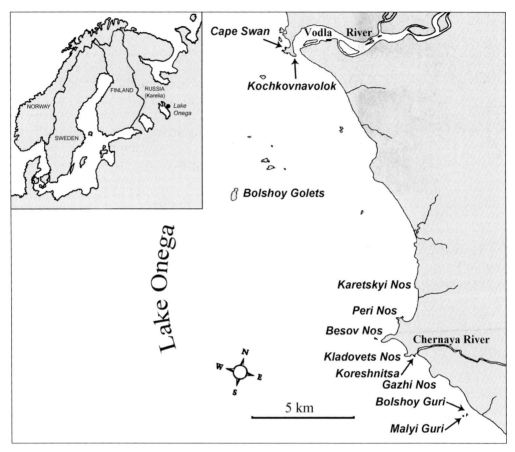

Figure 2.1: A map of the Lake Onega rock art region, showing the main carving localities (in italics) on the eastern shore of the lake.

families – have been depicted, and a few Common Cranes (*Grus grus*) are also recognisable. At first sight, the images may appear rather uniform and repetitive in shape, but upon closer inspection it becomes apparent that there is in fact great variety in the specific details of the birds and the contexts in which they occur. Some are comparatively naturalistic (cf. Figure 2.6a), others highly schematic; some are depicted in outline, some are fully pecked; some are small, others are life-sized and still others are positively huge (as much as 4m long). Although most of the swans seem to 'float' on the rock, iconic and frozen still, some are connected to other images or features of the rock in an apparently meaningful way. And on top of that, a few have strange or unrealistic features, such as little 'ears' on the head, human feet, a body formed by concentric arcs, or an impossibly long neck (Figure 2.2)

The Onega rock art often appears impenetrably puzzling and mysterious. Unlike in the other major Karelian rock art locality, that on the White Sea coast located *c.* 300km north of Lake Onega (Savvateyev 1970), clearly narrative or time-sequenced scenes are rare and the art in general offers relatively few clues to the interpreter. However, this has not stopped

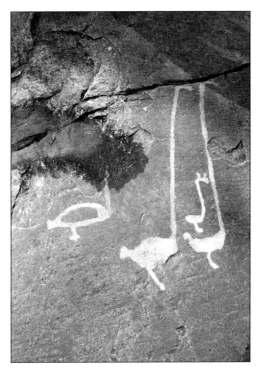

Figure 2.2: Four swans at the Besov Nos locality, painted white for better visibility. Two of the swans have unnaturally long necks and heads that connect to a crack in the bedrock. In between, a small swan has small 'ears' or 'horns' on the head. The fourth swan has been badly damaged by a recent fireplace. Photo: Heikki Simola (August 2000).

a lot of people from trying. Although some early writers (such as Linevsky 1939) took the carvings as a faithful and concrete depiction of the hunter-gatherer way of life, most have agreed that the swan was not depicted as a game animal but should be understood as a symbol that refers to something beyond the animal itself: to myths or cosmological concepts, as some have suggested (e.g., Laushkin 1959 1962; Stolyar 2000; Zhulnikov 2006), or perhaps to ancestors or totemic clans, as others have argued (e.g., Ravdonikas 1936; Poikalainen 1999).

In his recent book on *Rock Art Science*, Bednarik (2007, 154) uses the Lake Onega carvings to illustrate what he perceives as the futility of iconographic identification. He presents a comparison of eleven scholars and their identifications and interpretations of certain motifs, and notes that they seemingly cannot agree about anything. Bednarik's comparison is of course highly tendentious in its attempt to demonstrate that the whole exercise of rock art interpretation is pointless, and completely unfair in putting side by side the interpretations of people like Peter Shved and Vladislav Ravdonikas. Shved was a 19th century rural schoolmaster, who wrote a single newspaper article about the carvings (Shved 1850), while Ravdonikas is recognized as the leading Soviet archaeologist of the 1920s and '30s (Trigger 2006, 329–30), who spent several years documenting the Onega carvings first hand and published a painstakingly researched monograph on the subject (Ravdonikas 1936). Yet, there is a grain of truth in this comparison: the Onega carvings do defy simplistic identifications and interpretations, and there seems to be no single meaning associated with a particular motif. Given the subtle differences in detail and execution, the swans most likely should be seen as polysemic and ambiguous symbols, the meaning of which depended on a number of variables. In order to interpret them correctly, we would have to be able to identify and correctly read those variables. But is that possible, even in theory?

Statistic and spatial analysis such as conducted by Poikalainen (2004) and Vieira (2010) may provide some important pointers, but the only way to penetrate the ambiguity of Onega rock art and decipher its culturally specific meanings would be through 'informed' ethnographic knowledge (cf. Taçon and Chippindale 1998). Even though such information

is rarely available for prehistoric rock art in Europe, Chippindale (2000, 76) acknowledges a *'slim possible window'* for reaching informed knowledge on North European rock art through local ethnographic accounts. It is to these accounts that we must turn if we are to make sense of the Onega swans.

THE DEVIL AND HIS WIFE

Importantly, there may be some evidence for a direct link between petroglyphs and recent folklore at Lake Onega. When the first carvings were 'found' in 1848 by the geologist Constantin Grewingk, he was told by the villagers of nearby Besov Nos – who had always known about them – that the Devil himself was believed to be depicted in one particularly large and menacing human figure carved on the rock (Figure 2.3). During his visit, Grewingk recorded the following folktale concerning the carvings:

> *'According to popular legend, long time ago the Devil and his Wife (Bess and Bessicha) lived here and made their presence known through the strange pictures on the rock. But then came the incarnate Christ and the True Faith, and crosses were carved over the evil pictures. The evil spirits had to escape, but they wanted to take with them a memory of their home, a block of stone, that is. However, during this venture they fell in the lake together with the boulder, and drowned in a place which is still being shown.'* (Grewingk 1855, 98; translation from German by the author).[2]

This tale, simple though it is, is interesting because folklore sources in Northern Europe generally remains silent on the subject of rock art. In fact, in most cases local inhabitants

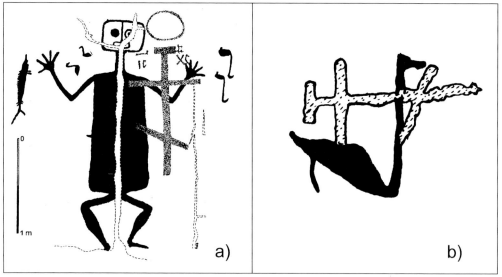

Figure 2.3: Signs of a Medieval iconoclasm at the Lake Onega carvings: the 'Devil' (a) or Bes of Besov Nos and one of the swan figures (b) at the same locale have been 'desecrated' with Greek Orthodox crosses. According to Ravdonikas (1936).

appear to have been totally oblivious to rock art. If they have known of its existence, it has been regarded as idle doodling and thought to be purely secular in character. The Bronze Age carvings at Backa Brastad in southern Sweden are a typical example. According to 17th century antiquarian accounts, the local farmers believed they had been made by workmen building a nearby Medieval church. The central human figure – a phallic Bronze Age warrior equipped with a war-axe and a sword scabbard – was interpreted as a shoemaker, hence the traditional Swedish name *Skomakarhällen* or 'Shoemaker Cliff' given to the site (Bahn 1998, 5–6). The story heard by Grewingk, which associates the carvings with the mythological realm and seems to bear an echo of a religious confrontation, is an exception to this rule. Its significance is underlined by the place names that likewise associate the carvings with the Devil: *Besov Nos* is Russian for 'Devil's Cape' and the name of a second important rock art locale, *Peri Nos*, may likewise refer to the Devil as *Piru* is a Finnish word for 'Devil'.

Here it should be pointed out that although the eastern Lake Onega region had become extensively Russified by mid-19th century, the original populace consisted of Finno-Ugric Vepsians and Karelians who – in spite of the language shift – retained many aspects of traditional Vepsian and Karelian culture (e.g., Saressalo 2005).

Does the story, then, preserve a memory of rock art-related pre-Christian practices at Besov Nos? Probably not in any literal sense, but some continuity of tradition is quite possible. There are several things to consider here. First, the story clearly has an etiological purpose: it is meant to explain the strange markings on the rock, as well as the shape of the Porshen Islet near Besov Nos, identified by the locals as the block of stone that caused the Devil to drown (Poikalainen and Ernits 1998, 42). (Figure 2.4) It also follows formulas well-known in Finnic folklore, relating the triumph of Christianity over pagan worship: giants or demons (sometimes together with their wives and children) flee from a bishop or the sound of church bells, sailing away on a boulder or a red cliff, in the process of which they are sometimes drowned (Jauhiainen 1999, 285). The two protagonists, 'Devil and His Wife', likewise appear to be stereotypical: in Vepsian lore, many places (forests, rivers, lakes, houses,

Figure 2.4: Russian archaeologist Nadezhda Lobanova photographed at Besov Nos, pouring a vodka libation to the crack that splits the 'Devil' in two – a contemporary ritual carried out by many visitors to the site. Porshen Islet, which according to local tradition was carried from the mainland by the Devil while fleeing from Christian missionaries, can be seen in the background. Photo: Heikki Simola (August 2000).

etc.) had a 'master' (in Vepsian *ižand*) and 'mistress' (*emag*) (Vinokurova 2005), and the demonised dwellers of Besov Nos clearly belong to the same category of beings.

Second, there are signs of Christian iconoclasm at the site. As mentioned in the story, two Greek Orthodox crosses have been superimposed on the pre-Christian carvings of Besov Nos. One of the crosses can be typologically dated to the 14th or 15th century AD, and it was suggested already by Grewingk (1855, 103) that the crosses were made by the monks of the nearby Greek Orthodox monastery of Muromsk, located *c.* 20km south-east of the carvings. Similar cases of rock art iconoclasm have been reported elsewhere in the world (e.g., Bednarik 2007, 159), but in Northern Europe the Onega carvings are unique in this respect – a fact that requires a good explanation. The larger and more elaborate of the crosses has been superimposed on the 'Devil', while a smaller one is carved over a swan figure. The choice of these two motifs does not appear random: the Devil is a singular figure at Lake Onega and probably a focal point of the rituals that once took place there, where as swans are the most common subject. Whoever made the crosses had some knowledge of the carvings and demonstrated a sense of intentionality and purpose in desecrating the two central symbols.

Third, an extensive number of dwelling sites (totalling 43 at present) have been discovered and partially excavated by Lobanova (1995; see also Savvateyev 1988) in the immediate vicinity of the petroglyphs. Material recovered from the excavations extends from the Mesolithic to the Middle Ages and, rather unusually, represents every single period and 'culture' of Karelian prehistory. The archaeological trajectory thus joins seamlessly with the history of the (now abandoned) village of Besov Nos, which is known already from Medieval written sources and remained inhabited until Soviet times. Archaeological continuity on this scale is unusual and suggests some form of continuity in the population and economic basis as well, at least in principle allowing a *longue durée* perspective on Lake Onega rock art and folklore. The situation is made more complicated by the observation that Lake Onega may have experienced a rapid transgression of as much three meters in the 3rd millennium BC (Poikalainen and Ernits 1998, 37). If this is correct, then all of the carvings of Besov Nos have been submerged for a period of time in later prehistory, temporarily putting an end to any human activity at that site – but not in the wider rock carving region. According to Stolyar (2000), as a result of the transgression the production of rock art at Lake Onega simply shifted to a different locality on slightly higher ground (a cape called Kochkovnavolok) and continued at least until the Early Metal Period or *c.* 1800 BC.

In sum, there appears to be a weak but still significant tradition that forms a direct link between 19th century folk-belief and the Neolithic carvings of Lake Onega. Although the folklore associated with the site is stereotypical and not particularly informative, it does indicate (together with the 'devilish' toponyms) that the area had a special mythological significance in the historical period. In particular, the carving locale of Besov Nos has been associated with 'pagan' forces of such vigour that medieval Christian proselytisers deemed it necessary to bring them under the Cross in a very literal fashion. Given the fact that the cape of Besov Nos and its surroundings have been continuously inhabited from the Mesolithic to the present day, this pre-Christian religious connotation – attested by the crosses and 19th century legends – may well derive from deep prehistory. It is thus conceivable that still in the Late Middle Ages the Onega carvings were perceived as

a kind of a pagan sanctuary, and they may have been in some form of continuous ritual use from the Stone Age until the Early Modern Period. Alone, this information might not be of much use in interpreting the carvings, but the informed approach to Karelian rock art is not exhausted by Grewingk's little tale. The real potential for fusing the horizons of archaeology and ethnography in Northern Europe lies elsewhere – in a close reading of Karelian mythic poetry and the reconstructions of comparative mythology.

A *LONGUE DURÉE* PERSPECTIVE ON KARELIAN ROCK ART

Although today the language spoken at the Lake Onega region is mostly Russian, its traditional inhabitants were Finno-Ugric speaking Karelians, Vepsians and (possibly) Saami. These peoples have been in contact with and influenced by Christianity since the Viking Age (9th–11th centuries AD) at least, when they fell within the sphere of influence of the Kievan Rus. Nominal conversion to Orthodox Christianity occurred in the course of the 11th and 14th centuries, when the Karelians and Vepsians were subject to the city-state of Novgorod, but it took a very long time for Christianity to take deeper root in Karelia and many aspects of pre-Christian ritual and belief survived in the region until recent times. In the beginning of the 19th century, scores of Finnish ethnologists and folklorists travelled to their close linguistic cousins in Karelia in search of a pure Finnic *Urkultur*. They documented this heritage in minute detail, most famously represented in the mythic/epic folk poetry, out of which the Finnish 'National Epic' *Kalevala* was fashioned by Elias Lönnrot in 1849 (for the most recent English translation, see Kalevala 1990). There is thus a wealth of ethnographic material available relating to pre-Christian myth and religion, some of it collected in the same region as the Onega rock carvings.

But can folklore collected in the 19th century really shed light on Neolithic rock art? It may seem preposterous to even suggest a connection, and Western European archaeologists have not generally warmed to the folklore-based interpretations of Karelian rock art (e.g., Bradley *et al.* 2001, 492–3). Russian archaeologists, by contrast, have for decades had a much more relaxed approach towards using ethnographic data – a fact that may partly relate to different attitudes towards employing ethnography and the 'direct historical approach' in the East and West, as the former never experienced the positivist currents of New Archaeology and its dismissal of analogy (Lahelma 2008, 158–62). At the same time, it has to be admitted that some works on Karelian rock art have been rather carefree and unmethodical in their use of ethnographic and folklore sources – the work of Laushkin (1959; 1962), in spite of its many good insights, deserves special mention in this respect – and the approach has been criticised even by some Russian writers (e.g., Savvateyev 1970).

Be that as it may, it needs to be stressed that the historical situation in Karelia differs a great deal from regions like Central Europe and the British Isles, where population history is more complex and the role of the Church has been much stronger. Karelia and Finland belong linguistically – and to a certain extent also culturally – to a vast world of Finno-Ugric peoples, which extends from the Saami of Arctic Norway in the west through northern Russia (home to peoples such as Komi, Mari and Udmurts), to western Siberia, the traditional homelands of the Khanty and Mansi. Still further east, several Siberian peoples, including the Nenets, Nganasans and Selkups, speak Samoyedic languages that are

related to Finno-Ugric and share many aspects of traditional mythology and worldview. Among many of these peoples, cultural transmission over deep time has been enabled by the relatively stable physical and natural environment, continuity in adaptive patterns and exploited resources, and the relatively low impact of agricultural social systems (Zvelebil 1997; Jordan 2004).

In Karelia, it is true, we find signs of incipient agriculture as early as 4000 BC (Vuorela *et al.* 2001), but while agriculture may have had considerable ideological significance, the real economic base in many parts of Karelia was based on hunting and fishing well into the 19th century AD. As noted, this striking economic continuity from the Mesolithic to the present is reflected also in the archaeology of the Lake Onega sites, and similar trajectories in habitation and material culture are characteristic of the entire Finno-Ugric world (e.g., Patrushev 2000). Many writers have argued that this continuity and stability in the archaeological record reflects a similar linguistic continuity. A strong case has been made for associating the Neolithic Pit and Comb Ware groups with the speakers of Proto-Uralic, the language ancestral to all modern Finno-Ugric languages, probably spoken *c.* 5000–4000 BC (e.g., K. Häkkinen 1996; Carpelan and Parpola 2001; Lehtinen 2007 – but see J. Häkkinen 2009 for a contrasting point of view). Significantly for the present discussion, the Pit and Comb Ware groups also appear to be responsible for creating much of the rock art of Lake Onega and adjacent regions.

Because myths, worldviews and languages are inextricably linked (Cook 1980), this extensive archaeological/linguistic trajectory also suggests continuity in religious ideas. Using the comparative method, several scholars have presented reconstructions of a hypothetical proto-Finno-Ugric or Proto-Uralic mythology and cosmology to accompany the reconstructions of proto-languages (Ajkhenvald *et al.* 1989; Napolskikh 1992; Siikala 2002b). From our point of view, the most interesting aspect of such reconstructions is the central role accorded to migratory water-birds. In the traditional religions of Uralic peoples (an umbrella term for Finno-Ugric and Samoyedic combined), water-birds were believed to be able to travel between the worlds – a belief manifested in the common Finno-Ugric cosmological concept of a 'Land of Birds' (Finn. *lintukoto*), an island located beyond the horizon at the south-western end of the Milky Way. This otherworldly place where migrating birds fly to is known for instance among the Finns, Komi, Khanty and Mansi (Napolskikh 1992). Accordingly, the Milky Way is known as a 'Pathway of the Birds', a name used for the galaxy in most Finno-Ugric languages (e.g., Finnish *linnunrata*, Estonian *linnutee*). If we believe the reconstructions of Napolskikh and others, such concepts were an essential element of Proto-Uralic cosmology and thus may date as far back as 5000 BC – or the time when the earliest rock carvings at Lake Onega were made. Material evidence for the continuing significance of waterfowl in a Finno-Ugric context is readily available, whether in Pit and Comb Ware pottery decoration (where waterfowl are sometimes depicted) or Iron Age jewellery, where ducks and swans are a common theme throughout the entire Finno-Ugric area. As a contemporary acknowledgement of their symbolic significance, Whooper Swans (the 'national bird' of Finland) are even depicted on the Finnish one Euro coin.

In Finno-Ugric myth and ritual, waterfowl also emerge as symbols of the soul or as messengers between the world of men and that of the gods. For example, in an Udmurt ritual, two swans were caught and sent swimming upstream the River Vyatka – representing

the World River – to deliver prayers to the Supreme Deity (Napolskikh 1992, 7). As Zvelebil and Jordan (1999, 199) point out, the roots of this circumpolar symbolism associated with migratory birds seems easy to understand: the arrival of the birds from the south signalled spring and life, and their departure was a sign of autumn and death. It is therefore not surprising to find that several Uralic peoples, including the Nganasan, Enets and Dolgans, have special rites for welcoming migratory ducks and swans in the spring (Napolskikh 1992, 9). Lake Onega, it should be pointed out, lies on the migratory path of Arctic ducks and geese, for which the estuaries of Vodla and Chernaya are natural resting places. After the lean months of winter, the arrival of thousands upon thousands of birds in vast formations must have been an awe-inspiring sight, their noisy calls and courtship rituals full of life-affirming symbolism.

THE SWAN AS A SOUL-BIRD

Returning back to Lake Onega, the first important clue concerning the meaning of the swan figures surely relates to their connection to the clefts and cracks of the rock. Clefts in general seem significant at the Lake Onega sites, as many of the carving panels are clearly structured by them. The carvings of the Cape Swan locality, for example, are largely aligned along what Poikalainen and Ernits (1998, 63) refer to as the Primary Crevice. A similar, 3 m long crevice running parallel to the shoreline divides the Kochkovnavolok locality and seems to have been the focus of the carvings. Individual images can also be associated with particular cracks. The Devil of Besov Nos is the most outstanding example: it has been positioned on a wide fissure in the bedrock so that the figure is divided into two equally sized halves (cf. Figure 2.3a). That the division is intentional is confirmed by the head of the creature, which is also divided in two by a pecked line, with the left eye being fully pecked and the right one depicted in outline.

Aside from the Devil, swan figures also clearly have a special connection to cracks in the rock, appearing in situations that very rarely occur with other types of figures. At the Western Besov Nos site, for example, two gracious necks of a swan rise from a rift, as if entering our world from somewhere below. Similar scenes occur at the Kochkovnavolok site (figures E-VIII-6, E-III-4 and E-III-3 in Poikalainen and Ernits 1998). At Karetskyi Nos we see the opposite happen: the head of a magnificent swan – its neck seven times the length of its body – disappearing into a crack, as if it were just about to dive to the world below. A similar scene involving two long-necked swans, can be found at Besov Nos (Figure 2.2). There are also disembodied swan heads, as well as 'decapitated' swans that, while having no relation to a crack, would seem to belong to the same group of images. Finally, a few images have adapted a straight crack into the composition so that it forms the neck of the bird; examples can be found at least at Besov Nos (Figure 2.5) and the Cape Swan locality (figure C-III-6 in Poikalainen and Ernits 1998).

In Finnish-Karelian shamanistic folklore, cracks in the rock would appear to be the archetypal entrances to the Lower World. Indeed, the very expression used for 'falling in trance' (Finn. *langeta loveen*) in Finnish folk poetry can be literally translated as 'falling into a crack' in the ground. What is more, there is evidence that painting or carving pictures on the rock was believed to open this portal for the skilled shaman. A remarkable folk poem

recorded by the folklorist D. E. D. Europaeus in 1837 at Akonlahti, north-western Karelia, describes how the main protagonist of the epic, the shaman Väinämöinen

> *[...] Drew a picture upon the stone,*
> *Drew a line upon the rock*
> *With the stump of his thumb,*
> *With his ring finger:*
> *The stone split into two*
> *The boulder into three parts.*
> *There an adder was drinking beer,*
> *A snake was sipping maltwort*
> *Inside the blue stone,*
> *On the thick boulder's ridge*
> (SKVR I: 35, lines 12–21; translation adapted from Siikala 2002a, 190)[3]

Although the interpretation of the entire poem, of which the above is but a fragment, is unclear and is unlikely to have been fully understood even by its 19th century singers, two details seem significant for the present discussion. First, the making of pictures on the rock causes the rock to open for the shaman, and second, inside the crack he finds a snake. The snake here evidently refers to the Lower World: it can be interpreted simply as a symbol of that *topos*, or as a rival shaman that has assumed the shape of an adder (in the poems the adder commonly occurs as a synonym for a 'seer' or a 'shaman'; Turunen 1981, 154).

The notion of the painted or carved rock face as a 'membrane' between the worlds, through cracks in which the subterranean Otherworld may be reached, is a cross-culturally attested phenomenon, with ethnographic examples commonly cited from places as far away from each other as South Africa (Lewis-Williams and Dowson 1990), south-western USA (Whitley 1998) and sub-Arctic Canada (Rajnovich 1994). Given the above discussion on Finno-Ugric bird-mythology, it seems probable that many of the images of swans at Onega are to be understood as symbols of the soul, or as messengers between the worlds of humans and spirits. Swans entering a crack or emerging from one appear to symbolize the passage of the soul – of a deceased person or a shaman – between this world and the Other. The close association of swans and humans is confirmed by some exceptional images, such as two human

Figure 2.5: A swan from Besov Nos, in which a natural crack in the bedrock features as the neck of the bird. Photo of a plaster cast made of the carving (from Poikalainen and Ernits 1990: 63).

figures at Besov Nos that appear to have a head of a swan (Figures 2.6g–h), or a swan figure at the same locale that clearly has a human foot (Figure 2.6i). This association of swans and people is by no means peculiar to Finno-Ugric myth. As Kinghorn (1994) writes, in European folklore and literature swans often occur in scenes of metamorphosis and have a relation to the Otherworld. In particular '*the swan has no peer as a symbol of perfectibility and of man's immortal longings*' (Kinghorn 1994, 518).

The notion of swans and ducks as 'soul-birds' can still be found among the Vepsians of the southern Lake Onega region (Vinokurova 2005). In traditional Vepsian burial laments, for example, the human soul is often described as a bird, and at some old Vepsian and

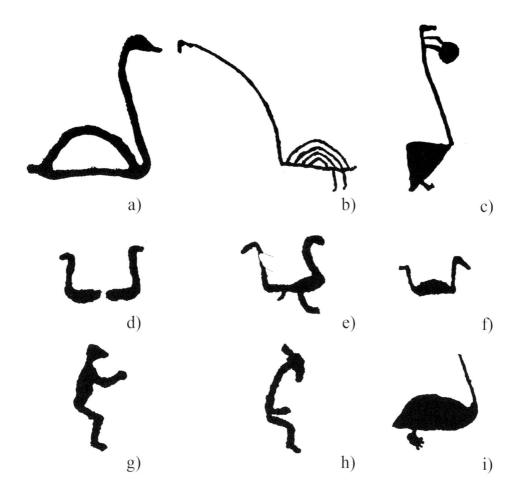

Figure 2.6: Ambiguous swans from various Lake Onega localities: a) a relatively 'naturalistic' swan; b) a 'striped' swan with an impossibly long neck; c) a long-necked swan with a 'solar symbol' attached the neck; d–f) 'double water-birds'; g–i) human-swan therianthropes. All tracings according to Ravdonikas (1936) (different scales).

Karelian cemeteries wooden bird-sculptures representing the soul of the deceased can still be found on top of the Christian cross (Vinokurova 2005, 148). Cross-culturally, swans are often employed as symbols of love or marital fidelity because of their long-lasting and (almost) monogamous relationships. Here it is interesting to note that the swans of Lake Onega are often juxtaposed, paired, or even merged together, forming two-headed bird figures (Figures 2.6d–f). Would it be too far-fetched to interpret them as representing married couples, who perhaps have died or been buried together? There may be no way to answer that question, but let it be pointed out that in Vepsian marriage poetry the soul of the bride is often described as duck (Vinokurova 2005, 147).

Pit and Comb Ware burials offer further confirmation of the association of waterfowl with death and *rites de passage* already in the Neolithic. Where organic material has been preserved, bird bones, bird-shaped pendants and objects fashioned out of bird bone are frequently found in burials (Antanaitis 1998). For example, one of the Early Neolithic burials at Zvejnieki (Latvia) included two complete mallards (*Anas platyrhynchos*), one in each arm of a young man, possibly intended to guide his soul to the Land of the Dead (Mannermaa 2008). A similar symbolism is evident in a present-day Khanty death ritual, in which a small hut was constructed to house a wooden effigy of the deceased (Zhulnikov 2008, 41). A duck was then killed and left in front of the doorway of the hut, its head oriented towards the north or the direction of the Land of Death. At the end of the ritual, the hut and the effigy were burned and the duck was boiled and eaten.

THE COSMIC SWANS

Many of the Lake Onega swans have no relation to cracks in the rock, but have other features such as size or stripes in the body that have given rise to a notion that they may represent beings of exceptional religious significance. Even today, swans are called 'god's birds' (*jumalanlind*) by the Vepsians and taboos exist against killing and eating them. Zhulnikov (2006, 42) believes that such taboos derive from the Stone Age, as there is some evidence for special treatment accorded to swan bones in the osteological material of the Russian Neolithic. Be that as it may, waterfowl have a very special role in Finno-Ugric mythology in that they are intimately associated with creation.

There are two main cosmogonic myths in the Finnish-Karelian tradition, both of them involving water-birds (Kuusi *et al.* 1977, 522–523). In the first version, known as the 'diving-bird myth', a duck dives to the bottom of the primordial ocean and brings up some mud, from which the earth is fashioned. This myth has a vast distribution in the circumpolar region, being found throughout Northern Eurasia, Siberia and even among the Algonquian-speaking peoples of North America (Berezkin 2010). In the second myth, also with a very wide distribution, the world is created from a bird's egg. Several versions of the myth have been recorded from the Finnish-Karelian region, with slight variations. In the following version, sung in 1893 by Iivana Shemeikka of Suistamo, Ladoga Karelia, to the Finnish historian Oskar Hainari, creation takes place on the mythical island of Imandra:

> *A scaup-duck, straight-flying bird*
> *flew, glided about*
> *it searched for a nesting-place:*

now it found a nesting-place
there on Imandra Island
on the knee of old Väinö
It cast a net of copper
and it laid an egg of gold
on the knee of old Väinö.
(SKVR VII1: 18, lines 29–37; translation according to Kuusi *et al.* 1977, 87–88).

Väinö (being short for Väinämöinen) then felt the heat from the nest and shifted his knee, as a result of which the eggs fell and were smashed into bits:

What was the egg's upper shell
became the heavens above
what was the egg's lower shell
became mother earth below
what was the white of the egg
became the moon in the sky
what was the yolk of the egg
became the sun in the sky
what on the egg was mottled
became the stars of heaven
what on the egg was blackish
became the clouds in the sky.
(SKVR VII1:18, lines 42–54; translation according to Kuusi *et al.* 1977, 88).

Laushkin (1962, 277–81) proposed that this myth may be depicted in an exceptional composition on the small, rocky island of Bolshoy Guri (Figure 2.7). Four figures – two elks, a geometric symbol (perhaps representing the sun) and a swan hatching an egg – have been carved inside a greenish oval lava formation in the rock. The swan is exceptional in that its body is neither an outline nor a fully pecked area, but is striped, consisting of three concentric lines. The swan of Bolshoy Guri thus differs from the mass of water-birds at Lake Onega and entails a different explanation: in this context it may be understood as a 'cosmic water-bird' and the small dot under the swan could represent the 'World Egg'. This hypothesis is strengthened by the fact that the lava formation, inside which the entire composition has been carved, is also egg-shaped. As for the three concentric lines in the body of the swan, they may be symbolic of a rainbow and hence of the sky (as suggested by Laushkin 1962, 279), or they may refer to the three levels of the universe – or some third meaning. It is difficult to be certain.

Simola (2001, 34) has pointed out that, viewed from the shore, the Guri Islands and other similar offshore islets may have evoked the image of gigantic egg-shell fragments floating in the World Ocean. Lake Onega is huge by any standards: more than 300 km long and 80 km wide, it is the second largest freshwater basin in Europe and large enough to give an impression of a boundless sea. The granitic bedrock, on the other hand, tends to fracture into large vertical and horizontal slabs created by frost action and major seismic events, which (unusually for Northern Europe) have occurred in the Lake Onega region even during the Holocene (Lukashov 1995). Egg-shell fragments seem like an appropriate analogue to the smooth and shiny, rounded but fractured cliffs. And while most carvings

sites are now located on peninsulas, the situation may have been somewhat different during the Neolithic, when at least the Vodla River localities still appear to have been small islands disconnected from the mainland (Lobanova 1995). Significantly, the poem cited above and the Finno-Ugric mythological tradition in general places the creation of the world on a mythical island – a reason, perhaps, for making carvings on small islands such as Bolshoy Guri.

Furthermore, it is important to note that the granite islets and lakeshore cliffs of the eastern shore of Lake Onega are the easternmost exposures of the Fennoscandian Shield (Simola 2001, 33). Further to the east and south, this Precambrian bedrock is covered by loose soils, making the landscape completely different. The Pit and Comb Ware culture, to which the first carvings at Lake Onega are attributed, seems to have spread to Lake Onega from the Valdai region in the east (Carpelan and Parpola 2001). To these newcomers, the granite cliffs – polished by the glaciers and reflecting the brilliance of the sun – would have been an unfamiliar and strange phenomenon that required an explanation. While the myth of the World Egg may well have been a part of their cultural repertoire, the egg-shell shaped cliffs and islands would have actualised the myth. Here, surely, may be found one reason for making rock carvings at Lake Onega: *the cliffs may have been viewed as a place where the world was created.*

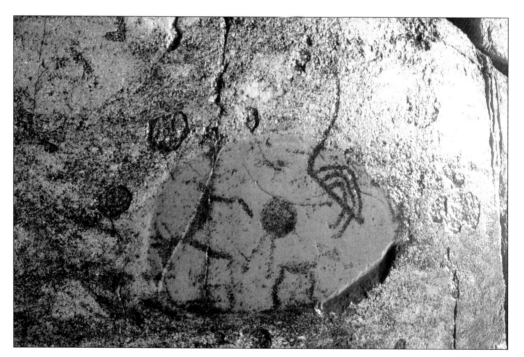

Figure 2.7: The World Egg? A group of carvings from Bolshoy Guri island, including (from left to right) an elk, a solar symbol, a second elk and a 'striped' swan with an egg – all carved within an egg-shaped lava formation. Photo: Heikki Simola (August 2000).

Rock carvings are not the only archaeological remains at the Guri Islands. Even though both the 'Big' (*Bolshoy*) and 'Small' (*Malyi*) Guri Island are very small (the latter being only 75 × 36m and only a couple of metres high). The former especially witnessed intensive use in the Pit and Comb Ware period, with several large fireplaces, some lithics and a large number of pottery vessels of different sizes having been excavated (Savvateyev 1988, 65–66). The excavations of a small sandy knoll in the middle of Bolshoy Guri in addition revealed a 80cm thick cultural layer, with a 30cm thick layer of charcoal on the bottom. Even little Malyi Guri island, which is regularly washed over by waves during storms, yielded some finds. The finds are less plentiful, consisting of lithics and pottery found under the turf in small cracks of the rock, but nonetheless testify to an extraordinary fascination for these little islets by the Neolithic inhabitants of Lake Onega.

LOST MEANINGS

The aim of this paper has been to explore the convergences of recent folklore and Neolithic rock art in North-Western Europe and to highlight the potential of folklore in deciphering the ambiguous imagery of rock art. The case study chosen, the waterfowl images of Lake Onega, is in my opinion particularly fruitful in this respect (although certainly not the only one, see e.g., Lahelma 2007). The swans of Lake Onega appear in a wide range of situations and contexts, as well as featuring a number of meaningful details, some of which find an explanation in the local folklore concerning swans and other migratory waterfowl. Needless to say, I am rather more optimistic than Bednarik (2007) about our capabilities of producing correct identifications and credible interpretations of Lake Onega rock art – even if I am, of course, somewhat biased in this question.

Yet, not every image at Lake Onega finds a convenient 'informed' interpretation based on folklore – far from it. To take just two examples, we may consider the swan-elk and swan-whale 'chimeras', discussed by Vieira (2010) and Poikalainen (1999) respectively. Vieira (2010, 257) found that the correlation of swan and cervid figures at the various Onega sites was particularly strong, and presented a few superimposed swan-elk compositions, where part of one animal contributes to the other's body. These correlations indicate some semantic link between elk and swans at the Lake Onega carvings, but although both elk and swans occupy significant roles in Finno-Ugric myth and folklore, there seem to be few conceptual links between the two.

Poikalainen (1999), on the other hand, has drawn attention to similarities between certain images at the two main carving areas of Karelia, the eastern shores of Lake Onega and River Vyg estuary on the White Sea, where beluga whales are commonly depicted. In spite of the distance of 300km, there are some unusual similarities that suggest direct contacts or a diffusion of ideas between these two regions. The most striking are the images of belugas at Lake Onega, which certainly seem out of place on the shores of a freshwater basin where no whales of any kind have ever lived. On the other hand, some swans and two-headed waterfowl images reminiscent of those of Lake Onega occur at River Vyg. Poikalainen suggests that this 'exchange' of images, which even includes some hybrid swan-whale motifs at Besov Nos, may refer to the coalition of 'swan' and 'whale' clans, or perhaps even mark the formation of a new 'swan-whale tribe'. Whether one agrees with

that interpretation or not, the conclusion that these images carry meanings that are lost to us is evident. As far as I know, there is little in Finno-Ugric myth and folklore that could provide an interpretation to rock carvings of whales or 'swan-whales' at Lake Onega.

Thus, even though Chippindale's *'slim possible window'* for ethnographically informed interpretation seems to be open in Karelia, we should remain vigilant in guarding it. Folklore-based interpretations must strive beyond mere superficial similarities between rock art images and mythological themes or personae. In the present case, two main justifications for using Finno-Ugric myths concerning swans and other waterfowl to interpret the swan petroglyphs of Lake Onega were presented. First, the archaeological record of the carving region suggests an unbroken sequence of habitation from the Mesolithic to the present day. And second, reconstructions of Proto-Uralic cosmology and myth were briefly reviewed. The latter offer the strongest line of support, in indicating that certain common Finno-Ugric mythological notions concerning waterfowl are thousands of years old and quite possibly existed already when the rock carvings were made.

NOTES

1 It should be pointed out here that the 'forest Neolithic' of the North Eurasian Boreal zone differs in some respects from the 'true Neolithic' of Southern and Central Europe. The differences may not be as great as once thought: the northern communities used pottery, made clay figurines, sometimes lived in village-like communities, and practiced some agriculture and animal husbandry (Mökkonen 2011). However, the role of the latter in food production was limited and the real subsistence base lay in hunting and fishing. There is little in the imagery of the Lake Onega carvings that could be interpreted as referring to 'true Neolithic' lifeways.

2 This is the original text: '*Im Munde des Volkes geht die Sage, als hätten vor langen langen Jahren hier der Teufel und seine Ehehälfte (Bess und Bessicha) gehaust und ihre Anwesenheit durch die wunderlichen Figuren auf dem Felsen beurkundet. Da sei aber der leibhaftige Christ und der wahre Glaube eingezogen und hätte über die teuflischen Bilder Kreuze geschlagen. Flugs mussten nun die bösen Geister weichen, wollten indessen, da sie sich auf den Weg machten, gar gerne noch eine Erinnerung, d. i. ein Felsstück, von der ihnen lieben Stätte mitnehmen, stürzten aber bei diesem Vorhaben, zusammt dem Felsblocke – der noch gezeigt wird – in den See und ertranken.*'

3 The translation offered in Siikala 2002 has Väinämöinen *'writing a rune'* upon the stone, which is misleading. In the Finnish original, the word translated as 'rune' is *kirja*, which in modern Finnish means 'book' but in the context of *Kalevala*-metric poetry (composed in a primarily non-literate culture) meant 'a drawing', 'a sign' or something that is decorated (Turunen 1981, 123–124). The verb *kirjoittaa* (modern Finnish 'to write') should similarly be tra0nslated as 'to decorate' or 'to draw'.

REFERENCES

Ajkhenvald, A., Helimski, E. and Petrukhin, V. 1989. On earliest Finno-Ugrian mythologic beliefs: comparative and historical considerations for reconstruction. In M. Hoppál and J. Pentikäinen (eds), *Uralic Mythology and Folklore*, 155–9. Helsinki: Finnish Literature Society.

Antanaitis, I. 1998. Interpreting the meaning of East Baltic Neolithic symbols. *Cambridge Archaeological Journal* 8(1), 55–68.

Bahn, P. 1998. *The Cambridge Illustrated History of Prehistoric Art*. Cambridge: Cambridge University Press.

Bednarik, R. 1992. Developments in rock art dating. *Acta Archaeologica* 63, 141–55.

Bednarik, R. 2007. *Rock Art Science: the scientific study of palaeoart*. New Delhi, Aryan Books International.

Berezkin, Y. 2010. The Pleiades as openings, the Milky Way as the Path of Birds, and the Girl on the Moon: cultural links across northern Eurasia. *Folklore* 44, 7–34.

Bradley, R., Chippindale, C. and Helskog, K. 2001. Post-Palaeolithic Europe. In D. Whitley (ed.), *Handbook of Rock Art Research*: 482–529. Walnut Creek: Altamira Press.

Carpelan, C. and Parpola, A. 2001. Emergence, contacts and dispersal of Proto-Indo-European, Proto-Uralic and Proto-Aryan in archaeological perspective. In C. Carpelan, A. Parpola and P. Koskikallio (eds), *Early Contacts between Uralic and Indo-European: linguistic and archaeological considerations*, 55–150. Helsinki: Suomalais-ugrilainen seura.

Chippindale, C. 2000. Theory and meaning of prehistoric European rock art: 'Informed Methods', 'Formal Methods' and questions of uniformitarianism. In K. Helskog (ed.), *Theoretical Perspectives in Rock Art Research,* 68–98. Oslo: Novus.

Cook, A. 1980. *Myth and Language*. Bloomington: Indiana University Press.

Grewingk, C. 1855. Über die in Granit geritzten Bildergruppen am Ostufer des Onega-Sees. *Bulletin de la Classe des Sciences historiques, philologiques et politiques de l'Académie Impériale des Sciences de Saint-Pétersbourg* 12(7–8), 97–103.

Häkkinen, J. 2009. Kanturalin ajoitus ja paikannus: perustelut puntarissa. *Suomalais-Ugrilaisen Seuran Aikakauskirja* 92, 9–56.

Häkkinen, K. 1996. *Suomalaisten esihistoria kielitieteen valossa*. Helsinki: Suomalaisen Kirjallisuuden Seura.

Hallström, G. 1960. *Monumental Art of Northern Sweden from the Stone Age: Nämforsen and other localities*. Stockholm: Almqvist and Wiksell.

Helskog, K. 1988. *Helleristningene i Alta*. Alta: Alta Museum.

Jauhiainen, M. 1999. *Suomalaiset uskomustarinat: tyypit ja motiivit*. Helsinki: Suomalaisen kirjallisuuden seura.

Jordan, P. 2004. Examining the role of agency in hunter-gatherer cultural transmission. In A. Gardner (ed.), *Agency Uncovered. Archaeological Perspectives on Social Agency, Power and Being Human,* 107–34. London: UCL Press.

Kalevala. 1990. *The Kalevala: Or the Land of Heroes*, translation by Keith Bosley, foreword by Albert B. Lord. Oxford: Oxford University Press.

Kinghorn, A. 1994. The swan in legend and literature. *Neophilologus* 78, 509–20.

Kuusi, M., Bosley, K. and Branch, M. (eds and transl.) 1977. *Finnish Folk Poetry: Epic*. Helsinki: Finnish Literature Society.

Lahelma, A. 2007. 'On the Back of a Blue Elk': recent ethnohistorical sources and 'ambiguous' Stone Age rock art at Pyhänpää, Central Finland. *Norwegian Archaeological Review* 40(2), 113–37.

Lahelma, A. 2008. A touch of red: archaeological and ethnographic approaches to interpreting Finnish rock paintings. *Iskos* 15. Helsinki: Finnish Antiquarian Society.

Laushkin, K. 1959. Онежское святилище. Часть 1. *Скандинавский сборник* IV, 83–110.

Laushkin, K. 1962. Онежское святилище. Часть 2. *Скандинавский сборник* V, 177–298.

Lehtinen, T. 2007. *Kielen vuosituhannet: suomen kielen kehitys kantauralista varhaissuomeen*. Helsinki: Suomalaisen Kirjallisuuden Seura.

Lewis-Williams, D. and Dowson, T. 1990. Through the veil: San rock paintings and the rock face. *South African Archaeological Bulletin* 45, 5–16.

Linevsky, A. M. 1939. *Петроглифы Карелии. Петрозаводск*.

Lobanova, N. 1995. Petroglyphs of the Kochkovnavolok Peninsula: dating, natural environment and the material culture of their creators. In K. Helskog and B. Olsen (eds), *Perceiving Rock Art: Social and Political Perspectives*: 359–66. Oslo: Novus.

Lukashov, A. 1995. Paleoseismotectonics in the northern part of Lake Onega (Zaonezhskij Peninsula, Russian Karelia). *Geological Survey of Finland Report YST–90*. Espoo: Geological Survey of Finland.

Mannermaa, K. 2008. Birds and burials at Ajvide (Gotland, Sweden) and Zvejnieki (Latvia) about 8000–3900 BP. *Journal of Anthropological Archaeology* 27(2), 201–225.

Mökkönen, T. 2011. *Studies on Stone Age Housepits in Fennoscandia (4000–2000 Cal BC): Changes in Ground Plan, Site Location, and Degree of Sedentism*. Helsinki.

Napolskikh, V. 1992. Proto-Uralic world picture: a reconstruction. In M. Hoppál and J. Pentikäinen (eds), *Northern Religions and Shamanism*: 3–20. Budapest: Akadémiai kiadó.

Patrushev, V. 2000. *The Early History of the Finno-Ugric Peoples of European Russia*. Oulu: Societas historiae Fenno-Ugricae.

Poikalainen, V. 1999. The diffusion of swan and whale motifs in Karelian rock art. In A. Gustafsson and H. Karlsson (eds), *Glyfer och arkeologiska rum: en vänbok till Jarl Nordbladh*: 699–717. Gothenburg: University of Gothenburg.

Poikalainen, V. 2004. Synopsis of the Lake Onega rock art. In M. Otte, L. Oosterbeek, D. Seglie and L. Remacle (eds), *Upper Palaeolithic and Mesolithic Art*, 135–50. Oxford: Archaeopress.

Poikalainen, V. and Ernits, E. 1998. *Rock Carvings of Lake Onega: the Vodla Region*. Tartu: Estonian Society of Prehistoric Art.

Rajnovich, G. 1994. *Reading Rock Art: Interpreting the Indian Rock Paintings of the Canadian Shield*. Ontario: Natural Heritage Books.

Ravdonikas, V. 1936. *Наскальные изображения Онежского озера и Белого моря. Часть 1*. Москва: Издательство академий наук.

Saressalo, L. (ed.) 2005. *Vepsä – maa, kansa, kulttuuri*. Helsinki: Suomalaisen kirjallisuuden seura.

Savvateyev, Y. 1970. *Залавруга: археологические памятники низовья реки Выг. Часть 1: петроглифы*. Наука: Ленинград.

Savvateyev, Y. 1982. Rock pictures of Lake Onega. *Bollettino del Centro Camuno di Studi Preistorici* XIX, 27–48.

Savvateyev, Y. 1988. Ancient settlements connected with rock art in Karelia. *Bollettino del Centro Camuno di Studi Preistorici* XXIV, 45–68.

Shved, P. 1850. *Крестовый и Пелий мысы на Онежском озере. Геогр. Изв. Рус. Геогр. О-ва* 1: 68–71.

Siikala, A.-L. 2002a. *Mythic Images and Shamanism. A Perspective on Kalevala Poetry*. Helsinki: Academia Scientiarum Fennica.

Siikala, A.-L. 2002b. What Myths Tell About Past Finno-Ugric Modes of Thinking. In Siikala, Anna-Leena (ed.), *Myth and Mentality*: 15–32. Helsinki: Finnish Literature Society.

Simola, H. 2001. Kallioon piirretyt kuvat: retki Äänisen kalliopiirrosten maailmaan. *Muinaistutkija* 4/2001, 33–41.

Stolyar, A. 2000. Spiritual Treasures of Ancient Karelia. In Kare, Antero (ed.) *Myanndash – Rock Art in the Ancient Arctic*: 136–73. Rovaniemi: Arctic Centre Foundation.

Taçon, P. and Chippindale, C. 1998. An archaeology of rock-art through informed methods and formal methods. In C. Chippindale and P. Taçon (eds), *The Archaeology of Rock-art*, 1–10. Cambridge: Cambridge University Press.

Trigger, B. 2006. *A History of Archaeological Thought* (2nd edition). Cambridge: Cambridge University Press.

Turunen, A. 1981. *Kalevalan sanat ja niiden taustat*. Joensuu: Karjalaisen kulttuurin edistämissäätiö.

Vieira, V. 2010. A context analysis of Neolithic *Cygnus* petroglyphs at Lake Onega. *Cambridge Archaeological Journal* 20(2), 255–61.

Vinokurova, I. 2005. Vepsäläisten mytologis-uskonnollisista käsityksistä. In L. Saressalo (ed.), *Vepsä – maa, kansa, kulttuuri*, 136–51. Helsinki: Suomalaisen kirjallisuuden seura.

Vuorela, I., Saarnisto, M., Lempiäinen, T. and Taavitsainen, J.-P. 2001. Stone Age to recent land-use history at Pegrema, northern Lake Onega, Russian Karelia. *Vegetation History and Archaeobotany* 10(3), 121–38.

Whitley, D. 1998. Finding rain in the desert: landscape, gender and Far Western North American rock-art. In C. Chippindale and P. Taçon (eds), *The Archaeology of Rock-Art*, 11–29. Cambridge: Cambridge University Press.

Zhulnikov, A. 2006. *Петроглифы Карелии: образ мира и миры образов*. Петрозаводск: Скандинавия.

Zhulnikov, A. 2010. New rock carvings from the Peri Nos VI Cape on Lake Onega. *Fennoscandia Archaeologica* XXVII, 89–96.

Zvelebil, M. 1997. Hunter-gatherer ritual landscapes: spatial organisation, social structure and ideology among hunter-gatherers of Northern Europe and Western Siberia. *Analecta Praehistorica Leidensia* 29, 33–50.

Zvelebil, M. and Jordan, P. 1999. Hunter fisher gatherer ritual landscapes – questions of time, space and representation. In J. Goldhahn (ed.), *Rock Art as Social Representation*, 101–27. Oxford: British Archaeological Reports S794.

'Noble death': images of violence in the rock art of the White Sea

Liliana Janik

INTRODUCTION

The creation of rock art was an effective way of keeping memory alive in the Neolithic. By carving images, by returning to the same locations over and over again and carving more, by performing rituals or simply reminiscing about events or retelling the stories carved into the rocks, memories were kept alive over thousands of years around the White Sea in north-western Russia. Using contemporary vocabulary in trying to categorise what this rock art is all about, I suggest it is a monument, whose location as a cultural marker in a very tangible way defines landscape. By carving the rocks the local community or communities committed events, people and ideas to cultural and social memory. The long term perspective offered by rock art allows us to look at these events, people and ideas as active elements, and sometimes as an agency that shapes *hard* and *soft* memory (Etkind 2004).

The ideas of hard and soft memory were introduced by Etkind (2004) in his study of cultural memory in Russia and Germany. In Etkind's formulation, hard memory is related to monuments and soft memory to text. Etkind proposes that these two forms can either be exclusive, 'monuments without inscription are mute, whereas texts without monuments are ephemeral', or they can strengthen each other (Etkind 2004, 40). In the case of the rock art I suggest they complement each other, since in the first instance rock art is based on non-verbal communication relying on visual narratives that convey the story through looking rather than reading (Janik 1999). Such an interpretation of rock art gives a voice to the images and allows the monument to communicate the stories in a way independent from other forms of message. At the same time, the monument/rock art enhances and complements other types of story telling, social or ritual communication and interaction.

In this paper, I concentrate on the memory of violence, in a situation where hard memory is exclusive to one particular site among a number of locations, and where soft memory undergoes transformation of what is carved. In such a way the monument and the memories embedded in it were culturally and socially active over the long term, while the carvings were 'rewritten' by subsequent generations of carvers.

THE MONUMENT

The carvings of the While Sea are found at 14 distinct locations in north-western Russia (Figure 3.1). In this paper, however, I concentrate on depictions that are only found at the Zalavruga site (Janik 2010). Zalavruga is historically divided into two parts: Old and New. Old Zalavruga was recorded for the first time by Ravdanikas and his team in 1936 (Ravdanikas 1938), while later investigations led to the discovery of New Zalavruga (Savvateev 1970; Lubanova 2007; Janik 2010). Overall more than 2200 images have been recorded at Zalavruga. Their chronology has been established on the basis of correlations between the isostatic changes in the levels of the White Sea and C14 dating of particular locations above sea level, which indicate that the carvings were created made between *c.* 4495–2080 cal BC (5625–4001 BP) (Janik 2010). These images thus provide us with the opportunity to study from a long term perspective the embedding of hard and soft memory on the rock surfaces.

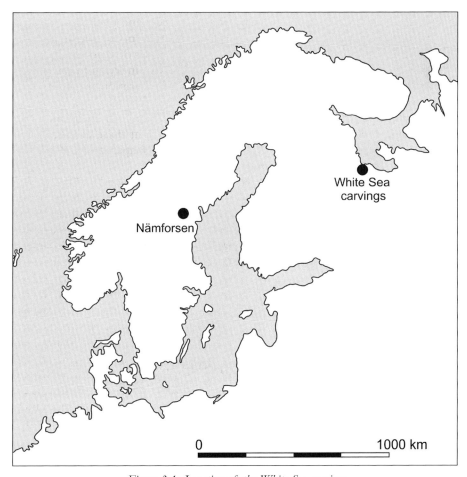

Figure 3.1: Location of the White Sea carvings.

VIOLENCE AND WARFARE

Violence and warfare were discussed in the context of the White Sea carvings as early as 1939 by Linevskij (Figure 3.2). He was the first archaeologist to conduct recording and field work in this region. Linevskij (1939) proposed that the carvings today known as Old Zalavruga show scenes of warlike conflict between land and sea communities. This interpretation of the carvings is framed within a classical understanding of war as a conflict between two distinct groups: '*a state of armed conflict between different countries or different groups within a country; a state of competition or hostility between different people or groups*' (Oxford Dictionaries).

The best known example of rock art depicting war is from the Spanish Levant (Beltran 1982; Osgood *et al.* 2000; Nash 2005). The Castellón carvings were at first dated to the Mesolithic but were later reclassified as Neolithic. These examples can also be understood as representations of acts of vendetta or feuds rather than expressions of war, other forms of organised violence (Christiansen 2004). Warfare is first evidenced in the archaeological literature in accounts of skeletal remains exhibiting injuries indicating a violent cause of death from the Palaeolithic in Europe and Africa. To these we can add the account of grave 179 from Zvejnieki (Latvia), dating to the Early Neolithic, although at this time communities living in this region still relied on a food procuring rather than a food producing economy. Grave 179 was a dual burial of a female and a male who 'had injuries: punctures in pelvis and lumbar vertebrae, and a flint flake lodged in one of the lumbar vertebrae. In the opinion of the palaeopathologist Vilis Derums, the injuries had been inflicted with considerable force, since they had left traces in dense hard bones' (Zagorskis 2004, 81).

Acts of violence in the rock art of Northern Europe are best known from the Bronze Age, where we can see contests being conducted between men. They fight with axes, spears or clubs, the scenes take place on land or on boats (Coles 1990; Osgood *et al.* 2000; Harding 2007). In some scenes, interpreted as representations of hunting, we can see two archers holding bows with arrows pointed at each other (Coles 1990, 33, 61). Harding suggests that Bronze Age scenes reflect ritual combat rather than actual acts of violence:

Figure 3.2: Representation of warlike combat in depictions F and D (adjusted after Savvateev 1970).

'The brandished weapons never seem actually to be striking the opponent, just waved in the air.
Swords are implied by the scabbards that are frequently depicted hanging by the waist, but swords
themselves are rarely depicted, and never in action. Vanquished or dead victims are not shown'
(Harding 2007, 116–17).

As I will present below, the acts of violence in the White Sea rock art differ dramatically
in that we do see the injured, though this does not necessarily mean that we are witnessing
representations of real combat.

The stress on looking for acts of violence and warfare is a part of a contemporary
paradigm in archaeology (Armit *et al*. 2007). As Thorpe (2003; 2005) has shown in several
publications, however, the expression and presence of violence differs through time and
space, and is culturally specific: '*historical contingency would reject any of the unified theories … in
favour of the examination of the particular circumstances of each conflict, and indeed, of each example
of the lack of conflict*' (Thorpe 2005, 6). Following such an approach I will provide an
interpretation of the White Sea art that opens up the possibility of violence as a symbolic
act that transcends the boundary between humans and animals, and moves us on from
regarding the violence depicted as an expression of fighting for resources or control over
particular territory (Sipilä and Lahelma 2007). As in most cases of archaeological enquiry,
the depictions I will discuss do not have analogies in prehistoric or historical data. Rare
Palaeolithic depictions show human-like figures struck by some kind of projectiles, although
it is often difficult to be certain about what kind of projectiles they are, or whether they
are lines symbolising other unknown entities entering or exiting the body (Guilaine and
Zammit 2005, 54, fig. 10). Depictions of violence towards animals is also sporadic, even
though it is more frequent than towards humans. The person causing injury to the animal
is never seen, and the animal does not appear to be in distress. Leroi-Gourhan (1968),
and following him Guilaine and Zammit (2005, 53) take this as an indication of ritualised
violence. Ritualised violence may provide a way to look at the depictions from the White
Sea, but the circumstances of what and how it is being depicted is unique to this region.

Injury-inflicting tools

Let us return to Linevskij's (1939) description of warlike combat centred on one image
depicting an injured individual, resembling a pin-cushion, i.e. stuck full with apparently sharp
objects, the type of injury on which I focus in this article. First, however, I will summarise
what we know about the types of tools that were used to inflict injuries.

Type of tools used to cause injuries known from the archaeological record can be divided
into two categories: those indicated by the wounds found on skeletal remains and those
depicted in rock art. The latter have been described by Chapman (1999) as tool-weapons,
as they can perform other functions, such as hunting tools, as well as causing injury to
other humans. As I demonstrate below, these tool-weapons are of vital importance in
looking at the injured.

In the White Sea region the preservation of bones is very poor. Therefore it is impossible
to infer the injuries inflicted in acts of violence based on skeletal data. This leaves us with
the second way to look at the cause of injuries: through depictions in the rock art itself.
When considering the type of tool-weapons used in inflicting injuries on humans, it is
striking that only one implement is depicted in the White Sea region, namely the bow and

arrow. This is in marked contrast to the iconography of the North European Bronze Age, which depicts a number of types of weapons employed in ritual violence.

It has been proposed, on the basis of arrowhead morphology and the technology that allowed the attachment of flint barbs into arrow shafts, that archery dates from the end of the Palaeolithic (Guilaine and Zammit 2005). The earliest remains of bows and arrow shafts date to about 11,000 years ago (Insulander 2002). One of the best examples of Mesolithic bows come from Vis I (Russia) and is dated to between 8000 and 7000 years ago (Burov 1989, Guilaine and Zammit 2005). The bows from Vis I differ in length from short bows *c.* 55cm long to large bows, 250–350cm in length. Guilaine and Zammit (2005) compare the large bows to Maglemosian bows similar in size found in Denmark, dating to between nine and ten thousand years ago. They also point out that the length of these bows does not differ from the depictions of majority of bows in Spanish Levantine rock art. The White Sea bows are not as long, and some look flexible, suggesting technologically advanced two-wood or composite bows (Figure 3.3) (Insulander 2002). Such composite bows would be used to release arrows perhaps up to a distance of 889m, the record attributed to Turkish Ottoman archers in 1789. Even if we half this distance assuming that neither the technology, skilfulness nor materials used in prehistory were as advanced, it is possible that arrows could still be shot over distances of up to half a kilometre. Not all the bows depicted in the White Sea rock art are two-wood or composite bows, some being the so-called self or simple bows (Figure 3.4). The depictions of the use of the bows in the rock art suggest a relatively short range. The space between the person who releases the arrow and the person who is struck is usually very short, possibly indicating a particular relationship between the 'slayer' and the 'slayed'. In most cases, however, we do not see the 'slayer'.

There are no other tool-weapons depicted in the White Sea carvings other

Figure 3.3: The image of a human with arrows in the back, depiction A (adjusted after Savvateev 1970).

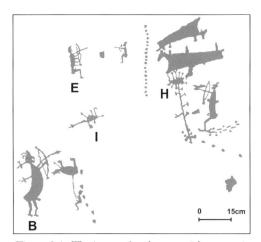

Figure 3.4: The image of a human with arrows in the back, depiction B; representation of 'pin-cushion' human, depiction E; representations of 'pin-cushion' non-humans, depictions H and I (adjusted after Savvateev 1970).

than bows and arrows. Images of clubs are linked with individuals taking part in processions or in boats. There is just one scene that might depict fighting with the fists, but this could equally be the depiction of some sort of embrace.

Looking again at the composition considered by Linevskij (1939) as an illustration of war, the imagery of the person struck by a number of arrows is compelling. Furthermore, on the right of this image we see a number of humans with arrows lodged in their bodies. What we see in this composition are two types of injuries: one showing arrows piercing the individual concerned in the back; the second depicting something resembling a human 'pin-cushion' (Figure 3.2).

ACTS OF MEMORY AND IMAGES: SOFT MEMORY AND TIME

Humans with arrow/s in their backs

The depiction of the first type of injury looks stylised (Table 3.1). The legs of individuals with arrow/s lodged in their backs can be straight as in a standing position, or with knees bent as if sitting but with the chair removed (e.g. Figure 3.4). The highest concentration of such carvings is at Old Zalavruga (Depiction D), dated as the last carved (Figure 3.2). Similar images can also be found in other locations at New Zalavruga, dating to a number of phases, suggesting they are persistent and not just introduced and later forgotten. Soft memory is thus carved into the rocks over time, but the message takes different trajectories as it was 'rewritten'. This phenomenon can be traced through representations of animals with arrows in their backs, or rather tails. Two images of water birds, one sitting in a tree, the second free standing is found in the first phase (Figure 3.6). It could be argued that the relationship between the arrow in the back and the human having the arrow in the back can be traced from the start to the end of carving at Zalavruga. It is significant, the relationship starts with the image of a bird which in subsequent carvings transcends the animal/human divide to become human, most probably male. In both humans and birds the arrows are very well defined, and there is no question that the carvings represent the lower part of the arrow with the shaft partly visible and well-defined fletching. Sometimes arrows are lodged in the back *per se*, sometimes in the bottom, and sometimes in the back of the head.

Soft memory when looked at from the perspective of the relationship between time and subject carved can be interpreted as the reworked 'text' according to particular needs to express ideas and concepts by the local communities at particular times. Hard memory

Table 3.1: Dating of the images representing humans with arrows in their backs (Janik 2010, 90).

DEPICTION NO	NON CAL BP
A	*c.* 4645
B	*c.* 4688–4340
C	*c.* 4210–4079
D	*c.* 3952–3666

on the other hand stays in place creating the focus for the soft memory to be reworked and redrafted in the process of carving.

The images of humans with arrows lodged in their backs differ through time. In the earliest Depiction A (Figure 3.3), the injured party with two arrows in his back is associated with the carving of a second individual. Both individuals hold a bow in their hands, but while the injured man holds an arrow in his bow ready to be released, the second person's bow is empty. The size and 'bendiness' of the bows might indicate the use of the two wood or composite bow, especially in the case of the bow held by the first person, while the second possibly has a soft bow. Both archers have special hairstyles, while the first also has a beard. It is significant that in a number of depictions from the whole range of carvings we can distinguish well-defined hairstyles or hair decorations as well as beards.

The second carving, Depiction B (Figure 3.4) shows a large man who holds a bow with an arrow ready to be released towards a swan. This man also has a special hairstyle or hair decoration, and indeed one of the arrows could almost be a ponytail.

The third image, Depiction C (Figure 3.5) is a composite of three male figures carved one after the other, creating a fan-like impression. The feet are close, while the torsos spread outwards. The figures are connected to each other, to the right they are linked to an unidentified object, and on the left to a large image in the shape of a salmon. The man in the middle has an arrow embedded in the area of his waist. The last man on the right holds a bow with an arrow directed at a creature in front of him. All the men have hairstyles with large folding-forward fringes and beards.

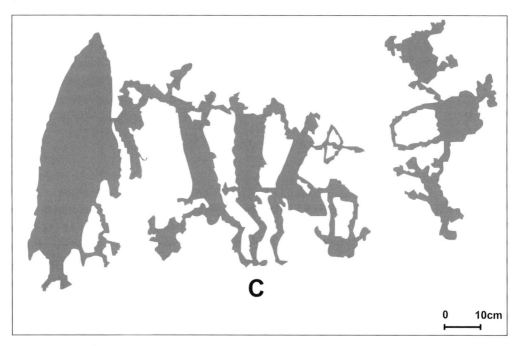

Figure 3.5: Image of a human with arrows in the back, depiction C (adjusted after Savvateev 1970).

The last figures, Depiction D (Figure 3.2), come from one of the latest compositions to be carved. They comprise three individuals with arrows in their backs. In this composition we can also see a 'pin-cushioned' individual.

'PIN-CUSHION' IMAGES: 'PIN-CUSHION' HUMANS

The idea of 'pin-cushion' death represents the symbolic act of destroying not only the body but also the spirit (Kelly 1999, 102, pl. 2; Guilaine and Zammit 2005, fig. 18). Extending modern distinctions back to the Neolithic may not always be appropriate, but in this case arguing for a spirit:body distinction is helpful and shows the scenes in the context of an understanding of what is being represented in the rock art. This practice has been known through the millennia:

> 'Perhaps the most common mutilation was "overkill" which involved shooting so many arrows into an enemy's body that he looked like a "human pin-cushion". In these cases, the disfigurements expressed hatred for the enemy and were meant to enrage surviving foes. Similar mutilations practiced on the bodies of the victims at Crow Creek in 1325, at the Larson site in 1785, and at Little Bighorn in 1876 show that the North American Plains' traditions of mutilation and scalp taking persisted for over 500 years. Over 11,000 years ago, overkilling with arrows was practiced by the enemies of the victims buried in the Gebel Sahaba cemetery in Egypt. Several adult skeletons,-male and female-bore evidence of having been shot with between 15 and 25 arrows' (Kelly 1999, 102).

The meaning of these acts, however, could have differed according to time and cultural context. Sipilä and Lahelma (2007) have argued for such an understanding of the Zalavruga carvings. Such an interpretation, however, points towards the need for a more intricate approach than just using direct ethnographic analogy when we look at other 'pin-cushion' depictions from this rock art complex.

At Zalavruga two depictions of humans being killed in this 'pin-cushion' manner have been found (Table 3.2). The first is part of a large composition (Figure 3.4), where two archers face each other, Depiction E. The one on the right has a bow with an arrow, while the larger figure on the left also holds a bow with an arrow and his upper torso is replete with three or four arrows. Both figures possibly have beards but different hairstyles: the hair on the right hand figure is similar to those of the Depiction C, while the hair on the left figure has an elaborated fringe as in the cases described above. What is important when thinking about the symbolic destruction of the spirit when the body is 'already' killed, is that both look the same, the 'killer' and the 'killed'. They hold their bows with arrows directed towards the person opposite and they are almost in a sitting position.

The second example shows an equally alive person (Janik 2005), Depiction F (Figure 3.2). The visual narrative in this image is slightly more complicated and its interpretation

Table 3.2: Dating of the images representing 'pin-cushion' humans (Janik 2010, 90).

DEPICTION NO	NON CAL BP
E	*c.* 4688–4340
F	*c.* 3952–3666

depends on our acceptance of where the arrows are coming from and who is shooting whom. Looking from the individual on the right we see arrows lodged in the body of the standing person who holds the bow. The bow is empty, but pierced by two incoming arrows, and the body of the person holding the bow is 'pin-cushioned' from head to toe by seven arrows. The arrows fly towards and behind the first archer reaching a second individual who holds and is pierced by one arrow. The carved marks most probably indicate footprints leading from one individual to the other. Visually, then, these two individuals are linked by flying arrows and footprints. The line of footsteps could indicate that the individual on the left, after covering the distance implied by the foot marks, was struck by all the arrows and that we do not in fact see the 'killer'. On the other hand we could also interpret this scene as representing one person in pursuit of the other. Whichever interpretation we choose, and even if it is possible that additional 'arrows' were added by different people at later times – thereby augmenting and altering earlier narratives the individual on the right has 'pin-cushion' injuries. Looking to the right we can see a number of individuals with arrows in their backs as indicated above, but none of them seems to have been targeted by particular arrows or any individual with a bow.

NON-HUMAN 'PIN-CUSHION' IMAGES

The injuries caused by overkill are not restricted to humans, but are also seen in birds, bears and other creatures of indeterminate shape (Table 3.3). This is the reason why I suggest that the interpretation of Zalavruga's human 'pin-cushion' human images needs to go beyond historical and ethnographic analogies.

Looking again at Figure 3.2 we can see a possible relationship between the variously injured humans, birds, indeterminate creatures and archers. As in the previous example, it is difficult to suggest only one interpretation for these images. For the purpose of this paper, however, I am concentrating on the images central to this discussion. Other aspects of this composition are discussed in my previous publications (e.g., Janik *et al.* 2007; Janik 2009).

Among the carvings of the first phase we find a scene of a water bird, probably a swan, being killed with a number of arrows, Depiction G (Figure 3.6). Three arrows entered the bird from various directions delivered by two hunters standing by the bird. The 'pin-cushion' effect of overkill is achieved here for the first time.

Table 3.3: Dating of the images representing 'pin-cushion' non humans (Janik 2010, 90).

FIGURE NO.	NON CAL BP
G	*c.* 4775–4718
H	*c.* 4688–4340
I	*c.* 4688–4340
J	*c.* 4688–4340
K	*c.* 4210–4079

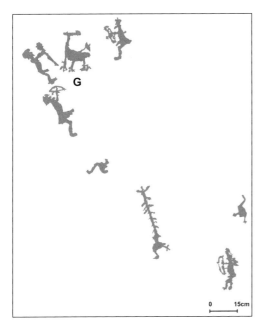

Figure 3.6: The depiction of a number of water birds with arrows in the tails, and 'pin-cushion' depiction G (adjusted after Savvateev 1970).

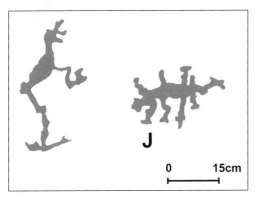

Figure 3.7: The image of a 'pin-cushion' indeterminate creature, depiction J (adjusted after Savvateev 1970).

The second representation of a 'pin-cushion' kill is part of a multifaceted composition, Depiction I (Figure 3.4). Starting from the top we see two individuals shooting at each other as presented above. Below the larger person we see a small carving of a human figure with an empty bow and, once again, an interesting hairstyle. In front of him/her we see a swan as if two arrows from this individual's bow have lodged in the bird's back. The swan's tail takes the shape of the arrow which could have been released from the bow of the male figure with two arrows in his back (as described above). Just below the arrow lodged in the bow, we see a bear impaled upside down on a spear held in both hands by the man. I suggest that the representation of the bear killed here is shown without overkill, indicating that it is part of hunting. The arrow lodged in its throat is a part of the tool rather than a tool-weapon, and the same can be said about the spear. Looking slightly above this scene and towards the right, we see a 'pin-cushion' creature sitting on top of a tree, Depiction H. This creature was most possibly 'killed' by the archer who holds a bow with arrow in his hand pointing towards it. This archer again has a hairstyle with a ponytail on top of his head, similar to the other individual hunting an elk elsewhere in this composition (Janik *et al.* 2007). It is a winter scene, but equally the hunter can be shooting at the overkilled swan, since the bird has an arrow depicted lodged in the end of its neck. Swans, however, do not normally overwinter in this region, but they perhaps arrived early, and unexpected snow could have fallen, creating winter scenery in the spring.

Another indeterminate creature is depicted within the winter scene, Depiction J (Figure 3.7). It is located at the end of the ski tracks with an individual bending towards it, possibly holding a bow in hand.

The last image indicating overkill depicts a bear, Depiction K (Figure 3.8). Despite the bear being injured by a spear, as in all images showing bear and hunter at Zalavruga,

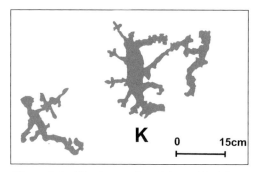

Figure 3.8: The image of a 'pin-cushion' bear, depiction K (adjusted after Savvateev 1970).

this particular bear has five arrows lodged in its back from the neck to its tail. The archer standing behind the bear is probably responsible for the arrows. This image is in a way transcendent between the human figures with arrows lodged in their backs and 'pin-cushion' injuries of humans and non-humans.

The 'pin-cushion' effect is always achieved by the use of a tool-weapon: the bow and arrow. Even when the bear is depicted as struck by a spear, the symbolic death is delivered by bow and arrows. These events could have taken place during different seasons, as suggested by the 'pin-cushion' kills which took place with or without the snow.

The kill involving a harpoon and whale, in addition to those showing elk being hunted by harpoon, are not depicted as 'pin-cushion' animals, as if the harpoon was a tool but not a weapon. Therefore animals killed with the harpoon are not part of this symbolic narrative. Furthermore, it is striking that elk, the symbolic meaning of which can be traced through material culture as well as mythological reality (Burov 1989; Janik 2007 *et al.* 2009; Lahelma 2008) is not a part of this visual account.

Despite all of the above, images of violence are sporadic and seldom, but they are a prominent part of the compositions in which they feature. What is perhaps most interesting when looking at the overkill injury and humans with arrows in their backs is that the tool-weapon transcends the type of the image as well as links them in a consistent symbolic interrelationship through the millennia. The hard memory captured in the location of the monument to which the local communities returned through time is linked with the process of 'rewriting' in the stone, where the humans and creatures depicted as overkilled differ, but the subjects persist.

NOBLE DEATH: TRANSCENDING CATEGORIES – CANNIBALISM

Performing overkill with bow and arrow, which we can conceptualise as a form of demise, seems to have been in a state of becoming in symbolic terms through time. Sometimes it is a human being undergoing this form of demise, sometimes it is a bird, bear or indeterminate creature. In a way these are not exclusive, because what unites these different creatures in these representations is death delivered by bow and arrow. This form of death, I suggest, is in opposition to that described in many historic and ethnographic accounts of hunting. Instead it forms part of the tradition of the 'noble death'. It allows community members to transcend the categories of what we think we know as human, bird and bear. Such boundary-crossing brings to mind the idea of cannibalism. We know from the analysis of human bone analysis in the Neolithic that certain bones were treated in a similar way to animal bones used for consumption, for example at the site of Jettböle on the Åland

islands and earlier at *Dyrholmen, Jutland* (Thorpe 2005; Sipilä and Lahelma 2007). These are not very frequent events, but like the rock art depictions discussed in this paper, they indicate particular rituals within symbolic and cultural transformations.

These transformations are captured in the soft memory that alters through time but is reinforced by the persistence of the use of a single location. This one locale of Zalavruga, among the 14 known at the White Sea, constitutes the hard memory of the rock art as a monument, which in turn focuses on the (re)creation of memory by the local community/ies. One could argue that this occurred in the process of 'habitus', but that would be a theme for another paper.

CONCLUSION

This paper has argued for the utility of a distinction between soft and hard memory in the interpretation of symbolic and ritual acts of violence in the Neolithic and Early Bronze Age rock art of the White Sea. Long-term perspective and the uniqueness of the archaeological data combined with contemporary understandings of acts of violence lead me to re-categorise the notion of 'pin-cushion' death as 'noble death', in which the transcendent nature of who was injured or killed allows us to look at acts of cannibalism in a new light.

ACKNOWLEDGEMENTS

I would like to thank Andrew Cochrane and Andy Jones for inviting me to participate in this volume. Special thanks go to Simon Kaner, Mark Sapwell and Grahame Appleby for their help with the paper. All errors of course remain my own responsibility.

REFERENCES

Armit, I., Knüsel, C. Robb, J. and Schulting, R. 2007. Warfare and violence in prehistoric Europe: an introduction. In T. Pollard and I. Banks (eds), *War and Sacrifice, studies in the archaeological conflict*, 1–11. Leiden and Boston: Brill.

Beltran, A. 1982. *Rock Art of the Spanish Levant*. Cambridge: Cambridge University Press.

Burov, G. M. 1989. Some Mesolithic wooden artefacts from the site of Vis I in the European North East of the U.S.S.R. In C. Bonsall (ed.), *The Mesolithic in Europe*, 391–401. Edinburgh: John Donald.

Chapman, J. 1999. The origins of warfare in Central and Eastern Europe. In J. Carman and A. Harding (eds), *Ancient Warfare, archaeological perspectives*, 101–42. Thrupp: Sutton Publishing Limited.

Christensen, J. 2004. Warfare in the European Neolithic. *Acta Archaeologica* 75, 129–56.

Coles, J. 1990. *Images of the Past*. Bohuslän: Skrifter utgivna av Bohusläns museum och Bohusläns hembygdsförbund 32.

Etkind, A. 2004. Hard and soft in cultural memory: political mourning in Russia and Germany. *Grey Room* 16, 36–59.

Guilaine, J. and Zammit, J. 2005. *The origins of war, violence in prehistory*. Oxford: Blackwell.

Harding, A. 2007. *Warriors and Weapons in Bronze Age Europe*. Budapest: Archaeolingua, Series Minor 25.

Insulander, R. 2002. The two-wood bow. *Acta Borealia* 19(1), 49–73.

Janik, L. 2010. Time and space: the chronology of White Sea rock carvings. *Acta Archaeologica* 81, 83–94.

Janik, L. 2009. Interpreting visual narrative: from North European rock art to shamanic drums of Northern Peoples. In M. Seglie, L. Otte, L. Oosterbeek, and L. Remacle (eds), *Prehistoric Art – signs, symbols, myth, ideology, IFRAO – Global State of the Art*, 79–85. Oxford: British Archaeological Reports S2028.

Janik, L. 2005. Refining social relations – tradition, complementarity and internal tension. In N. Milner and P. Woodman (eds), *Mesolithic Studies*, 176–94. Oxford: Oxbow Books.

Janik, L., Roughley, C. and Szczęsna, K. 2007. Skiing on the rocks: experiential art of prehistoric fisher-gatherer-hunters from Northern Russia. *Cambridge Archaeological Journal* 17(3), 297–310.

Janik, L. 1999. Rock art as a visual representation or how to travel to Sweden without Christopher Tilley. In J. Goldhahn (ed.), *Anthology of Rock Art*, 129–40. Oxford: British Archaeological Reports S794.

Kelly, L. H. 1999. *War before Civilization*. New York and Oxford: Oxford University Press.

Lahelma, A. 2008. On the back of a blue elk': recent ethnohistorical sources and 'ambiguous' Stone Age rock art at Pyhänpää, central Finland. *Norwegian Archaeological Review* 40(2), 113–37.

Leroi-Gourhan, A. 1986. *The Art of Prehistoric Man in Western Europe*. London: Thames & Hudson.

Linevskij, A. M. 1939. *Petroglify Karelii*. Karel. Nauchnyj Innstitut: Petrozavodzk.

Lobanova, N. V. 2007. Petroglyphs at Starya Zalavruga: new evidence – new outlook in archaeology. *Ethnology and Anthropology of Eurasia* 29(1), 127–35.

Nash, G. 2005. Assessing rank and warfare-strategy in prehistoric hunter-gatherer society: a study of the representation of warrior figures in rock-art from Spanish Levant, southeastern Spain. In M. Parker Pearson and I. J. Thorpe (eds), *Warfare, Violence and Slavery in Prehistory*, 75–85. Oxford: British Archaeological Reports S1374.

Osgood, R. and Monks, S. with Toms, J. 2000. *Bronze Age Warfare*. Thrupp: Sutton.

Oxford Dictionaries. Available at: http://oxforddictionaries.com/view/entry/m_en_gb0937420#m_en_gb0937420 Accessed: 1 December 2010.

Ravdanikas, V. I. 1938. *Naskalnye Izobrazhenia Belogo Moria* 2. Moscow and Leningrad: Academy of Sciences Press of Union of Soviet Socialist Republics.

Savvateev, Y. A. 1970. *Zalavruga, Petroglify*. Leningrad: Nauka.

Sipilä, J. and Lahelma, A. 2007. War as a paradigmatic phenomenon: endemic violence and the Finnish Subneolithic. In T. Pollard and I. Banks (eds), *War and Sacrifice, Studies in the Archaeological Conflict*, 189–209. Leiden and Boston: Brill.

Thorpe, I. J. K. 2003. Anthropology, archaeology, and the origin of warfare. *World Archaeology* 35(1), 145–65.

Thorpe, I. J. K. 2005. The ancient origins of warfare and violence. In M. Parker Pearson and I. J. Thorpe (eds), Warfare, Violence and Slavery in Prehistory, 1–18. Oxford: British Archaeological Reports S1374.

Zagorskis, F. 2004. *Zvejnieki (northern Latvia) Stone Age Cemetery*. Oxford: British Archaeological Reports S1292.

Reading between the grooves: regional variations in the style and deployment of 'cup and ring' marked stones across Britain and Ireland

Kate E. Sharpe

INTRODUCTION

In the introductory chapter of the Neolithic Studies Group publication from the 2001 seminar (Brophy and Barclay 2009), Barclay comments on the 'unified model' of prehistory that led to '*a generalized prehistory that over-emphasized similarity, underplayed diversity and assigned a primacy to data and explanation in 'core' areas*' (Barclay 2009, 2). This is also a problem for rock art studies in Britain and Ireland. The 'cup and ring' style of rock art tends to be discussed as a single, somewhat amorphous tradition of abstract motifs pecked onto natural rock surfaces. The regionally 'clustered' geographic distribution of the carved panels has resulted in 'core' areas such as north Northumberland, the Kilmartin Valley in Argyll, and Rombald's Moor in West Yorkshire attracting detailed, regionally-specific investigation at the expense of a broader, more contextualised analysis. Where observations have been made regarding 'rules of engagement', such as preferred topographical situations, proximity to water and route-ways, complexity and accessibility, or relationships to monuments (e.g., Jones *et al.* 2011, Boughey and Vickerman 2003; Bradley *et al.* 1993; Bradley 1997; Fairén-Jiménez 2007; Morris 1981; Purcell 2002; Van Hoek 1987; 1988) these have been undertaken in a single study area, remaining largely untested elsewhere. We are therefore left with a fragmented picture: a detailed but inconsistent record for the known rock art 'hot spots' but no clear overview of how these areas may relate to each other or to regional trends present within other archaeological datasets.

An examination of the many regional gazetteers and few published studies reveals that the growing corpus is far from homogeneous. The emerging picture is complex with variations between regional groups indicating local preferences in the motifs used, the form of surface embellished, and in the landscape settings selected. Some trends are readily apparent; others are more subtle, noticeable only to those with years of experience engaging with rock art across different areas. Practiced rock art recorders (often independent researchers without archaeological training) sometimes claim to have an instinct for finding panels in their own region: at a certain elevation; with a particular sort of view; on the right type of outcrop. Similar stylistic preferences are also evident at a more local, intra-regional level where the same protagonists might claim to know exactly what kind of motifs to expect on a particular moor, compared to those in a neighbouring valley. One experienced participant in the NADRAP project (see below) developed a keen instinct for the best place to look, identifying a number of new panels in the Barningham Moor area of County Durham (e.g., 'Barningham 101',

Kate E. Sharpe

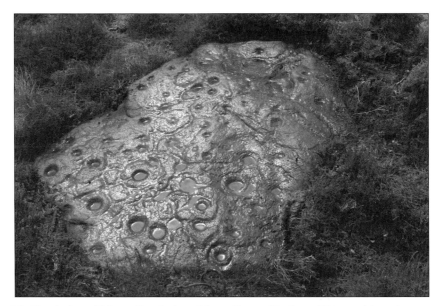

Figure 4.1: Barningham 101, on Barningham Moor, County Durham. Discovered by volunteer rock art recorder Richard Stroud, based on experience and a well-developed instinct for the right place to look. Image by Richard Stroud.

Figure 4.1). A more quantitative approach, using a topographic model to predict likely locations, has also produced a number of new finds in Cumbria (Sharpe 2007).

There has, to date, been only limited formal analysis to support the instincts and anecdotal evidence of rock art researchers, be they amateur or professional. Yet, the geographical distribution and contextual relationships of trends in the content and deployment of rock art may provide valuable insights into the way prehistoric communities negotiated their landscapes and related to one another. This paper reviews some of the broader evidence with respect to inter- and intra-regional variation within the rock art corpus, and considers the challenges of identifying patterns at both local and wider scales. The use of National Character Areas is suggested as a framework for regional comparisons, and examples are described in the context of regional prehistoric activities indicated by other evidence. The discussion then explores how variation might be used to explore the evolving social significance of the rock art over the extended period during which it was fashioned, used and re-used. Firstly though, we must return to the dataset in order to understand why it is currently so under-used.

THE RECORD

Around 6500 carved panels have now been identified across Britain and Ireland – a huge and richly diverse resource with the potential to reveal a great deal about the communities who inhabited these engraved landscapes. The individual panels are documented to varying

degrees by local groups, dedicated individuals, or very specific research projects, each with different agendas and approaches. Until recently there has been no attempt to create a comprehensive, consistent set of data which could be interrogated in order to draw out regional patterns. Maps of 'British rock art' show only vague areas or labels indicating higher densities (e.g., Bradley 1997, fig. 5.1); an accurately geo-referenced distribution map is yet to be produced; a significant effort would be required to collate all the raw data into a single, standardised resource. The publicly available *England's Rock Art* (ERA) database (http://archaeologydataservice.ac.uk/era/) is a first step in this direction. Around 1500 individual carved panels were recorded for the database by trained volunteers participating in the English Heritage sponsored *Northumberland and Durham Rock Art Pilot Project* (NADRAP). The long-term vision of the project was to create a standardised methodology that could be applied to other regions, so that the ERA database could be expanded with compatible records, thus facilitating direct comparisons across the wider corpus. This process is now beginning with a second volunteer recording project, *Carved Stone Investigations: Rombalds Moor,* currently underway in West Yorkshire. The project will employ the NADRAP methodology and will extend the scope of ERA. Volunteer endeavours in Scotland (Ross-shire, and Galloway) are also adopting the methodology to varying degrees, but the database will not, for now, extend beyond the English border.

The dataset then, is a work in progress which does not yet allow wide-scale analysis; few regional comparisons have been undertaken. The following discussion relies on small-scale analyses of local datasets to illustrate the potential of a larger study designed to compare and contrast rock art across several regions.

OTHER VARIABLES: CONTEXT-RELATED STYLE AND CHRONOLOGICAL EVOLUTION

There are, of course, factors other than regional trends that may have influenced the use of specific motifs and compositions. The two related and intertwined variables of chronology and context must be acknowledged. Lack of a firm chronological framework is clearly an issue for regional comparisons: a rock art tradition may have flourished in one region many years before it was adopted in another. This is not easily addressed, but the type of stylistic analysis proposed here, if firmly integrated with other archaeological information, may be one way to identify possible chronological developments. The correlation of rock art styles with their occurrence in dated contexts, or with time-specific activities and processes, will perhaps contribute to the development of a rock art chronology.

In Britain and Ireland, rock art 'style' has been understood in terms of two primary contexts, one very specific, and the second extremely broad. The geometric, angular form of 'passage tomb' art is associated with (although not limited to) very particular ritual monuments, and differentiated from the more fluid, natural compositions of the more widely occurring stylistic category of 'cup and ring' art (see Waddington 2007 for a discussion). Variously known as 'Atlantic' or 'Galician', the latter is found in a variety of landscape and monumental situations which testify to a continuing role throughout prehistory, extending before and beyond the shorter-lived passage tomb style. Carvings

are found on surfaces ranging from large expanses of exposed bedrock to small boulders and 'portable' cobbles. The majority are found in 'landscape' or 'open-air' contexts, with a general preference shown for elevated locations although, as we shall see, examples are also recorded in low-lying coastal and valley situations.

A subset of panels (around 25% if cairn cobbles are counted individually) have monumental associations, being found in structures ranging from the portal dolmens, long cairns, and standing stones of the Neolithic period, to the kerbed cairns and cists of the Bronze Age; some are also found associated with later prehistoric structures including enclosures, brochs, and settlements. Notwithstanding the complexities of re-use from earlier contexts, variations in the types and combinations of motifs found on rock art in ceremonial or burial contexts may reveal that specific designs were favoured for different purposes at different periods. A better understanding of monument-related style and associated chronological developments would potentially provide a valuable framework for understanding the rock art which remains *in situ* in the landscape.

For 'open air' (non-monumental) rock art, the situation of the panel within the landscape, perhaps selected to provide a specific view or to mark a particular place, may also have influenced the decoration applied. For example, one analysis relating motifs with landscape position found that the more complex panels were located at lower elevations (Fairén-Jiménez 2007). Similarly, the form of the panel – prominent outcrop, horizontal bedrock, or rounded boulder – may have inspired specific motifs. Finally, if we focus in on the panel surface itself, the inclination, e.g., horizontal or vertical, the orientation (with respect to the illuminating sun perhaps), and the natural geology, e.g., fissures or hollows (see Jones 2005; Sharpe and Watson 2010) may each have influenced the design process as much as local traditions.

Closer analysis of the data may reveal that rules relating to specific contexts extended across regions and that any local developments fit within a more universally understood framework. Accepting that a number of factors may be in play, how can we begin to tease out stylistic trends between and within rock art clusters? Do any 'rules' apply equally across Northumberland, northern England, Ross-shire, eastern Scotland and the Iveragh Peninsula, western Ireland? Can we detect local identities? Do different patterns emerge at different scales? The following section considers a small slice of the evidence which suggests that a detailed and comprehensive statistical analysis would be of great value.

INTER-REGIONAL VARIATION

The few published studies that compare rock art at a regional level suggest both marked and more subtle differences in deployment and style. In Aberdeenshire, Jones (2007) found that art is restricted to monuments and their immediate environs, whereas in Argyll it occurs both on monuments and on the periphery of ceremonial landscapes; differences argued to reflect distinct regional narratives of identity and recurring practice also shown in other archaeological evidence. Further south, analysis of Cumbrian rock art based on landscape situation, context, and motif-type identified three geographically discrete groups with distinctive contexts, styles, and potentially different functions (Sharpe 2007).

An alternative approach to identifying regional identities is to look for atypical or 'exotic' motifs specific to a particular region. Using a presence/absence methodology with carefully defined criteria for regional diversity, Cussen (2009) compared three rock art areas in the south west of Ireland: west Cork, the Iveragh Peninsula, and the Dingle Peninsula, County Kerry. Unusual motifs which occurred at fewer than three sites in one region were discounted as too localised and unrepresentative, however one motif, termed the 'pocked area' occurred with sufficient frequency within the Iveragh Peninsula (and was absent in other study areas) to be considered regionally specific. Not all unusual motifs have a regional distribution. Detailed analysis applied to other less common motifs such as rosettes, spirals, and grids would perhaps show whether these are simply less frequently used, are occasional divergences, or represent regional developments and identities. In his study of the spiral motif in British and Irish rock art, Van Hoek (1993) demonstrated a high frequency of spirals in the Galloway coast region. A study by Frodsham (1996) also mapped the motif across a variety of rock art contexts and other material culture such as pottery, maceheads, and carved stone balls, demonstrating a distinct mis-match between regions using the spiral in these different contexts. Frodsham notes a tendency for spirals to occur a) in compositions which include multiple ring motifs rather than with simple cup-marks, b) on vertical surfaces; and c) on red sandstone. He calls for an 'in-depth statistical analysis' to further explore these findings (*ibid*, 129).

A key challenge in studies of regional diversity is the definition of the boundaries to be used (see Kantner 2005, 1179). For example, the Cumbria study cited above, for example, would have produced very different results if the county had been considered as a whole, rather than broken into three sub-regions. The practice of carving on natural stone surfaces was widespread across the north of Britain and Ireland, with several areas of high concentration visable in the surviving record e.g., Rombalds Moor (West Yorkshire), Fylingdales Moor (North Yorkshire Moors), Barningham Moor (South Durham), Tayside (Strathclyde). Some clusters appear relatively discrete with defined edges (often coinciding with topographical changes); others are less clear with scatters gradually becoming less dense, or merging with neighbouring 'hot spots'. So how should we define the areas to be compared for the presence of regionality? Despite the obvious issues, modern administrative boundaries still frequently appear in the titles of regional studies (e.g., Watson and Bradley 2009; Clare 2009; Clay 2009), often requiring lengthy explanations and caveats in the opening paragraphs, and resulting in distribution maps which end at the administrative boundary, and present the study area in splendid isolation (e.g., Clay 2009, fig. 8.1). An alternative approach might be to use the geographic framework provided by the National Character Areas.

The 'Character of England Landscape, Wildlife and Cultural Features Map' produced in 2005 by Natural England with support from English Heritage, subdivides England into 159 National Character Areas (NCAs). These bio-geographic zones reflect the natural systems and processes, being based on the geological foundation, sub-soils, vegetation, and wildlife. The areas are described as having 'a unique sense of place' (Natural England 2011). This paper considers two NCAs in the north of England: No. 2, *The Northumberland Sandstone Hills*, and No. 8, *The Cumbria High Fells*. A third area discussed is the *Galloway Coast*, a topographically-defined, discrete cluster in southern Scotland, and hence not covered by the Natural England system. Figure 4.2 shows the location and extent of the three areas. These

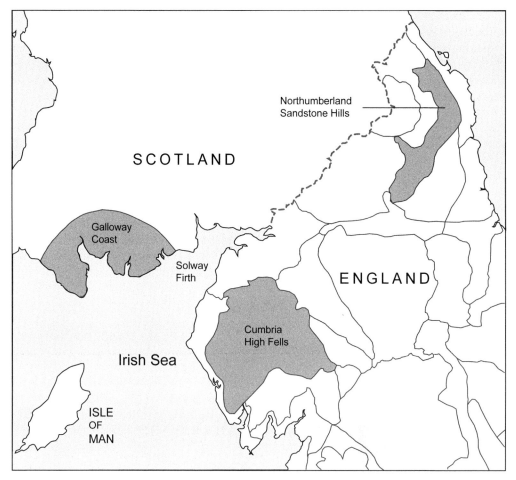

Figure 4.2: Location of Natural England Character Areas plus Galloway Coast area discussed in the text. Map data obtained from DEFRA MagicMap, http://magic.defra.gov.uk.

regions illustrate the variation present, however a full appreciation of the differences (and similarities) will only be gained through direct comparison of the respective, standardised datasets. Variation is also present at much smaller scales – for example, between one valley and the next. This is discussed in relation to specific areas within the Northumberland Sandstone Hills, where the density of carved panels makes analysis possible at a higher resolution.

The Northumberland Sandstone Hills

Northumberland, in north-east England, is possibly the most well documented rock art area in Britain with around 1200 panels recorded in the ERA database. The majority (83%) are in 'open-air' contexts (Figure 4.3). The motifs include a wide range from the 'cup and ring'

repertoire, from simple cup-marks to complex multiple rings and penannulars, and a few more exotic variations, e.g., rectangular grooves. The panels occur predominantly on the sandstone hills which run north–south between lower-lying land to the west, and the coastal plain to the east, an area roughly coincident with NCA No. 2: *The Northumberland Sandstone Hills*. The NCA summary describes the hills as forming '*a distinctive skyline characterised by generally level tops, north-west facing scarp slopes, and craggy outcrops.*' It also notes '*exceptional views from the hills of the coast and across the lowland fringe to the Cheviots*' (Natural England 2011). The area is archaeologically rich, with prehistoric remains including Bronze Age burial cists, standing stones, enclosures, cairns, and the earthwork remains of later Iron Age hill forts.

The rock art here has been investigated using GIS software to examine relationships between the rock art and the surrounding landscape (Fairén-Jiménez 2007). Results showed that the carved panels tend to be situated at middle elevations (125–300m OD), but are visually prominent at a local scale. They are likely to be found on sloping, marginal land within 15 minutes walk of a river basin. A preliminary analysis also suggested a relationship between motif complexity and landscape position with more complex panels (i.e. those with

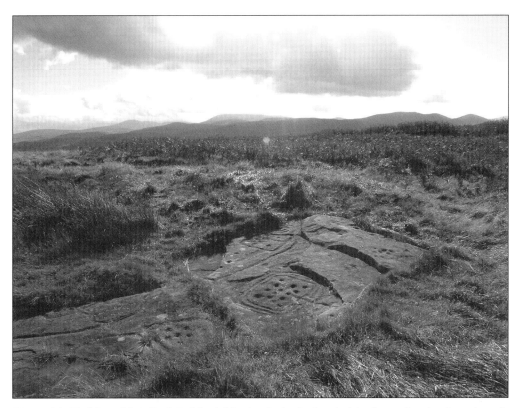

Figure 4.3: Dod Law Main Rock in North Northumberland. A typical landscape situation for rock art in the Northumberland Sandstone Hills character area: elevated with extended views. Image by Tertia Barnett.

cups combined with more than five rings or arcs) are located at lower (more accessible) elevations, closer to river basins, and are absent in areas where the slope exceeds 20% (*ibid,* 293). An earlier study of 64 panels in the region also revealed that complex carvings were more frequently applied to outcrops, with simpler motifs preferentially used on boulders (Bradley 1997, 79–80).

Fairén-Jiménez (2007) concluded that the panels were selected to give an optimal view-shed over natural axes of movement, possibly marking places controlling mobility networks. In an earlier study Waddington (1996; 1998) also set the Northumberland panels into a specific 'taskscape', relating the rock art distribution to early farming practices and land use, arguing that the carved panels may have marked woodland clearances attractive to both wild and domesticated animals, locales he terms 'inscribed grazing areas'.

The Cumbrian High Fells

Moving west across the Pennine fells into Cumbria we reach the English Lake District, and NCA No. 8: *The Cumbrian High Fells,* with its '*Spectacular and rugged mountain scenery …*' and '*… radiating pattern of deep glaciated valleys*' (Natural England 2011). Thirty-three carved panels have been identified at 23 sites, all since 1999. Although not as abundant as the rock art in Northumberland, this new group is somewhat different in character and offers a new dimension to analyses of rock art style and deployment (Sharpe 2007).

All the High Fells panels are in the open landscape, with no identified associations with other archaeological features. They occur on outcropping bedrock of either the Borrowdale Volcanic Series or Skiddaw Slates, with preference shown for the upper edge of glacially-smoothed *roche moutonée* outcrops (Figure 4.4). With one notable exception[1], the motifs comprise simple cup-marks with a few ovals, grooves, and dumb-bells. In sharp contrast to the upland locations described for Northumberland (and despite a number of surveys of such areas in the Cumbrian High Fells), all but one of the panels are situated on or just above the valley floor. Most lie within 1km of the head or tail of a major lake and close to a substantial beck. All lie on natural route-ways formed by the glacially scoured valleys which radiate from the central mountains to the lower lying land around the periphery. Other cultural material for the early prehistoric period indicates that communities were settled in these lowlands – particularly along the coastal plain and the Eden Valley – and were making seasonal journeys into the uplands, following or herding animals, and also seeking the valuable Group VI stone with which they made their axes. The cup-marked panels may have played a role in the successful outcome of these journeys, indicating a well-appointed location for a regular camp, or having a more spiritual role, protecting or sanctifying the immediate area. The marshy locations close to lakes would have provided rich resources, but are also suggestive of water-related ritual activities (cf. O'Sullivan and Sheehan 1993).

Galloway Coast

The rock art of Dumfries and Galloway in southern Scotland is largely confined to a 40km coastal band around the peninsulas and estuaries of the Solway Firth. The rock art extends inland for 15km, where the land rises into the Galloway Hills. Around 580 panels are recorded at *c.* 100 sites, mostly on greywacke slate outcrops. Many are decorated with

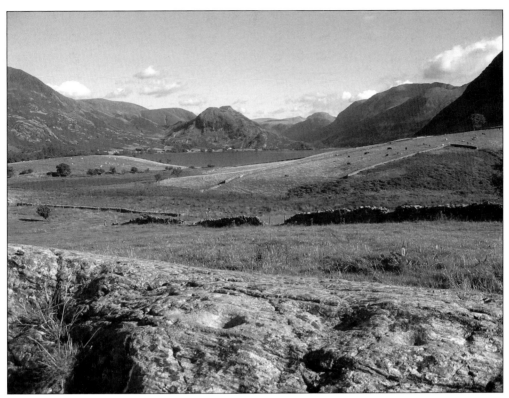

Figure 4.4: Cup-marked panel at Loweswater, Cumbria. This is a typical low-lying roche moutonnée *outcrop located at the north end of Crummock Water with views down the glaciated valley towards the central fells. Image by the author.*

simple cup-marks, however the area has a significant number of spirals compared to other regions (Van Hoek 1993, Frodsham 1996), and several other rare motifs such as 'rosettes' and 'keyholes'. Most panels are found at low elevations with 50% at 10–70m OD, and 86% below 120m (Beckensall 1999, 89). They are found along outcrop ridges with extensive sea views (Figure 4.5), or in shallow, estuarine valleys. In contrast to the pattern observed for Northumberland rock art, panels with simpler motifs are generally found at lower elevations nearer to the sea, having views across and along the wide river valleys (Bradley *et al.* 1993). Bradley suggests these may have marked the edges of a series

Figure 4.5: L Cup and ring marked panel at Knock on the western side of the Whithorn Peninsula of the Galloway Coast, overlooking Monreith Bay and the Irish Sea. Image by Suzanne Forster.

of valley territories leading to the sea, with simple motifs deployed in areas suitable for all year round occupation. The more complex art appears less consistently placed with some on higher ground, some near water, and some commanding an estuary or pass (*ibid.*).

These three rock art areas with their different topographical settings: inland (upland moor), coastal (estuarine?), and valley (lakeside?) demonstrate some of the diversity present between regions. Both sedimentary and igneous rocks are carved, and differences in geology must be taken into account, but there do seem to be regional preferences for particular rock surfaces. The range of motifs present also varies from simple cup-marks in the Cumbrian High Fells to more complex palettes and less common designs in both Galloway and Northumberland. The relationship between motif complexity and accessibility appears to differ between Northumberland and Galloway. These preferences may be best interpreted in terms of regional archaeological narratives, e.g., control of movement or marking of pastoral farming activities in Northumberland; transhumance and stone axe procurement in the Lake District valleys; and the marking of river territories along the Galloway coast. More detailed analysis may begin to tease out the relative influences of underlying rules which cut across regions, and more localised developments which relate to specific deployments of carved stones in response to regional processes, activities, and requirements.

INTRA-REGIONAL VARIATION

The density with which rock art occurs in the Northumberland Sandstone Hills area makes analysis possible at a higher resolution. Two studies are described here, both focused on the motif elements present. The first is from an unpublished Masters thesis (Ross 2004); the second represents a very preliminary analysis by the author. Both analyses were undertaken with reference to the motifs as indexed within the publicly available Beckensall Archive database (http://rockart.ncl.ac.uk).

Lordenshaw and Weetwood Moor

The rock art areas of Lordenshaw and Weetwood Moor in north Northumberland are located 30km apart in similar upland, moorland landscapes. They encompass discrete groups of 93 and 65 panels respectively. In both areas the rock art is found predominantly on outcropping bedrock, at relatively elevated positions with extensive vistas. Both areas are rich in early prehistoric features, including Neolithic and Bronze Age burial cairns and field systems. Ross (2004) analysed the motif elements present, finding statistically significant differences in the compositions preferred, as illustrated in Figures 4.6–7. At Lordenshaw 65% of panels had only cup-marks compared with 12% at Weetwood. Long grooves were found on 25% of the Lordenshaw panels, and on fewer than 10% at Weetwood where the dominant motif was the penannular, being present on 75% of panels compared to 10% at Lordenshaw. Motifs including rings were also more frequent at Weetwood (71%), occurring on only 32% of panels at Lordenshaw. These results are further emphasised when the overall frequency of occurrence is considered. Might the variation reflect the activities of two different, possibly contemporaneous groups with distinctive identities? Were the carvers responding to different surfaces or situations? Alternatively, might the difference represent a chronological development? The study clearly demonstrates the potential of rock art, with its relatively

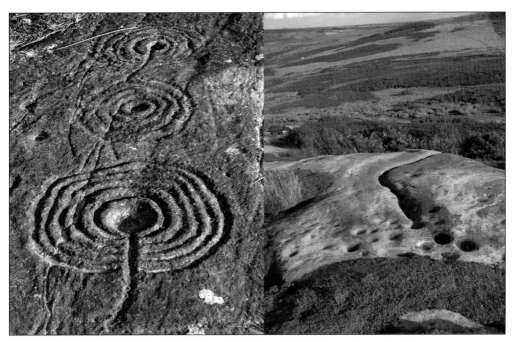

Figure 4.6: Multi-ring penannulars at Weetwood Moor (left) contrast with cup marks and enhanced natural channel at Lordenshaw (right), Northumberland). Images from the ERA database.

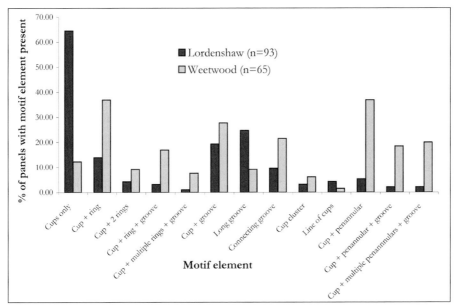

Figure 4.7: Occurrance of motif elements on panels at Lordenshaw and Weetwood, Northumberland (after Ross 2004). Based on data in the Beckensall Archive (http://rockart.ncl.ac.uk).

dense distribution and rich variation (compared to other forms of archaeological evidence) to reveal a nuanced map of variations at a local scale.

Millstone Burn and Snook Bank

The Millstone Burn valley is a key communication corridor linking low-lying land and coastal plains to the east with higher land to the north-west. Two groups of rock art panels face each other across the valley: Millstone Burn (71 panels) to the west and Snook Bank (73 panels) to the east. A gap of approximately 0.5km separates the two groups, which are each closely clustered within discrete 0.5km² areas. Bradley (1997) demonstrated that the panel locations were chosen to provide (in comparison to a control sample) extended views in both directions along the valley. But were the two sets of panels created by the same group of people or might the central stream represent some kind of territorial boundary? The motifs were analysed using four broad categories: fewer than five cup-marks; five or more cup-marks; multiple rings; and penannulars (see Table 4.2). This very coarse analysis suggests a subtle difference between the two groups of panels: to the west the Millstone Burn panels appear to be slightly more complex than those on the eastern slopes of Snook Bank with a higher percentage of multiple rings, penannulars, and higher numbers of cup marks. A relationship between motif and panel type can be ruled out: on each side of the valley 50% of panels are boulders and 50% are on bedrock. Other variables need further scrutiny: Roman and later historic quarrying at Snook Bank may have affected the current picture, and the prevailing weather may also have been a factor.

ROCK ART REGION	LANDSCAPE SITUATION	PANEL GEOLOGY AND FORM	MOTIFS	PATTERNS OBSERVED
Northumberland Sandstone Hills	Elevated (125–300m OD), sloping, marginal land with views over corridors of movement	Fell Sandstone Series, especially horizontal bedrock exposures	Simple cups to complex multi-ring, motifs and penannulars. Some rectangular grooves	Complex motifs at more accessible locations. Complex motifs on outcrop; simple motifs on boulders
Cumbria High Fells	Low-lying (40–150m OD) in glaciated valleys, close to head/tail of lake. On natural route-ways from coast to central fells	Borrowdale Volcanic Series, Skiddaw Slate; preference for prominent roche moutonée outcrops	Predominantly simple cup-marks in random clusters	–
Galloway Coast	Low-lying (10–120m OD) coastal locations with views over estuaries; close to settled areas	Greywacke slate; outcrop ridges	Simple cups to complex multi-ring, motifs and penannulars. Relatively high no. of spirals	Simple motifs at more accessible locations.

Table 4.1: Comparison of rock art characteristics for three regions in northern Britain.

ROCK ART GROUP	NO. PANELS WITH MOTIFS INDICATED (% OF TOTAL)				
	Cups only	< 5 cups	≥ 5 cups	Multi-rings	Penannulars
Snook Bank (n=73)	30 (41)	21 (29)	9 (12)	4 (5)	10 (14)
Millstone Burn (n=71)	31 (44)	14 (20)	17 (24)	10 (14)	13 (18)

Table 4.2: Presence of motif types on opposite valley sides at Snook Bank and Millstone Burn.

DISCUSSION

Style has long been used as a key organising principle and classificatory device in rock art studies, particularly for representational images. Yet, a unified concept of style and the degree to which stylistic variations may relate to social organisation and interaction remains elusive (see Wiessner 1990; Lorblanchet and Bahn 1993; Franklin 1991; 1993). For analyses of British and Irish rock art, the definition proposed by Ross seems appropriate:

> *'[Style is defined as] patterns in material culture, which provide evidence of the sets of choices made by the people who created them. These choices relate to, and negotiate, both individual and group identities (consciously and subconsciously), as they communicate messages, which are understood on an intra- and, or, inter- group level.'* (2004, 28)

I propose that these stylistic 'choices' be extended beyond the use of particular motifs and compositions, to include preferences for the situation of the panel in the surrounding landscape, and the form of panel or 'canvas'. These variables should be considered alongside 'content' in order to fully explore the influences governing the creation, use, and re-use of rock art.

Analysis of stylistic components in rock art around the world has revealed regional and temporal variations, which have in turn been used to explore social dynamics and to develop chronological frameworks. The distinctive art of particular regions has been used to demonstrate the existence of geographically discrete identities. For example, four geographical clusters within the schematic rock art of Valencia have been ascribed to different ethnic groups (Torregrosa Giménez 2000), and strong regional rock art variations have also been identified in Sweden (Ramqvist 2003). Similarly, the presence of related or similar styles in geographically separate locations has been argued to indicate extended social networks. However, regionality is not a static phenomenon and variations may reflect changes in cultural practices, social restructuring and even climatic conditions. Analyses of style alongside contextual evidence, superimposition and, more recently, direct dating, have been used to develop broad chronological schemas allowing researchers to observe the evolution of art, and to link changes to environmental and social influences. Increasing regionality in the rock art of Queensland has, for example, been linked to restructuring of relationships resulting from the closure of social networks (Morwood 1980). The extent of social boundaries was shown to impact on the art produced, with a greater diversity of designs found in the centre of a given territory than towards the periphery.

The abstract nature of British and Irish rock art should not preclude similar stylistic analyses. The rich diversity within the large corpus should provide ample material for such studies as a standardized recording methodology is applied and the data is consistently indexed. The following themes are suggested for further investigation:

- *Context/location*. Do specific styles relate to the choice of location, the choice of canvas, or the archaeological context of the panel? Are these relationships the same across regions?
- *Social dimensions*. Can the stylistic variations in the rock art be correlated with patterns identified in other aspects of material culture, in order to deepen understanding of prehistoric social and ideological developments?
- *Regional/local identity*. Can stylistic variations be detected between or within geographically discrete clusters of rock art and what can these tell us about the formation and negotiation of prehistoric identity?
- *Chronology*. Can detailed analysis of nuances in content, form, composition, superimposition, and execution of motifs, and correlation with their occurrence in dated contexts enable the development of an improved chronology?

CONCLUSION

Current understanding of the lives of the Neolithic and Early Bronze Age communities who occupied Britain and Ireland is informed primarily by the nature and distribution of their ritual monuments and material remains. The abstract motifs carved onto thousands of rock panels across the northern landscape represent an additional, valuable strand of evidence that has been largely overlooked. This chapter is intended to provide a brief illustration of the possibilities of regionality in British and Irish rock art. An extended definition of 'style' is proposed, encompassing variables and choices beyond the motifs, and the National Character Areas are suggested as a relevant framework for comparisons between topographically distinct regions. Where detected, stylistic variations must be firmly situated within the wider archaeological landscape and aligned with documented social and cultural trends to enable the creation of a geographically wider, chronologically deeper, and altogether richer interpretation of the cup and ring tradition. The examples used here are intended to demonstrate the wealth of data which remain untapped. Further work may provide new insights into identity formation at both regional and local scales, providing an extended context in which to explore the evolving relationships between prehistoric communities and their natural and social worlds.

ACKNOWLEDGEMENTS

Without a consistent set of data much of what is proposed would be extremely difficult to achieve. I would therefore like to acknowledge the various groups involved in the *Northumberland and Durham Rock Art Pilot Project*: English Heritage, Northumberland County Council, the Archaeology Data Service, my colleagues on the project team, Sara Rushton, Tertia Barnett, and Richard Stroud, and not least all the volunteers who took part. I am

optimistic that the vision to include all of England's rock art will eventually be realised. The *Carved Stone Investigations: Rombalds Moor* project is hopefully the first of several further projects which will extend the scope of the ERA database. I am pleased to be directly involved in this venture, which is part of the Pennine Prospects Watershed Landscapes Project, supported by the Heritage Lottery Fund, and with South Pennines Leadership funding. Finally, thanks are due to Aron Mazel for his encouragement and support in developing some of the themes discussed.

NOTE

1 Copt Howe in Great Langdale is an enormous earth-fast boulder that differs from the other Lakeland panels in having complex 'Passage tomb' motifs on a vertical face, suggesting links with monumental panels in the Eden Valley Character Area to the east.

REFERENCES

Barclay, G. 2009. Introduction: a regional agenda? In K. Brophy and G. Barclay (eds), *Defining a Regional Neolithic: The Evidence from Britain and Ireland*, 1–4. Oxford: Oxbow Books/Neolithic Studies Group Seminar Papers 9.

Beckensall, S. 1999. *British Prehistoric Rock Art*. Stroud: Tempus.

Beckensall, S. 2001. *Prehistoric Rock Art in Northumberland*. Stroud: Tempus.

Boughey, K. and Vickerman, E. 2003. *Prehistoric Rock Art of the West Riding. Cup-and-ring-marked rocks of the valleys of the Aire, Wharfe, Washburn and Nidd*. Leeds: West Yorkshire Archaeological Services.

Bradley, R. 1997. *Rock Art and the Prehistory of Atlantic Europe: Signing the Land*. London: Routledge.

Bradley, R. Harding, J. and Mathews, M. 1993. The siting of prehistoric rock art in Galloway, south-west Scotland. *Proceedings of the Prehistoric Society* 59, 269–83.

Brophy, K. and Barclay, G. (eds) 2009. *Defining a Regional Neolithic: The Evidence from Britain and Ireland*. Oxford: Oxbow Books/Neolithic Studies Group Seminar Papers 9.

Clare, T. 2009. No-man's land revisited: some patterns in the Neolithic of Cumbria. In K. Brophy and G. Barclay (eds), *Defining a Regional Neolithic: The Evidence from Britain and Ireland*, 78–91. Oxford: Oxbow Books/Neolithic Studies Group Seminar Papers 9.

Clay, P. 2009. Core or periphery? The case of the Neolithic of the East Midlands. In K. Brophy and G. Barclay (eds) *Defining a Regional Neolithic: The Evidence from Britain and Ireland*, 92–105. Oxford: Oxbow Books/Neolithic Studies Group Seminar Papers 9.

Cusson, R-M. 2009. *Regionality in Prehistoric Rock art Motifs of Ireland*. Unpublished MA thesis, Durham University.

Deakin, P. 2007. Exploring links between cupmarks and cairnfields. In A. Mazel, G. Nash and C. Waddington (eds), *Art as Metaphor: The Prehistoric Rock art of Britain*, 111–22. Oxford: Archaeopress.

Fairén-Jiménez, S. 2007. British Neolithic rock art in its landscape. *Journal of Field Archaeology* 32(3), 283–95.

Franklin, N. 1989. Research with style: a case study from Australian rock art. In S. Shennan (ed.), *Archaeological Approaches to Cultural identity*, 278–90. London: Unwin Hyman.

Franklin, N. 1993. Style and dating in rock art studies: the Post-Stylistic Era in Australia and Europe. In M. Lorblanchet and P. Bahn (eds), *Rock Art Studies: The Post Stylistic Era*. 1–13. Oxford: Oxbow Books, Oxbow Monograph 35.

Frodsham, P. 1996. Spirals in Time: Morwick Mill and the spiral motif in the British Neolithic. In Paul Frodsham (ed.) *Neolithic Studies in No-Man's Land*, 101–38. Northern Archaeology 13/14.

Jones, A. 2005. Between a rock and a hard place: rock art and mimesis in Neolithic and Bronze Age Scotland. In V. Cummings and A. Pannett (eds), *Set in Stone. New Approaches to Neolithic Monuments in Scotland,* 107–17. Oxford: Oxbow Books.

Jones, A. 2007. *Memory and Material Culture.* Cambridge: Cambridge University Press.

Jones, A. M., Freedman, D., O'Connor, B., Lamdin-Whymark, H., Tipping, R. and Watson, A. 2011. *An Animate Landscape: Rock Art and the Prehistory of Kilmartin, Argyll, Scotlnd.* Oxford: Windgather Press.

Kantner J. 2008. The archaeology of regions: from discrete analytical toolkit to ubiquitous spatial perspective. *Journal of Archaeological Research* 16(1), 37–81.

Lorblanchet, M. and Bahn, P. G. 1993. *Rock art Studies: the Post-Stylistic Era or Where Do We Go From Here?* Oxford: Oxbow Books, Oxbow Monograph 35.

Morris, R. 1981. *The Prehistoric Rock Art of Southern Scotland, except Argyll.* Oxford: British Archaeological Report 86.

Morwood, M. J. 1980. Time, space and prehistoric art: a principal components analysis. *Archaeology and Physical Anthropology of Oceania* 15, 98–109.

Natural England, 2011, Natural England National Character Areas. http://www.naturalengland.org. uk/ourwork/landscape/englands/character/areas/ Consulted 17 Feb 2011.

O'Sullivan, A. and Sheehan, J. 1993. Prospection and outlook. Aspects of rock art on the Iveragh Peninsula, Co. Kerry. In E. Shee Twohig and M. Ronayne (eds), *Past Perceptions: the Prehistoric Archaeology of South-West Ireland*, 75–84. Cork: University of Cork Press.

Purcell, A. 2002. The rock art landscape of the Iveragh Peninsula, County Kerry, south-west Ireland. In G. Nash and C. Chippindale (eds), *European Landscapes of Rock Art*, 71–92. London: Routledge.

Ramqvist, P. H. 2003. Rock art in Central Norrland (Sweden): reflections in settlement territories. In K. Sognnes (ed.), *Rock Art in Landscapes – Landscapes in Rock Art*, 71–84. Trondheim: Tapir Academic Press.

Ross, M. 2004. *Cups, Long Grooves and Penannulars. A comparative Study of Regional Styles in Northumberland Rock Art.* Unpublished MA Dissertation, Newcastle University.

Sharpe, K. 2007. *Motifs, Monuments and Mountains.* Unpublished PhD thesis, Durham University.

Sharpe, K. and Watson, A. 2010. Moving images: interpreting the Copt Howe petroglyphs. In T. Barnett and K. Sharpe (eds), *Carving a Future for British Rock Art*, 57–64. Oxford: Oxbow Books.

Thomas, J. 1999. *Understanding the Neolithic.* London: Routledge.

Torregrosa Giménez. 2000–1. Pintura Rupestre Esquematica e Territoria. *Lucentum* 19–20, 6–91.

Van Hoek, M. 1987. The prehistoric rock art of County Donegal (Part I). *Ulster Journal of Archaeology* 50, 23–46.

Van Hoek, M. 1988. The prehistoric rock art of County Donegal (Part II). *Ulster Journal of Archaeology*. 51, 21–48.

Van Hoek, M. 1993. The spiral in British and Irish Neolithic rock art. *Glasgow Archaeological Journal* 18, 11–32.

Waddington, C. 1996. Putting rock art to use. A model of early Neolithic transhumance in north Northumberland. In P. Frodsham (ed.), *Neolithic Studies in No Man's Land*, 47–177. Northern Archaeology 13/14. Newcastle: The Northumberland Archaeological Group

Waddington C. 1998. Cup and ring marks in context. *Cambridge Archaeological Journal* 8(1), 29–54.

Waddington, C. 2007. Cup and rings and passage grave art: insular and imported traditions? In C. Burgess, P. Toppping, and F. Lynch (eds), *Beyond Stonehenge. Essays on the Bronze Age in Honour of Colin Burgess*, 11–19. Oxford: Oxbow Books.

Watson, A. and Bradley, R. 2009. On the edge of England: Cumbria as a Neolithic region. In K. Brophy and G. Barclay (eds), *Defining a Regional Neolithic: the Evidence from Britain and Ireland*, 65–77. Oxford: Oxbow Books/Neolithic Studies Group Seminar Papers 9.

Wiessner, P. 1990. Is there a unity to Style? In M. Conkey and C. Hastorf (eds), *The Uses of Style in Archaeology*, 105–12. Cambridge: Cambridge University Press.

Ben Lawers: carved rocks on a loud mountain

Richard Bradley and Aaron Watson
with contributions by Alex Brown and Rosemary Stewart

THE PROJECT

The Ben Lawers Estate is located in the Southern Highlands and is the property of the National Trust for Scotland. It includes a large number of rock carvings, most of which were found during a survey undertaken by the Scottish Royal Commission (Hale 2003) or in subsequent fieldwork by George Currie (Figure 5.1). They survive in considerable numbers on the area of high ground which is managed by the Trust, but are less well preserved in the farmland outside it. One reason for studying the carved rocks in this region is that they have been recorded to a uniform standard. The other is that they are rather unusual because they are not associated with any prehistoric monuments. In that respect they contrast with the great concentration of rock carvings in Kilmartin Glen, 100km to the south-west (Jones this volume; Needham and Cowie this volume).

It was that feature which led to a new investigation of the decorated rocks on the Ben Lawers Estate between 2007 and 2010. As with many of the most complex images found in Britain and Ireland, the distinctive character of those around Kilmartin may have been influenced by the presence of a series of unusual monuments. Whilst the existence of these structures did not *determine* the locations of the rock carvings, it helps to account for their special character in comparison with those in the surrounding area. It seems likely that people travelled to the Glen from a wider region and that some of the decorated outcrops were along the routes leading into the valley.

The rock art on Ben Lawers is entirely different. Although it includes some complex designs, it is distributed across a considerable area and lacks a single focus. There are few monuments in the vicinity and the most obvious focal points are provided by the high ground radiating from the summit of Ben Lawers, and by Loch Tay which extends along the valley to its south. The contrast with Kilmartin is important for two reasons. Work at Torbhlaren, reported elsewhere in this volume (Jones this volume), had shown that decorated outcrops were associated with structural evidence and also with deposits of artefacts. Was it because the site was located in a special area, or would similar evidence be found in a region where Neolithic and Early Bronze Age monuments were absent? The character of the rock carvings on Ben Lawers could not have been influenced by the presence of structures of this kind, but how was it related to the natural topography? In this chapter we shall discuss the distinctive features of the Ben Lawers Estate – the mountains, streams, stones, and the loch below – before we turn to the investigations carried out at the carved rocks themselves.

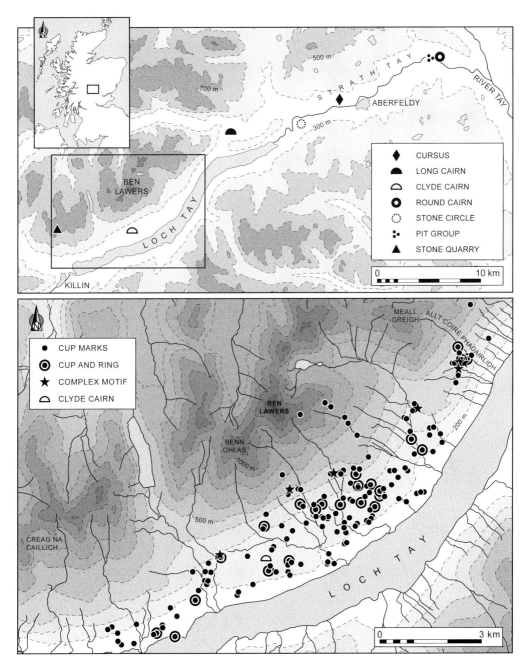

Figure 5.1: The study area. Only excavated Neolithic monuments are shown in Strath Tay, including the Croft Moraig stone circle which may have been built during that period. The map combines sites published by Hale (2003) with the results of subsequent fieldwork by George Currie, who kindly provided this information.

Post-excavation work is still in progress and a detailed report on the fieldwork will be the subject of another paper, but here we are able to draw on geological identifications by Rosemary Stewart and pollen analysis by Alex Brown.

THE MOUNTAIN

Ben Lawers rises to 1214m and is the tenth highest mountain in Britain (Figure 5.2). It is located 5km from the northern shore of Loch Tay. Other prominent peaks, *Meall Greigh* and *Benn Ghlas*, are closer to the water's edge. In two cases their Gaelic names are particularly informative. *Ben Lawers* means 'the loud mountain' or 'the mountain of the loud water': an obvious reference to the sound of streams draining from the high ground. The name *Meall Greigh* is more difficult to translate but probably means '*the hill of the cattle herd*' (otherwise the reference is to '*horses*').

It can take several hours to climb Ben Lawers from the loch, and some of the routes to the summit are demanding in good weather and challenging in winter when the high ground is covered by snow. The mountain is a conspicuous landmark and its jagged profile can be picked out from a considerable distance. It is particularly impressive when viewed from the opposite side of the loch, but cannot be seen from parts of its lower slopes where the summit is concealed behind intervening areas of high ground.

The land to the north of Loch Tay has a distinctive profile which to some extent it shares with the river valley (Strath Tay), which extends further east. The lower ground rises only gradually until it reaches about 200m, then the gradient changes sharply and the slope becomes considerably steeper. At a height of 400m, it levels out to form a series of comparatively sheltered terraces or basins, separated from one another by the gullies cut by streams discharging from the high ground. The lower slopes are separated from these basins by the head dyke which once marked the division between land that was farmed year round, and areas used as summer pasture (Boyle 2003). Even within the upland basins sharp changes of topography are created by the moraines deposited by ice. Above this zone the land rises steeply to the highest part of the estate.

THE STREAMS

The Gaelic name '*Ben Lawers*' refers to the sound made by the streams discharging from the high ground. It can be heard even in dry weather, and after heavy rain or melting snow the watercourses may be difficult to cross. For that reason the tracks recorded in the post-medieval period ran up and down the mountainside and did not follow the contours. In effect, those streams divided the terrain into a series of linear landholdings which extended from the high ground to the shore of the loch (Boyle 2003).

The streams excavated valleys or even gorges. Where they cross geological boundaries there are often waterfalls; the Ordnance Survey identifies no fewer than 19 examples to the north of Loch Tay. The amount of water coming down the mountain would have been greater in the past, as some of the streams have been dammed as part of a hydro-electric scheme which also drains two small lochs on the high ground.

Figure 5.2: The Ben Lawers ridge seen from the southern shore of Loch Tay (top); contrasting against views looking north-east (middle); and south from carved rocks around the 400 m contour near Allt Coire Phadairlidh.

Even today the current brings large quantities of rock down the slope. Among the debris there are pieces of rounded quartzite which originated further up the mountainside. As well as the stones in the stream bed, there are extensive trails of boulders along either side of the water. They must have been deposited when the stream was in spate and had overflowed its banks. There are also large blocks of water-worn epidiorite which have been brought down from the mountain.

THE ROCKS

Ben Lawers has an exceptionally complex geology. There are a few carvings on an exposure of limestone, but for the purposes of this chapter three kinds of rock are significant. They are schist, quartzite and epidiorite, the latter more technically grouped as 'metagabbro'. The epidiorite has a similar appearance wherever it occurs, but the schists are represented in a range of different types. They were recorded in the field but more exact petrological identifications are unnecessary in studying how the stone was used during prehistory. Schist and epidiorite were commonly decorated, and this seems to have been accomplished using pieces of quartz.

The distributions of these materials are by no means uniform. Schist is ubiquitous in the area although it is represented by more than one type. On the other hand, the epidiorite occurs in bands. Some of these are narrow toward the lower slopes of the valley, while others form wide outcrops near the summit of Ben Lawers. Boulders and cobbles of epidiorite were brought down slope by streams or ice-rafted along the valley during glacial episodes. The majority seem to have originated on the high ground of Ben Lawers and are especially abundant below the mountain itself. In sample areas studied further to the east and west, away from the main Ben Lawers outcrops, epidiorite was not so well represented. The quartzite found on the lower ground had a similar origin, and occurs widely in and around the streams. The distribution of boulders and outcrops has been modified by their use as building material. On the lower ground they were broken up to create field walls and the head dyke. Further up the mountain they were employed to construct the summer farms known as shielings.

The two main types of rock can be found together in the study area, but the largest pieces look rather different from one another. The exposures of epidiorite usually take the form of large rounded blocks and have a rough but almost level upper surface. Major exposures of schist are rather more varied. They resemble substantial outcrops even when they have been transported by ice, and individual examples provide prominent landmarks in the local topography. In two cases they were pushed on end by glacial action, creating conspicuous but entirely natural standing stones. Such striking effects are by no means common, and smaller pieces of schist are hard to distinguish from other kinds of stone unless they are examined at close quarters.

Each of these raw materials would have had its distinctive properties. Epidiorite is significantly denser than schist and for that reason it would have taken more effort to decorate it with pecked designs. When it is freshly broken, it exhibits a platy sheen. Schist, on the other hand, is softer and easier to work, but is relatively friable. A notable characteristic of most of the rocks on Ben Lawers is that they include large quantities of mica which glitters in strong light. This can be observed when the rock is illuminated by the sun, but moonlight has the same effect. The distinctive appearance of the rock can also be enhanced by the presence of quartz veins running through the stone. Vein quartz was rarely suitable for making artefacts, but quartz pebbles, whose origin was on the higher ground, are easy to find in or beside the streams. Any latent flaws in this material cause them to break as they are swept down the mountain, with the result that the pieces that survive intact may be unusually robust. Some schists are highly quartz-rich. In one case it is clear that fragments of quartz had been removed when a series of cup-marks was made. The quality of this material varies but a few pieces could be flaked to produce regular artefacts. As well as its practical uses, quartz has unusual properties and can spark or glow when it is worked.

THE LOCH

Loch Tay is 23km in length and is the sixth longest and fourth deepest loch in Scotland. It is flanked by areas of high ground on either side. To the east, an important river valley continues for a further 20km. The lake changes direction at two points, but the main section,

which is overlooked by Ben Lawers and Meall Greigh, follows a course from north-east to south-west. The loch has always formed part of a long distance route crossing the mainland of Scotland between the Atlantic coast and the North Sea. To the west this route could have connected the concentrations of rock carvings associated with Ben Lawers and Strath Tay with those around Kilmartin (Stewart 1961, 7–8).

From the high ground of the Ben Lawers Estate it is possible to observe the movement of the sun as it travels from east to west beyond the far side of the loch. In strong light the hills on the southern shore are reflected in the water, creating the illusion of a subterranean world. The surface of the loch is rarely still, and ripples and eddies create striking visual effects when viewed from the mountainside. It is unlikely that these would have been any different in the past. The lake and its shoreline provided important natural resources and were associated with an unusually large number of prehistoric crannogs.

THE ARCHAEOLOGICAL RECORD

The distribution of Neolithic and Early Bronze Age monuments is almost entirely confined to the low ground, and is especially dense along the river terraces of Strath Tay. Here there are also many crop-marks, but few have been diagnosed by excavation. The archaeological sequence probably begins with the round barrow (in its first phase a cairn) at Pitnacree (Coles and Simpson 1965) and the Castle Menzies cursus (Halliday 2002), but only one monument of similar date has been identified on the ground above Loch Tay. This is a ruined Clyde Cairn, located beside a natural standing stone 400m from the water's edge. Four kilometres north-west of the end of the loch at Killin is the Late Neolithic axe quarry at *Creag na Caillich* (Edmonds *et al.* 1992). The other site which may be of Neolithic date is the stone circle at Croft Moraig which was not far from the eastern limit of Loch Tay (Piggott and Simpson 1971). There is no shortage of smaller monuments which can be assigned to the Early Bronze Age, including a number of cairns and small stone settings, but with few exceptions they avoid the ground sloping down from Ben Lawers. Instead they are more common in Strath Tay and beyond the ends of the loch. They may be later in date than most of the carved rocks, and for that reason they are not mapped in Figure 5.1.

Little is known about the wider setting of these sites. A series of pits associated with Impressed Ware was excavated on a gravel terrace above the river in Strath Tay (Simpson and Coles 1990), and fieldwalking around Aberfeldy in the 1990s suggested that the main focus of earlier prehistoric activity was in a similar position (Phillips *et al.* 2002). The frequency of artefacts was significantly lower further up the valley side. The Neolithic quarry at *Creag na Caillich* saw more than one phase of activity but seems to have been located in a lightly wooded landscape which was only gradually cleared (Edmonds *et al.* 1992, 102–6). There are occasional finds of prehistoric artefacts from the high ground of the Ben Lawers Estate but monuments appear to be absent. In fact there is little evidence of intensive activity in the area below the mountain until the first crannogs were built in the Early Iron Age. It seems likely that other settlements on the low ground have been destroyed by later agriculture. In the light of these observations the concentration of carved rocks above the northern shore of Loch Tay is extremely striking.

THE DISTRIBUTION OF CARVED ROCKS

If the evidence of earlier prehistoric monuments differs between Ben Lawers and Strath Tay, the same applies to the rock carvings in these areas. Those in the river valley have been known for 40 years, but most of the examples above the loch are recent discoveries.

Like those found north of Loch Tay, the carved rocks in the valley extend onto the high ground. Their distribution runs continuously from examples associated with boulders on the gravel terraces to decorated outcrops in upland basins like those on the Ben Lawers ridge. Although there are certain exceptions, cup-marks are more frequent on the lower ground where monuments and scatters of worked quartz are found, whilst the more complex designs – mainly cups and rings – are located towards the upper limit of the distribution of carved rocks (Bradley 1997, 101–4). Recent discoveries by George Currie emphasise this distinction.

As Alex Hale has pointed out, this scheme cannot be extended to the carved rocks associated with Ben Lawers (2003, 8–9). Cup-marks extend up the mountainside from the shore of the loch and include the highest motifs so far discovered in Britain. Similarly, rocks embellished with cups and rings extend across almost the entire distribution of carvings. There is no obvious distinction between those below the 200m contour and the motifs associated with basins further up the mountainside. Perhaps this is not surprising as this area is quite different from Strath Tay. While the river valley includes large tracts of fertile soil, the equivalent position in the Ben Lawers landscape is occupied by Loch Tay.

In fact the carved motifs below the Ben Lawers ridge extend along a continuum from simple cup-marked rocks to ornate designs characterised by cups and rings and other, less standard motifs. There is little evidence of superimposition, but some panels seem to have developed incrementally and there is considerable variation between the designs found in different parts of the study area. In no sense do the decorated surfaces conform to a single 'style'. On the other hand, all the most lavish carvings are in the upland basins. Where cups and rings also occur on the low ground towards the loch, the motifs are simpler.

How were particular surfaces selected for treatment? Four of the upland basins are associated with one exceptionally complex carving; a fifth basin contains three. None occurs in isolation and in every case there are other decorated surfaces nearby. The most elaborate panel may be located within the basin itself, or it can be close to one of the streams running down the mountainside. In such cases it is within sight or sound of a waterfall. Complex designs were created on exposures of schist and epidiorite, and the same applies to the simpler designs in the vicinity. Despite the different physical properties of these stones, both were commonly used, even in the same small area.

On the high ground the decorated surfaces are scattered but are usually contained within the separate basins. This remains the case despite the fact that large amounts of stone were used to build shielings in the same areas. Lower down the slope the distribution of carved rocks is more difficult to interpret because so many are likely to have been removed from agricultural land (Hale 2003, 8–9). In both areas it is clear that concentrations of motifs – often cup-marks – follow the trails of boulders beside the streams. They may have been associated with the sources of the stone on the high mountains and might even have been thought of as animate as they moved downhill.

Post-medieval summer farms were located beside certain of these streams (Boyle 2003). In principle, the creation of so many buildings on the higher ground should have obscured any patterns in the distribution of rock art (Hale 2003, 8–9), but in fact the principal groups of carvings are found in the same areas as these structures. Although some carved stones were reused in their walls, it suggests that the concentrations of prehistoric rock art were closely related to the most sheltered land above 400m.

The distribution of rock art has another feature which is unlikely to be the product of later land use. It is concentrated along the lower slopes of the Ben Lawers range for a distance of approximately 10km; most of the examples cover a still more compact area. It is impossible to say whether their distribution extended into the forest to the east of the National Trust estate, but even the group of carved rocks located at its boundary is isolated from other examples. To the west there is a greater chance of finding new examples, yet their distribution thins out four kilometres before the end of the loch. It may be no accident that the carvings are most common *below the highest peaks in this area*. They are also located above a long section of Loch Tay which runs from north-east to south-west. That may be significant as it was also the dominant axis of the Kilmartin complex.

By comparison, very few carved rocks have been discovered on the southern side of Loch Tay. Here the mountains are not so prominent, although there are waterfalls. Perhaps the most important distinction is that, unlike their counterparts below Ben Lawers, decorated rocks on the sloping land above the water would not have faced into the sun.

THE SELECTION OF CARVED ROCKS

When considering the location of rock art in the landscape it is also important to reconstruct the local environment. Fortunately, there were two locations above the head dyke where it was possible to take pollen samples from deposits associated with fragments of quartz that were broken in carving the rock. In both cases this work showed that the landscape was largely open when the images were made. In one case it had been cleared of bracken to create an area of pasture not long before this activity took place. There was little evidence for trees on either of these sites. Those that were represented probably grew beside the streams (as they do now). The landscape associated with the rock art was not unlike the upland environment today.

Which features influenced the selection of rocks for embellishment with carved designs? They can be considered on three different levels: their placing in the wider terrain; the choice of individual exposures as the focus of attention; and their microtopography.

The pollen evidence makes it possible to discuss the views from and towards the decorated rocks. Two points can be made with some confidence. Although the three mountaintops – Ben Lawers, Meall Greigh and Benn Ghlas – are concealed from many of the areas with carved rocks, all the most complex panels command direct views of at least one of these summits, and sometimes more than one. They are close to streams that originated near to those places. At the same time, most of the carved rocks command views down slope towards, and along, Loch Tay where they include the hills on the opposite side of the water. This is important for several reasons. During fieldwork dynamic optical effects and illusions were frequently observed, including distinct reflections in the surface of the

loch (Figure 5.2). Because the carved surfaces were nearly all on south-facing slopes, the designs would have been highlighted at particular times by both the sun and the moon. These places would also have provided vantage points from which to watch the sun and moon travel across the sky, and to see them reflected in the water below. The main group of carvings also overlooks the section of the loch which is orientated from north-east to south-west – the axis of midsummer sunrise and the midwinter sunset respectively.

A recently discovered carving illustrates several of these points (Figure 5.3). This is an inconspicuous slab at a height of 500m. It is lavishly decorated and is a short distance

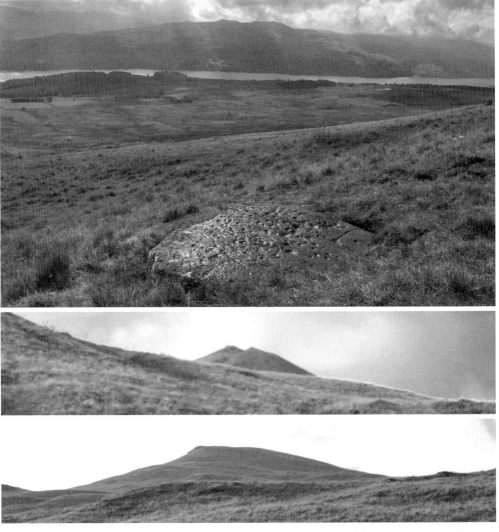

Figure 5.3: Views from a complex carving, showing how the vista of Loch Tay (top) is juxtaposed against glimpses of the summit ridges of Ben Lawers (middle) and Benn Ghlass (bottom).

above the post-medieval head dyke. To the south it commands a view of the loch extending without a break for 15km. This includes the section where most of the rock carvings have been found. Had the decorated surface been any further downhill, the view would have been interrupted by dead ground. At the same time, the rock also affords a glimpse of the summit ridges of Benn Ghlas and Ben Lawers. Again the same observation is important. From a position only slightly further down the slope these mountaintops would have been invisible. Similar, but less precise observations, can be made from the other rocks with complex decoration.

At the same time, certain kinds of rock may have been preferred to others. Those with cup marks are often inconspicuous, but exposures with cups and rings can occasionally be picked out from a distance. Blocks of epidiorite are sometimes on the edge of streams near the heads of waterfalls. Deposits of schist can be even more striking and may be characterised by hollows, fissures, cracks, veins and other inclusions of quartz, all of which could be worked into the carved designs. On the other hand, there is no obvious distinction between the kinds of motifs associated with these two types of stone. Perhaps any distinction depended on the amount of work required to decorate them and on the striking differences that would be evident in the freshly pecked surfaces. In one case, a lavishly carved rock contains a conspicuous quartz vein which resembles the appearance of a nearby waterfall, but that observation has not been repeated at other sites and the link may be fortuitous. In the same way, the freshly carved schist would have sparkled like the water of the loch. Indeed, the pecked designs recall the circular eddies that can be seen in the surface of the water. Again it is impossible to say whether this effect was intended, but it would have been recognised by anyone visiting these places.

Lastly, the main groups of carved rocks above the head dyke are rarely visible from one another. For the most part their distributions are confined to the basins occupied by shielings in the post-medieval period, and, like those summer farms, they may have been more closely related to locations on the lower ground (Boyle 2003). Although the most complex carvings commanded views of the principal summits, there is less to suggest the importance of movement *along* the ridge.

ALLT COIRE PHADAIRLIDH

Allt Coire Phadairlidh is a fast flowing stream, named after a water sprite. It marks the eastern limit of the Ben Lawers Estate and develops into an impressive series of cataracts. It also defines one edge of a shallow basin with a series of carved rocks (Figure 5.4). Somewhat unusually, it includes three complex carvings (two of schist and one of epidiorite), all of which were excavated between 2007 and 2010. The project also investigated a simpler panel dominated by cup marks, a large undecorated boulder, and a natural 'standing stone'. The work had four main objectives:

- To establish whether the carved rocks were associated with any structural features or with deposits of artefacts;
- To compare the excavated material associated with those rocks with the results of work at a control sample of rocks that had not been decorated;

- To investigate the relationship between the microtopography of the decorated surfaces, the placing of the motifs and their location in the wider landscape;
- To look for environmental evidence contemporary with the use of these places.

The final section of this paper summarises what has been achieved so far, but more detailed interpretations must await full analysis of the excavated material.

In most cases the rocks were investigated by excavating a ring of metre-square pits around the base of the stone and comparing the material recovered with the results of a second set of excavations 5m further out. This showed that, like those at Torbhlaren, the more elaborately decorated rocks were surrounded by a deposit of worked and broken quartz. Preliminary examination of the artefacts suggests that these contexts include a few pieces of broken hammerstones and a small fraction of flaked quartz. Two of the most elaborately carved rocks (Rocks 1 and 2) were associated with single pieces of Arran pitchstone. In one case a pebble from a storm beach had been placed at the foot of a decorated outcrop and a flint spall was found in a fissure on top of the same stone. By contrast, little material was found around a simple carving with a single ring and several cup-marks (Rock 3), and

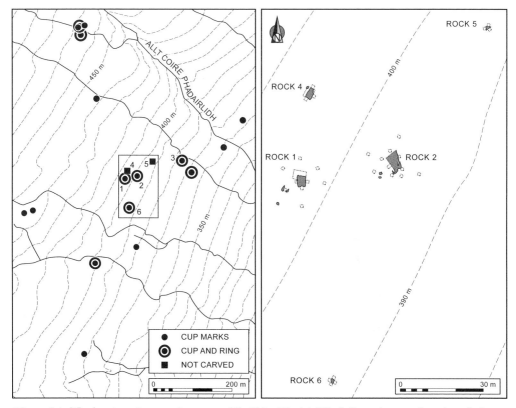

Figure 5.4: The location of excavations near Allt Coire Phadairlidh (left), and an outline plan of the test pits and other trenches.

a large uncarved block of epidiorite (Rock 4) investigated by the same method was not associated with any artefacts. The same was true of the 'standing stone' (Rock 5).

One of the rocks (Rock 1) had a steep domed surface surmounted by a cup with seven rings (Figure 5.5). It commanded an extensive view along the loch to the west and its characteristic shape was very similar to that of a hill on the far side of the water. This can only be seen from one point; it is the single location from which the carving can be identified. Here the ground surface had been consolidated by a discontinuous layer of cobbles containing a few pieces of broken quartz. It was the surface sealed by this deposit that provided pollen samples.

A second conspicuous rock (Rock 2) was decorated in a very different manner. Here the motifs were located in and around a large natural basin which contained another deposit of artefacts (Figure 5.6). In this case the carved rocks commanded an extended view along the loch to the east. Two groups of carved motifs were represented here, each of them made in a different technique. Like Rock 1, the carvings cut into schist and the surface of the stone glittered in the sun. In this case there was a series of hammerstones around the base of the outcrop. None was associated directly with the positions of the carved designs.

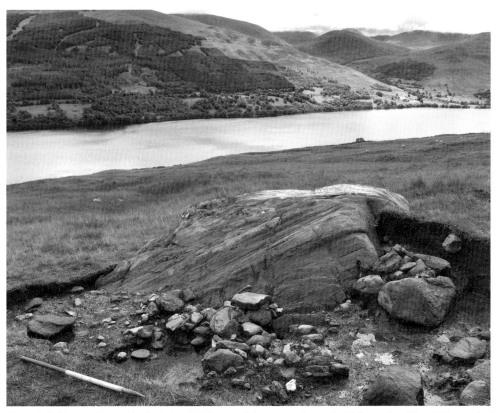

Figure 5.5: Excavation beside Rock 1, which has an elaborate carving on its highest point. The cobbles mark the optimal location from which to view this carving. The rock commands a view along Loch Tay to the south-west.

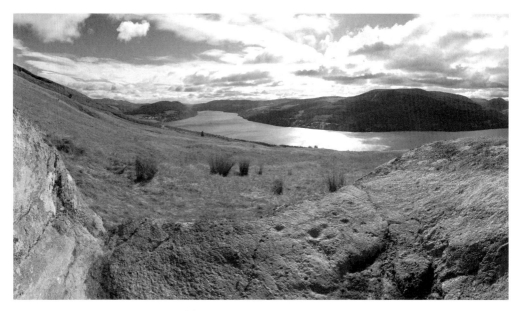

Figure 5.6: Panoramic vista of Loch Tay seen from inside the basin on Rock 2. Cup and ring marks can be seen around the margins of the basin. The rock commands a view along Loch Tay to the north-east.

The third complex carving was on Rock 6 and differed from the other examples in several ways (Figure 5.7). The stone was a rounded slab of epidiorite perched on the end of a moraine and could not be picked out from far away. It was decorated with a complex design, which was deeply pecked into the hard rock, and the motifs were characterised by unusually wide grooves. The design may have built up over separate phases. Although it overlooks Loch Tay, it seems likely that the surface was also viewed from below. Its upper edge is framed by a pecked line which had not been recorded before. It almost exactly mirrors the summit of Meall Greigh which is visible over the near horizon. Again, the top of the mountain cannot be recognised from much of the surrounding area, and it may be why this particular stone was chosen.

How were the excavated artefacts related to the carvings themselves? One point is very important. There was no direct relationship between the hardness of the decorated surfaces, the extent of the pecked designs and the quantity of broken quartz found in excavation. It raises a possibility that will be investigated as the finds are analysed in detail. Rock 2 which was associated with a number of hammerstones faces the rising sun and sparkles in strong light. Might some of these fragments result from striking the surface of the rock so that the mica grains would glitter? This is a tentative hypothesis but it does suggest that the stone should be treated on equal terms with the motifs that were created there.

In conclusion, the three main rocks to the west of Allt Coire Phadairlidh encapsulate many of the distinctive features of the decorated surfaces on the Ben Lawers Estate. Their characteristic forms and the placing of the decoration seem to link them to features of the wider topography and emphasize the special importance of high mountains and Loch Tay.

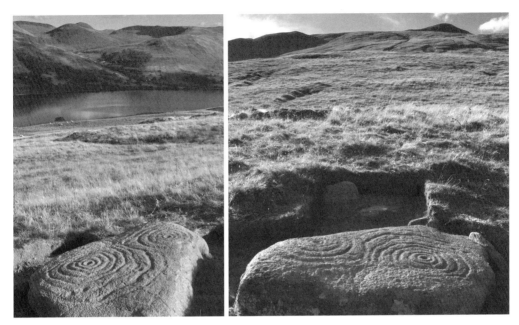

Figure 5.7: The complex carving on Rock 6, contrasting the view over Loch Tay (left) with that upslope to Meall Greigh (right); the mountaintop appears in the top right hand corner of the photograph.

The structural evidence from Rock 1 recalls the platform at Tiger Rock, Torbhlaren and suggests that decorated surfaces in apparently remote areas may have similar characteristics to those near important monuments. Pollen analysis not only helps to reconstruct the prehistoric vegetation, it also suggests that these sites may have been situated in upland pasture, as they were in the historic period. Most important of all, the results of this modest project show that excavation needs to take its place among the methods by which carved surfaces are investigated, but it will only achieve its objectives if the decorated panels are considered at the appropriate scale. Future work should involve a combination of large scale landscape survey and smaller investigations like this one if it is to enlarge our understanding of prehistoric art.

ACKNOWLEDGMENTS

The project took place with the permission of the National Trust for Scotland. We are especially grateful to Derek Alexander of NTS for his help and support. Excavation at Rock 6 was undertaken with permission from Historic Scotland. We are grateful to the Royal Commission survey team for their help and advice, and especially to George Currie who took part in the project and shared the results of his own research with us. We must also thank the small team who took part in the excavations, often in bad weather.

REFERENCES

Boyle, S. 2003. Ben Lawers: an Improvement-period landscape on Lochtayside, Perthshire. In S. Govan (ed.), *Medieval or Later Rural Settlement in Scotland Ten Years On*, 17–29. Edinburgh: Historic Scotland.

Bradley, R. 1997. *Rock Art and the Prehistory of Atlantic Europe*. London: Routledge.

Coles, J. and Simpson, D. 1965. The excavation of a Neolithic round barrow at Pitnacree, Perthshire, Scotland. *Proceedings of the Prehistoric Society* 31, 34–57.

Edmonds, M., Sheridan, A. and Tipping, R. 1992. Survey and excavation at Creag na Caillich, Perthshire. *Proceedings of the Society of Antiquaries of Scotland* 122, 77–112.

Hale, A. 2003. Prehistoric rock carvings in Strath Tay. *Tayside and Fife Archaeological Journal* 9, 6–13.

Halliday, S. 2002. Excavation of a Neolithic enclosure at Castle Menzies, Aberfeldy, Perthshire. *Tayside and Fife Archaeological Journal* 2, 10–18.

Phillips, T., Watson, A. and Bradley, R. 2002. Fieldwalking in Strath Tay, Perthshire, 1994. In T. Phillips*, Landscapes of the Living, Landscapes of the Dead*, 346–51. Oxford: British Archaeological Reports.

Piggott, S. and Simpson, D. 1971. The excavation of a stone circle at Croft Moraig, Perthshire, Scotland. *Proceedings of the Prehistoric Society* 37, 1–15.

Simpson, D. and Coles, J. 1990. Excavations at Grantully, Perthshire. *Proceedings of the Society of Antiquaries of Scotland* 120, 33–44.

Stewart, M. 1961. Strath Tay in the second millennium BC. A field survey. *Proceedings of the Society of Antiquaries of Scotland* 92, 71–84.

Living rocks: animacy, performance and the rock art of the Kilmartin region, Argyll, Scotland

Andrew Meirion Jones

INTRODUCTION

The abstract rock art traditions of Britain and Ireland stand in distinction to the figurative rock art traditions of Continental Europe; British and Irish rock art consists of a variety of abstract motifs, including cup-and-ring marks, cup and rings with gutters or tails, rosettes, star motifs and so on (Bradley 1997). As a result of their abstract nature, I argue that applying conventional stylistic and semiotic methods and approaches to the analysis of the rock art traditions of Britain and Ireland is unhelpful; instead we need to reappraise the performative qualities of rock art. In this paper I consider motifs as performances on a number of levels, examining the relationship between motifs and rock surfaces, the production of images, motifs and changing luminosity, and their interconnectedness.

This paper reports on fieldwork in the Kilmartin region of Argyll, Scotland (Figure 6.1). I have recently completed a more in-depth report on the rock art of the region (Jones *et al.* 2011). In that report I argued that prehistoric carvers perceived the rocks – on which the rock art of the region was carved – as animate; I want to emphasise a similar point here. However, rather than arguing that some prehistoric people *imbued* the rocks of the region with agency, I propose that people were instead *responding to the animacy* of the rocks. Let me explain this distinction. The notion of animism has often been considered a primitive belief, a fallacy or category mistake only made by superstitious or primitive peoples (see discussion in Harvey 2005). To argue such is to assume that the Western ontological distinction between active subjects and inanimate objects prevails for all people at all times; those who do not believe in this distinction must therefore be mistaken or acting on false belief.

The notion that a belief in animacy is mistaken rests on the rather peculiar assumption that the natural world is in fact inanimate. Careful observation, however, from a disparate group of people actively engaged in closely studying the natural world, ranging from indigenous peoples to ecologists and climatologists, attest to the changing and mutable nature of the environment. The natural world is animate: seasons change; weather alters the landscape (in the Kilmartin region on an almost hourly basis); animals and plants multiply and grow. If anyone were to doubt the animacy of the world they need only witness the surging power of the great Corryvreckan whirlpool between the isles of Scarba and Jura, off the coast of the Kilmartin region. Each of these aspects of the animated world intersect with humanity and each other (Whatmore 2002; Bennett 2010; Connolly 2011; Greenhough 2010; Ingold 2011), and people respond to their changing material environments in a variety of ways.

To recapitulate then, rather than thinking of rocks as being imbued with agency by people, instead I argue that rocks are part of the animate, mutable and changing environment, and that rock art motifs are produced in response to this mutability. In particular I want to relate how a close engagement with the rocks that were the focus of excavation and fieldwork generated an understanding of their animated and changing qualities.

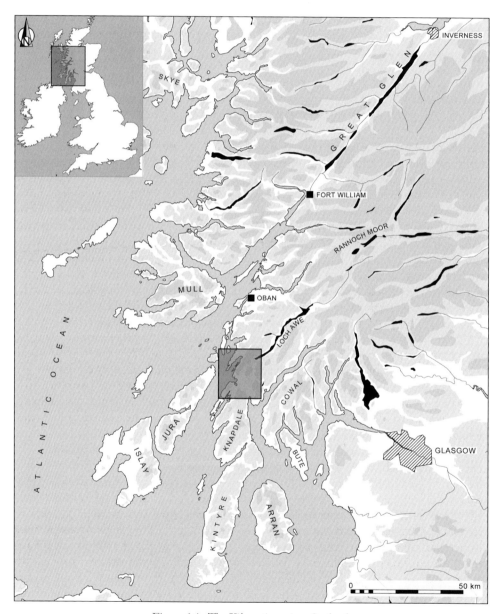

Figure 6.1: The Kilmartin region, Scotland.

ROCKS AND ROCK ART MOTIFS IN THE KILMARTIN REGION

The project initially began by surveying the more prominent rock art sites in the region. As we did this, it became apparent that there was a dynamic relationship between the characteristics of the rock surface, and the motifs carved from those surfaces.

The character of the rock surfaces have been formed by a series of events, including the folding which gave rise to the geological formation of rocks in the region. Many rock surfaces are deeply fissured along cleavage planes – natural breaks in the mineral structure of the rocks – and joints – cracks caused by the forces and pressures of folding. The rocks have also been scoured by ice action. All of this is to discuss the rocks as natural geological entities. I want to suggest that the prehistoric people who carved their surfaces may have considered the rocks differently; this is evident from the relationship between motifs and carved surface.

As we surveyed the rock surfaces it became apparent that the motifs were not randomly positioned on rock surfaces, but appeared to respond to the character of the geology (Figure 6.2). Motifs appeared to respond to the cleavage planes or joints, the cracks and fissures, of the rocks. Motifs also appeared to relate to quartz veins in the rocks. Certain motifs – such as cup-marks – were positioned in dynamic relationships with natural bowls or cups on the rock. In other cases, the gutters or tails of motifs corresponded with the contours and undulations in the rock surface. Again, gutters and tails also often conjoined motifs with the cracks and fissures in the rock surface, creating a visual dynamic between carved motifs and rock. Particular categories of motifs appeared to be carved on rocks of differing character: passage tomb art motifs on rocks with a criss-cross pattern of cleavage planes and joints; multiple ring motifs on surfaces with large rectangular cleavage planes and joints; and cup-and ring-marks or cups and tails on surfaces with small rectangular or lozenge shaped cleavage planes and joints. I will not dwell on all of the aspects of the rock art of the region here, as I have already discussed this at length elsewhere (Jones 2005; 2006; Jones *et al.* 2011). Importantly, this close attention to the features of the rock appear to be a predominant characteristic of the rock art of the Kilmartin region, although it does occur to a lesser degree in other neighbouring rock art regions (Freedman in Jones *et al.* 2011). In the Kilmartin region, the rock surfaces do not appear to be treated as inert materials, instead the carvers appear to have been responding to the cracks, fissures and undulations of the rocks; motifs were carved in answer to the uneven and changing character of the rocks.

THE ROCK ART SITES OF TORBHLAREN

While the distribution and occurrence of British and Irish rock art has been fairly well documented, we know remarkably little about these rock art traditions. For example, we are still uncertain of their date, with dates in both the Neolithic and the Bronze Age having been proposed. The primary impulse for fieldwork in the Kilmartin region was to excavate rock art sites to provide dating evidence.

The rock art sites at Torbhlaren are located in Kilmichael Glen and are intervisible with the well known carved outcrop at Kilmichael Glassary. The sites are situated on the

20m contour, in the bottom of the glen and consist of two major carved rock outcrops (Torbhlaren 1 and Torbhlaren 2) known to the members of the field project respectively as Tiger Rock and Lion Rock. Some 50m from Tiger Rock stands a decorated standing stone. A further decorated standing stone once stood close to Lion Rock, though it has since been removed.

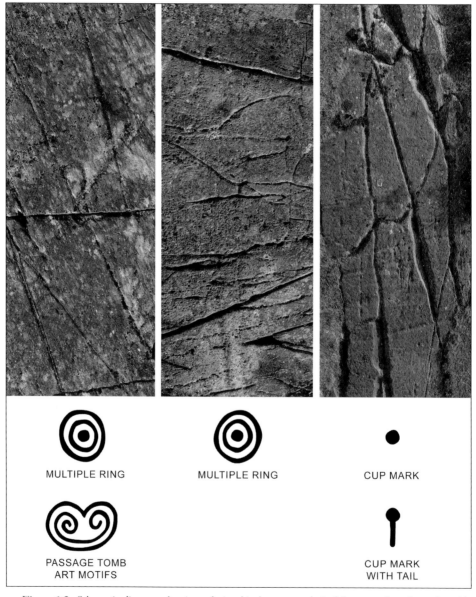

MULTIPLE RING MULTIPLE RING CUP MARK

PASSAGE TOMB ART MOTIFS CUP MARK WITH TAIL

Figure 6.2: Schematic diagram showing relationship between geological features of rocks and motifs.

Excavation around Tiger Rock produced evidence of a sequence of activities initiated by the construction of a small stake built circle of around 1.5m in diameter (Figure 6.3). The circle was built against the south-east end of the rock. This was subsequently burnt, and over the former site of the stake circle was constructed a stone and clay built platform. This platform enclosed the eastern side of the rock along its length. Activities also took place, however, on the rock surface itself, as excavation of fissures and crevices on the rock produced groups of lithic material, mainly composed of quartz. In addition to this, quartz artefacts, mainly hammerstones, were deposited on and around the platform abutting Tiger Rock.

Analysis of the lithic material by Hugo Anderson-Whymark (Whymark in Jones *et al.* 2011) indicated that most of the lithics derived from quartz cobbles and pebbles from fluvial sources. The lithic assemblage from the platform comprised 13 hammerstones, 18 possible hammerstones and one abraded or utilised pebble, mainly of milky quartz. The major fissure on the surface of Tiger Rock with a deposit of artefacts yielded an assemblage of 871 worked local lithics, 96 pieces of unworked local stone, and a single chip of flint. The assemblage was dominated by small chunks of quartz, and also includes a split quartz pebble, a core fragment, a bi-polar core, three hammerstones and one possible hammerstone. Practical experimentation by Anderson-Whymark with comparable quartz pebbles and using slabs of local epidiorite indicated that these pebbles were likely to have been used to produce rock art motifs. This therefore importantly indicates that the excavated lithic materials are likely to derive from rock art production activities.

Two dates for Neolithic activity were obtained from Tiger Rock, one from post-hole 18 of the stake circle provided a calibrated date of 2580–2340 BC at 95.4% probability. A further date from the fissure on the rock surface, that yielded the lithic material, fissure 20, provided a calibrated date of 2920–2860 BC at 95.4% probability. I argued above that the lithic materials derived from the fissure on the rock surface, and from the platform, are the probable residue of rock art production activities. As the deposits in the fissure on the rock surface have been dated to the Late Neolithic, it is possible to link rock art production activities to this date. On the basis that the platform immediately seals the stake circle – dated to the Late Neolithic – it is possible to argue that the platform also dates from the Neolithic. This is given additional support by the fact that the platform is covered in lithic materials with comparable form to those derived from the fissure on the rock surface.

While the Neolithic date for rock art production at Tiger Rock seems reasonably secure, a note of caution must be sounded, as the site also has dates from the early historic period (*c.* 5th–7th century AD), associated with a charcoal filled scoop cut into the top of the platform. Evidently the site continued to attract attention into the historic period. This much is evident when we look at activities associated with Lion Rock, the other major rock art site at Torbhlaren.

Lion Rock is an impressive whaleback rock. Although several trenches were excavated south, east and west of Lion Rock there was no activity around the rock, other than low-level lithic materials. Most of the activity appeared to occur on the rock surface itself. A large fissure was excavated on the southern end of the rock, fissure 16, this yielded a mixture of lithic materials, including a chip of Arran pitchstone. Radiocarbon dates from this area were, however, extremely mixed. A long linear cleavage plane, fissure 21, running

up the spine of the rock was excavated, yielding two clusters of artefacts. The first cluster included four struck flints, two pieces of pitchstone, 312 pieces of worked quartz and 66 unworked pebbles. The flints include one struck bipolar flake and three chips. The pitchstone comprises a burnt and broken parallel-sided micro-blade, characteristic of Early

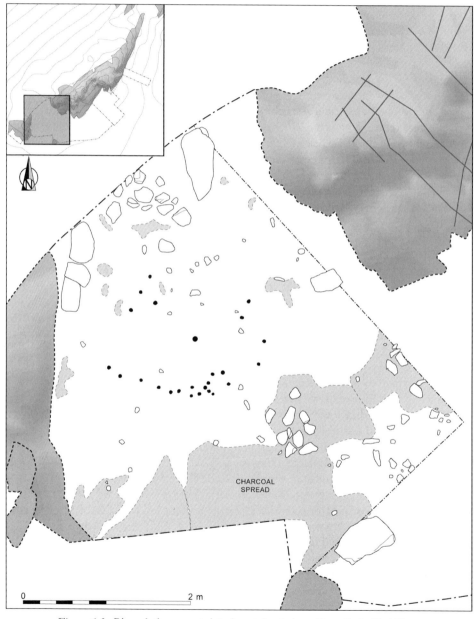

Figure 6.3: Plan of the excavated timber stake circle at Tiger Rock, Torbhlaren.

Neolithic working techniques (T. Ballin pers. comm.). The quartz and quartzite assemblage consists of flakes and chips that may have resulted from systematic core reduction. The second cluster of material in this cleavage plane comprised a limited assemblage of indistinct chunks of quartz.

A small crevice or fissure on the upper southern surface of the rock, fissure 18, was excavated and included lithic material comprising three flakes and 112 small indistinct chunks of quartz. These appear to result from the reduction or fracture of a single quartz pebble, although direct refits could not be found.

Finally, a long fissure on a shelf of rock to the west was excavated, fissure 19. Excavation of this fissure was in two spits. The upper spit yielded a mixture of materials, including lithic materials, modern field drain, and after sieving, two beads of probable Medieval date, one of amber, the other of blue glass. The lower spit comprised stratified lithic materials, including a substantial assemblage of 471 worked local lithics, three flints and 439 unworked local lithics. The lithic assemblage provides good evidence for the production of rock art, through the presence of nine hammerstones and four possible hammerstones of milky quartz, but only limited evidence for the splitting and systematic reduction of quartz pebbles as cores.

The radiocarbon dates obtained from Lion Rock were mixed. Many of the dates are unstratified, and the only reliable date derives from the lower spit 2 deposits from the fissure, dating to the Late Bronze Age, 1320–1110 BC at 95.4% level of probability. Like the fissure on the rock surface on Tiger Rock, this fissure was also associated with a deposit of hammerstones likely to have been utilised in rock art production.

The evidence from the two sites provides a complex picture of activities. Lithic evidence in the form of pitchstone from Lion Rock indicates probable activity at the site in the Early Neolithic, while the radiocarbon dates obtained from the stake circle at Tiger Rock indicate constructional activities dating to the Late Neolithic. The lithic and radiocarbon evidence from fissure 20 on Tiger Rock (Figure 6.4) is probably indicative of rock art production in the Late Neolithic, while similar evidence from fissure 19, Lion Rock is indicative of rock art production in the Late Bronze Age. We are therefore potentially looking at a long tradition of rock art production, with the initiation of rock art production in the Late Neolithic, and continuation of rock art production activities at the site into the Late Bronze Age.

Figure 6.4: Photograph of artefacts deposited in rock fissure, Torbhlaren.

One of the clear results of the fieldwork at Torbhlaren was evidence of rock art production activities. Notably rock art creation was a performance, it involved the construction of artificial platforms around one rock art site – Tiger Rock – and took place on a natural platform at the other site – Lion Rock. The production of rock art from these platforms would have elevated the carver above the audience, making them highly visible. Moreover, rock art production was performed using pebbles of quartz. Striking quartz produces a triboluminescent effect owing to the crystal structure of the material, and under certain lighting conditions this is spectacularly visible. Both the materials used to create rock art, and the use of platforms as a location for performance, suggest that rock art production was a striking and visually spectacular activity. This was an activity that responded to the differing character of the two major rocks at Torbhlaren and altered the character of the rocks. It was a performance whose residue shaped the environs of the rocks, and was responded to by successive generations visiting the rocks.

ROCKS AND LUMINOSITY

We have looked at the way in which the geological changes in the rocks were responded to by prehistoric rock art carvers, and we have looked at the way in which the two rock art sites at Torbhlaren were responded to and altered over time. In that sense I have looked at the way in which some prehistoric people responded to changes over lengthy periods of time. In what sense did prehistoric people respond to relatively brief changes in the character of the rocks?

The rock art motifs of the Kilmartin region are difficult to see under most lights, they are most visible under low light, during the early morning and evenings. At this time images appear from the rock surface, often etched in shadow. On certain panels, and in certain low sunlight, the colours of the rocks (and occasionally the motifs) are apparent. The best example of this is the Upper panel at Cairnbaan (Figure 6.5). Here, oblique sunlight shining on the surface of carved surfaces alters the character of the rock surface – occasionally altering the colour of the rock – and reveals the network of shadows in the undulating rock surface. At one moment the rock art motifs are inextricably related to the rock surface, while with the action of low sunlight the rock art motifs stand out from the rock surface, and through shadow – reveal the connection between surface and image.

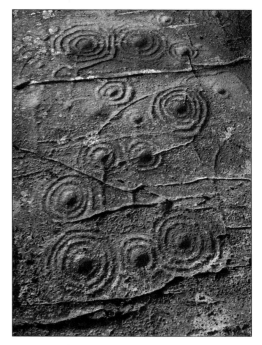

Figure 6.5: The Upper panel at Cairnbaan illustrating the play of colour and light on the rock surface.

This is but one example; analysis of the orientation of panels in the Kilmartin region demonstrates that of the 18 sites where it is possible to document the details 72% (13 sites) of the rock surfaces are oriented north-east to south-west. The remaining sites are mainly oriented east–west, with one exception oriented north–south. Therefore the majority of rock art motifs are carved on rock outcrops oriented so as to catch the light of the early morning and evening sun. As such the changing characters of the rocks are revealed by changing light levels; the relationship between rock surface and carved motifs is fleeting.

In discussing rock art production we assume the primacy of the act of carving stone, but should we not also consider the manipulation of light to be of equal importance? We cannot know what time of day that the motifs were carved, though the significance of early morning and evening sunlight might suggest either of these times were significant as this would be when freshly carved motifs were most visible. It would seem that rock art sites are not only places, but also times, as the action of light on rock surfaces produces differing effects at differing times. The carving of rocks is not only a response to the material of the rock, but also a response to light; the intersection of rocks and light alter the character of both, and rock art carvers emphasise this. Rock art carving is then a performance that shapes light as well as rock, a performance that appreciates and understands the changing character of the material environment over the day.

CONCLUSION

In this paper I have looked at various ways in which some Neolithic people responded to the changing character of the rocks on which they carved rock art in the Kilmartin region of Argyll, Scotland. In addition to the performance of carving rocks as a response to their changing character, rock carving was also performative; that is it was a performance that produced certain effects.

One of these effects was that rock art visualised relationships and connections. We have seen that carved motifs visualised the relationships between rock surface and carved motif. However relationships and connections were also performed at a regional scale, as the carving of common motifs connected individual rock art panels across the region (see Jones 2006; Jones *et al.* 2011). The individual carved panels were then part of a regional system, an interconnected series of performances.

I have argued in this paper that if we are to understand rock art it is necessary to understand the kinds of relationships being performed and established by the act of carving on rock. I have argued that the act of carving evinces a response to the changing geological character of rocks and to changes over both long periods of time and much shorter durations, such as are visible in the changing illumination of individual panels throughout the day. To examine the way in which people responded to rocks during the Neolithic and other periods by carving them is to entertain the possibility that people were treating rocks as quite different ontological entities. Carving rocks is less about signalling identity or defining territory, and more about establishing relationships with different places in the landscape.

REFERENCES

Bennett, J. 2010. *Vibrant Matter. A Political Ecology of Things*. Durham, NC: Duke University Press.
Bradley, R. 1997. *Rock Art and the Prehistory of Atlantic Europe: signing the land*. London: Routledge.
Connolly, W. E. 2011. *A World of Becoming*. Durham, NC: Duke University Press.
Greenhough, B. 2010. Vitalist geographies: life and the more-than-human. In B. Anderson and P. Harrison (eds), *Taking Place: non-representational theories and geography*, 37–54. Farnham: Ashgate.
Ingold, T. 2011. *Being Alive. Essays on Movement, Knowledge and Description*. London: Routledge.
Jones, A. 2005. Between a rock and a hard place: rock art and mimesis in Neolithic and Bronze Age Scotland. In V. Cummings and A. Pannett (eds), *Set in Stone: new approaches to Neolithic monuments in Scotland*, 107–17. Oxford: Oxbow Books.
Jones, A. 2006. Animated images: images, agency and landscape in Kilmartin, Argyll, Scotland, *Journal of Material Culture* 11, 211–25.
Jones, A., Freedman, D., O'Connor, B., Lamdin-Whymark, H., Tipping, R. and Watson, A. 2011. *An Animate Landscape: rock art and the prehistory of Argyll, Scotland*. Oxford: Windgather Press.
Whatmore, S. 2002. *Hybrid Geographies: natures, cultures, spaces*. London: Sage.

The halberd pillar at Ri Cruin cairn, Kilmartin, Argyll

Stuart Needham and Trevor Cowie
with a contribution by Fiona McGibbon

INTRODUCTION

The cairn of Ri Cruin is situated in the heart of the classic prehistoric complex in the Kilmartin valley (RCAHMS 1988, 72–4: inventory no 76; see also RCAHMS 1999, 34–6; Figure 7.1). Amongst a dense concentration of recorded sites are many examples of Neolithic and Early Bronze Age rock carvings; most are 'open air' sites, but some appear in burial monuments (summarised in Jones 2001). Ri Cruin has long attracted attention for its two carved slabs, both from the southernmost cist in the mound. One, the western end-slab of the cist, uncontroversially depicts a series of axe-heads but the other, a narrower slab forming part of the eastern end of the structure, has a much more enigmatic carving. Past attempts to interpret it have ranged from ogham inscription, long since discounted, to more figurative representation, either as a boat or as a halberd ornamented with ribbons or pennants. However, no single identification has seemed convincing or won consensus. At the risk of pre-empting our own argument, we shall for ease of description refer to this as the halberd stone or halberd pillar. One of the problems for re-assessing the stone is the fact that having been removed from the site to nearby Poltalloch House, it was apparently destroyed in a fire in 1893 (Craw 1930, 132). Since then, any study has had to rely on a nineteenth century cast which resides in the collections of the National Museums of Scotland (accession no: X.IA 13; Figure 7.2). Fortunately, the cast seems to have picked up much surface detail, some of it relatively subtle, and recent inspection by the authors has allowed some new observations to be made. Perhaps the most important point in relation to identifying objects or familiar motifs is the realisation that it was probably a palimpsest of two or three phases. In addition to the obvious bearing this has on the character of the motifs, recognition of a multi-phase composition also has implications for the history of both stone and site.

SITE CONTEXT

Although the original discovery of cists at Ri Cruin apparently dates to the 1830s, the first recorded accounts of the cairn were by the Rev. Reginald Mapleton (1870a; 1870b), who investigated the three cists still visible on the site today. It is clear that the enclosing cairn was already badly disturbed at the time, having evidently been encroached upon by houses

Stuart Needham and Trevor Cowie

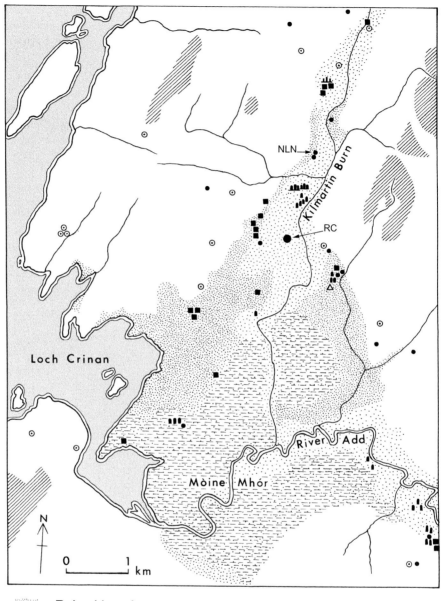

Figure 7.1: Location map for Ri Cruin, Argyllshire (RC). Nether Largie North cairn is also indicated (NLN).

and a lime kiln, though one of Mapleton's accounts suggests the cists came to light as a result of trenching for a plantation. Our concern here is primarily with the cist with the carvings; for a summary of the main features of the site, including the other two cists, the reader is referred to the RCAHMS Inventory entry.

Mapleton's account is ambiguous; although he correctly places the cist with the carvings as the southernmost of the three, he goes on to suggest it *'occupied the centre of the cairn'*, while admitting elsewhere that *'it is not easy to ascertain the limits or size of the cairn'*. However, in terms of the current restoration, largely based on excavations undertaken by Gordon Childe in 1936 to ready the site for public presentation, the cist is set instead towards the southern edge of the cairn and beyond the projected line of the original kerb (Figure 7.3a, after RCAHMS 1988, 72–4). As restored, this general disposition is apparently supported by the presence of kerb stones in the east and south sectors, some still being visible (see also Figure 7.5). Another inconsistency, which has been noted previously, lies in Mapleton's orientation of the cist, his text saying 'ENE–WSW' and his plan showing 'ESE–WNW' (Figure 7.3b; Mapleton 1870a, 379 fig. 1; Campbell and Sandeman 1962, 18, no 119). For reasons that will immediately become clear, it is the latter that appears to be correct.

In spite of these inconsistencies in Mapleton's own reporting, it now seems that he was able to draw on expert help. As a result of our research for this paper, we became aware of a previously unpublished measured drawing of the cist in the manuscript collection of the Society of Antiquaries

Figure 7.2: The cast of the halberd pillar. © National Museums Scotland.

of London (SAL BP 20 Scotland 66; Figure 7.4). Although unattributed, we can be confident that it was the work of Alexander Fraser, architect and Clerk of Works to John Malcolm, the 14th Laird of Poltalloch. Malcolm exhibited a cast and rubbings of the carvings at a meeting of the Society of Antiquaries of London in June 1870; according to the published proceedings of the meeting, these accompanied a letter addressed to A. W. Franks, then Vice President. In this, Malcolm reported the discoveries at Ri Cruin, drawing heavily upon (but apparently without crediting) the work of Mapleton (Malcolm 1870, 511–13; the drawing was presumably also sent to the Society at this time). Another letter, sent that April from Mapleton to the Society of Antiquaries of Scotland, establishes beyond doubt that it was Fraser who undertook the preparation of the plaster casts of the two decorated slabs, which he subsequently donated to the Society (SAS Ms Coll UC 17/37; see Appendix 1). That letter also allows us to infer that Fraser was responsible for what were, for their time, accomplished technical drawings of the cist. In effect, they now set the benchmark against which later depictions of the cist have to be viewed. Even here though, there is an internal inconsistency; the blocks forming the side walls are shown much wider in the sections than in the plan.

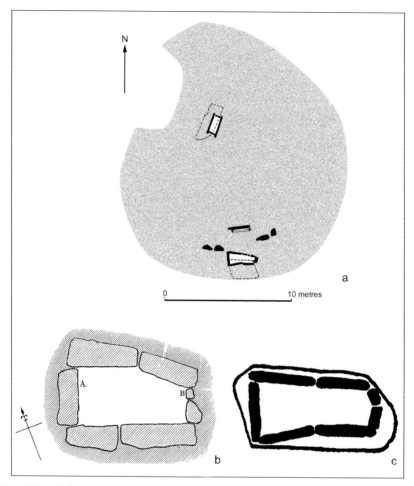

Figure 7.3: a) Plan of the cairn remains and the three cists, after RCAHMS (1999); plans of the southern cist as illustrated by b) Mapleton (1870a) and c) Craw (1930). The positions of the axe-carved slab (A) and the halberd pillar (B) are indicated by Mapleton.

The cist was described again a decade later by J. Romilly Allen (1880), later to become the doyen of study of Early Christian carved stone monuments in Scotland. Allen had visited the site with Mapleton the year before; he noted that '*the drawings exhibited had been prepared by himself from rubbings, sketches, and measurements taken at the time*'. His somewhat stylised published plan shows a cist of markedly different shape – not least as a result of the addition of an extra stone at the eastern end. The focus of Allen's interest was the western end-slab with the axe carvings; however, for our immediate purposes, Allen's drawings beg the question of whether the halberd stone was then still *in situ*, or whether its removal had somehow by then started to affect the structural integrity of the cist. His identification of the stone as '*metamorphic slate*' (1880, 148) was appropriate according to the terminology of the time.

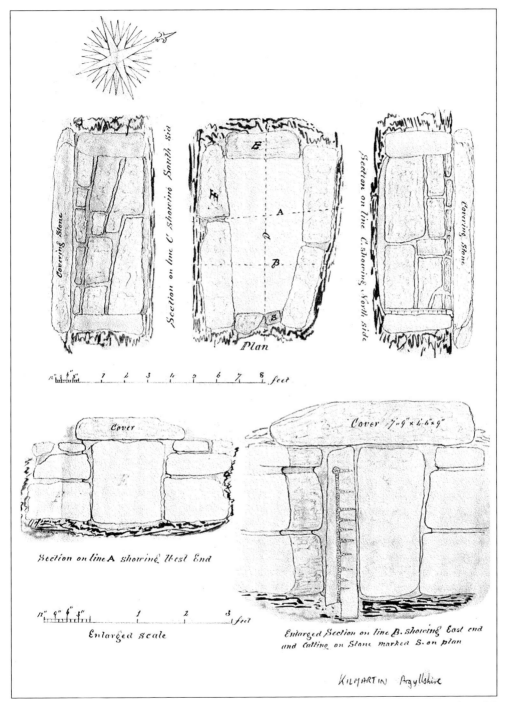

Figure 7.4: Drawing of the cist at Ri Cruin by Alexander Fraser, architect and Clerk of Works to John Malcolm of Poltalloch. © Society of Antiquaries of London (SAL BP 20 Scotland 66); on the plan the axe-carved slab is marked 'E' and the halberd pillar 'S'.

Further work was undertaken at the site by J. Hewat Craw in 1929. His plan shows the cist orientated close to east–west (Craw 1930, 132 fig. 15, as does the plan in the RCAHMS inventory). Craw noted the marked discrepancy between his and Mapleton's published plans: whereas Mapleton had shown the *north* wall to be slightly angled, Craw found this feature to be in the *south* wall (Figure 7.3b; *ibid.*, 132 footnote 1). Moreover, Craw shows the halberd stone still to be in position, but states that it was a *replacement* stone (*ibid.*, 134); it is no longer present in the RCAHMS plan.

However, in the light of the Fraser drawing, presumably not available to Craw, we can now see that Mapleton's published woodcut is reasonably reliable and differences between plans probably reflect changes in the structure precipitated by the removal of the halberd stone in the nineteenth century. As noted above, a plaster cast was also made of the slab with the axe carvings (accession no: NMS: X.IA 12) which may have led Craw to think that *both* carved slabs had been taken to Poltalloch House (*ibid.*, 132) for he was clearly not expecting to find either of them in place; later in the same paper he notes that '*it was with no small surprise and satisfaction that we found the axe-head slab to be still* in situ' (*ibid.*, 134). It may therefore be the case that the casting of the axe-carvings was achieved with the slab still in place.

Although not stated anywhere explicitly, damage by tree roots may have been distorting the form of the cist. Childe's excavations of 1936 had the remit of allowing the site to be '*properly proclaimed for visitors*'; the main tasks were careful clearance of dangerous tree roots and debris and the general repair and treatment of the site (National Archives of Scotland MW1/628: memo from J. S. Richardson 22 July 1936). The cairn had been heavily disturbed, but Childe located two partly intact segments of the original kerb on the east and was able to extrapolate that the original cairn had a diameter of 60–64ft [18.3–19.6m], centred on the northernmost cist (Figure 7.5: Childe's cist A). In his view, the collapsed, middle cist (B) would have lain on the extreme margin of the cairn and the cist with the carvings (C) outside it altogether. Childe appears not to have excavated the cist itself, but to its west, he found a line of three large blocks resting on the subsoil, the largest being 3ft long, 1ft 3in wide and 13in high [0.91 × 0.38 × 0.33m]. He noted that '*together with the end of a slab on the northern side of the cist, these blocks form a continuation westward … for a distance of 8'8'*' [2.64m]. Childe clearly struggled to make sense of this feature: in his report he pointed out that

> '*these slabs form no part of the kerb of the cairn …but no counterpart to them on the south side of Cist C survives. It cannot therefore be asserted that they represent a degenerate survival of the entrance passage to a burial chamber but no other interpretation suggests itself*' (*ibid.*: Cists at Ri Cruin, unpublished typed report).

Unfortunately the features revealed by Childe were not incorporated into the site as restored. In its current form the cairn shows intermittent traces of kerb stones on the south and east arcs; the four shown in the southern sector in the Royal Commission plan do not correspond well with Childe's field drawings. This may be explained by a brief and cryptic memo from James Richardson, the Principal Inspector of Ancient Monuments on the reverse of a letter from the Office of Works thanking Childe for carrying out the work at the site: '*I have seen this monument since Prof Childe completed his work and gave instructions to the Architect on the site concerning the adjustment of certain details and the lay-out of the area concerned*'.

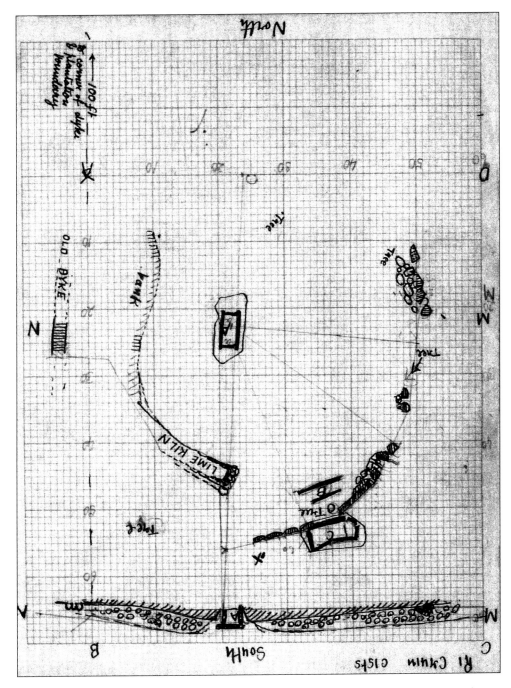

Figure 7.5: Childe's field plan (ink and pencil on graph paper), showing the main features revealed in the course of his excavation at Ri Cruin in 1936. The drawing is deliberately inverted to facilitate inter-comparison with plans in Figure 7.3. NAS: MW1/628. © National Archives of Scotland.

In summary, various aspects of the wider archaeological context of the cist with the carvings have been left ambiguous due to disturbance of the site in the course of tree planting, the construction of the lime kiln, poorly or completely unrecorded excavations, and ultimately tree root damage and decisions made in the process of restoration itself. Our suspicion is that the structure of the cist itself has been altered over time, particularly at the eastern end – a process doubtless set in train by the removal of the halberd stone. Despite these uncertainties, nothing detracts from the highly unusual nature of the cist which is reinforced by the previously unpublished Fraser drawing and Childe's unpublished report on his work.

THE CIST

Turning to the cist itself, the physical position of the halberd stone is intriguing. Not only was the slab unusually narrow, more like a pillar in fact, but Mapleton's published accounts, now supported by Fraser's drawings, combine to indicate an unusual form of cist construction, 2m long, 1m wide at the west end tapering to 0.66m at the east, and 0.91m deep [measurements taken from Fraser's plan are 6ft 7in, 3ft 4in, 2ft 2in and *c* 3ft respectively]. Early Bronze Age cists were normally symmetrically constructed from slabs, the ends almost invariably being formed of a single slab each, while the long sides might likewise be single-slabbed, or have opposing paired slabs. In this case both long sides and east end are unusual. The long sides were not of full-height slabs; instead, relatively low foundation blocks, two on either side, were heightened by using a drystone walling technique (Figure 7.4); Mapleton himself had drawn attention to the fact that the cist's *'form and construction are unusual in this locality; it seems [to be] a transition between the chambered and the ordinary cists'* (1870a, 379) and this was echoed by Malcolm, who refers to the cist as *'being* partly *built of large boulders and* partly *of slabs of stone: in this respect, it is unlike any other previously found'* (1870, 513). Judging from the position shown in Childe's plan, the cist's north wall was actually more or less on the line of the original kerb of the cairn; this might have explained the irregular mode of construction, except that the cist is stated to have been sunk into the ground, rather than stood on it.

The double-stone setting at the east end is also odd, as is the contraction of the cist towards this end. These features suggest further modifications of standard cist design presumably because of the desire to accommodate the halberd pillar. In this locality it seems unlikely that these features can be due to a shortage of appropriately sized slabs; instead they seem likely to reflect conscious design. Mapleton made a very interesting observation about the halberd pillar: 'it was more deeply fixed in the soil than the side slabs' (1870a, 380), and this is now seen to be fully borne out by Fraser's drawing (Figure 7.4). Although the standards of exploration and reporting are not as good as we would like today, the collective evidence is compelling that the halberd pillar had a decisive effect on the plan of the cist. This suggests a paramount need to incorporate a pre-existing stone that had dimensions that were not well suited to Early Bronze Age cist construction. Our reconsideration of the carved design below supports this scenario.

If the halberd pillar was unusual, what of the axe-carved slab? This is certainly a more conventional end-slab in terms of its size and proportions and, even if reworked, structurally

it conforms well to standard cist design. However, this does not necessarily mean that the carvings are contemporary; many examples of previously carved rock surfaces have been recognised to have been incorporated into cists and mounds (Simpson and Thawley 1972) and there are further examples in the Kilmartin area (Jones 2001).

Before turning to a fresh consideration of the carved stones themselves, brief mention may be made of the contents of the cist. What little information we have is dependent on Mapleton. The cist had been set in a pit so that its top was at around ground level. It had a large capstone, as is generally the case, and its floor comprised a *'rough pavement'*. The cist contained a dark clay deposit which was *'very unctuous, and, when first opened, the men complained of a very unpleasant smell'* (Mapleton 1870a, 380). Mapleton was undoubtedly correct to surmise that these were the signs of an almost wholly decayed inhumation; indeed, he obtained *'one minute portion of what I believe to be bone, not larger than a pea, which was amongst the most unctuous part of the clay ...'* (*ibid.*). No grave goods were found. In addition to the two main carved stones, Mapleton reported between nine and 11 small pits, *'as large as a fourpenny piece'* on one of the side slabs adjacent to the west end, but these are not mentioned by the Royal Commision, nor have authors noted any features matching that description.

THE AXE SLAB

Mapleton rhetorically asked opinion of his peers as to whether the *'nicely executed'* depictions at the west end were *'portraits of bronze weapons, placed there instead of the real weapons ...'* (1870a, 380). Apart from a rather misguided suggestion by Col. Lane Fox (later General Pitt Rivers) that they probably represented moulds (see Mapleton 1870b, 342 – report of discussion following meeting), there has since then been general acceptance that they represent flat copper or bronze axe-heads (e.g., Craw 1930, 132), but little attempt has been made to identify them further. The Royal Commission (1988, 73) refer to only seven carvings while Malcolm includes an inaccurate woodcut showing as many as nine (1870, fig. 2). Six of the Ri Cruin axe depictions are fairly well defined, but two others we can recognise are extremely diffuse (Figure 7.6). It is possible that a ninth existed in a defaced area towards the top of the slab. Assuming these were not accidentally defaced during the original discovery, there are various possibilities: first, that these two were never finished to the standard of the others; secondly, that they had been differentially weathered or abraded before or during incorporation in the cist; thirdly and least likely, that weathering or defacing took place after construction but while the cist was still open. None of the axe-heads is truncated, but they extend right to the base of the slab; this may simply mean that they were carved on the stone just before it was erected into the cist. Less easy to explain as a feature of contemporary design is the fact that the group of axe-heads is not centrally sited on the slab, occupying the middle to right-hand side (north). The surface of the slab would certainly have allowed more central positioning of the group even though a fissure and a step lie towards the left-hand margin. This might suggest the slab was cut from a previously decorated rock surface, but the main argument against this having happened is the absence of axe-heads in the extensive range of 'open-air' rock art.

There are legitimate concerns regarding potential stylisation of such carvings, concerns certainly emphasised by the obvious stylisation of the nearby axe-head carvings at Nether

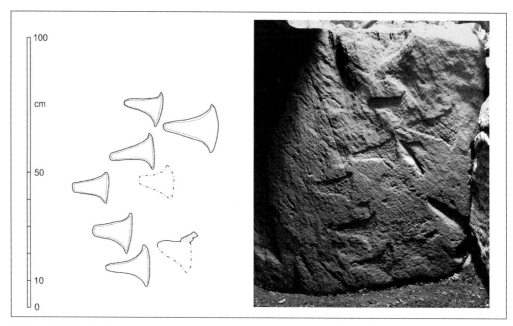

Figure 7.6: The Ri Cruin axe-head carvings; drawing based on author's field observation (SN) and photograph, after RCAHMS (1999).

Largie North (Figure 7.1; RCAHMS 1988, 68–70, Inventory no 68; RCAHMS 1999, 32–3); many depicted there are of shapes not especially well matched among the Chalcolithic and Early Bronze Age series of copper/alloy axe-heads. Likewise, the axe-heads on a slab from a barrow at Badbury, Dorset, are clearly stylised, being almost triangular (Piggott 1939, 294–9 pl. lix; Lawson 2007, 255 fig. 8.8). Nevertheless, it is worth considering the Ri Cruin carvings in their own right, for they are of different shape from those at Nether Largie North, and are not close either to recorded axe carvings elsewhere. The better preserved Ri Cruin examples consistently show very strongly splayed bodies starting at a narrow butt, sometimes very narrow (Figure 7.6). There is a further expansion at the blade tips and the curvature of the cutting edges is slight. These shapes can in fact be well matched among Killaha type axe-heads (Figure 7.7) and no other types have sufficiently broad cutting edges. Although Killaha axe-heads are most common in Ireland, they occur in small numbers in Britain and mould finds show that they could be manufactured here as well (Needham 2004; Cowie and O'Connor 2009, 6, 12). One cannot rule out stylisation, but given there is a viable specific comparison, it is not unreasonable to see the Ri Cruin axe-heads as representing Killaha axe-heads.

THE HALBERD PILLAR

The carving on the halberd stone from the opposite end of the cist is altogether more difficult to evaluate (Figure 7.8). Reliance on the surviving cast poses its own problems, since we cannot be sure whether all the fine detail has been replicated, in particular textural

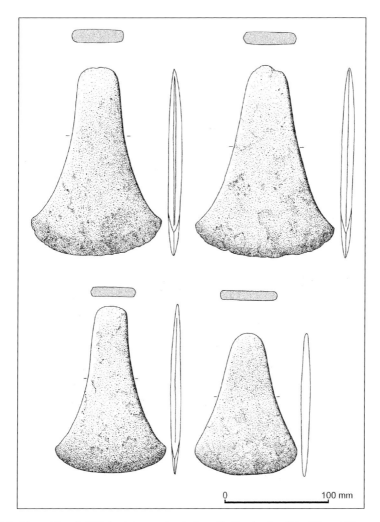

Figure 7.7: Examples of Killaha type axe-heads from Scotland, after Schmidt and Burgess (1981).

qualities. In addition to potential loss of information, this also precludes distinguishing between modern and ancient damage and constrains assessment of potential reworking. Nevertheless, as we have already stated, there does seem to be much faithful rendering of the original stone, including shallow scars and narrow grooves that may be features of the original rock's surface.

In order to help with such questions, Fiona McGibbon kindly examined the plaster cast (see Appendix 2). In summary, the surface features of the cast suggest the original lithology could be albitic chlorite schist, a rock type typical of this part of Argyllshire (Argyll Group, Dalradian Supergroup, metavolcanic and metavolcaniclastic lithologies). Pillar- and slab-shaped rocks would have been naturally available from suitable rock outcrops, requiring only to be snapped at their base to remove them from the rock mass.

The stone has a fairly regular rectangular section, and is also near rectangular in plan, although the left side is slightly bowed. The decorated face is flat but with minor irregularities. Mapleton gave the dimensions of the stone as 3ft 4in long, 7–8in wide, 7½in thick at the top and 5in at the bottom. These correspond tolerably well with the current dimensions of the cast (overall length 1045mm; width 215mm at base; 180mm at top; thickness not available – the cast is 60–70mm thick but probably fell short of the back edge). The bottom of the stone is a jagged line both in Mapleton's depiction and on the cast and, crucially, it is shown thus *in situ* in the cist in Alexander Fraser's drawing (Figure 7.4). From the drawing it appears that approximately 6in (15cm) of the extant pillar would have been buried, enough to warrant Mapleton's observation that it was set more deeply. McGibbon's assessment below suggests that this reveals features of a classic fracture pattern for the rock type, but unfortunately this cannot tell us when the fracture occurred. While it could be the result of the original detaching of the slab from its parent rock outcrop, our consideration of the design suggests that slab was originally longer and perhaps derived from some other monumental setting. Again, we cannot know whether it was broken accidentally on extraction from that primary use location, or deliberately in order to shorten it for re-use.

The 'design' that has always been depicted in past publications comprises a long near-straight groove running more-or-less axially along the slab; from this runs a set of ten or eleven orthogonal grooves, mostly reaching the right edge of the stone (Figure 7.8a). They are not evenly spaced and the top one, issuing from the end of the longitudinal, is different in shape – broader at the junction with a rounded butt from which it tapers to the outer end. This last is the element that has drawn comparison with a halberd blade. Overall, these obvious features might be described neutrally as a rake-like design (following Simpson and Thawley 1972). But there are also some more subtle features showing on the cast and even two of the rake's prongs now have to be reconsidered.

The rake-like carving has always in the past been taken to be a unitary image. Mapleton could only liken it to '*large Ogham letters*', presumably on account of the repeating horizontal strokes, although Col. Lane Fox immediately pointed out in the ensuing discussion that it did not conform to Ogham (Mapleton 1870b, 342). A little later, Callander remained cautious, describing the carving as '*a long groove with a sharp-pointed instrument, and … ten shorter grooves at right angles to it*' (1903–4, 494). Subsequent suggestions have been that it represents a boat or a beribboned halberd. The first of these was advanced by Craw (1930, 132–4; also Piggott 1939, 296; Morris 1977, 117–8; RCAHMS 1999, 36). The series of parallel grooves were seen to be like the vertical strokes frequent on boats in Scandinavian rock art; the long linear groove would thus be the hull of the boat terminating in a prow (or stern) which differed in shape from the ribs or oarsmen. One immediate problem with this suggestion is that the boat was set vertically in the cist. This is not an insurmountable obstacle if one considers the possibility that this carved stone was initially elsewhere and only secondarily built into the cist, its character perhaps no longer being understood. However, even set horizontally, the overall design bears little obvious resemblance to a boat and one would have to invoke a high degree of schematisation which, in the absence of parallels in this country, only increases the tenuousness of the argument.

The second specific identification depends on the different character of the topmost 'prong' (Figure 7.8b) which when combined with the long vertical groove gives a plausible depiction of a hafted halberd, albeit with a very long haft. If this was a halberd, however, the

remaining 'prongs', all pointing in the same direction as the blade, needed to be accounted for as attachments of some kind – hence the qualification 'beribboned' (RCAHMS 1999, 36). Since we almost never have such organic components surviving, there is no way of evaluating the likelihood of such attachments; but given the propensity of early societies to adorn weapons and status objects generally in quixotic ways, it is certainly not an inadmissible idea.

Our recent study of the cast immediately showed that the assumption of a unitary design is questionable. There are shallower seemingly pecked grooves towards the lower end of the pillar which seem to have little relationship to the long groove and its transverse prongs (Figures 7.8c and 7.9b). The shallower groove system is interrupted by the deeper ones and can be taken to be earlier; reconstruction suggests two different shapes: a near rectangular 'enclosure' and, above it, a sub-triangular form vaguely like an axe-head; it is not clear whether the central part of the latter was pecked. The two longer sides of the lower shape have in the past been taken to be prongs, but they are clearly distinct from all the others in not reaching the edge of the slab (Mapleton's depiction actually recognises this). There

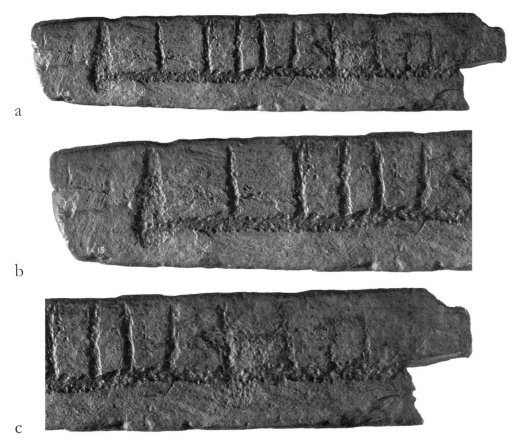

a

b

c

Figure 7.8: a) The halberd pillar, b) the blade end, c) the lower haft area © *National Museums Scotland.*

may though have been another prong below this enclosure which has not previously been noted, although it is just visible in Morris's published photograph (1977, 118 top plate); it is a very shallow depression running off the longitudinal fracture at the base (Figures 7.2 and 7.8c); the fracture may have removed a downward continuation of the vertical groove. The halberd is reasonably well set within the upper half of the slab, although its blade tip touches the edge, just as the rake prongs below do; this might be taken to suggest that even the blade of the halberd had modified a pre-existing prong (Figure 7.9). There are various other features on the carved face, some of which could conceivably be less distinctive carvings. However, Fiona McGibbon's assessment of the cast suggests that none of them can be taken to represent ancient working with any confidence.

Having disentangled the shallower motifs, we are still left with essentially the same strange looking object presented in previous illustrations, although with a different pattern of prongs towards the base. Careful inspection of the edges of the top end convinced us that this really was in the shape of a halberd blade (Figures 7.9 and 7.10). Not only are blade shape and proportions good, but, more specifically, the butt forms a bulbous projection beyond the line of the haft. This was seen as only a slight projection on the Carn halberd, fully hafted when found (Figure 7.10b; Raftery 1942; Harbison 1969, fig 4B), but

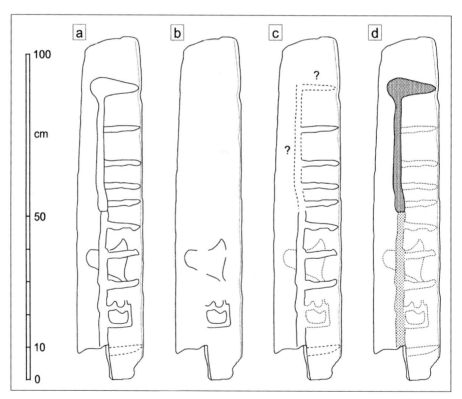

Figure 7.9: Interpreted phasing of the carvings on the halberd pillar: a) the palimpsest; b) possible early motifs; c) the 'rake' or scalariform design; d) hypothesised addition of the halberd. Scale 10%.

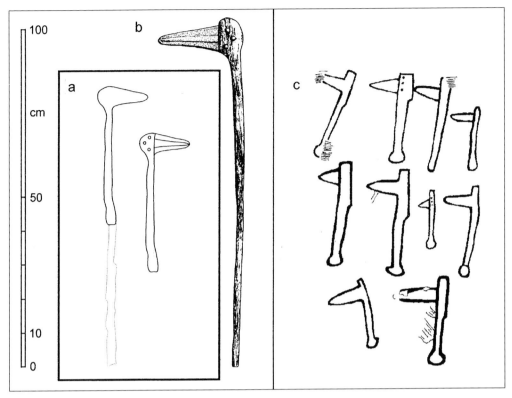

Figure 7.10: a) The reconstructed halberd from Ri Cruin; b) the Carn halberd as found (cast) – after Harbison (1969); c) halberd carvings in the Altas Mountains, Morocco – after Chernorkian (1988). Scale (a and b) 10%.

it is a more prominent feature on continental metal-hafted halberds. It is also repeatedly portrayed in rock carvings of halberds wherever they occur and is further implicit in the butt morphology and 'hilt-lines' of halberds generally. The orientation of the carving in the cist is presumably how a halberd would often be seen when displayed or raised in anger.

So, was this indeed a beribboned halberd? One of the famous Continental rock carvings depicting men wielding halberds, from Val Fontanalba, Italy (see, for example, O'Flaherty 2007, 426 fig. 3) does show knob-like features along the length of the shaft; three hafts have one, three and seven knobs respectively. These features make the point that halberd hafts might have been adorned or knurled, but they cannot be construed as ribbons and, moreover, they are very exceptional. The vast majority of halberd representations found in rock art in various regions of Europe and north Africa show plain shafts, though sometimes with terminal knobs or a degree of sinuosity (Figure 7.10c; e.g., O'Flaherty 2007, 430 fig. 9). The metal-shafted halberds from the Aunjetitz zone of northern Europe are also essentially straight, although they are frequently ornamented with encircling grooves or rib mouldings (Wüstemann 1995, pls 12–21). It would be a mistake to extrapolate from any of these regions to an entirely different cultural context in northern Britain.

The other subtle feature that came to our attention was the irregularity of the long vertical groove seemingly representing the haft. There are a number of slight waves or steps along its length. These might simply be the result of the technique of manufacture and a lack of desire to 'finish' the haft into a smooth form and some could be due to interference from what we take to be earlier grooves. Alternatively, McGibbon suggests that geological factors may also have played a part (Appendix 2); the long axial groove running right down to the broken end is also the deepest and could have exploited a natural fissure evident at the break. Its precise alignment might therefore have been determined by the nature of the rock. Nevertheless, there is a quite pronounced discontinuity around the middle of the long groove and, although there is no distinction in depth or texture apparent in the cast, it does seem to us that the stretch leading to the blade is more regularly shaped with just slight inflexions towards the head and towards its base, that is, near the middle of the whole groove.

If this subtle differentiation implies two phases of pecking out the long groove, or a second-phase improvement of the upper half, it could suggest that the halberd blade was only intended to have a modest length haft. Haft lengths of halberds may not have been standardised. While the surviving haft of the Carn halberd was almost four times as long as its blade, many examples depicted in Continental rock art appear to have short hafts. Any detailed inter-comparison is rendered futile due to not knowing the lengths of the blades represented in the carvings. Some carvings of hafts show a slight kink and swelling at the haft base, presumably to serve as a restraint on the haft slipping out of the gripping hand (Figure 7.10c). Such features are common, for example, on axe and other tool handles.

In sum, although we cannot be confident of the fine detail from the cast alone, there is the distinct possibility that the rake-like design is a palimpsest in which a representation of a hafted halberd (0.40m overall length) has been overlaid upon an original 'rake', which itself may have replaced earlier motifs.

DISCUSSION

Does this potential sequence for the halberd pillar make any more sense of the composite carving in its context? We are still left with the question of what the rake design represents, or what it symbolizes. It remains difficult to find parallels in an Early Bronze Age context, but there is something a little similar on kerbstone 16 on the south-west side of the kerb enclosing Hutton Buscel barrow 2, North Yorkshire (Brewster and Finney 1995, 6 and frontispiece); two other kerbstones from that site are stated to have incised lines, but their formation is not illustrated.

The possibility of the Ri Cruin 'rake' being an earlier, pre-cist phase, however, invites comparison with certain scalariform, or ladder-like motifs found especially in Neolithic passage grave art. Series of parallel strokes with or without linking longitudinal lines are not especially common, but do recur in well scattered zones of western Europe, including at Lough Crew and Newgrange in Ireland and at Skara Brae settlement, Orkney (e.g., Shee Tuohig 1981, figs 213 L1 and 287 no 7). Recent analysis by Guillame Robin suggests that the motif may be specific to threshold situations when found in tombs (Robin 2009; 2010). Of course, there are also more elaborate designs incorporating series of parallel strokes, and single lines are a recurrent element of 'open air' rock art, used in various ways in

conjunction with cups, rings and enclosures. However, a linear design at Broughton Mains 2, Dumfries & Galloway, is rather similar to the Ri Cruin rake – a long near-straight groove appears to have just five transverse strokes projecting from its middle section (Morris 1979, 70–1). This shows that there might well be occasional rake-like motifs in the landscape and architecture of south-west Scotland which could have been available for re-use. Morris also remarks on the unusual character of a set of four long and parallel grooves on a rock at Blairbuy 3 (*ibid.*, 62).

The enclosure motif at Ri Cruin, although rather generic in form, may also echo an established theme in Neolithic rock art; we do not include here the innumerable rings encircling cupmarks. It is intriguing that Nether Largie North has produced a slab with two enclosure motifs, these being near annular (RCAHMS 1999, 33 fig. E; might these conceivably represent armlets?). The slab in question is one of two small upright menhirs that had been built into the southern sector of the cairn (Craw 1931, 270 fig. 2 (marked 'A'), 273, 274 fig. 7). Again, it is possible this represents re-use of an earlier carved stone. It is also possible that this and its pair represented an 'entranceway', for they stood to either side of a horizontal slab on the southern approach to the central cist. The sub-triangular motif at Ri Cruin might also be compared loosely with those from a cist at Kilbride, a little to the north of Kilmartin; two sub-triangular motifs are formed of outline grooves and have been tentatively interpreted as axe-heads (RCAHMS 1999, 38).

Our favoured interpretation then is that there were probably two prior phases of carving before a depiction of a hafted halberd was created, its handle partially or wholly exploiting a pre-existing groove. The earlier phases can be identified as belonging to Neolithic traditions of rock art. McGibbon's analysis suggests the stone was most likely to have started pillar-like, so it could previously have formed a threshold or a lintel in Neolithic architecture – and this is surely given greater credibility in view of other occurrences of passage grave art in the Kilmartin area (RCAHMS 1988, 9–10; RCAHMS 1999, 4). This particular pillar, which did not suit as an end-slab for a cist, was then chosen because of the powerful significance of the earlier carvings, as suggested for other such incorporations in the locality (Jones 2001); but it was seen prudent to add something of contemporary significance – the halberd.

Of course, it is not impossible that one or both of the metalwork carvings was executed prior to any intention to embody them in the cist. Nevertheless, on the basis of the metalwork types identified, there is no difficulty with the two depictions being broadly contemporary. Killaha axe-heads belong to the first phase of bronze metallurgy – the Migdale tradition locally (*c.* 2200–1950 BC) and, while the use of halberds was mainly a feature of the preceding Chalcolithic, a small minority was made in bronze, especially in Scotland. They might still have been recognized as a defining symbol by Kilmartin Valley communities during the Migdale phase. Perhaps more important than their relative chronology, however, are the references they make to the broader connections and economic preoccupations of the region.

Both potentially refer to an Irish connection, but this is not necessarily direct in the sense of these carvings representing imported items *per se*. As we have seen, Killaha axes were made in northern England and perhaps also central Scotland (Cowie and O'Connor 2009, 6, 12), while halberds were an integral part of the metalwork repertoire of much of western and northern Britain and were often of non-Irish types (Needham 2004, 230 fig. 19.13, with minor changes since; notably, in this context, the fine halberd long thought to be a local find from the Poltalloch estate, has recently been re-provenanced to the Channel Island of

Alderney: O'Connor *et al.* 2010). Any Irish connection may be more to do with maintaining crucial lines of social affiliation which ensured the continued flow of metal resources from Ireland (Needham 2004). In this model of exchange patterns it is entirely plausible that the Kilmartin valley held a pivotal role in the flow of valuable materials between Scotland and Ireland. Irish connections are particularly well referenced in the Food Vessels found in Kilmartin valley, including a recent discovery from Upper Largie Quarry (Cook *et al.* 2010, 198–200). This certainly invites the suggestion that whoever was interred in the southern Ri Cruin cist was seen by the community as a key representative in those transactions. If such connections were instrumental in the decision to incorporate carvings of axe-heads and a halberd, it may not be without coincidence that these stones were erected on the south side of the cairn, which would be the route of approach from Ireland.

Just as interesting is the specific context of the final deployment of these two carved slabs at Ri Cruin – set at opposite ends of a cist. This raises the question as to whether the axe-heads and the halberd had opposing, or contradictory symbolic connotations. It is well established that the two types were rarely deposited with each other or any other type of metalwork; axes and halberds were kept to their own kind even when placed as hoards (Needham 1988). They undoubtedly had very different social roles. Another principle of the age, however, is that both halberds and axe-heads were embargoed as grave goods in Britain and Ireland (there are rare exceptions for axe-heads) so their representation in a single burial cist, albeit in a non-material form, suggests an unusual socio-political circumstance.

ACKNOWLEDGEMENTS

We are especially grateful to Fiona McGibbon for rising to the unusual challenge of investigating the petrology of a replica rock. By casting a more dispassionate eye over the cast, she prevented us from overstepping the mark in our interpretation of the stone – in particular by discounting some of the more ambiguous features which we might otherwise have been tempted to see as part of the human modification of the rock. Even so, we have probably strayed beyond what she would consider the bounds of caution! Archival work by TGC was aided by several individuals. The transcription of the letter from Mapleton to the Society of Antiquaries of Scotland is the work of Dr Anna Ritchie. Adrian James very kindly arranged for the scanning of the drawing of the cist in the Society of Antiquaries of London. Finally thanks are due to Lesley Ferguson and Kirsty Lingstadt for facilitating access to archival material in the RCAHMS and to staff at the National Archives of Scotland for access to former Office of Works files.

APPENDIX 1

Transcript of a letter from R. J. Mapleton at Duntroon Castle, Lochgilphead, dated 2 April 1870 referring to his intention to send a cast of an 'ogham' stone and a cast of a stone with axe carvings from a cist to the Society of Antiquaries of Scotland, as donations by Alexander Fraser, Malcolm of Poltalloch's architect and Clerk of Works at Kilmartin (Soc Antiq Scot Ms Collection UC 17/37)

Duntroon Castle
Lochgilphead
2nd April 1870

My dear Sir

I hope to send you before the end of next week a Cast of the stone, that I fancied was an Ogham – & also a Cast of that half of the stone at the other end of Cist, that contains the axe head impressions. These, you must please to remember are a gift from Mr Alexander Fraser – of Slockvullin near Kilmartin: he is Mr Malcolm's architect and Clerk of Works – and is very kind in taking casts for us, and making plans etc: so pray accept them as his work and present.

Mr Malcolm tells me, that both the British Museum and Ethnological authorities say, that the "Ogham" is <u>*not*</u> *an Ogham – but much earlier – & they know not what it is: they also say that no axe-head impressions have been found in Britain, but some have in Brittany – only* <u>*there*</u>*, they were representations of stone celts – ours are of Bronze axes.*

I have got a Cist & also a Cairn on the top of one our hills in this Glen. I have previously examined another, & I hear of others – Is this simply a peak on the part of old people, or can it be distinct tribe or period? The labour of stone carrying must have been exceptionally great.

If the cairn produces anything, I will report it. Will you kindly send me two copies of the "Scotsman" that reports your Meeting when our Stones are discussed.

Believe me
Yours very truly
R J Mapleton

APPENDIX 2

The plaster cast of the halberd pillar: a geological assessment
Fiona McGibbon, petrologist, Open University Scotland

Shape and clues to likely lithology
The plaster cast represents a narrow elongated slab, rectangular in section, giving an overall pillar-like shape. The casting process has been limited to only the carved front surface, sides and ends of the original rock, i.e. the back of the slab has not been cast. In addition the cast has been damaged and repaired resulting in some minor loss of detail along the edges. Presuming this is a good copy, this slab shape is likely to be natural rather than manufactured by quarrying and shaping. Metamorphic rocks have a pervasive planar fabric as well as joint sets that interplay to produce a variety of naturally occurring, rectangular, slab-like shapes at outcrops. In other words, it is likely that a pillar of rock of this shape and dimensions would be attainable in the landscape, shed from an outcrop or readily removed from it. Such a suggestion is supported by the lack of tool marks around the periphery of the slab; as such, there is no evidence of man-made roughing out of the original slab.

The plaster cast of the pillar of stone seems to have replicated a detailed surface texture that is consistent with the fabric of a fine grained, homogeneous metamorphic rock type.

It has a smooth, even surface texture, with no obvious granularity or protruding crystals. It does have small pits, recessed rectangular shapes that measure 5mm by 1mm that are aligned and appear to be parallel to a planar foliation noted later in this description. As such these can be interpreted as a lithological detail of the original rock and they testify to the fine detail captured by the casting process. These aligned elongate pits are best interpreted as porphyroblasts, metamorphic minerals that have grown during metamorphism of the original rock. They could represent amphibole or perhaps plagioclase by their shape, but without other observations (e.g., colour) specific identification would be impossible. The fact that they are recessed however, favours the suggestion of plagioclase. The bottom of the replica slab and its right edge reveal small spherical bubbles (less than 0.5mm) in the plaster and give greater confidence to the interpretation of the elongate pits as replicating an original lithological feature of the rock.

A planar fabric, or foliation, is imprinted onto the cast on all surfaces. It appears to be on a 1–2mm scale (this is not to be confused by the brush strokes evident on the top surface of the cast, running parallel with its length). The foliation is best revealed at the lower end of the cast which has a jagged irregular shape interpreted as a broken surface. Where the break surface is parallel to the foliation observed running the length of the pillar, it is smooth. The broken surface perpendicular to this however, reveals a pervasive fabric in the form of a fine series of parallel grooves, rather like the pages of a book, seen end on. This is interpreted as the imprint of a metamorphic foliation existing in the original rock.

This suggestion of a fine foliation and the earlier description of rectangular pits best interpreted as porphyroblasts, suggests the original lithology could be albitic chlorite schist, a rock type typical of this part of Argyllshire (Argyll Group, Dalradian Supergroup, metavolcanic and metavolcaniclastic lithologies). This is the lithology favoured for use in late medieval carved slabs typical of the region, some housed at the lapidarium at Kilmartin Church. In situ chlorite schist with aligned strings of albite crystals is noted in outcrops described as an ancient quarry examined near Doide (NR704769) on the southern shore of Loch Sween. Here it was noted that the outcrop is divided by joints which cut the foliation in the rock resulting in a blade-like appearance. This could supply readily available pillar and slab-shaped rocks that would only need to be snapped at their base to remove them from the rest of the rock mass. It is unlikely that this would have been the only outcrop in the area available, but nonetheless it offers the opportunity to describe typical lithology and joint patterns and gives confidence that rocks of similar petrographic and macro scale properties are available relatively locally.

Top and bottom ends of pillar

As noted already, the bottom of the slab is jagged in outline and can be interpreted as having been broken from the rest of the rock mass. Whether this happened at the original source of the rock (be it naturally, as it fell, or by the hand of man) or during its subsequent use cannot be determined. A break experienced at the outcrop, then buried when the stone was made upright would be protected from weathering and would not lose definition with time.

The top end of the stone has several notable features. There are two grooves that parallel the edges of the slab and cut halfway across the slab's thickness. As such they are parallel to the foliation already noted and indeed line up with a slight indentation on

the top surface of the replica slab. These grooves could be man-made (?perhaps even the result of wear by ropes during transport of the stone); equally, however, they could be due to natural weathering out of softer horizons within the rock while the pillar was exposed. There is also an irregular groove, subparallel to the front face of the slab which could be further evidence of exposure and resultant weathering. If confirmation of such features being the result of weathering could be proved, it would suggest long exposure of the top end of the pillar before its incorporation into the cist structure. This irregular, curving groove curves into the chip missing from the front top of the pillar. This chip appears to be roughly conchoidal and its surface texture is smoother than the man-made carved marks on the rock. As such it seems to be a natural chip rather than a carved feature. When the chip was lost from the original pillar and by what action, would be impossible to assess given the limited information.

Comments on decorative carving on top surface

The deepest incision has been made by the long groove carved down the long direction of the pillar going right to the broken end. The lengthwise groove curves slightly to the right about halfway down its length. This could be due to heterogeneity in the original rock material such as an undulation in the planar fabric, rather than a deliberate detail or evidence of two stages in the creation of the carving. This lengthwise groove is parallel to the foliation noted earlier in this description and as such would be easier to carve than the short grooves running orthogonally from it, the latter being against the grain or fabric of the rock. It is perhaps for this reason that the seven orthogonal grooves appear more crude, being slightly wedge shaped and irregular. The lowest orthogonal groove is carved down to the level of incision of the lengthwise groove but the other orthogonal grooves are not this deep. This observation does not prove a particular chronology of carving however. The only carved marks that appear to be superimposed on earlier ones are the two lowest orthogonal grooves that appear to be superimposed on a less defined set of features below.

REFERENCES

Allen, J. Romilly. 1880. Notes on a cist with axe-head sculptures, near Kilmartin, Argyleshire. *Journal of the British Archaeological Association* 36, 146–50.

Brewster, T. C. M. and Finney, A. E. 1995. *The Excavation of Seven Bronze Age Barrows on the Moorlands of North-East Yorkshire*. Leeds: Yorkshire Archaeological Society; Yorkshire Archaeological Report 1.

Callander, J. G. 1904. Notice of a stone mould for casting flat bronze axes and bars found in the parish of Insch, Aberdeenshire; with notes on the occurrence of flat axe moulds in Europe. *Proceedings of the Society of Antiquaries of Scotland* 38 (1903–4), 487–505.

Campbell, M. and Sandeman, M. 1962. Mid Argyll: a field survey of the Historic and prehistoric monuments. *Proceedings of the Society of Antiquaries of Scotland* 95 (1961–2), 1–125.

Cook, M., Ellis, C. and Sheridan, A. 2010. Excavations at Upper Largie Quarry, Argyll & Bute, Scotland: new light on the prehistoric ritual landscape of the Kilmartin Glen. *Proceedings of the Prehistoric Society* 76, 165–212.

Cowie, T. and O'Connor, B. 2009. Some Early Bronze Age stone moulds from Scotland. In T. Kienlin and B. Roberts (eds), *Metals and Societies. Studies in Honour of Barbara S. Ottoway*, 313–27. Bonn:

Universitätsforschungen zur Prähistorischesn Archäologie aus dem Insitut für Archäologische Wissenschaften der Universität Bochum Fach Ur- und Frühgeschichte Band 169.

Craw, J. H. 1930. Excavations at Dunadd and at other sites on the Poltalloch Estates, Argyll. *Proceedings of the Society of Antiquaries of Scotland* 64 (1929–30), 111–46.

Craw, J. H. 1931. Further excavations of cairns at Poltalloch, Argyll. *Proceedings of the Society of Antiquaries of Scotland* 65, (1930–1), 269–80.

Harbison, P. 1969. *The Daggers and Halberds of the Early Bronze Age in Ireland*. Munich: Prähistorische Bronzefunde VI(1).

Jones, A. 2001. Enduring images? Image production and memory in Earlier Bronze Age Scotland. In J. Brück (ed.), *Bronze Age Landscapes: tradition and transformation*, 217–228. Oxford: Oxbow Books.

Lawson, A. J. 2007. *Chalkland: an Archaeology of Stonehenge and its Region*. Salisbury: Hobnob Press.

Malcolm, J. 1870 [Exhibition of cast and rubbings and notice of discovery of cist at Ri Cruin], *Proceedings Society Antiquaries London*, 4, 2nd series, 511–13.

Mapleton, R. J. 1870a. Notice of remarkable cists in a gravel bank near Kilmartin, and of incised sculpturings of axe-heads and other markings on the stones of the cists. *Proceedings of the Society of Antiquaries of Scotland*, 8 (1868–70), 378–81.

Mapleton, R. J. 1870b. Note on a cist with engraved stones on the Poltalloch Estate, County of Argyll, N. B. *The Journal of the Ethnological Society of London* (1869–1870) 2(3), 340–42.

Morris, R. W. B. 1977. *The Prehistoric Rock Art of Argyll*. Poole: Dolphin Press.

Morris, R. W. B. 1979. *The Prehistoric Rock Art of Galloway & the Isle of Man*. Poole: Blandford Press.

Needham, S. P. 1988. Selective deposition in the British Early Bronze Age. *World Archaeology* 20, 229–48.

Needham, S. P. 2004. Migdale-Marnoch: sunburst of Scottish metallurgy. In I. A. Shepherd and G. J. Barclay (eds), *Scotland in Ancient Europe: the Neolithic and Early Bronze Age of Scotland in their European Context*, 217–45. Edinburgh: Society of Antiquaries of Scotland.

O'Connor, B., Cowie, T. and Horn, C. 2010. Une trouvaille oubliée de l'ancien duché de Normandie et sa redécouverte. *Bulletin de l'Association pour la Promotion des Recherches sur l'Age du Bronze* 7, 4–5.

O'Flaherty, R. 2007. A weapon of choice – experiments with a replica Irish Early Bronze Age halberd. *Antiquity* 81, 423–34.

Piggott, S. 1939. The Badbury Barrow, Dorset, and its carved stone. *Antiquaries Journal* 19, 291–99.

Raftery, J. 1942. A bronze halberd from Carn, Co Mayo. *Journal of the Galway Archaeological and Historical Society,* 54–6.

Robin, G. 2009. *L'architecture des signes: l'art parietal des tombeaux néolithiques autour de la mer d'Irlande*. Rennes: Presses Universitaires de Rennes.

Robin, G. 2010. Spatial structures and symbolic systems in Irish and British passage tombs: the organization of architectural elements, parietal carved signs and funerary deposits. *Cambridge Archaeological Journal* 20, 373–418.

RCAHMS 1988 *Argyll: an Inventory of the Monuments. Volume 6 Mid Argyll and Cowal Prehistoric and Early Historic Monuments*. Edinburgh: Royal Commission on the Ancient and Historical Monuments of Scotland.

RCAHMS 1999. *Kilmartin Prehistoric & Early Historic Monuments. An Inventory of the Monuments Extracted from Argyll, Volume 6*. Edinburgh: Royal Commission on the Ancient and Historical Monuments of Scotland.

Shee Tuohig, E. 1981. *The Megalithic Art of Western Europe*. Oxford: Clarendon Press.

Simpson, D. D. A. and Thawley, J. E. 1972. Single grave art in Britain. *Scottish Archaeological Forum* 4, 81–104.

Wüstemann, H. 1995. *Die Dolche und Stabdolche in Ostdeutschland*. Stuttgart: Prähistorische Bronzefunde VI(8).

Painting a picture of Neolithic Orkney: decorated stonework from the Ness of Brodgar

Nick Card and Antonia Thomas

INTRODUCTION

This paper presents some of the recent discoveries from the Ness of Brodgar, a remarkable complex of Later Neolithic buildings in the centre of the *Heart of Neolithic Orkney* World Heritage Site (Historic Scotland 1998; Figure 8.1). Over 100 decorated stones have been recovered from the ongoing excavations (Figure 8.2). The assemblage is characterised as much by its variety as by its size, consisting of both worked architectural stone and portable pieces with lightly incised 'scratch art' and deeply carved geometric motifs; ground and pecked cup-marks; and densely pick dressed masonry. Many of the carved stones remain *in situ* within the complex's buildings, offering a rare and direct insight into the ways in which these designs may have been created, seen and experienced during the Neolithic life of the site. In 2010, the discovery of painted stonework on the site added to this extraordinary collection.

The excavations and research are ongoing and as such, it is not the aim here to give a final analysis of the decorated stones from the site or a definitive account of Neolithic visual culture in Orkney. Comparable decorated stones from Orkney will be discussed and the Ness of Brodgar site will be introduced. Preliminary observations regarding the assemblage up to and including the 2010 season of excavation will then be summarised, with a focus upon the stones from one particular building, Structure 10. It will be argued that the variety of inscription processes seen across the site indicate more than a chronological development or aesthetic concerns. This is seen most clearly in Structure 10, the largest and latest building in the main phase of the site. The focus of the current paper is the decorated stone from the site; whilst it is accepted that pottery, bone and other materials are equally important to our understanding of Neolithic visual culture, space and the ongoing nature of the excavations preclude a wider discussion of these forms here.

NEOLITHIC DECORATED STONEWORK IN ORKNEY

Although Orkney has no known open-air rock art comparable to that found in the landscapes of many areas of northern and western Britain, there is a sizeable assemblage of decorated stonework from built structures such as tombs and houses. It is perhaps surprising, given the level of attention that Orkney's Neolithic monuments have received in the archaeological

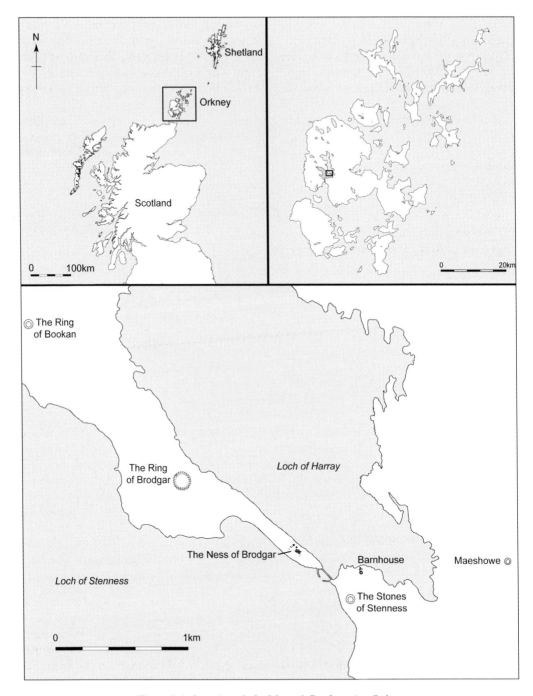

Figure 8.1: Location of the Ness of Brodgar site, Orkney.

literature, that the accompanying decoration of the stonework of those monuments has been so understudied (with notable exceptions such as Bradley *et al.* 2000 and Shepherd 2000) in comparison to material from Ireland or Brittany, for example. This can probably be partly explained by the fact that until recently (and in contrast to other regions) the majority of the known examples from Orkney came from a domestic, rather than a funerary or 'megalithic' context: Skara Brae.

Gordon Childe first recognised a large number of decorated stones at Skara Brae in the 1920s and recorded motifs ranging from '*random scribblings*' to '*carefully executed*' designs throughout the settlement (Childe 1931, 150). More decorated stones were recorded during the 1972–4 excavations and Elizabeth Shee Twohig subsequently added to Childe's (1931) original catalogue in her corpus of western European megalithic art (Shee Twohig 1981).

Childe identified four processes of decoration which he defined as: (i) simple scratchings; (ii) engraving involving deeper incisions; (iii) carving yielding deep V-shaped grooves; and, (iv) pecking from a chisel-like tool (Childe 1931, 150–1). Shepherd (2000, 141) rightly notes that the wide variation in treatment and process seen on the Skara Brae stones precludes them from being treated as a single assemblage; this is supported by the evidence from the Ness of Brodgar, as will be discussed below. The breadth of the evidence from Skara Brae also suggests that the scarcity of similar incised slabs from contemporary excavated settlements, such as Barnhouse (where only one incised slab was found: Downes and Richards 2005, 81, fig. 4.29) may only reflect the level of survival or recovery.

The discovery in the 1980s of 'scratch art' comparable to the Skara Brae designs inside Maeshowe (Ashmore 1986) gave a funerary as well as a domestic context to incised stones. Between 1998 and 1999, a team led by Richard Bradley discovered further designs in Maeshowe in addition to previously unrecorded incised and pecked motifs in the tombs of Cuween, Wideford, Quoyness and the Holm of Papa Westray South (Bradley *et al.* 2000). In addition to these designs, there are also a small number of elaborately carved and pecked stones in Orkney, the style of which invites comparison with the megalithic carvings from Newgrange and other sites in the Boyne Valley, Ireland (Shee Twohig 1997, 387). The most spectacular of these was found in 1981 during quarrying activity at Pierowall, Westray (Sharples 1984), where in addition to two smaller stones decorated with rough pecked spirals, a large stone block was found which was saturated with carved and smoothed spirals and concentric arcs. The largest stone was envisaged as the lintel for the entrance passage into the tomb; the two further decorated stones were recovered from the quarry spoil heaps and their original position is unknown (Sharples 1984, 4–5).

A further probable entrance passage lintel, similarly decorated by carved grooves subsequently pecked and smoothed to form a pair of spirals, two sets of concentric circles and part of a third and fourth set of circles was recovered from a destroyed tomb at Eday Manse in the nineteenth century (Davidson and Henshall 1989, 116; 81, pl. 25). Less elaborate designs are found within the Holm of Papa Westray South tomb, which may have originally contained up to 11 examples of pecked decoration on the flagstone masonry within the main chamber (Davidson and Henshall 1989, 81, pl. 24; 121–3). These exhibit a range of motifs including circles joined by horizontal lines, shallow cups, inverted Vs, a triangle shape, double arcs (the 'eye-brow' motif) and a number of further cupules, lines and Vs.

A flagstone slab was recently found at the Neolithic settlement site of Green on Eday (Coles *et al.* 2010) that exhibits a series of pecked designs that are similar to those in the Holm of Papa Westray South tomb. These designs overlie a series of fine, incised motifs but do not appear to respect them (Coles *et al.* 2010, 15). The slab appears to have been deliberately placed in the entrance to a dwelling when the building went out of use; the freshness of the pecking suggests that the stone was not re-used from elsewhere (*ibid.*, 16) and it may be that the stone was decorated as part of the 'decommissioning' of the building. A flagstone slab with a carved and pecked chevron and dot design was found in a similar context within the demolition layers infilling Structure 9 at Pool on Sanday (Hunter 2007, 49, illus. 3.18; 70).

The ongoing excavations at the Links of Noltland, Westray, from where the 'Orkney Venus' carved sandstone figurine was recovered in 2009, have produced architectural masonry displaying pecked chevron motifs and several cup-marked stones built into the walls of structures on the site (Moore and Wilson 2011). Pecked designs are known from a few other sites, such as the stone decorated with two weathered, indistinct spirals removed from a ruinous mound and built into the wall of a workshop at Arsdale in Evie (RCAHMS 1946, 85) and a spiral-pecked stone recorded from Redland Broch in Firth (*ibid.*, 91). A heavily weathered sandstone piece pecked with two sets of concentric circles was recently found on a South Ronaldsay beach (Towrie 2008); its original provenance is not known.

Pick dressing – involving the repeated, percussive act of hitting the stone to create a uniformly pecked surface – should also be regarded as a highly specialised process of stone decoration in its own right. It is relatively rare in Orkney, and is only really seen '*at sites that are apparently "different" or "important"*' (Philips and Bradley 2000, 109). This is in marked contrast to Neolithic tombs in the Boyne Valley, for example, where it is a well-recorded phenomenon (Eogan and Aboud 1990), often as the final stage in a succession of overlying treatments applied to decorated stones (Eogan 1997). Analysis of the pick dressing within Maeshowe revealed that it was concentrated at critical thresholds within the tomb (Philips and Bradley 2000, 107), indicating that it was meant to be seen and perhaps even felt (*ibid.*, 108). Extensive areas of pick dressing are also recorded at the rock-cut tomb of the Dwarfie Stane in Hoy and at the Stones of Stenness (*ibid.*, 106).

Cup-marked stones are also relatively rare in Orkney and when they are found, their context is often ambiguous. A stone with several cup-marks found at Howe, Stromness, formed part of a modified entrance arrangement (Ballin Smith 1994, 13), possibly to mark the transformation of the building from Early Neolithic house to Later Neolithic tomb. Many other examples appear in later monuments, such as the two cup-marked stones (one with partial ring-marks) at Midhowe Broch in Rousay: one built into the broch tower; the other in a later structure to the south (RCAHMS 1946, 200). The original provenance of these stones is not known, nor for the stone with five cup-marks built into a post-medieval byre at Quoys in Hoy (RCAHMS 1989, 17), or the stone pecked with several cup-marks, including one with concentric rings, found in an indeterminate structure at Pickaquoy near Kirkwall (RCAHMS 1946, 162).

THE NESS OF BRODGAR

As discussed above, until recently, relatively few examples of Neolithic decorated stonework had been found in Orkney, with even fewer from secure stratigraphic contexts. As a result of the excavations at the Ness of Brodgar however, the number of known examples has more than doubled.

The Ness lies in a natural bowl of the West Mainland of Orkney on the tip of the Brodgar peninsula midway between the Stones of Stenness and the Ring of Brodgar. It was clear that, even before excavation revealed the unusual nature of the Ness, the site occupied a key axial position in the centre of this monumental landscape.

An example of Neolithic art had been discovered on the site in the 1920s (Marwick 1926), but until recently this had been considered an isolated example of a reused slab associated with several conjoined Bronze Age stone 'cists'. Excavation has now shown that this slab was probably part of one of the Neolithic buildings. In 2002, Orkney Archaeological Trust (in association with Orkney College) initiated the World Heritage Area Geophysics Programme (Card *et al.* 2007, 422); as part of the first season the two fields constituting the Ness of Brodgar were surveyed and results indicated activity extending over an area some 250m by 100m north-west to south-east (GSB 2002).

Following the discovery of a large notched slab during ploughing in 2003, an evaluation revealed part of a building (Structure 1) with internal angular architecture (Ballin Smith

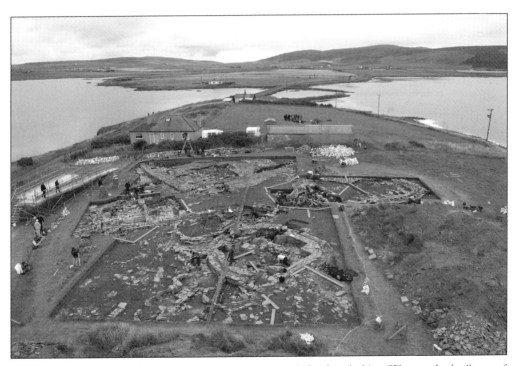

Figure 8.2: Aerial view of the main trench at the Ness of Brodgar looking SE towards the Stones of Stenness.

2003). In its primary phase this appears to have been very similar to Structure 2 at the nearby Neolithic site of Barnhouse some 300m to the south-east (Richards 2005). Further test-trenching and small-scale area excavations took place from 2004 to 2006 (Card 2004; 2006; Card and Cluett 2005). These investigations showed the large whaleback ridge to be largely artificial, comprising a tell-like accumulation of Neolithic middens, structures and enhanced soils, associated with Grooved Ware pottery (Card 2010). Ongoing open area excavation from 2007 (Card *et al.* 2007; 2008; 2009; 2010) is now revealing the full complexity and spectacular nature of the site (see Figure 8.2).

The exceptional preservation (several buildings surviving to over a metre in height) and complex deep stratigraphy mean that only the later phases have been revealed so far, giving an insight into a time when the Ness would have been dominated by a series of monumental stone buildings (see Figure 8.3). The first of these main phases is represented by several buildings: Structures 1, 8 and 12 – all in excess of 15m long – with further

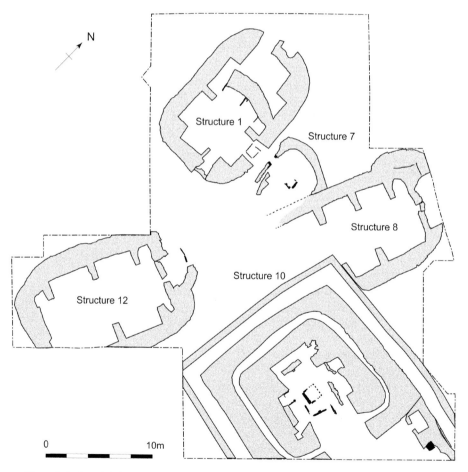

Figure 8.3: Simplified plan showing the structures in the main trench at the Ness of Brodgar.

structures indicated by geophysics outwith the excavated areas. In these three structures, the internal space is divided by opposing pairs of slightly tapered stone piers, creating a series of recesses along the internal wall faces. Although as yet stratigraphically unproven, their contemporaneous use is implied by their spatial respect for each other: roughly similar alignments (north–south), internal angular architecture, and layout (including almost identical internal widths between the ends of the piers).

In Structure 8, a horizon of collapsed thin stone roofing slabs was encountered just above the occupation layers. These had been trimmed into regular rectangular shapes as seen today on traditional stone-slated Orcadian roofs. Similar evidence for slated roofs has also been identified in Structure 1. The similarities in the architecture of Structures 1, 8 and 12 may reflect similar functions. Their special nature is also reflected in the unusual array of finds. Although floor levels have only been partially revealed in Structure 8, for example, the recovered artefacts include axes, maceheads, a cetacean tooth and a polished shale object.

The last major phases on the site are represented by the cessation of use, and perhaps deliberate destruction and infilling, of Structures 1, 8 and 12 (at least in their primary form) and the construction, use and decommissioning of Structure 10. This shows a marked departure from these earlier buildings: in its scale (over 20m long by 19m wide, and with 5m thick walls), complexity (the incorporation of a standing stone in its build, a paved surround and alignment with Maeshowe), and interior design (a cruciform shaped central chamber). Many of these characteristics can be paralleled in funerary architecture, but the building also exhibits features found in Orcadian Neolithic houses such as a central hearth and a 'dresser'[1]. Nevertheless, these are also of an unusual nature. The dresser incorporates naturally coloured red and yellow sandstones, which in several cases have extensive areas of pick dressing (discussed below), while the hearth is of a scale comparable to that at the Stones of Stenness (Ritchie 1978, 12) and Structure 8 at Barnhouse (Richards 2005, 172). As will be discussed further, the different nature of Structure 10 is also reflected in its decorated stones.

At the end of Structure 10's 'life', the building was decommissioned: an upturned cattle skull was placed in the central hearth beside an elaborately pecked stone and the pathway surrounding the building was filled with a thick deposit of bone (over 85% of which are tibia) representing hundreds of cattle. The interior was then suffocated with a sequence of dumps of midden-enhanced soils and rubble, and the walls systematically robbed.

The complexity of the structures on the Ness of Brodgar implies a detachment from the domestic sphere: this distinction is further emphasised by the striking manner of the buildings' enclosure. A 4m wide wall – later remodelled to 6m in width – forms the northern limit of the site. This wall has a large external ditch and runs perpendicular to the isthmus before gently curving round parallel to the loch shores. The southern limit of the main structures on the site is defined by a wall only 2m wide but surviving to over 1.7m in height. Although not yet proven stratigraphically, it seems that these two almost parallel walls are part of the same construction. They would have formed an enclosure *c.* 125m by 75m in size, which would have defined and emphasised the importance of all of the major buildings on the Ness – a walled precinct.

The Ness of Brodgar formed an integral part of a rich monumental landscape of stone circles, chambered tombs and henges that reflects the sophistication and dynamism of

Orkney in the Later Neolithic. It is in the context of these extraordinary structures that a vast array of decorated stonework has been found.

DECORATED STONEWORK AT THE NESS OF BRODGAR

Although one of the first indications of archaeological activity at the Ness of Brodgar had been the discovery of the carved stone in the 1920s, it was not really until 2008 and the uncovering of Structures 1, 8 and 10, that the true wealth of the decorated stones on the site was realised.

The most common form of stone decoration on the site is lightly incised, often multi-layered, geometric motifs, which are found both on and in the buildings: on and within the walls themselves, in collapsed masonry and on portable slabs. Despite the casual superficial appearance of these scratched designs, the execution of many of them would have required careful consideration (Figure 8.4). Moreover, the context of many of the portable examples, such as the cist capping in Trench J, or the pieces within the rubble filling the ditch associated with the enclosing wall and infilling Structure 1, indicates acts of considered votive deposition.

Stones with incised and carved geometric motifs have now been recorded on all of the main structures on the site. Last season, this extraordinary assemblage was enhanced by the discovery of painted stonework (Card 2010; Card *et al.* in prep.). Although a small portable slab emblazoned with a red arc was recovered from Structure 10, the use of pigment on *in situ* structural stone has only been recorded in Structures 1 and 8 so far. The probable source of haematite for these pigments came from the adjacent island of Hoy, whose dark hills dominate the skyline to the southwest of the site. At this stage, it is not clear how the application of pigment may have worked with the types of decoration described above: it is possible that the incised lines could have formed a sketch to be filled in later with paint, or the incised lines could have cut through painted surfaces. Richard Bradley found possible

Figure 8.4: Examples of the carefully executed designs from the site. Left: a portable slab recovered from Structure 10; right: a structural stone from Structure 8.

traces of pigment on the wall to the right of the entrance within Maeshowe that corresponds with an incised design (Bradley *et al.* 2000, 54) and it may be that the incised designs at the Ness would originally have been coloured in. At Skara Brae, Childe (1931, 137) recorded traces of red and white pigment and several small pottery vessels interpreted as paint pots; a number of similar potential 'paint pots' have also been found at the Ness of Brodgar. In Structure 8, the pigment is applied to form geometric designs such as rough chevrons; elsewhere it is used to cover stones completely, such as in the side entrance to Structure 1 where it complements naturally-coloured stones by creating a banded appearance.

The construction, use and decommissioning of Structure 10 represents the last stage of the main phase of buildings and is associated with a marked change in architecture and stone decoration. It is here that the most elaborate and greatest number of pecked and ground stones has been found. This structure does have a number of significant stones with incised designs, including the large flagstone slab forming part of the surrounding pathway, but its assemblage is dominated by cup-marked, pecked and pick dressed stones.

A large stone block, of a shape and size that would have fitted within the left-hand side of the dresser, and covered in roughly pecked cupules on two faces, was found placed in the centre of Structure 10's hearth. This stone represents one element in a series of 'closing events' that included the placing of an upturned cattle skull in the hearth; both sit upon occupation deposits but are themselves sealed by the primary infilling and demolition layers. Within the stratigraphic sequence therefore, this stone's placing marks the interface between the occupation of the building and the chain of demolition events signalling the end of Structure 10's use.

A cup-and-ring pecked stone from Structure 10 (Figure 8.5) was also recovered from rubble layers near to the dresser and it is tempting to think that this once occupied a prominent position. The discovery of this stone in the demolition layers, coupled with the freshness of the pecking offers a further possibility: the act of working this stone itself formed part of the process marking the decommissioning of the building and the end of Structure 10's life. This finds parallel with the carved stones found at Green, Eday (Coles

Figure 8.5. Examples of pecked and cup-marked decoration, Structure 10. Left: the multi-cupped stone in the entrance to the building; right: the cup-and-ring pecked stone recovered from demolition deposits filling Structure 10.

et al. 2010) and Pool, Sanday (Hunter 2007). Interpretation is cautious at this stage, as the particular biographies of many of the stones at the Ness of Brodgar are uncertain; however, the evidence does indicate that the placing of pecked and ground stones is associated with moments of change and transformation in the 'life' of Structure 10.

This is supported by the concentration of cup-marked stones in the eastern forecourt area, which is a later extension to the original construction and includes a paved cell and walls enveloping a substantial monolith of fine-grained camptonite. This standing stone contains a drilled hole in its southwest corner that has been bored in from both sides to create an hourglass-shaped perforation; half of a similarly perforated slab was recovered from within the rubble in the central chamber. There is a pecked cup-mark on its western face and the two large slabs immediately to the west of the monolith are covered in further pecked cup-marks. One of the packing stones within the socket for this standing stone was also covered with pecked and ground cup-marks (Figure 8.6). Its position buried in the cut for the stone suggests that once *in situ* neither its visibility nor its visual appearance was an important concern and it may have been the act or event of carving itself that was significant.

Many other cup-marked stones were at least partially hidden from view during the use of Structure 10, including the most elaborate stone so far discovered from the site, a multi-cupped block decorated on two faces and which sat within the internal entrance to the central chamber (see Figure 8.5). This stone cut into the rammed clay surface more deeply than the rest of the wall, meaning that the lower third of the stone sat below the wall-line. The full extent of the decoration on this stone may not have been visible to those allowed to enter the building.

In addition to the use of stones with incised and pecked decoration, key spaces in the interior of Structure 10 – the alcoves and the dresser – were enhanced through the use

Figure 8.6: Left: the standing stone in the eastern forecourt area of Structure 10 with associated cup-marked stones; right: detail of cup-marked packing stone in standing stone socket.

of coarse-grained red and yellow sandstone, contrasting strongly with the flagstone used more generally on site. These stones were treated differently from the others, not only in their placement in key locations in the structure, but also in their surface treatment. Both the red and yellow sandstones were dressed using a diffuse pecking process, covering the entire visible surface of the stone; this treatment of the *coloured* sandstones makes it seem unlikely that it was intended to create a surface for plaster, as suggested for the pick dressed areas within Maeshowe (Philips and Bradley 2000, 110).

This dressing may have served to enhance the natural aesthetic qualities of the stones' colour by creating a more uniform surface texture (Bradley 2009, 210), but the intensive engagement with the stone involved in this process also needs to be considered. As a method of stone working, pick dressing involves a deep attentiveness to the surface and material of the stone itself (Cochrane 2009, 164), and the exploitation of the red and yellow sandstones in this way emphasises their significance. The nearest source for this stone is at the Head of Houton, which lies some 10km from the Ness of Brodgar (John Flett Brown, pers. comm.; Mykura 1976, 80), and the use of these stones indicates something of the scale of labour involved in the procurement of materials from a range of different sources. This is particularly expressed in the construction of Structure 10, indicating a communal activity that would have brought together groups from across Orkney. It is also notable that – in contrast to the cup-marked stones, for example – it is only the visible areas of the stones that were pick dressed, indicating that they were decorated *after* being installed.

DISCUSSION

The Ness of Brodgar is, as yet, the only site in Orkney where the full suite of Neolithic decorative stone working practices – scratching, carving, pecking, pick dressing and painting – can be studied, and moreover, in secure stratigraphic contexts. Yet how are we to understand these inscriptions? The blanket designation of Neolithic carved stonework as 'art' by archaeologists has proven highly problematic as the use of this term immediately transposes modern notions onto prehistory (Bradley 2009, 4). It also has the consequence of treating all forms of stone working equally, without regard to subtleties of process or context. Traditional narratives have thus been predicated upon a series of interrelated assumptions: that images 'mean' something to start with; that such a meaning could be deciphered in the Neolithic; and by extension, that modern archaeologists should also be able to translate this meaning (Cochrane 2009, 173).

At the Ness of Brodgar, however, the different processes of stone treatment across the site merit further and more subtle consideration. This can be seen most clearly with the example of the cup-marked stones in Structure 10. Many of these would have been at least partially hidden from view. Once *in situ*, their appearance would not have been fully appreciated, indicating that their visual form was not a consistently important concern. This contrasts with the pick dressed and many of the incised designs, which were worked after they were put in place and which were clearly meant to be seen, or even touched (Philips and Bradley 2000, 108). It is difficult to explain such a disparity if only the seen characteristics of the carved stones are considered, and this observation suggests that the different processes of working the stone in the first place should also be examined.

Rather than focussing purely upon the stones' final visual form, the social and performative contexts by which the designs come to be created should be explored (Jones 2007, 175–6). These can be explored through a study of the different processes that created them and this study will form an important part of our ongoing research.

Pecked cup-and-ring marks and incised motifs are now generally recognised as broadly contemporaneous, as opposed to representing a chronological development (O'Connor 2007, 184; *contra* Waddington 2007), and this is supported by the evidence from Structure 10. The recurring link between carved stones and monuments associated with transformative rituals and commemorative traditions has been widely noted (e.g., Jones 2001). It is argued here that the cup-marking of the stones themselves played a crucial role in both the construction and the demolition of Structure 10. Coming at the end of a remarkable sequence, the construction of Structure 10 on the site represents a transformation of the Ness of Brodgar, and in Neolithic Orkney, times of transformation and change – both architectural and social – were accompanied by distinct stone carving processes. In Structure 10, it seems likely that the carving of many of the cup-marked stones represents 'votive motif deposition' (O'Connor 2009, 157), after which their visual characteristics ceased to be important. The acts of carving these stones formed key roles in both the construction and demolition of this building – and thus the transformation of the Ness of Brodgar site itself.

CONCLUSION

The structures at the Ness of Brodgar defy simple definition, containing the architectural features of both funerary and domestic structures but going far beyond either in terms of scale and elaboration. The diversity of processes and designs seen on the carved stones from the Ness of Brodgar is unparalleled in Orkney and offers a unique opportunity to understand stone carving in the Neolithic. Rather than reinforcing simplistic arguments concerning chronology, aesthetic form and representation, the Ness of Brodgar material can allow a meaningful response to recent calls to focus upon the role that working and decorating stone plays in the creation, maintenance and contestation of identities (O'Connor and Cooney 2009). The differential decoration of stonework seen across the site, most clearly with the dominance of pecked and ground stones in Structure 10, indicates much more than chronological sequence or pure decoration, leading us to challenge previous interpretations.

The Ness of Brodgar assemblage allows a thorough investigation of how both the process and products of inscription were deployed in different settings and at different stages in the life of monuments. The fieldwork is ongoing and the primary levels of occupation in the structures of these later phases have yet to be reached; in parallel to the continued work on site there is clearly a need for a re-evaluation of stonework from other Neolithic sites in Orkney. As a consequence, the interpretations put forward in this paper will be subject to reconsideration as the excavations progress and the full potential of the remarkable assemblage from the Ness of Brodgar reveals itself. Only then can we really start to paint a picture of life in Neolithic Orkney.

NOTE

1 We accept that 'dresser' is a problematic and loaded term, as it immediately connotes ideas of modern domesticity that have little validity when transposed onto the Neolithic. Despite these shortcomings, however, it has become common terminology and is seen as preferable in this instance rather than introducing a new, but equally loaded term (such as 'altar').

REFERENCES

Ashmore, P. 1986. Neolithic carvings in Maeshowe. *Proceedings of the Society of Antiquaries of Scotland* 116, 57–62.
Ballin Smith, B. (ed.) 1994. *Howe: four Millennia of Orkney Prehistory*. Edinburgh, Society of the Antiquaries of Scotland.
Ballin Smith, B. 2003. *A New Late Neolithic House at Brodgar Farm, Stenness, Orkney*. Unpublished *GUARD* Report 1506.
Bradley, J. 2009. *Image and Audience: rethinking prehistoric art*. Oxford: Oxford University Press.
Bradley, R., Philips, T., Richards, C. and Webb, M. 2001. Decorating the houses of the dead: incised and pecked motifs in Orkney chambered tombs. *Cambridge Archaeological Journal* 11, 45–67.
Card, N. 2004. *Ness of Brodgar Excavations 2004, Data Structure Report*. Unpublished OAT Report.
Card, N. 2006. *Ness of Brodgar Excavations 2006, Data Structure Report*. Unpublished OAT Report.
Card, N. 2010. Neolithic Temples of the Northern Isles. *Current Archaeology* 241, 12–19.
Card, N. and Cluett, J. 2005. *Ness of Brodgar Excavations 2005, Data Structure Report*. Unpublished OAT Report.
Card, N., Downes, J., Gibson, J. and Ovenden, S. 2007. Bringing a landscape to life? Researching and managing 'The Heart of Neolithic Orkney' World Heritage Site. *World Archaeology* 39(3), 417–35.
Card, N., Lee, D. and Sharman, P. 2007. *Ness of Brodgar Excavations 2007, Data Structure Report*. Unpublished ORCA Data Structure Report.
Card, N., Lee, D., Sharman, P. and Thomas, A. 2009. *Ness of Brodgar, Stenness, Orkney: Excavation 2008*. Unpublished ORCA Data Structure Report no. 201.
Card, N., Lee, D. and Thomas, A. 2010. *Ness of Brodgar, Stenness, Orkney: Excavation 2009*. Unpublished ORCA Data Structure Report 221.
Card, N., Lee, D. and Thomas, A. in prep. *Ness of Brodgar, Stenness, Orkney: Excavation 2010*. Unpublished ORCA Data Structure Report 244.
Childe, V. G. 1931. *Skara Brae. A Pictish village in Orkney*. Edinburgh, Kegan Paul, Trench, Trubner & Co.
Cochrane, A. 2009. Additive Subtraction: Addressing Pick Dressing in Irish Passage Tombs. In J. Thomas and V. O. Jorge (eds), *Archaeology and the Politics of Vision in a Post-Modern Context*, 163–85. Newcastle-upon-Tyne: Cambridge Scholars Publishing.
Coles, D., Miles, M. and Walkling, T. 2010. A pecked stone from a Neolithic settlement site at Green, Isle of Eday, Orkney. *PAST* 65, 15–16.
Davidson, J. L. and Henshall, A. S. 1989. *The Chambered Cairns of Orkney: an inventory of the structures and their contents*. Edinburgh: Edinburgh University Press.
Downes, J. and Richards, C. 2005. The dwellings at Barnhouse. In C. Richards (ed.), *Dwelling Among the Monuments. Excavations at Barnhouse and Maeshowe, Orkney*, 57–128. Cambridge: McDonald Institute for Archaeological Research.
Eogan, G. 1997. Overlays and underlays: aspects of megalithic art succession at Brugh Na Boinne, Ireland. *Brigantium* 10, 217–34.
Eogan, G. and Aboud, J. 1990. Diffuse pecking in megalithic art. *Revue Archéologique de l'Ouest. Supplément* 2, 121–40.

GSB. 2002. *Orkney World Heritage Site, Geophysical Report, Phase 1.*, Bradford: unpublished GSB Report 2002/61.

Historic Scotland. 1998. *Nomination of the Heart of Neolithic Orkney for Inclusion in the World Heritage List.* Document submitted to UNESCO.

Hunter, J. 2007 *Investigations in Sanday, Orkney: Vol 1. Excavations at Pool, Sanday. A multi-period settlement from Neolithic to late Norse times.* Kirkwall: Orcadian Ltd.

Jones, A. 2001. Enduring images? Image production and memory in Earlier Bronze Age Scotland. In J. Brück (ed.), *Bronze Age Landscapes: tradition and transformation*, 217–28. Oxford: Oxbow Books.

Jones, A. 2007. *Memory and Material Culture.* Cambridge: Cambridge University Press.

Marwick, J. G. 1926. Discovery of stone cists at Stenness, Orkney. *Proceedings of the Society of Antiquaries of Scotland* 60, 34–6.

Moore, H. and Wilson, G. 2011. *Shifting sands. Links of Noltand, Westray: Interim Report on Neolithic and Bronze Age Excavations, 2007–9.* Edinburgh: Historic Scotland Archaeology Report 4.

Mykura, W. 1976. *Orkney and Shetland* (British Regional Geology). British Geological Survey. London, HMSO.

O'Connor, B. 2007. Carving identity: the social context of Neolithic rock art and megalithic art. In D. A. Barrowclough and C. Malone (eds), *Cult in Context. Reconsidering Ritual in Archaeology*, 183–90. Oxford: Oxbow Books.

O'Connor, B. 2009. Re-collected objects: carved, worked and unworked stone in Bronze Age funerary monuments. In B. O'Connor, G. Cooney and J. Chapman (eds), *Materialitas: working stone, carving identity*, 147–68. Oxford: Prehistoric Society Research Papers 3.

O'Connor, B. and Cooney, G. 2009. Introduction: *Materialitas* and the significance of stone. In B. O'Connor, G. Cooney and J. Chapman (eds), *Materialitas: working stone, carving identity*, xxi–xxv. Oxford: Prehistoric Society Research Papers 3.

Philips, T. and Bradley, R. 2000. Pick-dressing in the Neolithic monuments of Orkney. *Scottish Archaeological Journal* 22(2), 103–10.

RCAHMS. 1946. *Twelfth Report with an Inventory of the Ancient Monuments of Orkney and Shetland, volume 2.* Edinburgh, HMSO.

RCAHMS. 1989. *The Archaeological Sites and Monuments of Rousay, Egilsay and Wyre, Orkney Islands Area.* The Archaeological Sites and Monuments of Scotland, Series 16. Edinburgh, HMSO.

Richards, C. (ed.) 2005. *Dwelling Among the Monuments. Excavations at Barnhouse and Maeshowe, Orkney.* Cambridge: McDonald Institute for Archaeological Research.

Ritchie, J. N. G. 1978. The Stones of Stenness, Orkney. *Proceedings of the Society of Antiquaries of Scotland* 107, 1–60.

Sharples, N. M. 1984. Excavations at Pierowall Quarry, Westray, Orkney. *Proceedings of the Society of Antiquaries of Scotland* 114, 75–126.

Shee Twohig, E. 1981. *The Megalithic Art of Western Europe.* Oxford: Clarendon Press.

Shee Twohig, E. 1997. 'Megalithic art' in a settlement context: Skara Brae and related sites in the Orkney islands. *Brigantium* 10, 377–89.

Shepherd, A. 2000. Skara Brae: expressing identity in a Neolithic Community. In A. Ritchie (ed.), *Neolithic Orkney in its European Context,* 139–58. Cambridge: McDonald Institute for Archaeological Research.

Towrie, S. 2008. *Neolithic carved stone found on beach.* Orkneyjar.com online news article dated Monday 17 March 2008. Available at: http://www.orkneyjar.com/archaeology/sandwickstone.htm. Accessed: 27th February 2011.

Waddington, C. 2007. Cup and rings and passage grave art: insular and imported Traditions? In C. Burgess, P. Topping and F. Lynch (eds), *Beyond Stonehenge. Essays on the Bronze Age in Honour of Colin Burgess*, 11–19. Oxford: Oxbow Books.

Inside and outside: visual culture at Loughcrew Co Meath

Elizabeth Shee Twohig

INTRODUCTION

Research on rock art occurring on natural outcrops or boulders in Ireland has been neglected in comparison with research on passage tomb art; rock art has received much less attention also in areas such as popular publications and from a heritage management point of view. Of course this is partly due to the fact that many of the Irish passage tombs are truly spectacular architectural achievements, and they are also much easier to visit and study than outcrops or boulders in the open landscape. Nor has Irish rock art benefitted much from the attention of dedicated amateur fieldworkers as has been the case in Britain; in Ireland most research has been done by full-time professional archaeologists or by post-graduates. Elsewhere in Europe open-air rock art has received more attention, notably in Scandinavia and in northern Italy, where rock art forms a very important element of cultural tourism. In the Galician region of north-west Spain, rock art is better known than passage tomb art, and has come to symbolise the region's distinctiveness from the rest of Spain and its connections with the Atlantic world.

LOUGHCREW

The Loughcrew parish in north-west county Meath has a remarkable series of carvings in the passage tombs which are situated on the tops of the north-east to south-west running Slieve na Calliagh range of hills (Figure 9.1) (Shee Twohig 1981). These carvings are much less well known than Newgrange, Knowth and Dowth in the Boyne Valley, situated *c.* 45km to the east (C. O'Kelly 1982; Eogan 1986; O'Kelly and O'Kelly 1983), but the Loughcrew area is particularly intriguing because at least 20 examples of rock art are now recorded in the same locale (Shee Twohig *et al.* 2010), making it effectively the only region where the two types of carvings occur together in the same landscape.

The Loughcrew passage tombs were described briefly in the 1820s and 1830s, though they were not included on the first edition of the Ordnance Survey 6 inch sheets. The art was first described in the mid-1860s by Eugene Conwell, a local Schools' Inspector, who carried out extensive excavations in the tombs, and who arranged for the carvings to be drawn in 1865 by George V. Du Noyer, a skilled draftsman then working with the Irish Geological Survey. These drawings were not published at the time, however, apparently owing to a

126 *Elizabeth Shee Twohig*

disagreement between the two men as a result of Du Noyer's publication of a short report on the site in a local newspaper. The drawings were finally purchased by a collector, the medical doctor, William Frazer and published (Frazer 1892–3). In the meantime Conwell had presented descriptions of the sites and the results of his excavations to the Royal Irish Academy, which were later published in a number of papers in the Academy's *Proceedings* (Conwell 1864; 1866) with virtually no illustrations of the carvings. He later published small drawings of the carvings in Cairn T, the most extensively carved tomb (Conwell 1872; 1873). Conwell also reported briefly on carvings on some 'earth-fast monuments' (1873, 68), which constitutes the first published reference to rock art in the area, but which has been completely overlooked by subsequent researchers, perhaps because of the lack of illustrations.

The first piece of rock art from Loughcrew to be illustrated was a small block found in a fence 'near Loughcrew'; its photograph (Coffey 1897, fig. 89) may in fact be the first published photograph of Irish rock art in Ireland. Already in reporting it, George Coffey, a distinguished scholar and first Keeper of Irish Antiquities at the National Museum of Ireland, and generally regarded as Ireland's first professional archaeologist, noted that the characteristic rock art motif which he described as a '*cup and circle with radial duct*' was never found in passage tombs or 'tumuli' (Coffey 1897, 37–9). Coffey should therefore be credited for recognising a critical element in the differences between passage tomb art and rock art. Although Eoin MacWhite is generally regarded (e.g., in O'Sullivan 2009b) as

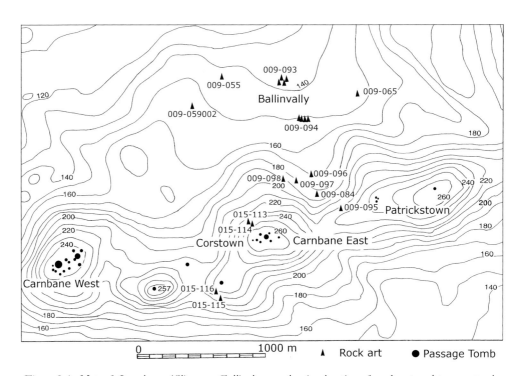

Figure 9.1: Map of Loughcrew/Slieve na Calliagh area showing location of rock art and passage tombs.

having presented the first substantive examination of this topic (MacWhite 1946) it should be remembered that he had made extensive use of a manuscript written by his mentor, R. A. S. Macalister, which he presented to the Royal Irish Academy in 1952 (Royal Irish Academy Macalister MSS 3B58). The question of the relationship between rock art and passage tomb art will be discussed further below.

Over the course of the 20th century, a number of examples of rock art were found in Ballinvally townland, which lies immediately north of the central group of passage tombs at Loughcrew (Figure 9.1). They were discovered through ploughing and field walking and all had been disturbed by agricultural activity on this intensively farmed northern part of the townland. Figure 9.1 shows the location of the carvings, with the numbers assigned to them in the Archaeological Survey of Ireland as part of the Sites and Monuments Record (SMR).[1] Full details of these finds are included in Shee (1972) and Shee Twohig (2001). The first discoveries were three stones reported at an earthwork (ME009-093) in the 1940s (*ibid.*, 2001). Two large stones were found during ploughing and both are now in the National Museum of Ireland. One (ME009-055) was found in 1965 (Figure 9.2) and the second was found in 1972, near the 1940s group and also numbered as ME009-093. Two stones in this area have carvings that are less typical of rock art: one which has sets of circles but no cupmarks was found in 1935 covering a cist containing a food vessel (ME009-055). The other, which was first noted in 1980, is more like passage tomb art, and has closely spaced circles or a possible spiral and arcs. It lies on top of a stone wall which cuts across the edge of a stone circle (ME009-095002).

Since 2003 a number of undisturbed examples of rock art have been discovered in the area (Figure 9.1), mainly in the southern part of Ballinvally townland (ME009-084, ME009-094, ME009-095, ME009-096, ME009-097 and ME009-098). These are on the lower slopes of the northern side of the range of hills, and are thus located between the

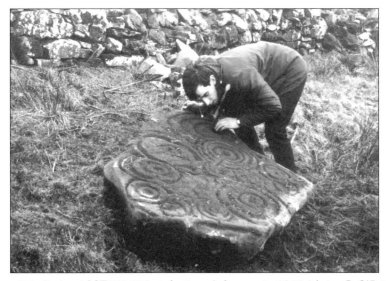

Figure 9.2: Rock art ME009-065 at the time of discovery in 1965 (photo: C. O'Reilly).

earlier discoveries of *ex situ* rock art and the passage tombs. Four examples have also been found in Corstown townland, further to the west (ME015-113, ME015-114, ME015-115, ME015-116). The first of these (ME009-084 and ME009-094) came to light more or less accidentally during the course of field walking in 2003–4 in connection with the Heritage Council funded project which explored the use of airborne laser scanning (LiDAR) to record and investigate spatially the archaeological landscape around Loughcrew (Shell and Roughley 2004), which followed on from earlier fieldwork (Shee Twohig 2001). The first finds were published briefly in the Prehistoric Society newsletter (Shell 2005). The more recent discoveries (in 2008–9) came about through the observations of people living or hill-walking in the locality and through subsequent more methodical field walking. The new finds are extensively reported and illustrated in Shee Twohig *et al.* (2010) and all the rock art of the area is listed in summary in Table 9.1. The numbers are those assigned to them in the Archaeological Survey of Ireland as part of the Sites and Monuments Record (SMR) and the National Grid co-ordinates were generated from the LiDAR survey data.

We now know of *c.* 20 examples of open air rock art from the Loughcrew area, with 2–3 further examples known only from vague older reports by Conwell (1873). Some of these carvings have almost certainly been seen by other field walkers from time to time. Evans reported the presence of four 'carved rocks' on the 'lower reaches of Carnbane East' (2004, 44), but it is difficult to be certain if these are the same as those recorded by us, with the possible exception of his No. 4, which is probably ME015-114 in Corstown townland.

All the rock art occurs on glacial erratic boulders, which have been identified as originating in a nearby source, just north-west of the Slieve na Calliagh range and which were carried by the ice to their present location during the last ice age (R. Meehan, pers. comm.); for the geology see Meehan and Warren (1999) and McConnell *et al.* (2001). The carving was generally done on the flatter upper surface of the boulders, but in a few instances it occurs on the edges. As far as can be determined the new discoveries are all on undisturbed boulders. However, although the area where they occur is now all in pasture, there has been considerable clearance in the past. The substantial stone walls which form the field boundaries are up to 2m wide and 1.5–2.0m high and are built from stones collected as part of field clearance. Thus an unknown, but possibly large, number of carved boulders may have been incorporated into the field walls. Two of the decorated stones were in fact found in or on walls – the first discovery, reported by Coffey in 1897, and also the stone at the stone circle (ME009-059002).

The repertoire of motifs is limited, as is characteristic of rock art, and a simple count shows the dominance of cup-marks, followed by single circles, usually with a cup-mark in the centre. The most spectacular of the new discoveries is undoubtedly ME009-094 (Figure 9.3), which is composed of four separate blocks, which would originally have formed a single large sandstone erratic boulder. The four carved surfaces in this cluster are in a flat location but with views towards all the higher cairns on each of the three main hills, and it is possible to see the site from almost all of the other rock art sites north of the hills (Shee Twohig *et al.* 2010, Pl. 21). The viewsheds to and from the carved sites were studied by Dr Corinne Roughley, with Dr Colin Shell, and are fully documented in Shee Twohig *et al.* (2010). The carvings on two (A and C) of the four stones consist mainly of cupmarks and cup and single circle, but each also has one cup and double circle. The other two stones

in the cluster have somewhat more complex carvings, with a greater range of motifs and also have surfaces which are subdivided naturally into sections by cracks or changes in level. Stone B has two long rectangular sections, with double circles placed at the end of each section. Stone D has the largest carved area of any of the rock art, measuring 3.6m in maximum dimensions, and is the only one of the surfaces in the cluster with cup marks surrounded by more than two circles. There are 4 sets of cup-marks with 3–4 concentric circles spaced out across the stone, separated from each other by natural features of the

Table 9.1: List of rock art sites in the Loughcrew area.

TD[1]	SURVEY[2]	NAT. GRID. REF.	HT[3]	MOTIFS	REFERENCE[4]
Blnvly[6]	009–055	258223,278889	*c.* 143	circles	Shee 1972
Blnvly[6]	009–059002	258104,278598	*c.* 153	arcs, circle/spiral	Shee Twohig 2001
Blnvly[6]	009–065	259363,278693	*c.* 147	Cupmarks, circles	Shee 1972
Blnvly[6]	009–084	259003,277909	183	cupmarks, circles	Shee 1972
Blnvly[6]	009–093	258761,278867	*c.* 137	A: cupmarks, circles	Shee Twohig 2001
Blnvly[6]	009–093	258761,278867	*c.* 137	B: unknown	Shee Twohig 2001
Blnvly[6]	009–093	258761,278867	*c.* 137	C: cupmarks, circles	Shee Twohig 2001
Blnvly[6]	009–093	258761,278867	*c.* 137	Cup + 6 circles + radial	Shee Twohig 2001
Blnvly[6]	009–094	258841,278550	150	A: cupmarks, circles	Shee Twohig *et al.* 2010
Blnvly[6]	009–094	258841,278550	150	B: cupmarks, circles	Shee Twohig *et al.* 2010
Blnvly[6]	009–094	258841,278550	150	C: cupmarks, circles	Shee Twohig *et al.* 2010
Blnvly[6]	009–094	258841,278550	150	D: cupmarks, circles	Shee Twohig *et al.* 2010
Blnvly[6]	009–095	259291,277884	219	circles	Shee Twohig *et al.* 2010
Blnvly[5]	009–096	259006–278015	173	cupmarks, circles	Shee Twohig *et al.* 2010
Blnvly[6]	009–097	258916,277976	183	cupmarks, arcs, circles	Shee Twohig *et al.* 2010
Blnvly[6]	009–098	258805,277977	194	cupmarks	Shee Twohig *et al.* 2010
Cstn[5]	015–113	258437,277681	230	cupmarks, circles	Shee Twohig *et al.* 2010
Cstn[5]	015–114	258487,277668	240	semicircles/arcs	Shee Twohig *et al.* 2010
Cstn[5]	015–115	258336,277113	233	cupmark, arc	Shee Twohig *et al.* 2010
Cstn[6]	015–116	258252,277132	233	cupmark, arcs	Shee Twohig *et al.* 2010
Blnvly[6](?)	–	'NE slopes of Carnbane East'		'star'	Conwell 1873
Ptkstn[7]	–	'near Cairn X₃'		cupmarks	Conwell 1873
unknown	–	'near Loughcrew'		Circles, cupmarks	Coffey 1897

Notes

1 Townland
2 Archaeological Survey of Ireland: these numbers are preceded by the prefix ME
3 Height above OD in m
4 See bibliography
5 Corstown townland
6 Ballinvally townland
7 Patrickstown townland

surface such as cracks or changes in height, resulting in four compositions, each consisting of a cup with a number of circles accompanied by cups and cups and single circles. This apparent organisation of carvings into panels defined by natural features has been remarked at rock art sites in Scotland, but at Loughcrew this feature is really only notable on this stone and on one other site (ME009-095).

In one large sloping field there are three boulders with very simple repertoires, comprising only cup-marks and a small number of cup and single circles (ME009-096, ME009-097, and ME009-098). A nearby boulder (ME009-084) is situated at the foot of the hills, at the point where an old route-way runs between the hills. This is known locally as the Mass Rock and the route led south to an old graveyard (Shee Twohig *et al.* 2010).

For the most part the carvings on higher ground have a greater proportion of simple carvings, such as cupmarks and single circles, and a smaller proportion of cupmarks with multiple circles (Table 9.2). A natural division appears to occur between the carvings below 150m above OD and those at more than 170m above OD. Only one of the boulders (ME009-095) on higher ground (at 219m above OD) has multiple circles, and this is a particularly large boulder with commanding views over many of the other carved rocks to the north. It is interesting to note that this is the only stone where one has to stand on the uphill side of the carved surface in order to view the carvings. The highest of the Corstown boulders (ME015-114) is at 240m above OD, and this is only just downslope from Cairn T, and it appears to have multiple arcs rather than complete circles, but the weathering makes it difficult to be sure.

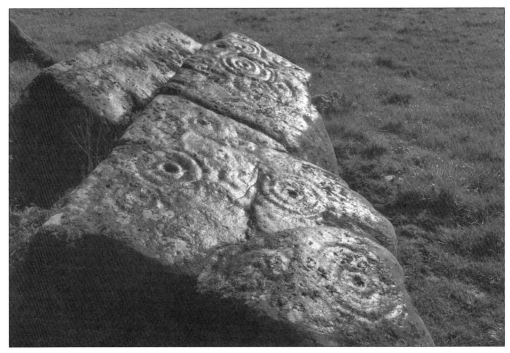

Figure 9.3: Rock art site ME009-094 (photo: E. Twohig). Stone D, with Stone C to the left.

Table 9.2: Number of occurrences of particular motifs relative to height above OD.

HEIGHT ABOVE OD	SINGLE CUPMARK	1 CIRCLE	2 CIRCLES	3/3+ CIRCLES
<150m	69	69	17	20
170m>	96	17	4	4

The more complex motifs are generally situated below 150m above OD, particularly on the flat northern section of Ballinvally. It should be noted, however, that the more complex carvings on the flat lower ground are all on potentially movable stones and it is not possible to be absolutely sure that they are in their original positions. Most are quite large, however, and seem unlikely to have been moved any appreciable distance.

The more elaborate carvings in the northern part of Ballinvally townland include ME009-065 (Figure 9.2), and ME009-093, both of which have multiple rings. These also have radial lines, a feature which is almost absent from the newly discovered *in situ* stones, where there are only two examples of radial lines, both quite short and they are used to connect two sets of circles (on ME009-084 and ME009-095).

ROCK ART AND PASSAGE TOMB ART

The question of the relationship between the rock art and the carvings in the passage tombs is clearly one that needs to be examined in light of these new discoveries of rock art so near to the passage tombs. The rock art at Corstown ME015-114 is downhill from Cairn T and the passage tombs surrounding it and there are some further, albeit very simple, examples of rock art on the south western spur of the same hill. One of these (ME015-115) is of particular interest as the boulder appears to have had a section of the upper part of the block removed (Figure 9.4). The matrix of the missing section suggests a tall narrow block of stone, of a type which occurs as orthostats in the passage tombs and a row of chock stones are still in situ in a parallel crack, as if to remove a second section. Smaller chock stones can be seen on ME009-084, which in this case are positioned as if to prise off the upper section of the stone. Of course it is difficult to know when the removal or attempted removal of the sections of these boulders took place but it is not impossible that this was done in the period of the construction of the passage tombs. Nor do we know if the rock art was already carved on these blocks before the attempts were made to remove the sections, but it is possible that it was. Rock art might therefore have been removed from the landscape and incorporated into the passage tombs at the time of construction, an idea which has been suggested previously but without any actual examples being cited in the field.

It had been traditional for Irish archaeologists to date rock art later than passage tomb art, perhaps following interpretations inherited from their mentors. Arguments have been made, however, for a Neolithic date for at least some rock art, initially by Colin Burgess (1990a and b) just over 20 years ago and subsequently by Clive Waddington (1998, 32; 2007, 15). While the cup-marked stone from a sealed context at Dalladies long barrow seems certainly

dated to the later 4th millennium BC, the cup-marks on top of portal tomb capstones are less convincingly dated to the Neolithic, as they could have been carved at almost any period. For Ireland in particular the traditional Bronze Age dating for rock art has been challenged by researchers coming from outside the Irish/British system, notably American Susan Johnston (Johnston 1993) and New Zealander Blaze O'Connor (O'Connor 2007; 2009). Johnston concluded that '... *whatever the chronology and the associated cultural implications, petroglyphs* [rock art] *are clearly not out of place in a cultural context which includes passage tombs ...*' (1993, 278). More recently O'Connor claimed that '... *the two traditions are now recognised as being broadly contemporaneous, as opposed to strictly chronological developments in visual culture, with both practices originating during the Neolithic*' (2007, 184), and these views have now been followed by O'Sullivan (2009a) and Shee Twohig *et al.* (2010).

A number of passage tomb orthostats at Loughcrew have carvings which are very similar to rock art (Shee Twohig *et al.* 2010; see also Evans 2004, chapter 4). In particular the following examples may be cited on Carnbane West, the backstone (C16) of the inner right-hand side chamber in Cairn L (Figure 9.5), the largest carved stone on the hills. On this stone it can be argued that the cup-and-ring motifs form the focus for the rest of the carvings, which were organised around the cup-and-ring motifs. In the adjacent chamber there are cup-marks carved at the bottom of the C17, one with a rough circle carved around it (Shee Twohig 1981, fig. 226), while a loose stone from

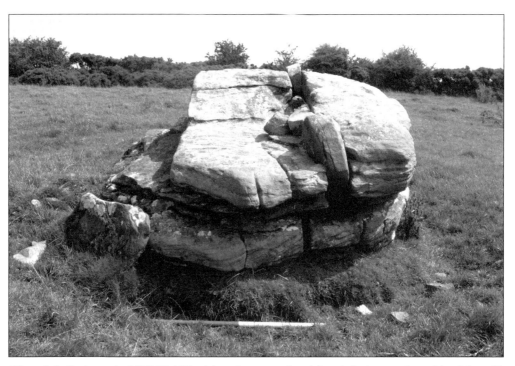

Figure 9.4: Rock art site ME015-115, with section removed on left and chock stones in position (photo: E. Twohig).

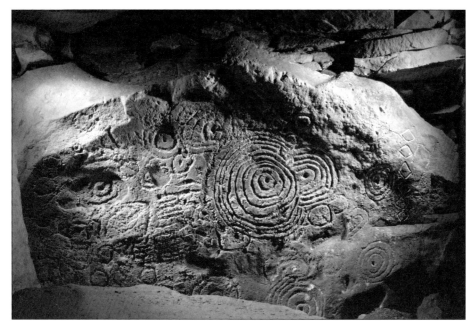

Figure 9.5: Orthostat C16, Cairn L (photo: K. Williams).

Figure 9.6: Orthostat C5 Cairn H (photo: E. Twohig).

Cairn L has cup-marks and irregular lines (Shee Twohig 1981, fig. 228). Orthostat R4 in the passage of the same tomb is almost completely covered in hollows and even if, as seems likely, these are natural, it is clear that the stone was chosen because of this feature (Shee Twohig 1981, fig. 223). Cairn H nearby has several sets of cup-and-rings on a very weathered surface of C5 (Shee Twohig 1981, fig. 216) which could well have been an example of rock art carvings which weathered in the open air before being incorporated into this particular passage tomb (Figure 9.6).

On the central, highest, of the hilltops, Carnbane East/Slieve na Calliagh, a number of cairns surround Cairn T which reaches 276m above OD. Possible examples of rock art in the passage tombs on this hill top include the cup-and-rings on two chamber orthostats in Cairn S (Shee Twohig 1981, fig. 231) and on three chamber orthostats of Cairn V on the other side of Cairn T

(Figure 9.7). However, it is the dominant passage tomb, Cairn T which exhibits the greatest number of examples of rock art type carvings, particularly cupmarks, as indeed was noted by Evans who argued that the carvings on inner passage in particular were '...*becoming distinctly landscape-like in character*' (2004, 49). Nearly all the passage orthostats have multiple cupmarks, many enclosed by rings (Shee Twohig 1981, figs 232 and 233), and the general similarity to rock art can be seen looking inwards along the passage towards the chamber (Figure 9.8). Most of the carved surfaces have a weathered appearance, as if they were possibly exposed before being incorporated into the monument. The roof at Cairn T has survived to a large extent and so the inner surfaces have been protected from weathering, in contrast to most of the other tombs, so the weathering is almost certainly an original feature, not something that has occurred since the monument was built. It is interesting that the fresh surfaces tend to have more typically passage tomb than rock art type motifs and the carvings themselves are also quite fresh and unweathered. This is notable on Orthostat C8, the innermost/backstone of the tomb (in the end chamber) whose fresh surface contrasts sharply with the weathered surfaces of most of the other orthostats (Figure 9.8). This stone is illuminated by sunshine streaming down the passage at dawn on the equinox days. The capstone of the end chamber also has a fresh surface, its carvings are very clear and executed with a tools of varying sizes, and possibly therefore at different times or by different carvers (Shee Twohig 1981, fig. 238, Plate 36). The carvings run beyond the supporting corbels and must have been done before the stone was put in place. The uppermost corbel over Orthostat

Figure 9.7: Orthostat C3 Cairn V, with Cairn T in the background (photo: E. Twohig).

C2 in the left-hand side chamber also has very fresh carvings, in contrast to those on the corbel immediately beneath it (Shee Twohig 1981, pl. 35).

There are few surviving carvings on Patrickstown, the easternmost hill, but what appears to be a fallen kerbstone of Cairn X_2 is covered almost entirely in cupmarks, most of which are arranged in a pattern, so these are, therefore, definitely not natural features (Shee Twohig *et al.* 2010, fig. 13). As we now know from clear evidence at the Boyne Valley sites, the carvings in passage tombs can be executed in more than one phase (Eogan 1998a; Shee Twohig 2000), with images frequently found overlying one another. At Loughcrew, and in particular at Cairn T, it is possible that the more typically passage-tomb art motifs may have been added to the rock-art type motifs (cup-and-rings).

Unfortunately lack of modern excavations at Loughcrew does not allow us to check out many of the inner surfaces of the structural stones, or the upper surfaces of the roofstones, as has been possible in the Boyne Valley sites, so we have very little information on the type of carvings which might have been executed before the completion of the structure. No carvings have been identified on those parts of the orthostats-backs which are now visible, with the exception of the very large kerbstone on the north side of Cairn T, traditionally known as The Hag's Chair, which has irregular circles on the inner face (Shee Twohig 1981, fig. 238).

The extensive excavations at both Newgrange and Knowth have revealed carvings on the inner surfaces of many of the orthostats and kerbstones, including the so-called 're-

Figure 9.8: View along passage of Cairn T, with Orthostat C8 illuminated (photo: K. Williams).

cycled' stones at Knowth, where the dominant motifs are spirals and zigzags, and these are interpreted as coming from an earlier tomb (Tomb A) (Eogan 1998b; Eogan and Cleary forthcoming). In contrast to that rather sophisticated carving, at least nine of the 124 surviving kerbstones at Knowth have cup-marks or irregular pick-marks or dots on their back surfaces Eogan 2008a, fig. 2; Eogan and Shee Twohig forthcoming). A photograph from the excavation archives of Tara shows a cupmark with single circle enclosing it on the back of one of the passage tomb orthostats (O'Sullivan 2005, fig. 63), and the hidden art at Newgrange shows a higher proportion of cup-marks and circles than is found on the outer surfaces (C. O'Kelly 1982). Cup-marks are also known on passage tombs beyond Ireland, and are located in primary positions in the passage tombs of La Hougue Bie in Jersey (Patton *et al.* 1999) and at La Table des Marchands in Brittany (Cassen and Robin 2009).

The passage tomb art at Loughcrew is more like rock art than passage tomb art elsewhere in Ireland. The typical Irish rock art motifs of cups and circles are commoner at Loughcrew than at other Irish passage tombs as are arcs and cup-marks/dots. Overall there are fewer spirals at Loughcrew than in Ireland generally. Table 9.3 shows the occurrence of individual motifs as a percentage of the total number of surfaces.

It is not only in the matter of simple motif counts that Loughcrew passage tomb art can be seen to have more in common with rock art than the passage tomb art. The placement of the carvings on the stones does not appear to be well organised either in respect to other carvings or to the shape of the stones. The same feature can be seen at most other passage tombs, with the notable exception of a number of stones at Newgrange, Knowth and Fourknocks, and two of the stones at Dowth. Techniques at those sites are also more sophisticated, with relief carvings and a number of examples of an almost sculptural style, seen for example on the entrance stone and the edge of the roofbox at Newgrange. In addition there is extensive use of angular motifs at Newgrange, Knowth, and Fourknocks, and this angularity is reflected in some of the mobiliary art from those sites, notably the

Table 9.3: Number of occurrences of surfaces with particular motifs.

	IRELAND[1]	LOUGHCREW	CAIRN T
No. of carved surfaces	463	124	32
Cup and circles	19	36	68
Arcs	34	59	81
Concentric circles	47	44	68
Cupmarks/dots	19	27	50
Spirals	25	14	19

Note

1 Based on numbers in Shee Twohig (1981, Table 13). Though the carvings at Newgrange, Dowth and some minor additional sites have been systematically published or revised since that publication, it is unlikely that the relative proportions will have changed significantly. The full corpus of carvings from Knowth is due to be published within a short time (Eogan and Shee Twohig, forthcoming).

bone pins carved with zigzag motifs. This is not the case, however, for the hidden art at those sites which, as already noted is often quite similar to rock art, but can also include angular motifs, as on Stone Y in the roof at Newgrange.

CONCLUSION

Without independent dating evidence for either the passage tomb art or the rock art at Loughcrew, it is difficult to determine the relationship between the two traditions. Radiocarbon dating on some of the human bone remains from Loughcrew would help fix the chronology of the use of the passage tombs but the dating of the open air art is altogether more problematic. All that can be said at present is that it is possible that some rock art has been incorporated into the passage tombs, suggesting that it is contemporary with them, or even earlier in date.

ACKNOWLEDGEMENTS

As noted, full details of the rock art at Loughcrew have been published in Shee Twohig *et al.* (2010), and I wish to acknowledge the contribution of my fellow-authors of that paper to the gathering and processing of the information contained in both papers. In particular Dr Corinne Roughley worked on data gathered through LiDAR survey to produce the maps and details on the location of sites, viewsheds and intervisibility. In this she was helped by Dr Colin Shell, and she, Dr Shell, Gillian Swanton and I carried out the original field work. The field work was funded largely by grants in 2003 and 2005 from the Heritage Council and was also supported by the Departments of Archaeology, University College, Cork and University of Cambridge. I am also grateful to Ciarán O'Reilly and Peter Clarke who were responsible for finding a number of sites and helping in the fieldwork and to Ciarán for Figure 9.2 and last but certainly not least to Ken Williams who provided Figures 9.5 and 9.8.

NOTE

1 ME indicates Co Meath. 009 refers to the Ordnance Survey 6 inch sheet Number 9. The last number is the individual site number.

REFERENCES

Burgess, C. 1990a. The chronology of cup and ring marks in Britain and Ireland. *Northern Archaeology* 10, 21–6.
Burgess, C. 1990b. The chronology of cup- and cup-and-ring marks in Atlantic Europe. *Revue archéologique de la Ouest,* Supplément 2, 157–71.
Cassen, S. and Robin, G. 2009. Le corpus des signes à la Table des Marchands. Enregistrement et analyses descriptive. In S. Cassen (ed.), *Autour de la Table: explorations archéologiques et discours*

savants sur des architectures néolithiques à Locmariaquer, Morbihan (Table des Marchands et Grand Menhir,* 826–53. Nantes.

Coffey, G. 1897. Origins of prehistoric ornament in Ireland. *Journal of the Royal Society of Antiquaries of Ireland* 27, 28–52.

Conwell, E. A. 1864. On the Ancient remains hitherto undescribed in the County of Meath. *Proceedings of the Royal Irish Academy* Series 1(9), 42–50.

Conwell, E. A. 1866. Examination of the Ancient Sepulchral Cairns on the Loughcrew Hills, Co. Meath. *Proceedings of the Royal Irish Academy* Series 1(9), 355–79.

Conwell, E. A. 1872. On the identification of the ancient cemetery at Loughcrew, Co. Meath, and the discovery of the tomb of Ollamh Fodhla. *Proceedings of the Royal Irish Academy* Series 2(1), 72–106.

Conwell, E. A. 1873. *Discovery of the Tomb of Ollamh Fodhla.* Dublin: McGlashan & Gill.

Eogan, G. 1986. *Knowth and the Passage Tombs of Ireland.* London: Thames & Hudson.

Eogan, G. 1998. Overlays and underlays: aspects of megalithic art succession at Brugh na Bóinne, Ireland. *Brigantium* 10, III Coloquio Internacional de Arte Megalítico, 217–34.

Eogan, G. 1998. Knowth before Knowth. *Antiquity* 72, 162–72.

Eogan, G. and Cleary, K. forthcoming. *The Archaeology of the Large Mound at Knowth, Co. Meath.* Dublin: Royal Irish Academy.

Eogan, G. and Shee Twohig, E. (in prep.) *The Megalithic Art at Knowth, Co. Meath.* Dublin: Royal Irish Academy.

Evans, E. 2004. *Archaeology from Art: Exploring the interpretative potential of British and Irish Neolithic rock art.* Oxford British Archaeological Report 363.

Frazer, W. 1892–3. Notes on incised sculpturing on stones in the cairns of Sliabh na Calliaghe near Loughcrew, Co. Meath, Ireland, with illustrations from a series of Ground Plans and Water-Colour Sketches by the late G. V. Du Noyer, of the Geological Survey of Ireland. *Proceedings of the Society of Antiquaries of Scotland* 27, 294–340.

Johnston, S. A. 1993. The relationship between Prehistoric Irish rock art and Irish passage tomb art. *Oxford Journal of Archaeology* 12, 257–79

MacWhite, E. 1946. A new view on Irish Bronze Age rock-scribings. *Journal of the Royal Society of Antiquaries of Ireland* 76, 59–80.

McConnell, B., Philcox, M. and Geraghty, M. 2001. *Geology of Meath: a geological description to accompany the Bedrock Geology 1:100,000 Scale Map Series, Sheet 13, Meath.* Dublin: Geological Survey of Ireland.

Meehan, R. G. and Warren, W. P. 1999. *The Boyne Valley in the Ice Age.* Dublin: Geological Survey of Ireland.

O'Connor, B. 2007. Carving identity: the social context of Neolithic rock art and megalithic art. In D. Barraclough and C. Malone (eds), *Cult in Context: reconsidering ritual in archaeology,* 183–90. Oxford: Oxbow Books.

O'Connor, B. 2009. Re-collected objects: carved, worked and unworked stone in Bronze Age funerary monuments. In B. O'Connor, G. Cooney, G. and J. Chapman (eds), *Materialitas: working stone, carving identity,* 147–60. Oxford: Prehistoric Society Research Papers 3.

O'Kelly, C. 1982. Corpus of Newgrange art. In M. J. O'Kelly, *Newgrange: archaeology, art and legend,* 146–85. London: Thames & Hudson.

O'Kelly, M. J. and O'Kelly, C. 1983. The tumulus of Dowth, County Meath. *Proceedings of the Royal Irish Academy* 83C, 135–90.

O'Sullivan, M. 2005. *Dumna na nGiall: the Mound of the Hostages, Tara.* Dublin: Wordwell.

O'Sullivan, M. 2009a. Preserved in stone: material and ideology in the Neolithic. B. O'Connor, G. Cooney, G. and J. Chapman (eds) *Materialitas: working stone, carving identity,* 18–28. Oxford: Prehistoric Society Research Papers 3.

O'Sullivan, M. 2009b. Living stones. Decoration and ritual in 4th and 3rd millennium BC Ireland. In R. de Balbín Behrmann, P. Bueno Ramirez, R. González Antón, and C. Del Arco Aguilar (eds), *Grabados rupestres de la fachada atlántica europea y Africans. Rock Carvings of the European and African Atlantic façade*, 5–12. Oxford: British Archaeological Report.

Patton, M., Rodwell, W. and Finch, O. 1999. *La Hogue Bie, Jersey: a study of the Neolithic tomb, medieval Chapel and Prince's Tower*. St Helier: Société Jersiaise.

Shee, E. 1972. Three decorated stones from Loughcrew, Co. Meath. *Journal of the Royal Society of Antiquaries of Ireland* 102, 224–33.

Shee Twohig, E. 1981. *The Megalithic Art of Western Europe*. Oxford: Clarendon Press.

Shee Twohig, E. 1997. Context and content of Irish passage tomb art. *Revue Archéologique de l'Ouest, Supplément* 8, 67–80.

Shee Twohig, E. 2000. Frameworks for the megalithic art of the Boyne Valley. In A. Desmond, G. Johnson, M. McCarthy, J. Sheehan and E. Shee Twohig (eds), *New Agendas in Irish Prehistory: papers in commemoration of Liz Anderson*, 89–105. Bray: Wordwell.

Shee Twohig, E. 2001. Change and continuity: post passage tomb ceremonial near Loughcrew, Co. Meath. *Révue Archeologique de l'Ouest, Supplément 9*, 113–24.

Shee Twohig, E., Roughley, C., Shell, C., O'Reilly, C., Clarke, P. and Swanton, G. 2010. Open air rock art at Loughcrew Co Meath. *Journal of Irish Archaeology* 19, 1–28.

Shell, C. 2005. The Loughcrew Landscape Project. *PAST* 51, 1–3.

Shell, C. and Roughley, C. 2004. Exploring the Loughcrew landscape: a new airborne approach. *Archaeology Ireland* 18, 22–25.

Waddington, C. 1998. Cup and ring marks in context. *Cambridge Archaeological Journal* 8, 29–54.

Waddington, C. 2007. Cup and rings and passage grave art: insular and imported traditions? In C. Burgess, P. Topping, F. and Lynch (eds), *Beyond Stonehenge: essays on the Bronze Age in honour of Colin Burgess*, 11–19. Oxford: Oxbow Books.

The figurative part of an abstract Neolithic iconography: hypotheses and directions of research in Irish and British passage tomb art

Guillaume Robin

INTRODUCTION

The principle characteristic of Irish and British passage tomb art is the abstract nature of its repertoire, which is exclusively composed of geometric motifs: circles, spirals, arcs, radiate motifs, chevrons, triangles, lozenges, scalariform motifs and meandering lines (Shee Twohig 1981; Robin 2009). This contrasts with the other traditions of megalithic art found in western France and Iberia where figurative motifs, such as weapons, animals or human figures, were represented together with abstract motifs. Why is there a total absence of figurative forms in Irish and British passage tombs? What are the origin and reasons for this specificity, which distinguishes the isles from the continent?

In reality, the problem may be more complex, and the frontier between abstraction and figuration less clear than it appears. These classifications depend on the degree of knowledge that we have of the art. For example, the aboriginal Walbiri iconography is composed of geometric figures only that look totally abstract at first glance: but the descriptions and analyses of Nancy Munn (1973), who was explained the art by its creators and users, have shown that a large number of the motifs are in fact very schematised figuration of objects or scenes. A penannular motif, for instance, represents the plan of a hut, and a circle with radiating arcs (a 'flower-like' motif as the ones found in the Neolithic tombs of Loughcrew in Ireland) represent people sitting around a fire (Munn 1973, 66, 79). Many other signs are direct references to identifiable beings or objects and show that despite its abstract appearance, Walbiri art has a significant figurative dimension (also see Hensey this volume).

In this paper I will examine the potential figurative elements within Irish and British passage tomb art. Does this art include motifs that are graphical references to the world of the Neolithic people? How can this be identified today without the direct explanation of the Neolithic carvers? After a presentation of the historical debates and theories about a possible figurative dimension of the art, I will focus on a selected number of case studies that are interpreted as schematic figurations of objects and abstract concepts. These hypotheses are based on an analysis of the design of the motifs but also and above all from an analysis of their location on the stones, their relationships with other motifs and with the architecture of the tombs. Comparisons with continental contexts, such as the megalithic art of Brittany and Iberia, or the hypogea art of Neolithic Sardinia, will also be used.

ABSTRACTION VERSUS FIGURATION: AN HISTORICAL DEBATE

'It is too easy for a modern sophisticated imagination to see faces or figures where neither were intended by those who carved the patterns. In many instances, the ability shown is such, that one must feel that if the carvers wanted to represent a person, animal or plant, they could have done so with little trouble.' Michael J. O'Kelly (1970, 535).

As soon as the first studies on Irish and British passage tomb art were published, in the middle of the 19th century, the abstract nature of the motifs was a source of debates. The first problem was to understand the elementary *function* of the art: was such an abstraction intended to be decorative or symbolic? For some scholars (Simpson 1866, 102–5; Frazer 1893, 296) the main purpose of the art was to embellish the architecture of the tombs. George Coffey also interpreted the geometric motifs carved inside Irish passage tombs as purely decorative in function (Coffey 1894; 1895a; 1895b; 1896); but he also acknowledged that these abstract figures, which he though to originate from central Europe, might have had originally a symbolic signification that was lost when they were adopted in Ireland (Coffey 1892, 22). Other scholars had the opinion that the role of the abstract motifs was more symbolic than ornamental (Wilde 1847, 179–80; Allen 1904, 54; Shee Twohig 1981, 120, 134; Eogan 1986, 146). However, the majority of experts in that area were or are inclined to the opinion that both functions, symbolic and decorative, were attached to the art by the passage tombs builders (Wakeman 1881, 545; Macalister 1921, 218; Lynch 1967, 12; C. O'Kelly 1973, 362; Herity 1974, 91, 103, 106).

On many occasions, the abstract nature of Irish and British passage tomb art was brought into question when some archaeologists proposed to interpret carved motifs and combinations as representations of real objects or living beings. The most important (in terms of time and publications), and still ongoing, debate is about the representation of human faces amongst the carvings (Figure 10.1). First proposed by William Borlase (1897, 220), who saw human eyes in a pair of lozenges carved on a stone at Kiltierney (Co. Fermanagh, Ireland), the theory was adopted by the French archaeologist Joseph Déchelette (1912, 35, 42) who interpreted certain carved composition in Newgrange as the representation of female eyes (spirals) with facial tattoos (chevrons and lozenges). But the most significant contribution was made by another French scholar, Henri Breuil, who gave more than 30 examples of human faces from the drawing of Irish passage tombs motifs (Breuil 1934). His work had a large and durable influence: many archaeologists after him (Mahr 1937, 354, 359–60; Macalister 1943; Piggott 1954, 211–8; Hartnett 1957; Eogan 1967), and particularly Michael Herity (1974), interpreted geometric carvings of Irish passage tombs as schematic human representations.

The theory of anthropomorphic figures in Irish and British monuments, and its connection with the worship of a 'Mother Goddess' (Crawford 1957), were criticised by Andrew Fleming (1969) and Claire O'Kelly (1973, 361). For Michael O'Kelly, who also rejected the theory, Irish passage tomb art is clearly abstract in nature and was deliberately made so (O'Kelly 1970, 535 – see citation above). More recently, Elizabeth Shee Twohig (1998) has demonstrated that human faces or female representations are improbable in Neolithic Ireland and Britain; she has also argued that many of Breuil's drawings of megalithic art that show human faces were actually inaccurate and influenced by its own interpretation.

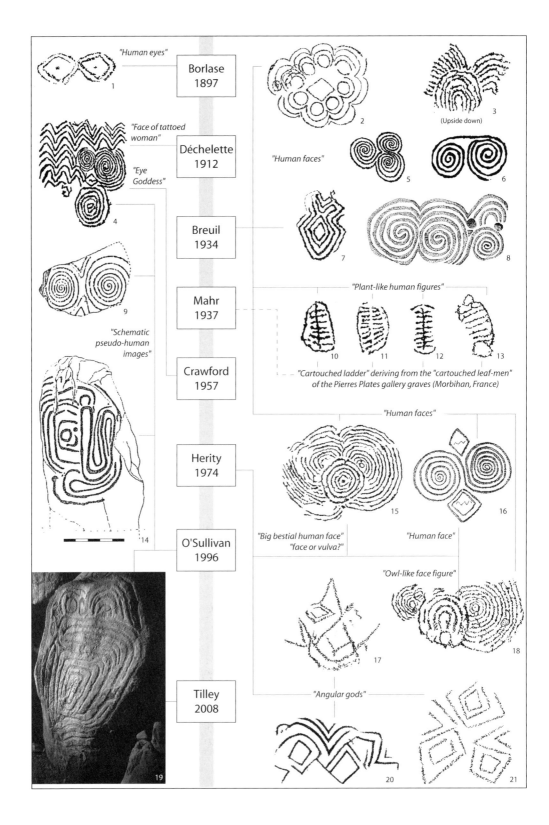

"Human eyes"

Borlase
1897

"Face of tattoed woman"

Déchelette
1912

"Eye Goddess"

"Human faces"

(Upside down)

Breuil
1934

"Schematic pseudo-human images"

Mahr
1937

"Plant-like human figures"

Crawford
1957

"Cartouched ladder" deriving from the "cartouched leaf-men" of the Pierres Plates gallery graves (Morbihan, France)

"Human faces"

Herity
1974

O'Sullivan
1996

"Big bestial human face"
"face or vulva?"

"Human face"

"Owl-like face figure"

Tilley
2008

"Angular gods"

The excavations of the large tumulus of Knowth and the discovery inside the eastern and western tombs of a style of art not encountered before, however, brought new elements to the debate. For Muiris O'Sullivan: '*the old theory of anthropomorphism has to be resurrected*' (O'Sullivan 1986, 81). This new form of art, termed 'plastic art' by O'Sullivan (1986) or 'ribbon art' by George Eogan (1986), would include two human figures (14 and 19 in Figure 10.1) imported from Brittany and Iberia and placed on key-location inside the tombs (O'Sullivan 1986; 1996). In a recent publication, Christopher Tilley describes the carvings on orthostat 49 in Knowth West as '*uniquely anthropomorphic in form*' (2008, 156–7, 172–4).

O'Sullivan's (1986) and Tilley's (2008) interpretation, as other anthropomorphic theories before (Mahr 1937, 358–9; Le Roux 1992), is based on comparisons with carvings found in Breton passage tombs like Gavrinis, Goërem or Les Pierres Plates, and in particular with the so-called 'buckler-motif', which was traditionally interpreted as a schematised human (often female) representation (e.g., Breuil 1936; 1937; L'Helgouac'h 1983; O'Sullivan 1996; Eogan 1999). Yet recently, Serge Cassen (2000a; 2000b) has convincingly demonstrated the unlikelihood of such interpretation for the Breton motifs.

If any comparison with indisputable anthropomorphic figures should be made, I would propose an analogy between three M-shaped motifs found in Knowth: kerbstone 40, left jamb in the northern recess in tomb East, orthostat 41 in tomb West (see Robin 2009, fig. 151), and the schematised faces carved on Iberian passage tombs and steles (Bueno Ramírez and Balbín Behrmann 1996). Particularly, the similarities between the decorated jambstone in Knowth East and the carved stele found in Chão do Brinco in Portugal (Silva 1993) deserve to be pointed out. Though I personally do not think that any schematic face was ever represented on the surfaces of Irish and British passage tombs, from a methodological point of view, the three stones mentioned above are the best candidates I would propose for such a hypothesis. They are the only examples of insular art that can be compared with the T-shaped or M-shaped motifs that were conventionally used all over western Europe during the Neolithic to represent human faces: in Iberia (see above), on the standing stones of southern France (D'Anna *et al.* 1996) and in the Alps (Saulieu 2004), or on the walls of hypogea and gallery graves of Paris basin (Bailloud 1964; Shee Twohig 1981; Tarrête 1996; Villes 1998).

Besides anthropomorphic theories, other attempts were made to see figuration in passage tomb art. For examples, many archaeologists interpreted the radiate motifs and concentric circular designs in Newgrange, Dowth or Loughcrew as representations of stars

Figure 10.1: (opposite) Examples of Irish and British passage tomb motifs interpreted as anthropomorphic representations. (1) Kiltiernev, stone west; (2) Newgrange, roofstone of cell East; (3) Loughcrew T, orthostat C14; (4) Newgrange, orthostat L19; (5) Newgrange, orthostat C10; (6) Eday Manse; (7) Sess Kilgreen, orthostat C5; (8) Newgrange, kerbstone 52; (9) Knowth East, corbel 5D-6E; (10) and (12) Loughcrew T, orthostat C8; (11) Dowth North, orthostat C5; (13) Loughcrew U, orthostat C2; (14) Knowth East, orthostat 69; (15) Sess Kilgreen, orthostat C6; (16) Newgrange, kerbstone 67; (17) Fourknocks, stone C1; (18) Loughcrew U, orthostat C3; (19) Knowth West, orthostat 49; (20) Barclodiad y Gawres, orthostat L8; (21) Seefin, orthostat R4. Images 1, 3, 6, 7, 10, 12, 13, 15, 17, 18 and 21 after Shee Twohig 1981; 2, 4, 5, 8 and 16 after O'Kelly 1982; 9 and 14 after O'Sullivan 1988; 11 after O'Kelly and O'Kelly 1983; 20 after Lynch 1967. Image 19: Irish Department of the Environment, Heritage and Local Government.

or celestial bodies (Nilsson 1843, 143; Allen 1904, 54). Such symbols would be related to an astronomic religion and/or science in which the passage tombs were involved (Coffey 1912, 76–7, 88–90; Flom 1924; Brennan 1983; Thomas 1988; O'Brien 1989; 1992; Stooke 1994; Saunders 2004; Garnett 2005; O'Sullivan *et al.* 2010). A more recent series of studies has proposed to interpret the geometric forms of the art as depictions of entoptic visions that Neolithic people (often called shamans) would obtain through altered states of consciousness (Eichmeier and Höfer 1974, 151–60; Bradley 1989; Sherratt 1991; Le Roux 1992, 101; Lewis-Willams and Dowson 1993; Dronfield 1993; 1995; 1996a; Lewis-Williams and Pearce 2005, 260–80). In both theories, the motifs carved in Irish passage tombs are considered as schematic representations of real (material and immaterial) objects: they consequently (but not explicitly) view the art as figurative and not abstract.

Here again, I am not personally convinced that astronomic elements or entoptic visions were depicted by the Neolithic people of Ireland and Britain on the inner and outer walls of the tombs. However, in the course of the research that I undertook on the organisation of the motifs, their combinations and their relations with the stones and with the architecture of the monuments (Robin 2009), several alternative hypotheses arose regarding a possible figurative dimension of the art. This paper gives me the occasion to develop these hypotheses, which will be presented in two parts.

THE ABSTRACTION OF FIGURES

Amongst the thousands of individual motifs that were carved in Irish and British passage tombs, a very small number might be schematic representations of living beings and architectural elements. These hypotheses are supported by the graphic forms of these motifs but also by their location on the stones, their spatial relations with the architecture of the tombs, and comparisons with continental contexts. They constitute the first dimension of the figurative part of the art.

Schematic representation of living figures

An original motif, called 'Fir Tree Man' by Breuil (1934, 297), and one that I will call 'ramiform motif', was recorded on only eight stones in Ireland: roofstone 3 and kerbstones 4, 51 and 91 in Newgrange, orthostat 37 in Knowth East, corbel 37/38 in Knowth West, orthostat C4 in Loughcrew W, and a stone (now lost) in Loughcrew L (Robin 2009, fig. 63). I will focus on three of these stones (Figure 10.2).

Timothy Darvill (2001, 54–5) has pointed out the similarities of the compositions carved on kerbstones 4 and 51 in Newgrange and on the decorated vessel found in the middle Neolithic barrow of Lannec er Gadouer in Morbihan, Brittany (Cassen 2000c). In a previous work (Robin and Cassen 2009a), I also stressed the analogy between these elements and others in Ireland (corbel 37/38 in Knowth East) and Morbihan (a decorated standing stone at Guib and orthostat 3 in La Table des Marchands passage tomb). I drew attention to the constructional pattern used in the compositions: on these Irish and Breton stones and vessel, a vertical ramiform motif is placed above a horizontal (carved or natural) line, below which are represented serpentiforms or spiral-serpentiform motifs.

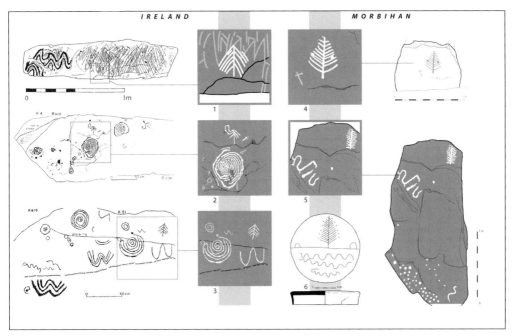

Figure 10.2: Ramiform motifs in Ireland and Brittany interpreted as probable representations of trees. (1) Knowth West, corbel 37/38; (2) and (3) Newgrange, kerbstones 4 and 51; (4) Guib, stele; (5) Table des Marchands, orthostat 3; (6) Lannec er Gadouer, vessel. Image 1 after Eogan 1997; 2 and 3 after O'Kelly 1982; 4 and 6 after Cassen 2000c; 5 after Robin and Cassen 2009b.

In Morbihan, where figurative motifs are common, it is not a problem to interpret the ramiform motif as a schematic representation of a tree (Cassen 2000c). In Ireland, however, this interpretation is much more difficult to accept *a priori*. Yet, the shape of the motifs, their orientation and location on the stone, the associations with the stones relief and other motifs are exactly the same as in Morbihan. We very probably have the same model (the origin of which is another problem), represented in both regions. Consequently, if we interpret the Breton motifs as representations of trees, we must admit the same interpretation for the three Irish examples.

Other schematic representations of living figures can be proposed from among the catalogue of Irish motifs. Several serpentiform motifs are represented with a cup, a circle, a V, a lozenge or a rectilinear angle at one end (Figure 10.3). These endings, added to the irregular (i.e. non-sinusoidal) form of many motifs, support the idea that snakes were represented in Irish passage tombs (Robin 2009, 77–85). This interpretation is not new but rarely have scholars expressed it in explicit terms. Edward Lhwyd described the spirals on kerbstone 1 at Newgrange as 'barbarous carvings, like snakes encircled, but without head' (cited by Wilde 1847, 168) and Claire O'Kelly (1973, 366) mentioned 'heads' (with inverted commas) that are represented by large cup-marks at the end of some serpentiforms in the Boyne valley. Only Hubert Savory (1973, 81) clearly described some Irish serpentiforms, particularly the ones on orthostat 8 in Knowth 14, as representations of headed snakes.

Figure 10.3: Example of headed serpentiform motifs, which are possible snake representations. (1) Newgrange L, stone A; (2) Dowth South, orthostat R1; (3) Loughcrew T, orthostat C3; (4) Newgrange, kerbstone 18; (5) Knockroe, kerbstone 31; (6) Barclodiad y Gawres; (7), (10), (12) and (13) Knowth 14, orthostat 8; (8) Newgrange, orthostat C3; (9) Loughcrew H, orthostat C14; (11) Knowth 4, stone A; (14) Knowth, kerbstone 94; (15) Knowth, kerbstone 64; (16) Knowth, kerbstone 113. Images 1 after O'Kelly et al. 1978; 2 after O'Kelly and O'Kelly 1983; 3 and 9 after Robin 2009; 4 and 8 after O'Kelly 1982; 5 after O'Sullivan 1987; 6 after Shee Twohig 1981; 7, 10, 12, 13, 14 and 16 after Eogan 1968; 11 after Eogan 1974; 15 after O'Sullivan 1988.

This interpretation can be further supported by an examination of the location of the Irish motifs, and by comparisons with continental examples. First, it is interesting to mention the paper by Primitiva Bueno Ramírez and Rodrigo de Balbín Behrmann (1995) devoted to the serpentiform motifs in Iberia: a significant number of the motifs, which are interpreted as snakes representations by the authors, have a head that is represented by a cup, a circle, a V, a lozenge or a rectilinear angle. Exactly the same forms are found in Ireland (see corpus in Robin 2009, 80–2). The location of the Irish motifs is also interesting; 11% of the serpentiforms are located on hidden faces of the stones, principally the back and top faces (*ibid.*, 265–7). Moreover, in many other instances, where the carvings are not hidden, the motifs were executed on the less visible parts of the stones, like their sides or bottom surfaces: see kerbstone 36 in Dowth, orthostat C9 in Dowth North, orthostats C7 and R2 in Dowth South (O'Kelly and O'Kelly 1983), kerbstones 4, 13, 14, 32, 71, 94 and 124 in Knowth 1, orthostat 92 in Knowth East, orthostat 38 in Knowth West, kerbstones 17 and 24 in Knowth 13, orthostat 8 in Knowth 14 (Eogan 1974; 1984; 1986; 1996), kerbstones 9, 52 and 89 in Newgrange (O'Kelly 1982), stone A in Newgrange L (O'Kelly *et al.* 1978) or kerbstone 8 in Loughcrew H (Shee Twohig 1981). In Brittany too, snake motifs are often

located on stone surfaces that are in direct connection with the ground or with the mass of the tumulus, as for example the serpentiforms hidden on the buried base of the famous decorated stele at Le Manio (Bailloud *et al.* 1995).

In Ireland and Brittany, the physical connection of the serpentiform motifs with the 'underworld', created by their placement close to the ground level and/or the mass of the tumulus, is probably related to the universal chthonian symbolism of the reptile. This observation supports the interpretation of the Irish serpentiforms (or at least a part of them) as schematic representations of snakes. One problem with this theory is the biological absence of snakes in Ireland: during the postglacial they reached Britain but were stopped by the Irish Sea. This absence is traditionally attributed to St Patrick, who chased all the reptiles away from Ireland, though this is a late hagiographical invention of the 12th century since only birds are mentioned by the early sources (MacNeill 1962, 73–4; Ó hÓgáin 2006, 421). If snakes were represented on the walls of the Irish Neolithic tombs, where did they come from? One possible explanation is that they were part of a system of beliefs imported from Britain and/or the Continent. But they can also be imaginary worm-like creatures, as the ones battled with by pre-Christian heroes of the Irish mythology (MacNeill 1962). An examination of this problem would deserve a comprehensive study, which is not the object of the present paper.

Schematic representation of architectural figures

The possibility that the monuments, or a part of them, may be represented by the geometric motifs has almost never been taken into consideration: Breuil interpreted certain nested arcs as '*standing stones or huts*' (1934, 296), and more recently Jeremy Dronfield argued that concentric motifs in Irish passage tombs (spirals, nested arcs and concentric circles) were '*representations … of subjective tunnel experiences*' (1996b, 52; see also discussion in Cooney 1996). Two case studies will be presented here, which are interpreted as two different ways to represent a perspective of the megalithic passage of the tombs.

In several Irish passage tombs, a particular motif composed of a row of single arcs was recorded (Figure 10.4). In the passage tomb of Carnanmore, Co. Antrim, the motif is located on the top face of a roofstone, as in the western tomb in Knockroe, Co. Kilkenny. In Loughcrew F, it is represented on the backstone of the chamber. At Knowth, the motif is found on four kerbstones: K11, K29, K52, K76, and K93. By examining the relationships between this motif and the architecture of the tombs, I have shown that in each case, the orientation of the arcs row corresponds to the orientation of the axis created by the passage and chamber of the monuments (Robin 2009, 170–3; 2010, 397–401).

The graphical shape of the motif and its exclusive relationship to the tombs passage, allow us to interpret it as a schematic representation in perspective of the megalithic passage: each arc is a transversal 'section' of the passage, and the multiplication of these sections in a row represents the passage. This interpretation also explains the decreasing size of the arcs at Carnanmore and Knowth (1 and 5 in Figure 10.4): the lower arc, closer in the perspective, is represented bigger than the upper one, which is the most distant section from the viewer. On kerbstone 93 in Knowth 1, an opposition between two groups of arcs, carved on a single line, can be noted (7 in Figure 10.4): the three signs on the left are open leftwards while the four arcs on the right open rightwards. This can be interpreted

as a representation of the western and eastern tombs, which are opposed on the same axis inside the large tumulus of Knowth (see Robin 2010, fig. 20).

This false perspective is of a particular type. It combines two different views: a horizontal or frontal view (the arcs or 'sections') and an aerial or vertical view (the alignment of arcs). Such contradictory representation is not an isolated example: see for instance the Iron Age carts that are carved in the Maurienne valley (French Alps), some elements of which (the box, the shaft and the yoke) are represented as seen from above whereas others (the wheels and the harness quadrupeds) are represented as seen from the side (Ballet 2003, 277–9; Figure 10.4).

A perspective effect was also very probably sought in the execution of the original motif that was carved on the backstone of the western tomb in Knowth 1 (Figure 10.5). This stone is twice lower than the adjoining orthostats and its decoration in nested arcs or rectangles is a reproduction of the motif carved on kerbstone 74, which is the entrance stone of the tomb. Thus it has more the characteristics of a sillstone than the one of an orthostat, and for these reasons it has been recently interpreted as a symbolic doorway leading beyond the tomb towards the world of the dead (Tilley 2008, 159; Robin 2009, 234; 2010, 395).

If we accept this interpretation, the design of the motif becomes particularly interesting. Inside the Neolithic hypogea of Sardinia, the back wall is often occupied by a false door, which is interpreted as a symbolic doorway to the world of the dead (Tanda 1984, vol. 2, 70–1). The Sardinian false doors are usually represented in a realistic or figurative way,

Figure 10.4: Motifs in row of single arcs, interpreted as possible representations of the megalithic passage of the tombs. (1) Carnanmore, capstone of chamber; (2) Loughcrew F, orthostat C5; (3) Knockroe, capstone of western tomb; (4) to (7) Knowth 1, kerbstones 76, 29, 52 and 93; (8) Aussois (France), Iron Age cart with carriage. Images 1, 2 and 3 after Robin 2009; 4, 5 and 6 after O'Sullivan 1988; 7 after Eogan 1968; 8 after Ballet 2003.

but some of them are symbolised by more conceptual, more abstract motifs such as nested squares sculpted in stairs, which give the illusion of an architectural prolongation of the tomb space (Figure 10.5). This is particularly apparent in Ochila tomb VI where

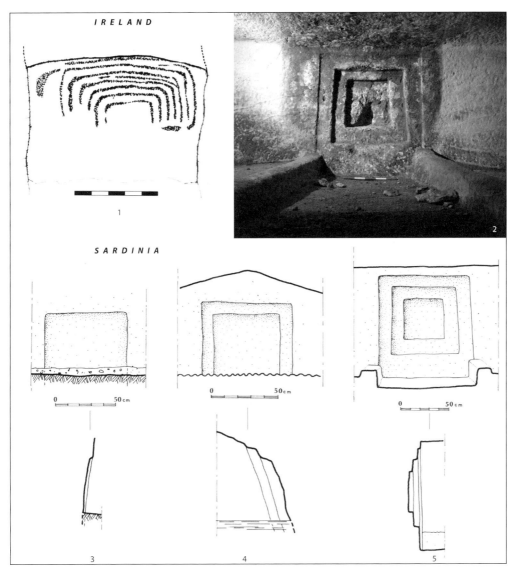

Figure 10.5: Symbolic doorways in Ireland and Sardinia, represented by a false perspective in trompe l'oeil on the back wall of the tombs. (1) Knowth West, backstone of the chamber (orthostat 42), after Eogan 1990; (2) back wall of hypogeum VI at Ochila, photograph Guillaume Robin; (3), (4) and (5) back walls of the Tomba Maggiore at S'Adde 'e Asile, hypogeum VI at Sos Furrighesos and hypogeum VI at Ochila, after Tanda 1984.

the false door is represented by three nested rectangles which symbolise the continuity of the chamber beyond the back wall, and therefore the space beyond which the living are barred access. The backstone of Knowth West and its decoration probably uses the same visual process of symbolisation and figuration of architectural perspective. By imitating a perspective view of a megalithic passage or tunnel, the carved semi-rectangles create a representation in *trompe l'oeil* of the immaterial space of the beyond, which was located behind the backstone and in the continuity of the axis made by the passage and chamber of the tomb (Robin 2009, 234–7; 2010, 394–5).

THE FIGURATION OF THE ABSTRACT

Thus far I have proposed and discussed the possible schematic representation of objects from the real or imaginary world of the Neolithic people of Ireland and Britain (living beings and architectural structures). This is the first dimension of the figurative part of passage tomb art. Now I wish to present further case studies and hypotheses and to propose a second dimension of this figurative part. From the results of a recent research (Robin 2009), which shows the spatial relationships between the art and the architectural structure of the tombs, I propose to interpret certain carved motifs, which I have called 'threshold-signs', as graphic representations of abstract concepts or ideas.

The threshold-signs: presentation

In Irish and British passage tombs, specific types of motifs were placed in direct connection with structural limits of the architecture, such as entrances, sillstones, jambstones or lintels, as well as with symbolic limits, such as the backstone of the tomb and the ground level of the recesses (Robin 2009, 179–201, 205–9; 2010, 385–97). The first of these 'threshold-signs' are the parallel chevrons or zigzags motifs (Robin 2009, fig. 128–34). In Fourknocks (Figure 10.7), they were executed on the four lintels that were placed respectively over four main entrances of the tomb (passage, chamber and two recesses). In Knowth East, parallel zigzags are positioned on roofstones and orthostats that are associated with two sillstones in the passage, and with the entrance of two recesses. Other motifs in tombs I, T and U at Loughcrew mark the entrance of recesses. In Knowth 17 and Barclodiad y Gawres, a same combination of spiral, chevrons and lozenges is carved on the last orthostat on the right side of the passage and marks the junction between the passage and chamber of the tombs.

Interestingly, this spatial syntax can also be observed outside Ireland and Britain. In Morbihan, inside the third passage tomb at Le Petit Mont, the orthostats that are carved exclusively with zigzags are located at the junction between the passage and chamber. In the passage tomb of Gavrinis, chevrons are also associated with two important limits of the architecture: a sillstone in the middle of the passage and the chamber entrance (Robin 2009, figs 135–6). Farther to the south-east, inside the Neolithic hypogea of Sardinia, the same rule was followed. Carved zigzags frame the entrance that leads from the antechamber to the chamber of Is Gannaus hypogeum (Atzeni 1987). The same symbolic use of the motif can be seen inside the hypogeum of Coròngiu (Atzeni 1962). Inside the fourth tomb of

Pubusattile necropolis, chevrons are carved and painted at the entrance of the antechamber (Tanda 1992). The placement of zigzags at structural junctions of hypogea can also be noted in tomb I at Monte Sirai (Usai 1995), tomb II at Cungiau Su Tuttui (Usai 2000), tomb IV at Matteatu (Contu 1968, 424–5), tomb I at Sa Pala Larga (Solinas 2003), tomb II at Mesu'e Montes (Demartis and Canalis 1989), tomb III at S'Adde 'e Asile (Moravetti 2001), and Coda di Palma (Demartis and Canalis 1989, 54).

The second type of threshold-signs are the scalariform motifs, which are formed by one or two row of short parallel lines, often with a central perpendicular line or blank linear space. Like parallel chevrons, the scalariform motifs are directly associated with liminal structures inside Irish and British passage tombs (Robin 2009, fig. 138–45, 157). At Loughcrew, for example, scalariforms were placed at the entrance of the passage of tomb F, at the entrance of the chamber and of a recess in tomb I, at the entrance of the chamber in tomb S, and at the entrance of the chamber and of the three recesses in tomb T. In Dowth North, scalariforms are associated with the first sillstone in the passage, and with the chamber and side recesses entrances, whereas in the southern tomb, two signs mark the entrance of the single recess. In Newgrange, Knowth East and Knowth West, scalariform motifs are located at the entrances of the passage, antechamber and chamber.

The rare scalariform motifs executed in Morbihan were also used as threshold markers. In the Table des Marchands passage tomb, a motif carved on orthostat 3 indicates, together with two orthogneiss orthostats, the point in which the passage marks a slight angle (Robin and Cassen 2009b). In Les Pierres Plates, three signs are located at the entrances of the passage recess, chamber and final recess (Robin 2009, fig. 147). In the Neolithic hypogea of the Marne district (Paris Basin), simple scalariform motifs were recorded on the wall that separates the chamber from the antechamber (Bailloud 1964, 182). In Iberia, several signs of the same type are also associated with the different structural limits of the passage tombs (Bueno Ramírez and Balbín Behrmann 1996).

The last type of threshold-signs is represented by the motif in an alignment of circles (Figure 10.6; see also Robin 2009, fig. 158). Like the two others described above, this motif is located on liminal structures of the tombs. In Dowth North, Newgrange, Knowth West and Loughcrew F, a sign marks the junction between the passage and chamber, and in Loughcrew U, Dowth North and Knowth East, it is placed at the entrance of a recess.

The figuration of the abstract idea of limit and its crossing

One interesting fact with these threshold-signs is their *location* inside the monuments: I have shown here and in previous works that their recurring relationship with structural junctions demonstrate that they are associated with the notion of passage and transition (Robin 2009; 2010). Two other important points, which will be discussed in further details now, are their *orientation* and their graphical *structure* (Figure 10.7).

The three types of threshold-signs are of different shape and design but they all have a linear structure. Contrary to other motifs such as spirals or concentric circles, they have a principal axis and therefore each motif has a specific orientation, which can be vertical or horizontal on the wall surfaces of the tombs. When we observe the orientation of the threshold-signs inside the tombs, we realise that they are almost always oriented perpendicularly to the axis of circulation inside the tomb: they are set vertically on

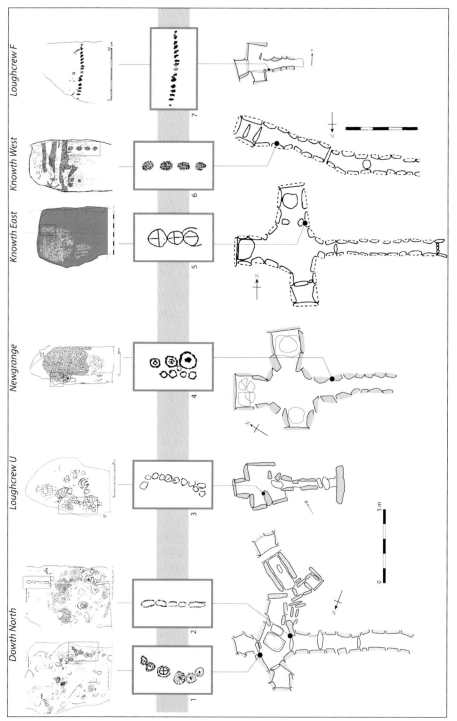

Figure 10.6: Motifs in line of circles and their relationships with architectural thresholds. (1) and (2) Dowth North, orthostats C7 and C19, after O'Kelly and O'Kelly 1983; (3) Loughcrew U, orthostat C2, after Shee Twohig 1981; (4) Newgrange, orthostat R20, after O'Kelly 1982; (5) Knowth East, orthostat 56; (6) Knowth West, orthostat 39, after O'Sullivan 1988, Eogan 1990, 1998; (7) Loughcrew F, orthostat L4, after Shee Twohig 1981.

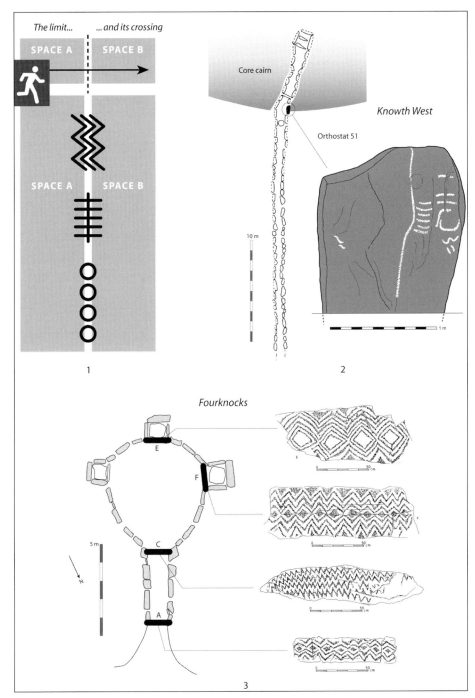

The limit... ... and its crossing

SPACE A SPACE B

SPACE A SPACE B

1

Core cairn

Orthostat 51

Knowth West

10 m

1 m

2

Fourknocks

E

F

C

A

5 m

N

E

0 50 cm

F

0 50 cm

0 50 cm

0 50 cm

3

Figure 10.7: The figuration of the limit and of its crossing. (1) Structural analysis of the three threshold-signs; (2) the scalariform motif on orthostat 51, Knowth West, and its relationship with the major architectural threshold inside the tomb (after Eogan 1986 and O'Sullivan 1988); (3) Fourknocks, the lintels decorated with chevrons and their relationship with four major thresholds inside the tomb (after Hartnett 1957 and Shee Twohig 1981).

the orthostats and horizontally on the lintels and roofstones. The axis of the motifs is oriented so as to be 'crossed' over by the movement of the visitor that is walking inside the tomb.

This is also demonstrated outside the tomb, on the kerbstones, which constitute the monumental limit between the tumulus and the outside world. The few scalariforms (on K51 at Dowth, K7 at Newgrange, K79 at Knowth, stone B at Newgrange L – see Robin 2009, fig. 98), lines of circles (on K5 and K42 at Knowth) and parallel zigzags (on K12 at Dowth, K12 and K41 at Knowth, K2 at Newgrange) that were carved on kerbstones are all placed horizontally on the front surface, and most often along the top ridge of the stone, so as to emphasize the relationship between the liminal function of the stone and the symbolic function of the motif: entering the kerb enclosure requires one to walk over/across the kerbstones *and* across the linear axis of these threshold-signs.

The idea that I would like to stress is that there is a link between the graphical structure of these motifs and their symbolic function of 'threshold-signs' (Figure 10.7). Let us take the zigzag motif first: from a graphical point of view, its principal axis creates a line, a limit between two spaces, but the series of opposed Vs of the motif also represents two opposite directions, or a series of passages backward and forward from one space to another. The chevrons motif represents a fixed line and a movement at the same time, a limit and its crossing. The same graphic principles can be recognized in the structure of the scalariform motifs: the limit is represented by the central line of the motif while the movement of the visitor across this limit is represented and symbolized by the short parallel lines that perpendicularly meet or cut the central line. This is particularly explicit on orthostat 51 in Knowth West (Figure 10.7), which is located at a fundamental liminal point inside the monument (i.e. the passage angle, which corresponds to the entrance of the 'core cairn' inside the tumulus). A long vertical line, which represents this major architectural limit, is carved all across the surface of this stone while several short, horizontal parallel lines symbolize the movement inside the tomb.

Lastly, the motifs in circle alignment can be analysed in the same way. The symbolic limit is represented by the axis that is created by the repetition of the circles, while the crossing of the limit is permitted by the spaces that are let between each element of the motif. This last model should be considered together with Serge Cassen's (2009; 2010) interpretation of megalithic stone rows, which are interpreted as symbolic barriers placed perpendicularly across natural axis of circulation.

The three threshold-signs are different in shape, but they have common structures that form together a graphical figuration and schematisation of the idea of limit and its crossing. These motifs attest a particular level of language and visual communication: they do not represent real visible objects but abstract, conceptual and complex ideas. However, despite their extreme abstraction, the threshold-signs are part figuration. Their design was not chosen and created in a haphazard way: there is a significant correspondence between the graphical structure of the motifs and their symbolic function, a visual correspondence between the signifier and the signified.

CONCLUSION

We can classify Irish and British passage tomb art as an abstract iconography because abstraction is its principal characteristic. Yet we cannot maintain that this Neolithic system of visual communication is *totally* abstract, as is, for example, the Latin alphabet that I use to write this paper. Through a small number of specific examples, and with the help of a particular methodology (spatial analyses and comparisons with other European contexts), I have shown that, even 5000 years after the motifs were executed, it is possible to identify elements of figuration within this abstract art. This dimension of figuration includes two distinct levels. Firstly, there are schematised representations of living beings (trees and snakes) and architectural structures (the megalithic passage represented from different perspectives). Secondly, there are abstract concepts and ideas (the limit and its crossing) represented by geometric motifs, the design of which is a graphical schematisation (and therefore figuration) of the meaning.

Many important questions, however, remain unanswered. Why in contrast with Breton and Iberian passage tomb art, are Irish and British examples abstract? How are we to explain the many similarities between the insular art and other European contexts? Ireland and Sardinia, in particular, were probably not in direct contact during the Neolithic but the passage tombs and hypogea of these islands have many common characteristics, like the partition of the tomb space (passage, antechamber, chamber, recesses) and parietal motifs (spirals, chevrons, chequered). In addition, chevrons were used in both contexts as thresholds markers: how do we explain that the same 'grammatical' rule was observed at exactly the same period in those very distant (and naturally isolated) regions of Europe? Irish and British passage tomb art is not a hermetic code whose key is completely lost to us. Entrance doors can still be found between the signs that lead us to new answers as well as new questions.

ACKNOWLEDGEMENTS

I am very grateful to Dr Andrew Jones and Dr Andrew Cochrane for their kind invitation to present my research and for giving me the opportunity to publish some of my interpretations regarding this fascinating art. Many points of this paper results from discussions I had with Dr Serge Cassen, my PhD supervisor. Finally, I wish to thank Dr Robert Hensey for his valuable corrections and suggestions on an early version of this paper.

REFERENCES

Allen, J. R. 1883. On the circle of stones at Calderstones near Liverpool. *Journal of the British Archaeological Association* 39, 304–16.
Atzeni, E. 1962. I villaggi preistorici di S. Gemiliano di Sestu e di Monte Ollardiri di Monastir presso Cagliari e le ceramiche della 'facies' Monte Claro. *Studi Sardi* XVII (1959–1961), 1–216.
Atzeni, E. 1987. *La preistoria del Sulcis-Iglesiente.* Cagliari: Stef.
Bailloud, G. 1964. *Le Néolithique dans le Bassin parisien.* Paris: CNRS.
Bailloud, G., Boujot, C., Cassen, S. and Le Roux, C.-T. 1995. *Carnac: les premières architectures de pierre.* Paris: CNMHS/CNRS.

Ballet, F. 2003. L'art rupestre protohistorique de Savoie, expression symbolique et artistique des premières communautés alpines. In J. Guilaine (ed.), *Arts et symboles du Néolithique à la Protohistoire*, 263–83. Paris: Errance.

Borlase, W. 1897. *The Dolmens of Ireland: their distribution, structural characteristics, and affinities in other countries; together with the folk-lore attaching to them; supplemented by considerations on the anthropology, ethnology, and traditions of the Irish people.* London: Chapman & Hall.

Bradley, R. 1989. Deaths and entrances: a contextual analysis of megalithic art. *Current Anthropology* 30, 68–75.

Brennan, M. 1983. *The Stars and the Stones: ancient art and astronomy in Ireland.* London: Thames & Hudson.

Breuil, H. 1934. Presidential address for 1934. *Proceedings of the Prehistoric Society of East Anglia* 7, 289–322.

Breuil, H. 1936. La figure humaine dans la décoration des chambres mégalithiques du Morbihan. *Comptes-rendus des séances de l'Académie des Inscriptions et Belles-Lettres* 80(4), 292–9.

Breuil, H. 1937. La figuration humaine dans la décoration des allées-couvertes du Morbihan. *Préhistoire* 6, 7–48.

Bueno Ramírez, P. and Balbín Behrmann, R. 1995. La graphie du serpent dans la culture mégalithique péninsulaire. Représentations de plein air et représentations dolméniques. *L'Anthropologie* 99(2–3), 357–81.

Bueno Ramírez, P. and Balbín Behrmann, R. 1996. El papel del elemento antropomorfo en el arte megalitico ibérico. In J. L'Helgouac'h, C.-T. Le Roux and J. Lecornec (eds), *Art et symboles du mégalithisme européen. Actes du 2ème Colloque International sur l'Art Mégalithique, Nantes, juin 1995*, 41–64. Rennes: Association pour la diffusion des recherches archéologiques dans l'ouest de la France.

Cassen, S. 2000a. Du réemploi des dalles gravées à la sexualisation des signes. Petite histoire de la recherche. In S. Cassen (ed.), *Éléments d'architecture. Exploration d'un tertre funéraire à Lannec er Gadouer, Erdeven, Morbihan. Constructions et reconstructions dans le Néolithique morbihannais. Propositions pour une lecture symbolique*, 593–610. Chauvigny: Editions chauvinoises.

Cassen, S. 2000b. La forme d'une déesse. In S. Cassen (ed.), *Éléments d'architecture. Exploration d'un tertre funéraire à Lannec er Gadouer, Erdeven, Morbihan. Constructions et reconstructions dans le Néolithique morbihannais. Propositions pour une lecture symbolique*, 657–81. Chauvigny: Editions chauvinoises.

Cassen, S. 2000c. Architecture du tombeau, équipement mortuaire, décor céramique et art gravé du Ve millénaire en Morbihan. In S. Cassen (ed.), *Éléments d'architecture. Exploration d'un tertre funéraire à Lannec er Gadouer, Erdeven, Morbihan. Constructions et reconstructions dans le Néolithique morbihannais. Propositions pour une lecture symbolique*, 717–35. Chauvigny: Editions chauvinoises.

Cassen, S. 2009. *Exercice de stèle. Une archéologie des pierres dressées. Réflexion autour de menhirs de Carnac.* Paris: Errance.

Cassen, S. 2010. Carnac in the landscape or laying the threshold: a theoretical framework for thinking about the architecture of standing stones. In Kiel Graduate School 'Human Development in Landscapes' (ed.), *Landscapes and Human Development: the contribution of European archaeology.* 109–23. Bonn: Rudolf Habelt GmbH.

Coffey, G. 1892. On the tumuli and inscribed stones at New Grange, Dowth and Knowth. *Transactions of the Royal Irish Academy* 30(1), 1–95.

Coffey, G. 1894. The origins of prehistoric ornament in Ireland. *Journal of the Royal Society of Antiquaries of Ireland* 24, 349–79.

Coffey, G. 1895a. The origins of prehistoric ornament in Ireland. *Journal of the Royal Society of Antiquaries of Ireland* 25, 16–29.

Coffey, G. 1895b. The origins of prehistoric ornament in Ireland. *Journal of the Royal Society of Antiquaries of Ireland* 25, 195–211.

Coffey, G. 1896. The origins of prehistoric ornament in Ireland. *Journal of the Royal Society of Antiquaries of Ireland* 26, 34–69.

Coffey, G. 1912. *Newgrange (Brugh na Boinne) and Other Incised Tumuli in Ireland: the influence of Crete and the Ægean in the extreme west of Europe in early times.* Dublin: Hodges, Figgis & Co.

Contu, E. 1968. Notiziario-Sardegna. *Rivista di Scienze Preistoriche* XXIII(2), 421–30.

Cooney, G. 1996. Comments on J. Dronfield: Cognition, art and architecture in Irish passage tombs. *Cambridge Archaeological Journal* 6(1), 59–60.

Crawford, O. G. S. 1957. *The Eye Goddess.* London: Phoenix House.

D'Anna, A., Gutherz, X. and Jallot, L. 1996. L'art mégalithique dans le Midi de la France: les stèles anthropomorphes et les statues-menhirs néolithiques. In J. L'Helgouac'h, C.-T. Le Roux and J. Lecornec (eds), *Art et symboles du mégalithisme européen*, 179–93. Rennes: Association pour la diffusion des recherches archéologiques dans l'ouest de la France.

Darvill, T. 2001. *Billown Neolithic Landscape Project, Isle of Man. Sixth Report: 2000.* Bournemouth and Douglas: Bournemouth University and Manx National Heritage.

Déchelette, J. 1912. Une nouvelle interprétation des gravures de New-Grange et de Gavr'inis. *L'Anthropologie* 23, 29–52.

Demartis, G. M. and Canalis, V. 1989. La Tomba II di Mesu 'e Montes (Ossi-Sassari). *Nuovo Bullettino Archeologico Sardo* 2 (1985), 41–76.

Dronfield, J. 1993. Ways of seeing, ways of telling: Irish passage-tomb art, style and the universality of vision. In M. Lorblanchet and P. Bahn (eds), *Rock Art Studies: the post-stylistic era or where do we go from here?*, 179–35. Oxford: Oxbow Books.

Dronfield, J. 1995. Subjective vision and the source of Irish megalithic art. *Antiquity* 69, 539–49.

Dronfield, J. 1996a. The vision thing: diagnosis of endogenous derivation in abstract arts. *Current Anthropology* 37, 373–93.

Dronfield, J. 1996b. Entering alternative realities: cognition, art and architecture in Irish passage tombs. *Cambridge Archaeological Journal* 6(1), 37–55.

Eichmeier, J. and Höfer, O. 1974. *Endogene Bildmuster.* München: Urban und Schwarzenberg.

Eogan, G. 1967. The Knowth (Co. Meath) excavations. *Antiquity* 41, 302–4.

Eogan, G. 1968. Excavation at Knowth, Co. Meath, 1962–1965. *Proceedings of the Royal Irish Academy* 66C, 299–400.

Eogan, G. 1974. Report on the excavations of some passage graves, unprotected inhumation burials and a settlement site at Knowth, Co. Meath. *Proceedings of the Royal Irish Academy* 74C, 11–112.

Eogan, G. 1984. *Excavations at Knowth – 1: smaller passage tombs, Neolithic occupation and Beaker activity.* Dublin: Royal Irish Academy.

Eogan, G. 1986. *Knowth and the Other Passage-tombs of Ireland.* London: Thames & Hudson.

Eogan, G. 1990. Irish megalithic tombs and Iberia. Comparisons and contrasts. In Deutsches Archäologisches Institut (ed.), *Probleme der megalithgräberforschung: vorträge zum 100. Geburstag von Vera Leisner*, 113–37. Berlin: Walter de Gruyter.

Eogan, G. 1996. Pattern and place: a preliminary study of the decorated kerbstones at site 1, Knowth, Co. Meath, and their comparative setting. In J. L'Helgouac'h, C.-T. Le Roux and J. Lecornec (eds), *Art et symboles du mégalithisme européen*, 97–104. Rennes: Association pour la diffusion des recherches archéologiques dans l'ouest de la France.

Eogan, G. 1997. Overlays and underlays: aspects of megalithic art succession at Brugh na Bóinne, Ireland. In J. M. Bello Diéguez (ed.), *III Coloquio internacional de arte megalítico: A Coruña, 8–13 de septiembre de 1997: actas*, 217–34. A Coruña: Museo arqueolóxico e histórico.

Eogan, G. 1998. Knowth before Knowth. *Antiquity* 72, 162–72.

Eogan, G. 1999. Megalithic art and society. *Proceedings of the Prehistoric Society* 65, 415–46.

Fleming, A. 1969. The myth of the Mother Goddess. *World Archaeology* 1, 247–61.

Flom, G. T. 1924. Sun symbols of the tomb sculptures at Loughcrew, Ireland. *American Anthropologist* 26, 139–59.

Frazer, W. 1893. Notes on incised sculpturings on stones in the cairns of Sliabh-na-Calliaghe, near Loughcrew, County Meath, Ireland. *Proceedings of the Society of Antiquaries of Scotland* 27, 294–340.

Garnett, J. I. 2005. *Newgrange Speaks for Itself. Forty Carved Motifs.* London: Trafford.

Hartnett, P. J. 1957. Excavation of a passage grave at Fourknocks, Co. Meath. *Proceedings of the Royal Irish Academy* 58C, 197–277.

Herity, M. 1974. *Irish Passage Graves: Neolithic tomb builders in Ireland and Britain 2500 B.C.* Dublin: Irish University Press.

Le Roux, C.-T. 1992. The art of Gavrinis presented in its Armorican context and comparison with Ireland. *Journal of the Royal Society of Antiquaries of Ireland* 122, 79–108.

Lewis-Williams, J. D. and Dowson, T. A. 1993. On vision and power in the Neolithic: evidence from the decorated monuments. *Current Anthropology* 34, 55–65.

Lewis-Williams, J. D. and Pearce, D. G. 2005. *Inside the Neolithic Mind. Consciousness, Cosmos and the Realm of the Gods.* London: Thames & Hudson.

L'Helgouac'h, J. 1983. Les idoles qu'on abat ou les vicissitudes des grandes stèles de Locmariaquer. *Bulletin de la Société Polymathique du Morbihan* 110, 57–68.

Lynch, F. 1967. Barclodiad y Gawres: comparative notes on the decorated stones. *Archaeologia Cambrensis* 116, 1–22.

Macalister, R. A. S. 1921. *Ireland in pre-Celtic times.* Dublin: Maunsel & Roberts.

Macalister, R. A. S. 1943. A preliminary report on the excavation of Knowth. *Proceedings of the Royal Irish Academy* 49C, 131–66.

MacNeill, M. 1962. *The Festival of Lughnasa. A Study of the Survival of the Celtic Festival of the Beginning of Harvest.* London: Oxford University Press.

Mahr, A. 1937. New aspects and problems in Irish prehistory. *Proceedings of the Prehistoric Society* 3, 261–437.

Moravetti, A. 2001. Materiali campaniformi dalla tomba III di S'Adde Asile (Ossi, Sassari). In F. Nicolis (ed.), *Bell Beakers Today. Pottery, People, Cculture, Symbols in Prehistoric Europe*, 697–9. Trento: Provincia Autonoma di Trento.

Munn, N. D. 1973. *Walbiri Iconography. Graphic Representation and Cultural Symbolism in a Central Australian Society.* London: Cornell University Press.

Nilsson, S. 1843. *Skandinaviska nordens ur-invånare: ett försök i komparativa ethnografien och ett bidrag till menniskoslägtets utvecklings-historia.* Lund: Berlingska boktryckeriet.

O'Brien, T. 1989. Winter solstice and decoration at Newgrange. *Ríocht na Midhe* 8(2), 50–9.

O'Brien, T. 1992. *Light Years Ago: a study of the cairns of Newgrange and Cairn T, Loughcrew, Co. Meath, Ireland.* Monkstown: Black Cat Press.

Ó hÓgáin, D. 2006. *The Lore of Ireland: an encyclopaedia of myth, legend and romance.* Cork: Collins.

O'Kelly, C. 1973. Passage grave art in the Boyne Valley, Ireland. *Proceedings of the Prehistoric Society* 39, 354–82.

O'Kelly, M. J. 1970. Newgrange passage-grave, Ireland, the mural art. In J. Filip (ed.), *Actes du VII^e Congrès International des Sciences Préhistoriques et Protohistoriques, Prague 21–27 août 1966*, vol. 1, 534–6. Prague: Institut d'Archéologie de l'Académie Tchécoslovaque des Sciences à Prague.

O'Kelly, M. J. 1982. *Newgrange: archaeology, art and legend.* London: Thames & Hudson.

O'Kelly, M. J., Lynch, F. and O'Kelly, C. 1978. Three passage-graves at Newgrange, Co. Meath. *Proceedings of the Royal Irish Academy* 78C, 249–352.

O'Kelly, M. J. and O'Kelly, C. 1983. The tumulus of Dowth, County Meath. *Proceedings of the Royal Irish Academy* 83C, 135–90.

O'Sullivan, M. 1986. Approaches to passage tomb art. *Journal of the Royal Society of Antiquaries of Ireland* 116, 68–83.

O'Sullivan, M. 1987. The art of a passage tomb at Knockroe, County Kilkenny. *Journal of the Royal Society of Antiquaries of Ireland* 117, 84–95.

O'Sullivan, M. 1988. *Irish Passage Tomb Art in Context*. Unpublished Ph.D. thesis, University College Dublin.

O'Sullivan, M. 1996. Megalithic art in Ireland and Brittany: divergence or convergence. In J. L'Helgouac'h, C.-T. Le Roux and J. Lecornec (eds), *Art et symboles du mégalithisme européen*, 81–96. Rennes: Association pour la diffusion des recherches archéologiques dans l'ouest de la France.

O'Sullivan, M., Prendergast, F. and Stout, G. 2010. An intriguing monument. New discoveries at Loughcrew cairn X$_1$. *Archaeology Ireland* 91, 20–2.

Piggott, S. 1954. *Neolithic Cultures of the British Isles*. Cambridge: Cambridge University Press.

Robin, G. 2009. *L'architecture des signes. L'art pariétal des tombeaux néolithiques autour de la mer d'Irlande*. Rennes: Presses Universitaires de Rennes.

Robin, G. 2010. Spatial structures and symbolic systems in Irish and British passage tombs: the organization of architectural elements, parietal carved signs and funerary deposits. *Cambridge Archaeological Journal* 20(3), 373–418.

Robin, G. and Cassen, S. 2009a. The role of the stone in Neolithic monumental art: case-studies and methods of representation in Ireland and Brittany. In V. Davis and M. Edmonds (eds), *Stone Artefacts as Material and Symbolic Markers in Cultural Landscapes: an International perspective*. Internet Archaeology 26/27. Available at: http://intarch.ac.uk/journal/issue26/robin_toc.html. Accessed: 9 May 2011.

Robin, G. and Cassen, S. 2009b. L'orthostate 3 de la Table des Marchands et l'art pariétal d'Irlande: étude iconographique et symbolique comparée. In S. Cassen (ed.), *Autour de la Table: explorations archéologiques et discours savants sur une architecture néolithique restaurée à Locmariaquer, Morbihan (Table des Marchands et Grand Menhir)*, 845–49. Nantes: Université de Nantes.

Saulieu, G. 2004. *Art rupestre et statues-menhirs dans les Alpes: des pierres et des pouvoirs, 3000–2000 av. J.-C.* Paris: Errance.

Saunders, L. 2004. A new theory of abstract rock art in the British Isles: archaeoastronomical evidence from the moon, Newgrange-Stonehenge and rock art indicates lunar disturbance. In E. Anati (ed.), *Pre-proceedings of the XXI Valcamonica Symposium, 8–14 September 2004*, 404–25. Capo di Ponte: Centro Camuno di Studi Preistorici.

Savory, H .N. 1973. Serpentiforms in megalithic art: a link between Wales and the Iberian North-West. *Cuardenos de Estudios Gallegos* 28(84), 80–9.

Shee Twohig, E. 1981. *The Megalithic Art of Western Europe*. Oxford: Clarendon Press.

Shee Twohig, E. 1998. A 'Mother Goddess' in North-West Europe *c.* 4200–2500 BC? In L. Goodison and C. Morris (eds), *Ancient Goddesses: the myths and the evidence*, 164–79. London: British Museum Press.

Sherratt, A., 1991. Sacred and profane substances: the ritual of narcotics in later Neolithic Europe. In P. Garwood, D. Jennings, R. Skeates and J. Toms (eds), *Sacred and Profane: proceedings of a conference in archaeology, ritual and religion*, 50–64. Oxford: Oxford University Committee for Archaeology.

Silva, E. J. L. 1993. Representações antropomórficas da Mamoa 1 de Chão de Brinco (Cinfães). In M. J. Barroca (ed.), *Carlos Alberto Ferreira de Almeida: in memoriam*, 375–82. Porto: Faculdade de Letras da Universidade do Porto.

Simpson, J. 1866. On ancient sculpturings of cups and concentric rings in various part of Scotland. *Proceedings of the Society of Antiquaries of Scotland* 6 (1864–65), appendix.

Stooke, P. J. 1994. Neolithic lunar maps at Knowth and Baltinglass, Ireland. *Journal for the History of Astronomy* 25, 39–55.

Solinas, M. 2003. Bonorva (Sassari). Località Sa Pala Larga. *Bollettino di Archeologia* 43–5 (1997), 110–13.

Tanda, G. 1984. *Arte e religione della Sardegna preistorica nella necropoli di Sos Furrighesos – Anela (SS)*. Sassari: Chiarella

Tanda, G. 1992. L'arte del Neolitico e dell'età del Rame in Sardegna: nuovi dati e recenti acquisizioni. In Istituto Italiano di Preistoria e Protostoria (ed.), *Atti della XXVIII riunione scientifica. L'arte in Italia dal Paleolitico all'Età del Bronzo. Firenze, 20–22 Novembre 1989. In Memoria di Paolo Graziosi*, 479–93. Firenze: Istituto Italiano di Preistoria e Protostoria.

Tarrête, J. 1996. L'art mégalithique dans le Bassin parisien ; symétrie et latéralités dans les représentations du Néolithique final. In J. L'Helgouac'h, C.-T. Le Roux and J. Lecornec (eds), *Art et symboles du mégalithisme européen*, 149–59. Rennes: Association pour la diffusion des recherches archéologiques dans l'ouest de la France.

Thomas, N. L. 1988. *Irish Symbols of 3500 B.C.* Cork: Mercier.

Tilley, C. 2008. *Body and Image: explorations in landscape phenomenology 2*. Walnut Creek: Left Coast Press.

Usai, E. 1995. Monte Sirai prima dei Fenici. In V. Santoni (ed.), *Carbonia e il Sulcis. Archeologia e territorio*, 83–93. Oristano: S'Alvure.

Usai, L. 2000. La tomba n. 2 di 'Cungiau su Tuttui' in territorio di Piscinas (Cagliari). Nota preliminare. In M. G. Melis (ed.), *L'ipogeismo nel mediterraneo. Origini, sviluppo, quadri culturali*, 875–86. Sassari: Università degli Studi di Sassari.

Villes, A. 1998. Les figurations néolithiques de la Marne, dans le contexte du Bassin parisien. *Bulletin de la Société Archéologique Champenoise* 91(2), 7–45.

Wakeman, W. F. 1881. On several sepulchral scribings and rock markings. *Journal of the Royal Society of Antiquaries of Ireland* 15, 538–60.

Wilde, W. R. 1847. *The Beauties of the Boyne and its Tributary the Blackwater*. Dublin: Kevin Duffy.

Assuming the jigsaw had only one piece: abstraction, figuration and the interpretation of Irish passage tomb art

Robert Hensey

INTRODUCTION

The combination of unknown motivations for the creation of megalithic art, the varied styles within the tradition, and the possibility that this art is entirely abstract do not encourage cohesive interpretation. It is therefore not surprising that as of yet there has been no single theory that has explained the origin and function of megalithic art. Yet ought we to expect that there could be. One of the more essential features of art, whether modern or ancient, is that it functions in several ways and on different levels, we should not expect it to have only one explanation (Gell 1998; O'Sullivan 2006, 671).

Here, it is proposed that one of the limiting factors of previous interpretations of passage tomb art is that too often it has been treated as a phenomenon that had only a singular meaning and a uniform response, or as a subject that can be somehow separated from other activities associated with the construction and use of the monuments. In contrast, in this paper, the various interpretations of passage tomb art, those that focus on the art as figurative, as abstract, and also those interpretations which do not stand or fall in relation to the figuration/abstraction question are discussed with a view to understanding the multiple roles that megalithic art may have fulfilled. It is suggested that there may be more validity to some previous interpretations than is usually acknowledged, but because we are constantly in the process of shelving the last account in favour of a newer or more theoretically sophisticated one we generally fail to allow for this. Often the issue is not whether a particular interpretation has validity or not but rather that archaeologists have tried to put their interpretation of the art forward as exclusively correct. Yet, when the time-depth and stylistic variety of the art is taken into account we realise that there may be more than one passage tomb art and hence more than one valid explanation. This paper begins with an examination of the varied interpretations of passage tomb art and concludes with a discussion of the art making traditions of the Warlpiri and the Yolngu peoples of central and northern Australia.

GODDESSES AND SOLAR DEITIES

Recorded interpretation of passage tomb art began with Edward Lhwyd's visit to Newgrange in 1699 (1700; 1709). Lhwyd, Keeper of the Ashmolean Museum, noted elements of the monument's architecture, including what he described as 'barbarous sculpture' and a 'rudely carved' stone at the entrance (1709, 64). Subsequent accounts were often somewhat

less circumspect than Lhwyd's, some even proposing that megalithic art was a script that could, and would, one-day be deciphered (e.g., Conwell 1873, 31–2). Indeed, Charles Vallancey (1786) felt confident he could translate the 'symbolic characters' found on the construction stones of passage tombs. In one instance, he translated the carvings on the ceiling stone above the left recess at Newgrange Site 1 as the 'house of God'; other pieces of art were variously deciphered as 'to the great mother Ops, or the great mother Nature' and 'the sepulchre of the Hero' (1786, 211–2). Though his methods could, at best, be described as untempered, his conclusions betray many of the prevailing ideas of the time: the monuments, and hence the art, were linked to sacrifice, the burial of elites, and to a goddess of the earth.

Some of these ideas have had great longevity in the history of interpretation of passage tombs. For example, it has been suggested almost continually over the last hundred years that megalithic art provides evidence of anthropomorphism or representations of a female deity. Out of passage tombs spirals the 'oculi' of the goddess could be seen peering back. Such luminaries as the Abbé Breuil (1934) and R. A. S. Macalister (Breuil and Macalister 1921) lent their weight to the anthropomorphic interpretation of megalithic art (cf. Robin this volume). The interpretation was bolstered by a raft of supporting goddess-oriented archaeological literature in the years that followed, most famously perhaps Crawford's *The eye goddess* (1957). Discussion of a mother goddess, or at least of a female face, eyes or vulva perceived to be represented in the art, continued to be a relatively common feature in accounts of the megalith-building peoples of northwest Europe up to the 1970s (Daniel 1958; C. F. C. Hawkes 1940; J. Hawkes 1945; Herity 1974, 105–6; Ó Ríordáin and Daniel 1964). Though the goddess interpretation began to be seriously questioned around this time (Fleming 1969; see Shee Twohig 1998 for an overview), it was still found in academic work up to the 1990s, most vehemently perhaps through the many controversial publications of Marija Gimbutas (e.g., 1989; 1991; see Meskell 1995). Recently, O'Sullivan has attempted to revitalise an anthropomorphic interpretation of megalithic art, though not within the context of claims for deities, female or otherwise (1986; 1993, 37–40; 1997a, 92–4).

Another figurative interpretation, that like the goddess proposition has had enormous longevity, is the idea that particular motifs are representations of the sun or other heavenly bodies. Coffey (1912, 76 and 88–9) and Du Noyer (1865), for example, interpreted several passage tomb motifs as relating to the sun, though the subject was perhaps treated most extensively by Flom (1924). Suffice it to say, the suggestion that elements of passage tomb art may be solar representations has always had some currency, and the discovery and validation of astronomical alignments at several passage tombs, especially subsequent to the discoveries at Newgrange, has done much to keep the idea in vogue. The idea has perhaps been most popularly presented by Brennan (1983) who maintained the art was primarily astronomical and computational, created for the explicit purpose of counting the days of the solar and lunar cycles. Though it could be argued that one or two individual pieces of art do have the appearance of a counting device, conceivably of an astronomical nature – the so-called 'sundial' from Knowth Site 1 (Figure 11.1), for example – Brennan (1983) inflated the idea to argue that all passage tomb art was related to the heavenly bodies or astronomical calculation. As with other interpretations the astronomical proposition was undermined by its unifactoralism, that is, its claim to be *the* interpretation of megalithic art.

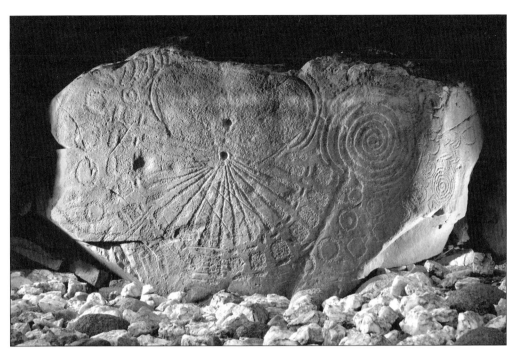

Figure 11.1: Sundial-like carving, kerbstone 15, Knowth Site 1 (Ken Williams).

A MORE MEASURED APPROACH

The speculative excesses of antiquarian writers and others engendered much caution within academia, leaving figurative interpretations of the art very much on the shelf. Indeed from the late 1960s up to the 1990s speculative analysis of megalithic art was considered very much *démodé* (see O'Sullivan 1986, 73; 2006 and Shee Twohig 1997 for discussion). As O'Sullivan pointed out: *'Research into the meaning of the art was regarded as something of a cul-de-sac by many archaeologists and the field was effectively abandoned to pseudo-scientists'* (1996, 59). Consequently, research was predominantly concerned with the recording and categorising of motifs, and consideration of the methods used to create them (e.g., Shee 1973; Shee Twohig 1981). Shee Twohig's (1981) catalogue of western European megalithic art was especially important in demonstrating for the first time the art was not a homogeneous phenomenon, rather there were distinct groups of motifs associated with particular regions. Significantly, it was concluded that figurative motifs were not part of the repertoire in Ireland as in other regions where megalithic art occurred (*ibid.*).

Other work dealt primarily with the identification of styles, for instance Eogan's research at Knowth (1986; 1997a; 1997b; 1998; 1999; Eogan and Aboud 1990). However, as pointed out by O'Sullivan, on analysis, that contribution was in reality *'more concerned with formal content than with real differences in style'* (1986, 75). O'Sullivan also has focused on stylistic categorisation (1986; 1989; 1997a; 1997b; 2006). His contribution to understanding passage tomb art has been particularly valuable with regard to the identification of artistic styles

and phases, initially with respect to the identification of so-called 'plastic' art (O'Sullivan 1986; 1989; 1997a). The term 'plastic art' refers to sculptural art pieces, approaching three-dimensionality and fitted to the form of the stone, as opposed to the more common and simplistic 'depictive' art. Plastic art is typically not hidden, nor on the back of stones, and usually not found on the part of the stone inserted into the ground, which suggests that it is a late phase of carving completed when the stones were *in situ*.

O'Sullivan (1997a) developed the distinction between these two types of art ('depictive' and 'plastic') with a more nuanced categorisation in which he outlined the four stages of artistic creation in the Boyne Valley. It may be worthwhile to expand on this analysis at this point as it has relevance to the topics yet to be discussed in this paper. In brief, the first stage is simple 'depictive' art; many of the classic passage tomb motifs found in compositional tables fall into this category: spiral, lozenge, zig-zag, and so on (Figure 11.2; also see Eogan 1968, fig. 22; C. O'Kelly 1973, fig. 11; Piggott 1954, fig. 33; Shee Twohig 1981, fig. 11). This art takes little account of the shape of the surface on which it is placed, and significantly, as O'Sullivan (1997a) has indicated in the choice of name, the act of depicting the art may have been more important than its visual presentation to an observer. This is the most ubiquitous form of passage tomb art in Ireland and Britain and occurs both on visible and hidden surfaces of the monument (O'Sullivan 1997a, 83). *Stage 2* involves the combination of the various motifs from *stage 1* to create sophisticated compositions, for example K1 and K52 at Newgrange Site 1. *Stage 3* is plastic art; here depictive symbols are almost entirely absent. Instead ribbon-like bands are created; the shape and contours of the stone are features in a kind of three dimensional sculptural gesture. Finally, *stage 4* is represented by dense picking, which often obliterates all other artistic elements on the stone, and is best exemplified by the picking used in the passage, chamber, and on the kerbstones immediately outside the entrance of Newgrange Site 1. Though the chronology of these stages is not made explicit in O'Sullivan's (1997a) discussion, it is clear that a process of superimposition is occurring. Moreover, recent discoveries have demonstrated that megalithic art is present in each of the four major passage tomb complexes in Ireland (Hensey and Robin 2011), thus indicating that art making was an integral aspect of the traditions around this monument type over much of their developmental history.

OTHER AVENUES OF INVESTIGATION

Outside of approaches to megalithic art that could be considered technical and stylistic, a limited number of new ways of investigating the art have been forthcoming in recent years. It is notable that the question as to whether the carvings were figurative or abstract has not been a feature of these accounts. Interest in phenomenological perspectives in the 1990s influenced how the art was understood as part of the overall experience of entering and moving within a megalithic monument. Thomas (1990; 1992; 1993) analysed movement within a megalithic space and the possible role that art played in this 'choreographed' experience (1990, 175). Essentially, the event was seen to be 'stage managed', the art having a role in 'introducing visual signification into the experience of the tomb' (Thomas 1990, 175). Several interesting insights have resulted from the phenomenological approach, not

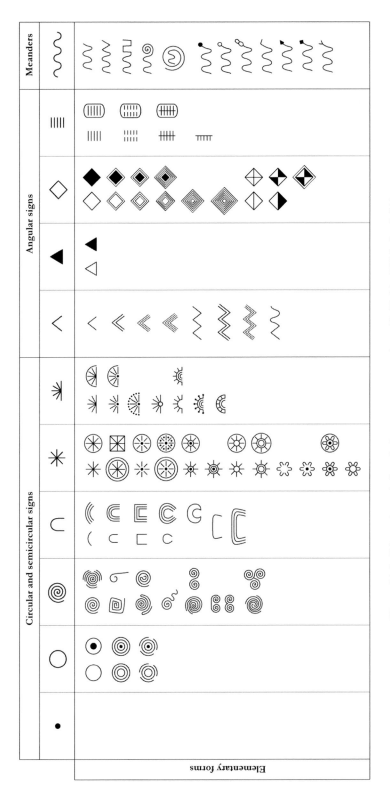

Figure 11.2: Schematic rendering of the core passage tomb motifs (Robin 2008, fig. 3.34).

least that through focusing on the experience of the art it has allowed us to discuss its impact in a more visceral way and at the level of emotional response.

Equally, spatial analysis of the art is proving to be a successful line of enquiry and important insights have been forthcoming with regard to the structured placement of selected motifs on the construction stones of passage tombs (Robin 2009; 2010 and this volume). This research has demonstrated what has often been assumed or partially voiced (e.g., Shee Twohig 1997) but only recently convincingly proven, that is, that some motifs are not placed randomly on the constructional stones of Irish passage tombs, rather rules are observed, and that particular motifs recur repeatedly at distinct locations within and around the monuments.

Finally, in recent years, the artistic process, memory and performance have also been given more consideration (e.g., Cochrane 2005; 2008; Jones 2004). These approaches have stimulated new ways of looking at passage tomb art, as well as many new questions: what kind of performances surrounded these activities; how was the art used in maintaining or changing conventions; how did later Neolithic people relate to and engage with older art, and so on? As the scholars who have presented these latter approaches are represented in this volume, I will let their contributions on the subject speak for themselves rather than paraphrase them here.

WHERE ANGELS FEAR TO TREAD: REPRESENTATION OF INNER EXPERIENCE

One of the most contentious interpretations of passage tomb art over the last twenty years has been the explanation of the art as depictions of visions seen by individuals in altered states of consciousness (see responses to Dronfield 1996a; Helvenston and Bahn 2002; 2004; Shee Twohig 2000; also see Hensey 2010). This could be seen as perhaps the most unifactoral of recent interpretations because it attempts to explicate the origin of the majority of motifs from the passage tomb corpus and provide an overarching explanation for the creation of passage tomb art.

In this interpretation we move into unclear territory somewhere between figuration and abstraction. If the artists were carving images as they saw them within their minds, then from their perspective they were depicting images that were 'real', even if not portrayals of objects from the external world. However, if the art did not record inner experience, then the repetition of many of the motifs indicates the artists were more likely to have been elaborating on a culturally prescribed (i.e., non-subjective) repertoire of motifs which may or may not have been representations of objects from the physical world. Either way, a difficulty with most of this interpretation has been that it has demonstrated a lack of recognition of the phases of carving or has been insufficiently cognisant of the variety of art styles contained within the tradition. As Jones has noted, it tended to treat the art as if it were created in a 'temporal stasis' (2004, 202). For instance, it is now clear that several layers of art often occur on passage tomb stones; frequently previous layers were destroyed to make way for new ones (O'Sullivan 1986; Eogan 1999, fig. 3). This is perhaps demonstrated most dramatically by the annihilation of depictive art at Newgrange with the superimposition of blanket picking (O'Sullivan's 1997a *stage four*), which may have had political implications (Cochrane 2009). Clearly, megalithic artwork was not static in form or meaning.

In the Brú na Bóinne complex 'aesthetic' considerations – harmonious composition, visual effect, size of the art – appear to take precedence over time, whereas a tradition of executing simple motifs, as found for example at Loughcrew, is less in evidence. Claire O'Kelly (1973, 379; 1982, 146) noted that in the Brú na Bóinne complex, the art on the outside of the monuments, on the kerbstones, is often larger than the art inside. For example, the triple spiral inside Newgrange Site 1 is barely one third the size of the similar example on the entrance stone outside the passage. This may have been the case because the kerbstone art was created to allow it to be viewed by observers from a distance (C. O'Kelly 1982, 146). If so, much of the visible art at Brú na Bóinne was a planned aspect

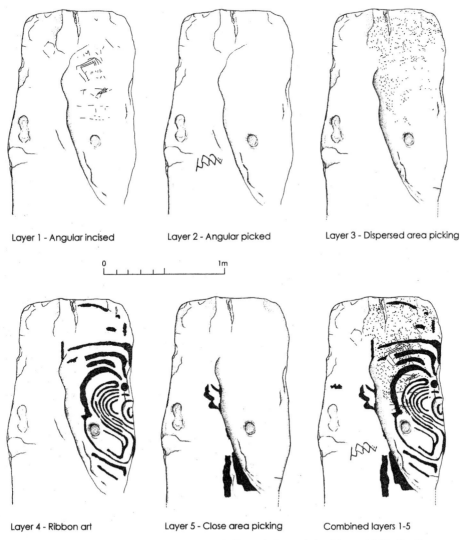

Figure 11.3: Orthostat 45, western tomb, Knowth Site 1 (after Eogan 1999, fig. 3).

of the monument, meant for display, and not an improvised recording of a subjective visual experience. As O'Kelly (1982, 148) perceptively noted:

> *'It seems to me ... that the symbolical meaning was the original inspiration for Irish passage-grave art, beginning with the random carving of motifs which had meaning for those that applied them, or who caused them to be applied, and that it was only with the passage of time, as the tomb builders became more expert and sophisticated generally, that the aesthetic element of the carvings began to emerge and develop and designs and patterns began to be achieved, though perhaps this aspect never entirely overruled the symbolism, latent or otherwise.'*

As indicated in this quote, there is an argument that images that might originally have been associated with what O'Kelly calls 'symbolic meaning' (or perhaps recordings of individuals' visions), have now become absorbed into a repertoire of motifs deemed appropriate for inclusion in 'designed' art pieces. Consequently, *contra* Dronfield (1996b) and Lewis-Williams and Pearce (2005), passage tomb carvers in the Boyne Valley were usually employing a culturally sanctioned range of motifs rather than making direct recordings of their subjective visual experience. This seems to equate with O'Sullivan's *stage 2* art: it draws on a core group of motifs that *could* be considered entoptic after Lewis-Williams *et al.*, but uses these motifs as blocks in building sophisticated compositions. Notably, *stage 2* art is constituted by designs and motifs that may now have become standardised within passage tomb society (for example, some of these motifs are now found on ornaments such as bone pins). Furthermore, art from *stage 3*, plastic art, also has a sense of planned composition, but does *not* draw on the catalogue of depictive motifs from *stage 1;* instead the artists chose to focus on combining the art with the form of the stone and its position within within the monument to maximise the affect on the viewer. What *stage 2* and *stage 3* have in common is that there is an emphasis on the observer of the art, the intentional creation of striking visual composition. This could explain why huge quantities of *stage 1* art are sometimes hidden, for instance on the back of kerbstones at Newgrange (e.g., Figure 11.4): the simple depiction of art – which might be recordings of images experienced in trance – was no longer in vogue in the later phases of passage tomb construction.

To state this in another way, figurative recordings of subjective visual experience had evolved into the use of a set of standardised motifs for abstract schematic design. These designs were intended to adorn monuments and have maximum affect on the viewer. As the tradition developed, impact on the viewer continued to increase in importance, ultimately no longer necessitating use of traditional depictive motifs to achieve this outcome.

ABSTRACTION AND FIGURATION IN CENTRAL AND NORTHERN AUSTRALIA

A feature of the major strands of interpretation of passage tomb art is that they tend towards unifactoralism, each vying for precedence over other interpretations, each claiming that it has superseded previous accounts, now deemed to be old fashioned, naïve, or theoretically outmoded. Yet if we fully incorporate the time-depth and variety of styles that seem to be apparent within the passage tomb art making tradition, then it may not be that only one interpretation is necessary or correct. A deeper analysis of the figurative versus abstract issue makes this clear.

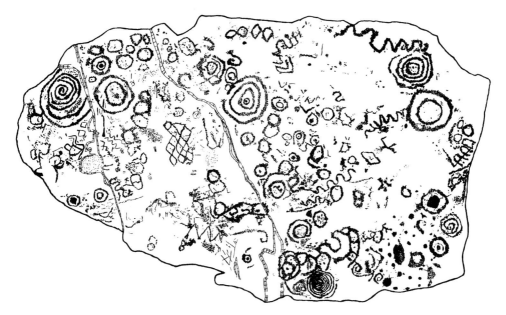

Figure 11.4: Hidden art. Newgrange Site 1, K18 (after C. O'Kelly 1982, fig. 27).

In recent years, interpretations that envisioned megalithic art as figurative have been largely dismissed and new accounts that focus on how making and viewing megalithic art may have affected people in the Neolithic have emerged (e.g., Bradley 2009; Cochrane 2006; Thomas 1990; 1992; Tilley 2008). Nevertheless, if we are truthful, it needs to be acknowledged that even though, from a modern perspective, the majority of this art appears non-figurative, there is no way of demonstrating *a priori* that the art was considered in this way for people that created it. It is instructive to consider Nancy Munn's (1973) illustration below (Figure 11.5), which shows how, in the Warlpiri art-making tradition of central Australia, simple elements are combined to form complex designs. The illustration demonstrates how seemingly non-representative geometric designs could be created by combining motifs that are in fact depictions of real world objects and activities. In this case the various components of the abstract design relate to the *honey ant ancestor*: real world objects such as digging sticks, burrows, nests and so on are used to create complex geometric designs. Interestingly, Faulstich has noted that in Warlpiri art *'Highly abstracted symbols generally depict mundane subjects …'* and conversely *'naturalistic motifs usually depict mythological beings and concepts …'* (1992, 1) – the very reverse of what one might expect. If we were to apply this formula to Irish Passage tomb art we should be looking for representations in the most geometric examples of the art. It may be worthwhile to consider Munn's (1973) graphic in relation to O'Sullivan's (1997a) *stage 2* art which, as already stated, involves the combination of simple depictive motifs to create complex apparently 'non-figurative' compositions.

Of interest also is the art of the Yolngu people from northern Australia. For the Yolngu, abstract geometric patterns are often thought to be transformations of ancestral beings

Features	Element combinations	Design examples
::,)) = ant	**((**	
/ = central passage (underground path) digging sticks of women	**/ – ::**	
)),)), ≣ = side burrows	**/ – ((≣ – ,,**	
,, = (linked) vine ancestor **U** = woman digging	**/ – (((((– ,, – U**	
O = nest (hole)	**O – / – (((((– ::**	

Figure 11.5: Warlpiri art of central Australia (after Munn 1973, fig. 15).

(Morphy 1989). Morphy has noted that '*Frequently, sacred paintings have no obvious figurative component and various aspects of the Ancestral Being concerned are encoded in different geometric elements*' (*ibid.* 153–5). His explication of the Munyuku clan depiction of diamonds within a cross-hatched motif (Figure 11.6) demonstrates this point:

> '*At one level of interpretation the diamonds represent the cells of the hive, the cross-hatching signifies different components of the hive, the grubs, the honey, the pollen, and the bees; the cross-bars that*

bisect some of the diamonds represent small sticks that are found in the hive; while the dots within the circles represent the bees swarming from the entrance of the hive. At another level, elements of the design signify attributes of the fires lit by hunters who collected the wild honey; the white cross-hatching is the smoke, the red is sparks, and the white dots ash. At another level still, the diamond pattern represents the sparkling fresh water as it flows beside the flowering paperbark trees, the trees in which the honey is found.'

In a similar way, it is entirely plausible that some passage tomb art motifs, though conventionally regarded as non-representational, may for the carvers have had associations with elements of their physical world. That we do not know or cannot find these representations is not proof of their absence.

ART AND THE TRANSFERENCE OF RITUAL KNOWLEDGE

Leaving aside the figuration versus abstraction question for a moment, one aspect of passage tomb art which is rarely discussed is the process by which the skills of carving the art must have been passed on to the next generation. This becomes more relevant if we once again focus on the potential time-depth of the art. In pre-literate societies, skills are often passed on in a one-to-one manner, and great emphasis is placed on the

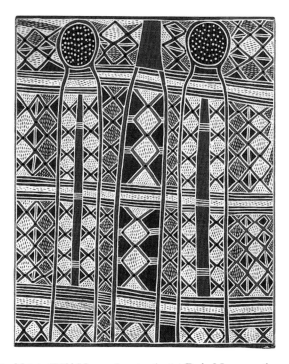

Figure 11.6: Yirritja Moiety, Wild Honey Ancestor (artist Dula Ngurruwuthun, natural pigments on board, Morphy 1998, fig. 63).

transmission of sacred knowledge and skills to the next generation (Ingold 2000), especially knowledge that would have taken many years to learn. It is important to remember that life expectancy in the Neolithic would have afforded limited years to accumulate and transmit this knowledge (Cooney 2000, 87). We also know that what is perhaps naïvely referred to as 'passage-tomb art', as if it were a homogenous entity, was in reality a very long-lived and extremely dynamic tradition; it may well have been in existence for half a millennium. There is a strong likelihood that it was at the important ritual centres such as passage tomb complexes, some of which were in use for primary passage tomb rituals over many hundreds of years, that these kinds of skills were passed on to the next generation (cf. O'Kelly *et al.* 1978, 325). It has already been noted that at some sites much of the art was executed when the stones were *in situ*. Consequently, we can safely conclude that artists must have spent a significant amount of time outside and inside the monuments to make the copious amount of art found there, and hence, presumably, this is also where carving skills were taught.

People who have spent a long time examining megalithic art are often able to identify specific artists likely to have been responsible for several different pieces of art. It is possible for example to recognise art created in similar styles, with similar technique, and to a similar level of skill. C. O'Kelly (1982, 150) and others have suggested that the same accomplished artist was probably responsible for the art on Kerbstones K1 and K52 at Newgrange Site 1, so closely related is the technique used on both stones. Similarly, at Knowth, after many seasons spent recording the art in the course of the excavations, it was possible for one archaeologist (J. Fenwick) to identify a highly 'unaccomplished' Neolithic artist through their trademark carving. He was also in some instances able to identify if individual carvings or diffuse picking were executed by a right- or left-handed person, as *'often in drawing the stone one had to assume the same pose and occupy the same space as the person who originally carved the stone'* (Joe Fenwick, pers. comm.). This raises the question as to whether we can speak about specific artists, or even art that could be the work of more experienced artists and that of novices – perhaps a rare insight into how knowledge and techniques were transferred from one generation to the next.

However, the passing on of this knowledge is unlikely to have been simply a technical exercise. The attitude of the Yolngu is interesting in this regard:

> *'From the Yolngu perspective, art ... is an extension of the ancestral past into the present and one of the main ways in which ideas or information about the ancestral past is transmitted from one human generation to the next. The ancestral past is never directly experienced, in that no human beings living today were present when the ancestral events took place. Rather, an understanding of the ancestral past is developed through representations and encodings in art and ceremony. Such understandings may be converted by the imagination into feelings of participation in the ancestral past, when stimulated by certain events or induced by periods of reflection'* (Morphy 1989, 144).

Similarly, one of the roles of passage tomb art may have been the creation of *'feelings of participation in the ancestral past'*. It is possible that neophytes stationed within passage tombs re-traced, re-carved, or – in light of recent evidence (Card and Thomas this volume) – even re-coloured motifs found in passage tombs, as another way of increasing a sense of participation with this perceived alternate reality. Time may have been spent reflecting on the art as well as creating new images.

For the Yolngu, the cumulative absorption of sacred substances and signs through body painting, the singing of ceremonial songs, and the creation of ceremonial sculpture over many years all deepen the association with the ancestors. Morphy notes that, '*By the time they have reached old age they are thought increasingly to resemble the ancestral beings themselves; they have absorbed the substance of the ancestral past and are about to move once again into the dimension of the dreaming*' (1998, 79). Equally, it must have taken considerable practice to hone the skills necessary to create some of the art that is found at the Brú na Bóinne complex. Perhaps we could ask, were older passage tomb artists thought to be closer to the ancestors – however these were imagined in the Neolithic – having had a greater experience in the execution of carvings? Certainly, if a similar regard for the expert artist prevailed in the passage tomb tradition, one imagines that the right to carve designs into the stones of these monuments must have been seen as a great privilege.

CONCLUSION

Too often the discussion of megalithic art has taken place within the context of its origin rather than its use, and typically the reasons given for its presence are unifactoral. What I have attempted to do in this paper is not only to review the main interpretations of the art, but to view explanations of the carvings as potentially complimentary rather than as competing possibilities. In examining these interpretations, I have tried to demonstrate that an approach that has perhaps been missing in these studies is a reflection on the potential roles that different types of art may have had. Like other areas of passage tomb study, there has been a tendency towards unifactoral explanations, '*assuming the jigsaw only has one piece*' as Bahn (1996, 56) once put it. However, if the time-depth and stylistic variety within the

Figure 11.7: Preparation for an initiation ceremony, Arnhem Land, Australia (after Morphy 1998, fig. 45).

tradition are incorporated into our interpretive frameworks, it becomes clear that we may be dealing with several different passage tomb arts. In this context it is entirely possible that certain motifs may have been located in preordained positions within and around the monument, perhaps used as 'signifiers', while other carvings may have been decorative and meant to impress. Equally, certain motifs may have been figurative, while others were abstract presentations of aspects of Neolithic cosmology or other worlds.

I have also dealt with what is possibly the most unifactoral proposition of the last twenty years, that megalithic art was entoptic and related to trance ritual. A significant problem for the entoptic theorists is that much of passage tomb art was clearly 'planned'. Some art is placed only in certain positions on and within the monument (Robin 2009), that is, it has become standardised, and is therefore abundantly *not* a product of 'subjective' vision (*contra* Dronfield 1995a; 1995b). Similarly, that passage tomb art can be found in equivalent positions on monuments on both sides of the Irish Sea and elsewhere is testament to the prescriptive nature of this art making tradition. Thus, a great deal of the art was, I suggest, demonstrably planned, and though it may have drawn on a repertoire of sacred motifs, it was unlikely to have been a direct recording of subjective visual experiences. The principle art style that can be suggested as possible recording of images seen in altered states is art from O'Sullivan's (1997a) *stage 1,* and the majority of that art, at Brú na Bóinne at least, is hidden or has been obliterated by later carvings.

By use of ethnographic examples, I have attempted to draw the discussion away from neurologically deterministic arguments and to flesh out how geometric motifs may have been conceived of by both the artists and people entering passage tombs for ceremony or other activity. In particular, the interpretive fatalism prompted by the geometric nature of many of these motifs was addressed. This was accomplished by considering that some designs may have been perceived as representations of – or signs of the activity of – ancestral beings. I have also tried to bring some awareness to the carvers themselves, their training, and how learning the skills involved in creating megalithic art may have been a way to bring younger members of society into connection with the spiritual forces of the Neolithic world.

In summary, megalithic art is not a homogenous entity, it is a complex aspect of passage tomb design, construction and ritual, it probably had a lengthy history and multiple roles; some of which I have attempted to outline here. We should not discount the possibility that elements of passage tomb art making tradition were figurative; though we have to acknowledge that the probability of proving any such claim is very unlikely. Figuration and abstraction were in all likelihood part of a single continuum and, as demonstrated by the Warlpiri example, attempts to separate pieces of art into either category are probably doomed to failure. Outside of that possibility, an under-theorised area that could reward further exploration is a greater focus on the art making process, including the potential identification of particular artists and its implications as regards our comprehension of the processes involved in the transference of ritual knowledge. In this way we can perhaps begin to better appreciate the society responsible for these intriguing practices and the many meanings of passage tomb art.

ACKNOWLEDGEMENTS

I would like to acknowledge the valuable contribution made to this paper by Guillaume Robin, Marion Dowd and Joe Fenwick. Their comments and critiques improved it immensely. I would also like to thank the editors for the generous invitation to contribute to this volume.

REFERENCES

Bahn, P. G. 1996. Comment on 'Entering alternative realities: cognition, art and architecture in Irish Passage Tombs', by J. Dronfield. *Cambridge Archaeological Journal* 6(1), 55–7.
Bradley, R. 2009. *Image and Audience: rethinking prehistoric art*. Oxford: Oxford University Press.
Brennan, M. 1983. *The Stars and the Stones: ancient art and astronomy in Ireland*. London: Thames & Hudson.
Breuil, H. 1934. Presidential Address for 1934. *Proceedings of the Prehistoric Society of East Anglia* 7, 289–322.
Breuil, H. and Macalister, R. A. S. 1921. A study of the chronology of bronze age sculpture in Ireland. *Proceedings of the Royal Irish Academy* 36C, 1–9.
Cochrane, A. 2005. A taste of the unexpected: subverting mentalités through the motifs and settings of Irish passage tombs. In D. Hofmann, J. Mills and A. Cochrane (eds), Elements of being: mentalities, identities and movements, 5–19. Oxford: British Archaeological Reports S1437.
Cochrane, A. 2006. The simulacra and simulations of Irish Neolithic passage tombs. In I. Russell (ed.), *Images, Representations and Heritage: moving beyond modern approaches to archaeology*, 247–78. New York: Springer.
Cochrane, A. 2008. Some stimulating solutions. In C. Knappett and L. Malafouris (eds), *Material Agency: towards a non-anthropocentric approach*, 157–86. New York: Springer-Kluwer.
Cochrane, A. 2009. Additive subtraction: addressing pick-dressing in Irish passage tombs. In J. Thomas and V. Oliveira Jorge (eds), *Archaeology and the Politics of Vision in a Post-modern Context*, 163–85. Cambridge: Cambridge Scholars Publishing.
Coffey, G. 1912. *New Grange and other Incised Tumuli in Ireland*. Dublin: Hodges Figgis.
Conwell, E. A. 1873. *Discovery of the tomb of Ollamh Fodhla*. Dublin: McGlashan and Gill
Cooney, G. 2000. *Landscapes of Neolithic Ireland*. London: Routledge.
Crawford, O. G. S. 1957. *The Eye Goddess*. London: Phoenix.
Daniel, G. 1958. *The Megalith Builders of Western Europe*. London: Hutchinson.
Dronfield, J. 1995a. Migraine, light, and hallucinogens: the neurocognitive basis of Irish megalithic art. *Oxford Journal of Archaeology* 14, 261–75.
Dronfield, J. 1995b. Subjective vision and the source of Irish megalithic art. *Antiquity* 69, 539–49.
Dronfield, J. 1996a. Entering alternative realities: cognition, art and architecture in Irish passage-tombs. *Cambridge Archaeological Journal* 6, 37–72.
Dronfield, J. 1996b. The vision thing: diagnosis of endogenous derivation in abstract arts. *Current Anthropology* 37(2), 373–91.
Du Noyer, G. 1865. Antiquities in County Meath: notes on the late explorations at Loughcrew. *The Meath Herald*, Oct. 21.
Eogan, G. 1968. Excavation at Knowth, Co. Meath, 1962–1965. *Proceedings of the Royal Irish Academy* 66C, 299–400.
Eogan, G. 1986. *Knowth and the Passage Tombs of Ireland*. London: Thames & Hudson.

Eogan, G. 1997a. Pattern and place: a preliminary study of the decorated kerbstones at Site 1, Knowth, Co. Meath and their comparative setting. In J. L'Helgouac'h, C. Le Roux and J. Lecornec (eds), *Art et symboles du mégalithisme Européen. Actes du 2ème Colloque International surl'artmégalithique, Nantes, juin 1995.Revue archéologique de l'Ouest, Supplément n°8*, 97–104. Nantes.

Eogan, G. 1997b. Overlays and underlays: aspects of megalithic art succession at Brugh na Bóinne, Ireland. *Brigantium* 10, 217–34.

Eogan, G. 1998. Knowth before Knowth. *Antiquity* 72, 162–72.

Eogan, G. 1999. Megalithic art and society. *Proceedings of the Prehistoric Society* 65, 415–46.

Eogan, G. and Aboud, J. 1990. Diffuse picking in megalithic art. In J. L'Helgouac'h (ed.), *La Bretagne et l'Europepréhistoriques: Mémoire en l'hommage de Pierre-Roland Giot*, 121–40. Rennes: RAO suppl. n° 2.

Faulstich, P. 1992. Of earth and dreaming: abstraction and naturalism in Warlpiri art. In M. J. Morwood and D. R. Hobbs (eds), *Rock Art and Ethnography*, 19–23. Melbourne: Occasional AURA Publication 5.

Fleming, A. 1969. The myth of the mother goddess. *World Archaeology* 1(2), 247–61.

Flom, G. T. 1924. Sun-symbols of the tomb-sculptures at Loughcrew, Ireland, Illustrated by Similar Figures in Scandinavian Rock-Tracings. *American Anthropologist* 26(2), 139–59.

Gell, A. 1998. *Art and Agency: an anthropological theory*. Oxford: Oxford University Press.

Gimbutas, M. 1989. *The Language of the Goddess*. London: Thames & Hudson.

Gimbutas, M. 1991. *The Civilisation of the Goddess: the world of old Europe*. San Francisco: Harper and Row.

Hawkes, C. F. C. 1940. *The Prehistoric Foundations of Europe*. London: Methuen.

Hawkes, J. 1945. *Early Britain*. London: Collins

Helvenston, P. A. and Bahn, P.G. 2002. *Desperately Seeking Trance Plants: testing the 'Three Stages of Trance' model*. New York: R. J. Communications.

Helvenston, P. A. and Bahn, P. G. 2004. Waking the trance fixed. *Cambridge Archaeological Journal* 14(1), 90–100.

Hensey, R. 2010. *Ritual and belief in the passage tomb tradition of Ireland* (Unpublished PhD, National University of Ireland, Galway).

Hensey, R. and Robin, G. 2011. More than meets the eye: new passage tomb art in Co. Sligo, Ireland. *Oxford Journal of Archaeology* 30(2), 109–30.

Herity, M. 1974. *Irish Passage Graves: Neolithic tomb-builders in Ireland and Britain, 2500 BC*. Dublin: Irish University Press.

Ingold, T. 2000. *The Perception of the Environment: essays in livelihood, dwelling and skill*. London: Routledge.

Jones, A. 2004. By way of illustration: art, memory and materiality in the Irish Sea and beyond. In V. Cummings and C. Fowler (eds), *The Neolithic of the Irish Sea: materiality and traditions of practice*, 202–13. Oxford: Oxbow Books.

Lewis-Williams, J. D. and Pearce, D. 2005. *Inside the Neolithic Mind: consciousness, cosmos and the realm of the gods*. London: Thames & Hudson.

Lhwyd, E. 1700. *Two letters to Dr. T. Molyneux* (unpublished). Library of Trinity College Dublin.

Lhwyd, E. 1709. Letter to Dr. Tancred Robinson.*Transactions of the Royal Society* Abridged Series V, 1703–12, 694.

Meskell, L. 1995. Goddesses, Gimbutas and 'New Age' archaeology. *Antiquity* 68, 74–86.

Morphy, H. 1989. On representing Ancestral Beings. In H. Morphy (ed.), *Animals into Art*, 144–60. London: Unwin.

Morphy, H. 1998. *Aboriginal art*. London: Phaidon Press.

Munn, N. D. 1973. *Walbiri Iconography*. Ithaca: Cornell University Press.

O'Kelly, C. 1973. Passage-grave art in the Boyne Valley. *Proceedings of the Prehistoric Society* 39, 354–82.

O'Kelly, C. 1978. *Illustrated Guide to Newgrange.* Wexford: John English.

O'Kelly, C. 1982. Corpus of Newgrange art. In M. J. O'Kelly, *Newgrange: archaeology, art and legend,* 146–85. London: Thames & Hudson.

O'Kelly, M. J., Lynch, F. and O'Kelly, C. 1978. Three passage graves at Newgrange, Co. Meath. *Proceedings of the Royal Irish Academy* 78C, 249–352.

Ó'Ríordáin, S. P. and Daniel, G. 1964. *Newgrange and the Bend of the Boyne.* London: Thames & Hudson.

O'Sullivan, M. 1986. Approaches to passage tomb art. *Journal of the Royal Society of Antiquaries of Ireland* 116, 68–83.

O'Sullivan, M. 1989. A stylistic revolution in the megalithic art of the Boyne Valley. *Archaeology Ireland* 3(4), 138–42.

O'Sullivan, M. 1993. *Megalithic art in Ireland.* Dublin: Town House and Country House.

O'Sullivan, M. 1996. Comment on 'Entering alternative realities: cognition, art and architecture in Irish Passage Tombs' by J. Dronfield. *Cambridge Archaeological Journal* 6(1), 59.

O'Sullivan, M. 1997a. Megalithic art in Ireland and Brittany: divergence or convergence. In J. L'Helgouac'h, C. Le Roux and J. Lecornec (eds). *Art et symboles du mégalithismeEuropéen. Actes du 2ème Colloque International surl'artmégalithique, Nantes, juin 1995. Revue archéologique de l'Ouest, Supplément n°8,* 81–96. Nantes.

O'Sullivan, M. 1997b. Megalithic art in the Boyne Valley. Brú na Bóinne supplement. *Archaeology Ireland* 11(3), 19–21.

O'Sullivan, M. 2006. The Boyne and beyond: a review of megalithic art in Ireland. In R. Joussaume, L. Laporte and C. Scarre (eds), *Origine et développement du mégalithisme de l'ouest de l'Europe. Actes du colloque international, 26–30 Octobre 2002, Bougon (France), Niort: Conseil Général des Deux-Sèvres,* 649–86. Bougon.

Piggott, S. 1954. *The Neolithic cultures of the British Isles.* Cambridge: Cambridge University Press.

Robin, G. 2008. *Neolithic passage tomb art around the Irish Sea: iconography and spatial organization.* Ph.D. Thesis submitted to the University of Nantes.

Robin, G. 2009. *L'architecture des signes. L'artpariétal des tombeaux néolithiques autour de la mer d'Irlande.* Collection Archéologie & Culture. Rennes: Presses Universitaires de Rennes.

Robin, G. 2010. Spatial structures and symbolic systems in Irish and British passage tombs: the organization of architectural elements, parietal carved signs and funerary deposits. *Cambridge Archaeological Journal* 20(3), 373–418.

Shee, E. 1973. Techniques of Irish passage grave art. In G. Daniel and P. Kjærum (eds), *Megalithic graves and ritual: papers presented at the III Atlantic colloquium, Moesgård 1969,* 163–72. Copenhagen: Jutland Archaeological Society.

Shee Twohig, E. 1981. *The megalithic art of western Europe.* Oxford: Clarendon Press.

Shee Twohig, E. 1997. Context and content of Irish passage tomb art. In *Art et Symboles du Mégalithisme Européen. Actes du 2ème Colloque International surl'ArtMégalithique, Nantes, juin 1995. Revue archéologique de l'Ouest Supplément* 8, 67–80. Nantes.

Shee Twohig, E. 1998. A 'Mother Goddess' in North West Europe *c.* 4200–2500 BC? In L. Goodison and C. Morris (ed.), *Ancient Goddesses, the Myths and the Evidence,* 164–79. London: British Museum Press.

Shee Twohig, E. 2000. Frameworks for the megalithic art of the Boyne valley. In A. Desmond, G. Johnston, M. McCarthy, J. Sheehan and E. S. Twohig (eds), *New Agendas in Irish Prehistory: papers in commemoration of Liz Anderson,* 89–105. Bray: Wordwell.

Thomas, J. S. 1990. Monuments from the inside: the case of the Irish megalithic tombs. *World Archaeology* 22(2), 168–78.

Thomas, J. S. 1992. Monuments, movement and the context of megalithic art. In N. Sharples and A. Sheridan (eds), *Vessels for the Ancestors*, 143–155. Edinburgh: Edinburgh University.

Thomas, J. S. 1993. The hermeneutics of megalithic space. In C. Tilley (ed.), *Interpretative Archaeology*, 73–97. Oxford: Berg.

Tilley, C. 2008. *Body and Image: explorations in landscape phenomenology 2*. Walnut Creek, CA: Left Coast Press.

Vallancey, C. 1786. Druidism revised: or, a dissertation on the characters and modes of writing used by the Irish. *Collectanea de Rebus Hibernicis* 2(7): 161–217.

Composing the Neolithic at Knockroe

Andrew Cochrane

This paper does not represent you. To be honest, it does not represent me either, so we already have something in common. What it does rather is present ideas that I have been working through for a while now. I am not expressing an anti-representational approach to Neolithic imagery – nor do I necessarily advocate that scholars adopt non-representational approaches verbatim. Instead, I traverse along paths that move beyond and are therefore more than representational understandings. The stimulus for such action derives from a recent sabbatical that I took away from passage tomb imagery. For the last two years I have been researching Jōmon dogū from the Japanese archipelago and prehistoric clay figurines from the Balkans (e.g. Bailey *et al.* 2010). I discovered that representational approaches to most archaeological enquiry occupied the dominant position. So implicit are representational understandings, that they often inhabit uncontested *a priori* assumptions. If we can no longer assume that anything can be assumed (Sloterdijk 2005; Shanks and Witmore 2009; Koerner 2010a) – why is this? What are the risks and implications of such a prevailing representational belief system within archaeology? What do we exclude when we focus on images as just being representational? Here, and via a case study of the passage tomb Knockroe, Co. Kilkenny, Ireland, I will explore what alternatives are available and demonstrate how these might work.

BEING MORE THAN REPRESENTATIONAL

> '*the representation of history. It requires a falsification of perspective*'
> W. G. Sebald

I think I understand why some people want to live in a world of symbols; it is after all comforting. To live without indices is destabilising – as Ronald Barthes (1970) and I (much later) discovered in Japan, through our inabilities to decipher the signs. This need or acceptance by some to read the world is manifest in some creations of Neolithic pasts and its imagery[1] – and my concern is that this often appears to be done without overt qualification or reflection. In many ways, this situation reminds me of Alice's experiences in Wonderland – in which the Red Queen demanded the *sentence* first and the *evidence* after. Such positions are so dominant that even abstract geometric images are recast as being essentially representational and static – resulting in invisible transcendentals or first principles

(Anderson and Harrison 2010, 14). Rendering the image depleted rather than pregnant (Lorimer 2005; Self 2006). It appears that no image can escape the modernist significances of representation and realism.[2]

Many expect one medium to replay what has already been given in another; the creation of original and copy – semblance and return (Doel 2010, 119). There is an idea that some archaeologists can discover a true or more correct world of realities lying behind a veil of appearances (Cochrane 2009a; Latour 2010). At a most honest level, however, images are sometimes just images. They can be stimulated by references to other images and they can be performative. Yet, they do not always just represent – in fact they can create situations whereby they only *present* with there being nothing behind them – often (to be playful?) they dissimulate that there is nothing to conceal (see Cochrane 2006). Within such approaches, the image is acknowledged to be sophisticated and autonomous enough to abolish prescribed referents and replace it with itself, creating a performance where the image is much more than applied representation. Here, the image is not passively awaiting overlays of meaning. Images are not *about* a thing – they *are* the thing.

À REBOURS – AGAINST THE GRAIN

Elsewhere, I have utilised select ethnographic accounts (e.g. Cochrane 2009a) to emphasis that not all recorded societies adopt representational approaches to the world, as is dominant in Western understandings (and Western accounts of non-Western people?). Thus far, alterity is not determined by how one (re)presents the world. Here, I will instead work with two vignettes of contemporary imagery as a means of discussing ways in which we can participate that is beyond mere representation, whilst opening up new and interesting questions[3].

VIGNETTE #1

As artists, The Chapman brothers (Jake and Dinos Chapman) explore scale and move through many of its spectrums. With many of their works there is no realism – their work does not represent – they include absurdities that defy realism and that do not allude to other meanings. Instead, their motivations are to stimulate and to be problematic. Contestation with reception can occur as some people are seeing what *they think they see*, rather than what is actually there. Interpretations for some are therefore based on illusion (or delusion), and a belief that the works represent things that are not present – meanings that are hidden – intangibles. Which the Chapmans explain is not the case – the works are what they are.

Some of their expressions deal in the diminutive; here, we have miniature-based sculptures of things that sometimes look like people within environments. The works *Hell* (1999–2000) – and *Fucking Hell* (2008) (remade after the original was ironically consumed by flames), produced thousands of miniature figurines, images, architectures and technologies within their own environments or 'hellscapes'. The dioramas can be interpreted as expressing some of the atrocities that some humans are capable of, such as genocide and mass destruction, but in the most inappropriate forms, with distortions of perception

via medium and size. An important distinction in such interpretations is that the themed Nazis are not inflicting these horrors upon others, but rather themselves – they become the victims. These nightmarish acts are also administered to the Nazis by mutants and animals. If the figurines are to be interpreted as actual evil Nazis, the Chapmans argued that they thought people might be happy to see 10,000 of them being punished eternally for their sins in hell (Barrett and Head 2007, 5). Reception and opinion was, however, mixed with some people feeling that the figurines represented actual historical events (e.g., World War II and the Holocaust) or political statements (see Molyneux 1998). Indeed, at first glance the figurines can appear realistically accurate (e.g., the military uniforms). Yet on closer inspection, these works included absurdities that defy realism – incongruous things such as: a three-headed baby playing with a beach ball; Nazi astronauts; or an undead soldier riding a giant tortoise encouraging it forward with lettuce on a stick. Following Ingold (2007), we might be better by returning straight to the materials – this work is not human, it is a mixture of glass-fibre, plastic, and mixed media (in nine parts). The Chapmans explain that there are no hidden meanings – they have not added in this sense, but rather they are attempting to misplace (Barrett and Head 2007). These works are not analogies of something else – they are perfect models of themselves.

The Chapman works illustrate problems that face the study of prehistoric imagery and raises questions. For instance, what happens when we see motifs as having invisible or hidden analogies? Do the forms of motifs emulate other worlds, and is it useful to think in these terms? Can we consider Neolithic imagery as a reflection of realism? Are they created to be challenging and problematic? Is it more profitable to think about them for what they actually are or do?

VIGNETTE #2

Franz West is an artist who creates interactive art with the assertion that it does not matter what it looks like but how it is used (Fleck *et al.* 1999). Inspired initially by the avant-garde Actionists and literary groups in Vienna during the late 1960s, West eventually developed a fascination with the writings of Ludwig Wittgenstein (Badura-Triska 2006). West posited that performances are never fixed, but rather they change with the context of their application, only ever occurring within spaces of exchange. For West, art is meaningless and functionless unless it is interacted with – performance is key.

From the mid-1970s onwards, West began creating portable objects termed 'Adaptives' (Passtücke) – things that allow direct experiences beyond the mediation of language (Verwoert 2003). Varying in scale, but smaller than average human size, the Adaptives are found objects mixed with papier-mâché, wire, cloth bandages and plaster. The Adaptives are abstract and anamorphic shapes that can be held, manipulated, hugged or positioned in any manner chosen. They do not represent. The Adaptives sometimes look soothing and invite the handler to press them snugly into their body, and yet they almost always never fit – which can result in feelings of discomfort. These interactions with Adaptives often lead to the striking of amusing poses – destabilising the spectator and rendering them as performer – often facilitating a corporeal comedy (Storr 2003; Marcoci 2007). Here, activation is achieved by situations and by the objects inducing play. The objects percolate

the uncanny, disrupt the quotidian, releasing tensions and previously unconsidered bodily gestures. As Ian Russell and I discovered in 2010 at the Hayward Gallery in London, the handler adapts to the object. These performances with objects are considered by West to be both liberating and acute reminders of existing repressions (Verwoert 2003). The Adaptive objects – as prosthesis – often create unease and site specific dislocations.

West argues that his objects present perspectives on how some people negotiate objects within the world. With the suggestion that Adaptives are prosthetic additions to the body, West attempts to blur modern distinctions that separate movement, human body, object and environment. West does not, however, communicate his ideas as text – it is usage and participation that articulate. That understanding and experience can be stimulated by physical contact and corporeal expression, presents challenges to how some archaeologists 'use' prehistoric material. West poses questions regarding not only the power of objects, but also the roles of play and performance in highlighting norms, and then subverting them. Following West, can we ever interpret the meaning of an object or image via notions of language and text alone? Or do we need to start handling and looking at them more and see what they do to us? How do seemingly functionless abstract objects and images work? At what point do the things we create stop adapting for us and when do we start adapting for them?

With these two modern examples and questions in mind I will now turn to the Neolithic.

ÉLAN VITAL – KNOCKROE

> '*a picture's beauty does not depend on the things portrayed in it*'
> Marcel Proust

Located near the modern village of Tullahought, Co. Kilkenny, Ireland, the Knockroe passage tomb, known also as the 'The Caiseal', is sited just above the 91m contour on fields that fall to the west, above the bend in the Lingaun River, at the point where the east-flowing waterway fords and turns to the south, being 120m to the east of it (Ó Nualláin and Cody 1987, 69; O'Sullivan 1993b, 17; 2004, 46; see Figure 12.1). The positioning of this passage tomb differs from many others in Ireland (e.g. Newgrange Site 1, Co. Meath) in that it is placed on the side of the hill, rather than the highest elevated spot (O'Sullivan 1995, 11). The views are still impressive. Visible is the Baunfree tomb, located 4km away on the northern edge of Kilmacoliver Hill, and the Slievenamon cairn approximately 11km away on the mountain (Ó Nualláin and Cody 1987, 69). There is another cairn 1.1km north-east of the Slievenamon cairn, but this is currently less prominent, due to its ruined condition. These sites may form a Slievenamon complex, similar in distribution pattern to the Boyne Valley and Loughcrew complexes in Co. Meath, albeit less compact (O'Sullivan 1993b, 15–16; 1995, 24), with Knockroe located towards the eastern end (O'Sullivan 2004, 44; see also Cooney 1990). The complex might also be associated to another scatter of monuments sited in the hills flanking the Aherlow River, a tributary entering the Suir River further to the west (O'Sullivan 2004, 44). The nearest decorated complex is Baltinglass Hill in Co. Wicklow, *c.* 60km to the north-east (O'Sullivan 2004, 44). The geology of this area is Upper

Silurian formations. The passage tomb was only brought to the attention of archaeologists very recently, when John Maher rediscovered the denuded remains in the very late twentieth century (Ó Nualláin and Cody 1987, 82; O'Sullivan 1993a, 33). This may have been as a result of it being recorded, but not shown, on the late nineteenth century and subsequent Ordnance Survey maps of Co. Kilkenny (Ó Nualláin and Cody 1987, 71). The structure consists of a semi-circular or elliptical kerbed earthen cairn (*c.* 15 –25m wide from east to west), with a small passage tomb on the western edge, and a second transeptal passage on the eastern side. In this respect it is remarkably similar to Knowth Site 1 and Dowth, Co. Meath, which also possess decorated motifs with two passage tombs within their mounds, and both are relatively close to waterways and smaller tombs (O'Sullivan 2004; Kondō 2001). It also highlights that the southern areas of Ireland, away from the Meath-Sligo axis, may not have been as bereft of megalithic motifs as was previously thought (O'Sullivan 1996a, 91; 2004, 44). The positioning of a single mound in a commanding position on a hilltop (albeit not the summit; see Figure 12.1) is similar to the Mound of the Hostages, Co. Meath and Knockmany, Co. Tyrone.

About 30 decorated stones are visible in the structural stones of Knockroe, with at least 10 of the kerbstones bearing motifs, 10 decorated stones in the western tomb and 10 in the eastern (O'Sullivan 1987, 92; 1996a, 91; 1996c, 11). Other than the main passage tombs in the Boyne Valley complex (e.g. Newgrange Site 1 and Knowth Site 1), this presents the

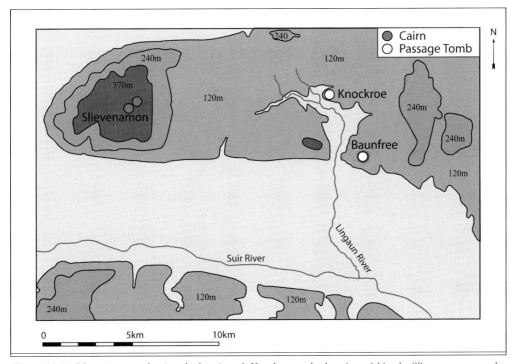

Figure 12.1: Schematic map showing the location of Knockroe and other sites within the Slievenamom complex (adapted from Ó Nualláin and Cody 1987, fig. 8).

largest amount of decorated kerbstones in one particular monument (O'Sullivan 1987, 92; 1996a, 91; see Figure 12.2). I will highlight some of the more visually notable stones, to demonstrate the wealth of imagery present at Knockroe. Only eight of the kerbstones are thought to be *in situ*; four of these form pairs either side of the entrance to the western passage tomb, marking an in-turn into the entrance. The other four stones form an arc on the southern edge of the kerb (Ó Nualláin and Cody 1987, 73). The stones are mostly local sandstone, with green greywacke or grit bearing the majority of the imagery. This is argued to be a deliberate placement (O'Sullivan 1995, 12); green grit is also the favoured choice on some of the structural stones in the Boyne Valley passage tombs, such as Newgrange

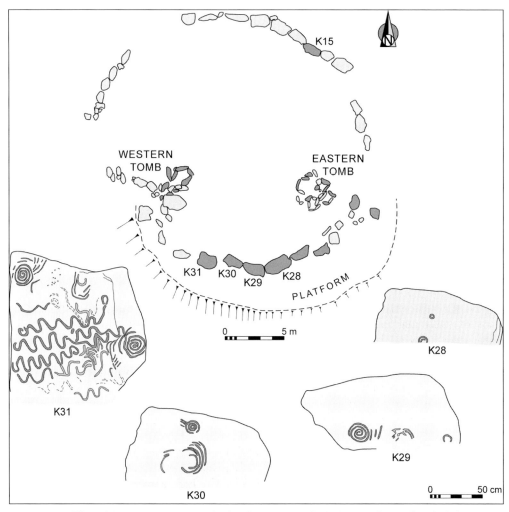

Figure 12.2: Plan of Knockroe passage tombs detailing some of the kerbstones discussed – shaded stones are decorated (adapted from Ó Nualláin and Cody 1987, fig. 9; O'Sullivan 1993b, 6; 1996c, 12; illustration by Aaron Watson).

Site 1 and Dowth (Eogan 1986, 112). Ó Nualláin and Cody argue that the 'inconspicuous' (1987, 81) siting of this tomb on a slope was visually countered by the initial creation of a re-deposited yellow boulder clay platform, twice the diameter of the mound, which provided a level surface (see Figure 12.2). The extension of the earthen platform beyond the kerbstones could have also effectively created a stage (O'Sullivan 1996c, 13) for specific performances in front of both the western and eastern tombs, that may have allowed certain people to appear raised or above others. Such site specific performances may have been highly charged with emotions, with intoxicant fuelled carnal and sexual actions used as powerful tools to enhance experiences (see Cochrane 2005; 2008). Cacophony is not the right word – but it is one that springs to mind. The yellow boulder clay may also have been adapted for its impact (especially if illuminated by fire, moon or sunlight), for the feel and smell of it, and its contrast with the surrounding areas. Whether it stimulated such reactions or not, it does suggest that some people were actively altering the environment and being altered (or adapted) by it for different purposes (see also Cooney 2000a, 135). Interestingly, oval settings have been found directly in front of the entrances and façades of Cairn T Loughcrew, Knowth Site 1 and Newgrange Site 1, Co. Meath (Cochrane 2006a). Placed on this platform was a nodule of Galway granite; it is the only granite discovered at Knockroe and is reminiscent of granite placed at the entrances of Newgrange Site 1 and Knowth Site 1 (O'Sullivan 1997, 29). That Knockroe emerges out of the yellow clay and was constructed on top of it, rather than the clay merely being placed in front of it, may at some level indicate performances that invert or subvert worldviews. For instance, at Loughcrew, Co. Meath, I have previously discussed possible stage settings *in between* the passage tomb cairns (Cochrane 2005); at Knockroe the stage is now below and in front of the passage tombs, and possibly emphasises and allows alternative *underlying* engagements. The mixture of clay platforms, rock imagery and quartz is very reminiscent of Cairn T, Loughcrew where oval settings were cut into yellow clay, and contained a large quantity of white quartz fragments (Rotherham 1895, 311), and Torbhlaren, Argyll, Scotland, where quartz and clay is actively involved in the performance of image production and reception (see Jones this volume).

The western passage tomb consists of a widening passage (facing south-west) that leads to a terminal space that is only slightly larger at the inner end of the passage (Ó Nualláin and Cody 1987, 82; O'Sullivan 1993b, 5; see Figure 12.3). The passage tomb is compartmentalised into three sections, each entered over a sillstone and floored with a large stone slab (O'Sullivan 1996c, 12). This passage is 3.5m long, 0.2m wide at the entrance/exit and *c.*1m wide at the deepest end. As with Newgrange Site 1, the floor level rises in height from entrance to rear (O'Sullivan 1993b, 9; 1996c, 12). The passage tomb is aligned on the rising and setting sun on midwinter day, 21 December (O'Sullivan 1996a, 91; 2004, 47; see Figure 12.4). The structure consists of 12 orthostats, 5 on the southern side and 6 on the north side with one backstone. To the south of the entrance, 0.5m away, is located a single stone (0.6m high) that may have presented an extension of the entrance beyond the line of the kerb (Ó Nualláin and Cody 1987, 73). The kerb appears to have been related to the western passage tomb, whereas the eastern passage tomb seems more detached and independent (O'Sullivan 1995, 12).

This extension beyond the kerb, combined with other stones, may have formed a sandstone block façade built upon the stage setting, creating a forecourt for possible

activities to have taken place (Ó Nualláin and Cody 1987, 81; O'Sullivan 2004, 47). This extensive sandstone façade contrasts in colour and texture to the greywackes, and the stones do not contain imagery. This structural feature currently has no parallel (Ó Nualláin and Cody 1987, 73; O'Sullivan 1996c, 13; 2004, 47). The stage is also delineated by a broken line of flattish undecorated quartzite boulders that run adjacent to the earthen platform. That particular performances occurred here is supported by the discovery of a large pit cut into the platform, in-line with the passage tomb entrance (again similar to pits at the

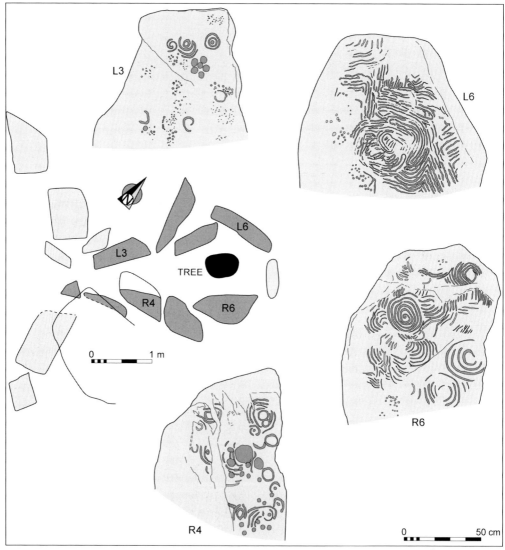

Figure 12.3: Plan of the western passage tomb – shaded stones are decorated (adapted from Ó Nualláin and Cody 1987, fig. 10; O'Sullivan 1987, figs. 15, 16, 17; illustration by Aaron Watson).

Loughcrew and Boyne Valley complexes). The pit fill consisted of ash and baked soil, suggesting an intense or reoccurring fire(s) (O'Sullivan 1996c, 13). Just north of this feature another fire-pit was discovered; neither pit contained bone. Later activities on this platform include the placement of boulders (the largest being *c.* 1m in length), in front of the passage tomb entrance (O'Sullivan 1996c, 13). These features may have been positioned to restrict movement in or out of the tomb, to stimulate bodily adaption, or they may have been used for some other purpose. Certainly, the blocking of the passage tomb sits well with Lynch's (1973, 152) communication proposal, although in this instance there is no aperture present (see also Sheridan 1985/6, 28). Here, we have active performances, rather than passive representation.

The heights of the kerbstones vary between 0.6m and 1.3m. Most of the stones within this structure are green greywackes or grits and most are decorated. The exception is the unusually tall and oddly shaped undecorated pink sandstone located beside the sillstone at the entrance to the inner chamber (formerly known as Orthostat 9, western tomb) (O'Sullivan 1996a, 94). It is not local to the region and it is 'warped and asymmetrical' (O'Sullivan 2004, 48), being structurally 'illogical' (1996a, 94; 1996c, 12) – maybe performance was at play. Certainly, the visual and haptic aspects of this differently coloured and shaped stone and its ability to rupture the dynamics of the construction cannot be denied. The world is after all sensed and not just seen (Greenhough 2010, 43). Following the work of the Chapman brothers, this might be less about addition, and more about displacement. What we may be witnessing are subversive acts within the building process, with emphasis on the right hand side of the tomb. The priority of 'dexter over sinister' (Herity 1974, 123) is interestingly a feature of most passage tombs: evinced in the size of the right hand recesses; the motifs; artefacts and human remains (see also Robin 2010). Material discovered included 'mixtures of mixtures': cremated bone from several persons, some unburnt human and cattle bone, a mushroom-headed pin, a pendant and a bead (O'Sullivan 1996c, 12; see discussions in Cochrane 2007). Interestingly, a chevron decorated fragmented bone object (possibly a pin) was discovered – only three other similar examples are known in Ireland: two from Knowth Site 1 and one from Fourknocks I, Co, Meath (Eogan 1986, 143; O'Sullivan 2004, 49).

Figure 12.4: The winter late evening sun-setting in line with the western passage tomb (digital photograph: Ken Williams).

There are 10 decorated stones within this passage tomb and they fit well within O'Sullivan's Stage 2 sequence (1996a), in that they are mostly basic geometric, yet with a coherent consideration to the modulations of the stone's surface – exploring the tensions. The carving on this tomb is bolder than that on the eastern one with the images themselves more extensively covering particular stones. In one instance, two opposing stones have mutually sympathetic/similar images. Creative movements of concern that affect through action (Anderson and Harrison 2010; Harris and Sørensen 2010). The substantive entrance to the passage here suggests that the structure remained open for longer periods of time than the eastern tomb, perhaps as a result of its particular solar alignment, and that successive performances occurred may explain why the motifs developed past Stage 1 images (O'Sullivan 1996a, 92). I will now briefly describe some of these decorated stones.

Located in the western passage tomb on the left-hand side of the chamber is Stone L3, which stands opposite Stone R4. The front face of Stone L3 is divided by an interrupted diagonal fissure/shelf (not humanly made) and contains extensive areas of loose picking and curvilinear motifs with cupmarks. The picking stops short of covering the entire surface – but creates impressions of generalisation, exaggeration and distortion. Concentric circles occur on the upper right of the stone and are 'delicately applied', with spiral forms nearby (O'Sullivan 1987, 84). Below these motifs are six cupmarks that are placed to produce a coherent looking shape, which suggests that they are deliberate. Stone L6 is located at the left hand inner end of the chamber as one enters it. The decoration occurs on the front face of this orthostat and is badly weathered and damaged, possibly from tree growth. The main design has been described as being integrated and structured around a curvilinear form in the centre, with radiating straight lines. Cupmarks are also present on the lower left segment of the stone (O'Sullivan 1987, 88). Next to this orthostat is positioned the backstone to the chamber at 0.95m above the modern ground-level (O'Sullivan 1987, 88). The front face of this stone is flattish and smooth in texture, with imagery adorning it. The decoration is predominantly formed by zones of loose picking with some curvilinear shapes. The designs cover most of the front face of the stone but they do not reach the extreme edges. There is a single circle at the top of the stone in the middle and above this there is a penannular circle surrounding a cupmark. Interestingly, below the modern ground level is located a spiral (O'Sullivan 1987, 88). There are also patches of loose picking located on the back face of the stone.

Positioned adjacent to Stone L6, with similar imagery, is Stone R6. The motifs on this orthostat seem to respect the fissures in the stone, and therefore may conform to Stage 2 of O'Sullivan's (1996a) sequence. The middle face of the stone is dominated by a central spiral that is surrounded by radiating curvilinear arc shapes and parallel lines near the fissures. These tightly coiled linear designs are not found elsewhere in Ireland (O'Sullivan 2004, 49). Above and below the naturally demarcated band zone on the front face are located groups of concentric circles, and loose arc shapes (O'Sullivan 1987, 88). Experiencing the images here can create a visual stutter in the primary visual cortex, a moment of hesitation, stimulated by the saturation of imagery.

On the right of the main chamber is Stone R4. Although a large section of the front left hand face of this chamber has detached itself, it is still *in situ*. The dominant imagery on this stone consists of circles, loose concentric circles, cupmarks and radiating curvilinear lines that cover the front face and continue below the current ground level (O'Sullivan

1987, 88). This feature may suggest that the orthostat was decorated before being placed in the passage tomb. Each new composition could have produced new experiences – not only the experience of touching it, or seeing it – but also in creating it. There does not have to be linear progression here – each fresh application is an encounter in it own right. Next to this orthostat, Stone R3 is located, near the entrance to the passage tomb. The documented imagery on this stone is currently very limited as most of the orthostat is still buried beneath the modern ground level. The visible motifs consist of a few curvilinear arcs, circles and a possible cupmark (O'Sullivan 1987, 88).

There are approximately six decorated kerbstones on the western passage tomb (Stones K26, K27, K28, K29, K30, K31; see also Figure 12.3). Stone K31 is extensively decorated, with imagery present over the entire front face. Motifs include large meandering lines that change from convex to concave and *vice versa* across the middle of the kerbstone, spirals that are diametrically opposed at an angle, and concentric circles (see Figure 12.5). Combined the motifs create a sense of modulated motion. There are also picking areas present on the left-hand side of the front face (O'Sullivan 1987, 88). Stones K30, K29, K28 and K27 are less dramatically decorated. The scope of the imagery is restricted to concentric arcs and circles, spirals and arcs. It is interesting to note that Stone K27 is possibly a green-grit, as is found in the Boyne Valley (O'Sullivan 1987, 90).

The eastern passage tomb is roughly aligned east–west, with a possibly transept-like feature on the north side, and is formed by a number of set stones that support large

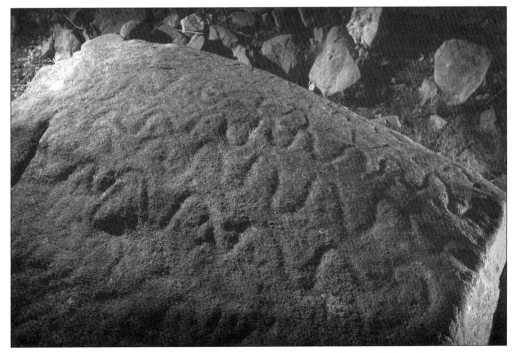

Figure 12.5: Stone K31, Knockroe (digital photograph: Ken Williams).

slabs (six in total), with internal spatial divisions being indicated by sill stones. These compartments include outer, middle and inner sections, opposed lateral recesses and a cist-like structure (O'Sullivan 1995, 19; see Figure 12.6). The occurrence of a cist feature, filled with cremated human remains, is reminiscent of those found at the Mound of the Hostages, Tara, Co. Meath (O'Sullivan 2005; 2006). The passage tomb measures *c.* 3m from entrance to rear and *c.* 2.3m from side to side and probably had a corbelled roof (O'Sullivan 1995, 17; 20). There are two set stones on the southern end and four on the northern end,

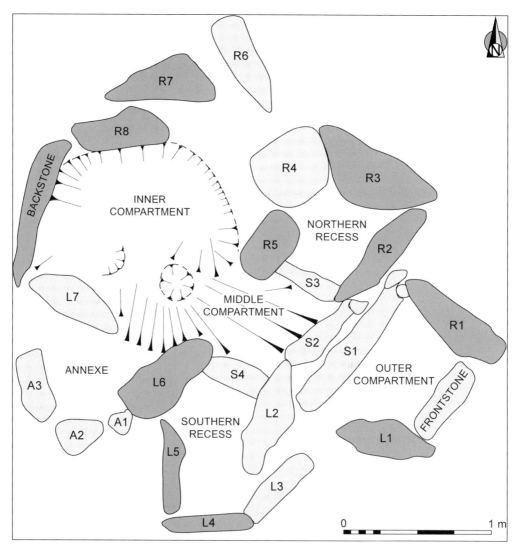

Figure 12.6: Knockroe East – shaded stones are decorated (adapted from O'Sullivan 1995, fig. 3; illustration by Aaron Watson).

ranging in height between 0.13m and 0.7m. The tomb in its current state is severely damaged (Ó Nualláin and Cody 1987, 82), with there being no evidence for an outer passage. The entrance is delineated by a transverse sandstone slab that is *c.* 0.7m high and flanked by Orthostats L1 and R1 (O'Sullivan 1995, 18). Located near this sandstone 'front-stone' was a similar shaped slab that may have rested above and acted as a temporary closing piece that could be swivelled sideways when admittance or exit was required (O'Sullivan 1995, 18). Access to this feature could have been granted via a puncture in the cairn, but only for a limited period of time (O'Sullivan 1996a, 91). Interestingly, scale is key to engagements with passage tombs – they can make one feel diminutive – and yet they can also make one feel large and awkward. Material discovered included more than 15kg of cremated bone, mostly from within the tomb, Carrowkeel decorated red ware and undecorated flat-based pottery, bone pins, beads and a miniature macehead (O'Sullivan 1995, 23). The discovery of a Carrowkeel pot *in situ* mirrors the almost complete pots found in the Mound of the Hostages, Tara, suggesting that some pots were originally deposited intact, only fragmenting through later disturbances (O'Sullivan 1995, 26–7; Cochrane 2007). It is interesting to also note that the Carrowkeel pot was discovered in the right hand recess, near the backstone covered in natural hollows (O'Sullivan 1997, 26; 2004, 48). Here we have performances of articulation and disarticulation – composition and de-composition.

Three patches of burnt platform were also discovered in front of the eastern tomb (O'Sullivan 1993b, 14; 1996c, 13), and although they are not part of cut pits, they may be comparable to the fire-pits of the western passage tomb. Such fires may have been thought of as alive, being both gentle and comforting, but also unruly and dangerous, especially when roaring in the wind at night (Tringham 2005, 107). The fires would have enhanced sensational performances, with the colours of the flames and embers continually changing, accompanied by the sounds of cracking wood and stones, providing an ephemeral focus. The illuminating fire would have influenced the effects of the images enticing them to dance and move (Bradley 2010, 199). The smoke may have brought tears to the eyes, with the smell impregnating the hair and clothes. The heat itself from the fire may have warmed the skin and fuelled passions via the 'sexual excitement' that fire can bring (Tringham 2005, 107).

Although the eastern tomb has no formal passage, the kerb where an entrance area would have been was altered at some point in its life history, with the general greywacke or grit kerbstones being replaced with one conglomerate (K44) and four sandstones (e.g., K43 and K45) (O'Sullivan 1993b, 12). The eastern passage tomb also demonstrates some similarities with the Boyne Valley complex in that a quartz facing occurred above and in front of the sandstone kerbstones and stones mentioned above, with there also being water-rolled nodules on the ground in front of the entrance, and three sandstone balls (Ó Nualláin and Cody 1987, 73; O'Sullivan 1996a, 91; 1996c, 11; 2004, 48). This quartz layer has been interpreted as having slipped from the cairn sides in successive episodes, rather than being placed on the ground as is postulated as a possibility at Knowth Site 1, the eastern tomb (Eogan 1986, 45, 47, 65; O'Sullivan 1993b, 13). Quartz pieces were also discovered overlaying the primary deposits in the outer compartment, and this has been interpreted to have fallen in from overhead on the cairn (O'Sullivan 1995, 19). Within the fill of the annexe was located a large quartz block which may have originally been a roof-stone (O'Sullivan 1995, 21). There has been no attempt to describe a near-vertical quartz wall as is suggested for Newgrange Site 1 (O'Kelly 1982, 72, 110; cf. Bradley 1998, 101; Darvill

2002, 82; Cooney 2006; 704; Eriksen 2006, 709; Stout and Stout 2008, 4–6). Associations with quartz and rock images are becoming increasingly complex, with evidences suggesting that quartz was also incorporated within performances of image production (e.g. Jones 2007; Jones *et al.* 2011; this volume).

Although no stone basin has been found in the eastern tomb, a large bowl shaped pit was discovered in the terminal chamber that may have served similar functions (O'Sullivan 1995, 21; for extend discussion see Cochrane 2007). Up to 10 structural stones are decorated, including Stones L1, L6, R1, R2, R3, R5, R7, R8 (O'Sullivan 1987, 90). All of the motifs in this passage tomb are badly weathered and can be described as belonging to O'Sullivan's Stage 1, in that they are restricted to spirals, circles and ovals, with the plastic qualities seldom explored (O'Sullivan 1995, 15; 1996a, 91). The designs are lightly picked and small in scale, and in contrast to the western passage tomb appear less orientated towards a large scale visual impact and were possibly created in an earlier phase (see also O'Sullivan 1995, 25). Interestingly, the eastern tomb did not contain stone balls or mushroom-head pins, both of which normally form part of the passage tomb assemblages (O'Sullivan 1995, 26).

INCITEMENT

> *'One thing that literature would be greatly the better for*
> *Would be a more restricted employment by the authors of simile and metaphor.'*
> Ogden Nash

With most passage tombs in Ireland there are similarities between their spatial contexts on topographically high locations, with the passage tomb mounds generally occupying positions long-ways on an east–west axis ridge (see also Herity 1974, 156; Cooney 1990, 743). That Knockroe locates itself in a visually commanding site within the side of a hilltop, might reflect an illusion or impression of centrality within the environment (see Watson 2004, 88), allowing the site to be witnessed from lowland perspectives and *vice versa*. The physical effort involved in ascending the hill slopes, the politics of verticality, may have added to or influenced the experiences of the passage tomb. The compositions of the two passage tombs, platforms and mound may bespeak of emerging engagements within the broader environment (see also Bradley 1998, 100, 122–3). As such, Knockroe may have been responding to the hill upon which it resides, with the megalithic kerbs adapting to the mountains that frame the horizons. The initial condition of a place or chamber may have also allowed the creation of a conception place for performances, being *'hierophanies'* (Eliade 1964, 32) or *'heterotopias'* (Foucault 2002, 231–33; see discussions in Cochrane 2005); this would have possibly included the motifs and the placement of the dead. The noted interest in solar alignments might support this (see Hensey 2008). The usage of circular mounds and motifs may also have embodied different expressions of temporality that deny transformation as a forward striving force, instead being more about (dis)continuity and reduplicating reorganisations. Thus fostering experimental enactments – whilst encouraging flourishing forms (Rose 2010, 343). The motifs can be experienced as manipulations through stone (see Gormley 2004, 139), rendering presentations *in* rather than representations *of* the world. The repeated form of similar images may have served as acts to revitalise a particular integrity or sense of identity (see also O'Sullivan 2004, 49). It is the changes

and stabilities that stimulate the fluid dialogues. The occurrence of quartz, the limited range of material remains (e.g. Carrowkeel ware, pins and stone balls), cremated remains, performances near the entrances and preferences for the right-hand side of the passage tomb may also support these propositions. The absence of stone basins is noteworthy. These locales, passage tombs and motifs move from merely occupying places of certainty in the world, and become the uncertain and provocative places of narrative and experience. If some people were attempting to perform a common world, it was something they were composing, building, fabricating and making together (Latour 2004, 455).

BEING COMPOSED

> *I have an idea for a new composition, which has no programme but will express what we understand by the spirit of life or manifestations of life, that is: everything that moves, that wants to live*
>
> Carl Nielsen

Nothing will ever be as good as you imagine it – significances, meanings, memories, (de)illusions to other worlds and entities – they are the intangibles – and they rarely wither. To move beyond these perennial occurrences has been one of the aims of this paper. Passage tombs were probably more sites of creation than curation – fluid rather than stable – adaptations in performance with folds with eddies (Cochrane 2006; 2010; Van Saaze 2009; Shanks and Witmore 2010). Motifs are therefore events in their own right and not subservient to an invisible immutable symbolic original – that is located just out there – or over there, or behind and below. Passage tomb images are an emergent novelty and a moment of uncertain hesitation with possibility.

ACKNOWLEDGMENTS

I would like to thank Alasdair Whittle and Douglass Bailey for commenting on very early drafts of this paper. Special thanks to Aaron Watson for creating the superb illustrations and for discussions, and also to Kate Waddington for helping create the map in Figure 12.1. The Knockroe photographs were created by Ken Williams – Ken's work never ceases to amazing me – the man is a legend! A big thank you to Muiris O'Sullivan for his support and for allowing me access to unpublished data on the Knockroe excavations (due out in 2012). Thank you to Simon Kaner for his support with this and other work. Andy Jones has big respect for his ongoing encouragement and for batting back critical comments – thank you! I dedicate this paper to James Marshall for his continual friendship.

NOTES

1 Such approaches have been dominant for over *150 years*. They are representational and stipulate that things and meanings lie behind or just beyond the image – through the cracks if you like. They mostly subscribe to textual understandings – and often can be very expressionistic and poetic. Ultimately based on the idea that an image can represent something else – be it an ancestor,

text, creature, hybrid, language, face, god, swastika, plant, celestial phenomenon, worldview or another image, like a hallucination. This sample list is by no means exhaustive: Wilde (1849); Deane (1889-91); Coffey (1912); Breuil (1921); Macalister (1921); Mahr (1937); Crawford (1957); Herity (1974); Brennan (1983); Thomas (1992); Lewis-Williams and Dowson (1993); Dronfield (1995); Tilley (1999); Nash (2002).

 Within modernity it increasingly seems as if *all* images must represent. Supported by a long (a very long) history of archaeological assertion, I wonder how much more ink needs to be spent arguing that they can. In doing so, what would be the benefit to archaeology? At what point does it become cliché?

2 I am not proposing that we do away with representational understandings, as to do so would be to 'throw the baby out with the bath water' (Cochrane 2009a, 174). I have no wish either to replace the myth of representation with the 'myth of the clean slate', which demands negating all that went before and establishing a new order (Koerner 2010b). I also appreciate that categorisations of 'abstract' and 'geometric' are just conceits. As a beginning to a solution I suggest that we attempt to create a sense of conceptual equivalence in our interpretations (see also Introduction chapter in this volume).

3 As the Neolithic and contemporary art are both products of modernity, and only ever exist in the present, I feel that the creation of narratives with contemporary examples is perfectly appropriate (see Thomas 2004; Cochrane and Russell 2007; Renfrew 2003; Bradley 2009; Cochrane 2009b; Shanks and Witmore 2010; Russell 2011).

REFERENCES

Anderson, B. and Harrison, P. 2010. The promise of non-representational theories. In B. Anderson and P. Harrison (eds), *Taking Place: non-representational theories and geography*, 1–34. Farnham: Ashgate Publishing.

Badura-Triska, E. 2006. *Franz West: early work*. New York: David Zwirner.

Bailey, D., Cochrane, A. and Zambelli, J. 2010. u*nearthed: a comparative study of Jōmon dogū and Neolithic figurines*. Norwich: SCVA.

Barrett, D. and Head, L. 2007. *Jake and Dinos Chapman (New Art Up-Close 3)*. London: The Royal Jelly Factory.

Barthes, R. 1970 [2005]. *Empire of Signs*. Trans. R. Howard. London: Anchor Books.

Bradley, R. 1998 *The Significance of Monuments: on the shaping of human experience in Neolithic and Bronze Europe*. London: Routledge.

Bradley, R. 2010. Epilogue: drawing on stone. In J. Goldhahn, I. Fuglestvedt and A. Jones (eds), *Changing Pictures: rock art traditions and visions in northern Europe*, 197–205. Oxford: Oxbow Books.

Brennan, M. 1983. *The Stars and the Stones: ancient art and astronomy in Ireland*. London: Thames & Hudson.

Breuil, H. 1921. Les pétroglyphes d'Irlande. *Revue Archéologique* 13, 75–8.

Cochrane, A. 2005. A taste of the unexpected: subverting mentalités through the motifs and settings of Irish passage tombs. In D. Hofmann, J. Mills and A. Cochrane (eds), *Elements of Being: mentalités, identities and movement*, 5–19. Oxford: British Archaeological Report 1437.

Cochrane, A. 2006. The simulacra and simulations of Irish Neolithic passage tombs. In I. Russell (ed.), *Images, Representations and Heritage: moving beyond a modern approach to archaeology*, 251–82. New York: Springer-Kluwer.

Cochrane, A. 2007. We have never been material. *Journal of Iberian Archaeology* 9/10, 138–57.

Cochrane, A. 2008. Some stimulating solutions. In C. Knappett and L. Malafouris (eds), *Material Agency: towards a non-anthropocentric approach*, 157–86. New York: Springer-Kluwer.

Cochrane, A. 2009a. Additive subtraction: addressing pick-dressing in Irish passage tombs. In J. Thomas and V. Oliveira Jorge (eds), *Archaeology and the Politics of Vision in a Post-modern Context*, 163–85. Cambridge: Cambridge Scholars Publishing.

Cochrane, A. 2009b. What I think about when I think about Time. In J. Savage (ed.), *Depending on Time*, 30–4. Cardiff: Safle.

Cochrane, A. 2010. Re-playing the past in an age of mechanical reproduction. In S. Koerner and I. Russell (eds), *The Unquiet Past*, 33–47. Aldershot: Ashgate Publishing.

Cochrane, A. and Russell, I. 2007. Visualizing archaeologies: a manifesto. *Cambridge Archaeological Journal* 17(1), 3–19.

Coffey, G. 1912. *New Grange and other Incised Tumuli in Ireland: the influence of Crete and the Aegean in the extreme west of Europe in early times*. Dublin: Hodges, Figgis and Co.

Cooney, G. 1990. The place of megalithic tomb cemeteries in Ireland. *Antiquity* 64, 741–753.

Cooney, G. 2006. Newgrange – a view from the platform. *Antiquity* 80, 697–710.

Crawford, O. G. S. 1957. *The Eye Goddess*. London: Phoenix House.

Darvill, T. 2002. White on blonde: quartz pebbles and the use of quartz at Neolithic monuments in the Isle of Man and beyond. In A. Jones and G. Macgregor (eds.), *Colouring the Past: the significance of colour in archaeological research*, 73–91. Oxford: Berg.

Deane, T. N. 1889–91. On some ancient monuments scheduled under Sir John Lubbock's Act, 1882. *Proceedings of the Royal Irish Academy* 1 (Third Series), 161–5.

Doel, M. A. 2010. Representation and difference. In B. Anderson and P. Harrison (eds), *Taking Place: non-representational theories and geography*, 117–30. Farnham: Ashgate Publishing.

Dronfield, J. 1995. Subjective vision and the source of megalithic art. *Antiquity* 69, 539–49.

Eliade, M. 1964. *Shamanism: archaic techniques of ecstasy*. Princetown: Princetown University Press.

Eriksen, P. 2006. The rolling stones of Newgrange. *Antiquity* 80, 709–10.

Eogan, G. 1986 *Knowth and the passage-tombs of Ireland*. London: Thames & Hudson.

Fleck, R., Curiger, B. and Benezra, N. 1999. *Franz West*. London: Phaidon Press.

Foucault, M. 2002. Of other spaces. Trans. J. Miskowiec. In N. Mirzoeff (ed.), *The Visual Culture Reader: second edition*, 229–36. London: Routledge.

Greenhough, B. 2010. Vitalist geographies: life and the more-than-human. In B. Anderson and P. Harrison (eds), *Taking Place: non-representational theories and geography*, 37–54. Farnham: Ashgate Publishing.

Gormley, A. 2004. Art as process. In C. Renfrew, C. Gosden and E. DeMarrais (eds), *Substance, Memory, Display: archaeology and art*, 131–51. Oxford: McDonald Institute for Archaeological Research.

Harris, O. and Sørensen, T. F. 2010. Rethinking emotion and material culture. *Archaeological Dialogues* 17(2) 145–63.

Hensey, R. 2008. The observance of light: a ritualistic perspective on 'imperfectly' aligned passage tombs. *Time and Mind* 1(3), 319–29.

Herity, M. 1974. *Irish Passage Graves: Neolithic tomb-builders in Ireland and Britain, 2500 BC*. Dublin: Irish University Press.

Jones, A. 2007. Excavating art: recent excavations at the rock art sites at Torbhlaren, near Kilmartin, mid-Argyll, Scotland. *Past* 57, 1–3.

Jones, A., Freedman, D., Lamdin-Whymark, H., O'Connor, B., Tipping, R. and Watson, A. 2011. *An Animate Landscape: rock art and the prehistory of Kilmartin, Argyll*. Oxford: Windgather Press.

Koerner, S. 2010a. Preface: 'Playing Statues'. In S. Koerner and I. Russell (eds), *The Unquiet Past*, xiii–xv. Aldershot: Ashgate Publishing.

Koerner, S. 2010b. rethinking 'crises over representation'. In S. Koerner and I. Russell (eds), *The Unquiet Past*, 1–7. Aldershot: Ashgate Publishing.

Kondō, Y. 2011. *Passage Grave Cemeteries of Ireland: focusing on Loughcrew*. Kyoto: Shin'yosha Co.

Latour, B. 2004. Whose cosmos? Which cosmopolitics? *Common Knowledge* 10(3), 450–62.

Latour, B. 2010. An attempt at a 'Compositionist Manifesto'. *New Literary History* 41, 471–90.

Lewis-Williams, J. D. and Dowson, T. A. 1993. On vision and power in the Neolithic: evidence from the decorated monuments. *Current Anthropology* 34(1), 55–65.

Lorimer, H. 2005. Cultural geography: the busyness of being 'more-than-representational'. *Progress in Human Geography* 29(1), 83–94.

Macalister, R. A. S. 1921. *Ireland in pre-Celtic Times.* Dublin.

Mahr, A. 1937. New prospects and problems in Irish prehistory: presidential address for 1937. *Proceedings of the Prehistoric Society* 3, 201–436.

Marcoci, R. 2007. Interview with Franz West. In R, Marcoci (ed.), *Comic Abstraction: image-breaking, image-making*, 114–19. New York: The Museum of Modern Art.

Molyneux, J. 1998. State of the art: a review of the 'Sensation' exhibition at the Royal Academy of Arts, September–December 1997. *INTERNATIONAL SOCIALISM* 79. Available at: http://pubs.socialistreviewindex.org.uk/isj79/molyneux.htm Accessed: 15 December 2009.

Nash, G. 2002. The landscape brought within: a re-evaluation of the rock-painting site at Tumlehed, Torslanda, Göteborg, west Sweden. In G. Nash and C. Chippindale (eds), *European Landscapes of Rock-art*, 176–94. London: Routledge.

O'Sullivan, M. 1986. Approaches to passage tomb art. *Journal of the Royal Society of Antiquaries of Ireland* 116, 68–83.

O'Sullivan, M. 1987. The art of the passage tomb at Knockroe, county Kilkenny. *of the Royal Society of Antiquaries of Ireland* 117, 84–95.

O'Sullivan, M. 1989. A stylistic revolution in the megalithic art of the Boyne Valley. *Archaeology Ireland* 3(4), 138–142.

O'Sullivan, M. 1993a. *Megalithic Art in Ireland.* Dublin: Country House.

O'Sullivan, M. 1993b. Recent investigations at Knockroe passage tomb. *Journal of Royal Society of Antiquaries of Ireland* 123, 5–8.

O'Sullivan, M. 1995. The east tomb at Knockroe. *Old Kilkenny Review* 47, 11–30.

O'Sullivan, M. 1996a. Megalithic art in Ireland and Brittany: divergence or convergence? *Revue Archéologique de l'Ouest*, supplément 8, 81–96.

O'Sullivan, M. 1996b. Comment on 'Entering alternative realities: cognition, art and architecture in Irish Passage Tombs' by J. Dronfield. *Cambridge Archaeological Journal* 6(1), 59.

O'Sullivan, M. 1996c. A platform to the past – Knockroe passage tomb. *Archaeology Ireland* 10(2), 11–13.

O'Sullivan, M. 1997. On the meaning of megalithic art. *Brigantium* 10, 23–35.

O'Sullivan, M. 2004. Little and large: comparing Knockroe with Knowth. In H. Roche, E. Grogan, J. Bradley, J. Coles and B. Raftery (eds), *From Megaliths to Metals: essays in honour of George Eogan*, 44–50. Oxford: Oxbow Books.

O'Sullivan, M. 2005. *Duma na nGiall: the Mound of the Hostages, Tara.* Bray: Wordwell.

O'Sullivan, M. 2006. The Mound of the Hostages, Tara: a pivotal monument in a ceremonial landscape. *Archaeology Ireland. Heritage Guide 32*.

Renfrew, C. 2003. *Figuring it out. What are we? Where do we come from? The parallel visions of artists and archaeologists.* London: Thames & Hudson.

Robin, G. 2010. Spatial structures and symbolic systems in Irish and British passage tombs: the organization of architectural elements, parietal carved signs and funerary deposits. *Cambridge Archaeological Journal* 20(3), 373–418.

Rose, M. 2010. Envisioning the future: ontology, time and the politics of non-representation. In B. Anderson and P. Harrison (eds), *Taking Place: non-representational theories and geography*, 341–61. Farnham: Ashgate Publishing.

Rotherham, E. C. 1895. On the excavation of a cairn on Slieve-na-Caillighe, Loughcrew. *Journal of the Royal Society of Antiquaries of Ireland* 25(3), 311–6.

Russell, I. 2011. Art and archaeology. A modern allegory. *Archaeological Dialogues* 18 (2) 172–76.

Sagmeister, R. 2005. 'Sex' and 'Death': the body as battlefield between heaven and hell. In E. Schneider (ed.), *Jake and Dinos Chapman: Hell. Sixty-Five Million Years BC. Sex Death Insult to Injury. The Chapman Family Collection.* Bregenz: *Kunsthaus Bregenz.*

Self, W. 2006. Art for fiction's sake. *Tate etc.* 8, 84–5.

Shanks, M. and Witmore, C. 2009. Memory practices and the archaeological imagination in risk society: design and long term community. Available at: http://documents.stanford.edu/michaelshanks/438?view=print Accessed: 20 February 2010.

Shanks, M. and Witmore, C. 2010. Memory practices and the archaeological imagination in Risk Society: design and long term community. In S. Koerner and I. Russell (eds), *The Unquiet Past*, 269–89. Aldershot: Ashgate Publishing.

Sheridan, J. A. 1985/1986. Megaliths and megalomania: an account, and interpretation, of the development of passage tombs in Ireland. *Journal of Irish Archaeology* 3, 17–30.

Sloterdijk, P. 2005. Forward to the theory of spheres. In M. Ohanian and J. C. Royoux (eds), *Cosmographs*, 223–41. New York: Lukas and Sternberg.

Storr, R. 2003. Franz West's corporeal comedy. *Art in America* 91(10), 96–99.

Stout, G. and Stout. M. 2008. *Newgrange.* Cork: Cork University Press.

Thomas, J. 1992. Monuments, movement and the context of megalithic art. In N. Sharples and A. Sheridan (eds), *Vessels for the Ancestors*, 143–55. Edinburgh: Edinburgh University.

Thomas, J. 2004. *Archaeology and Modernity.* London: Routledge.

Tilley, C. 1991. *Material Culture and Text: the art of ambiguity.* London: Routledge.

Tringham, R. 2005. Weaving house life and death into places: a blueprint for a hypermedia narrative. In D. Bailey, A. Whittle and V. Cummings (eds), *(Un)settling the Neolithic*, 98–111. Oxford: Oxbow Books.

Van Saaze, V. 2009. Doing artworks. An ethnographic account of the acquisition and conservation of *No Ghost just Shell. Krisis: Journal for Contemporary Philosophy* 1, 20–32.

Verwoert, J. 2003. Adaptation: Franz West. *Frieze* 76, 98–101.

Wilde, W. 1849. *The Beauties of the Boyne and the Blackwater.* Reprinted [2003]. County Galway: Kevin Duffey.

The circle, the cross and the limits of abstraction and figuration in north-western Iberian rock art

Lara Bacelar Alves

> '...*though the echoes and shadows of art enrich the life of the plains, her spirit dwells on the mountains.*'
>
> (Clive Bell, 1914, 23)

INTRODUCTION: CONTRASTING IMAGES

The circle and the cross are paradoxical images. In this paper I shall consider these antagonistic forms as symbols of the relationship between two prehistoric rock art traditions in Western Iberia: Atlantic Art and Schematic Art.

The former is found along the Atlantic façade of Galicia and northern Portugal whereas Schematic Art generally extends across Mediterranean or sub-Mediterranean areas of Iberia. This distribution probably echoes their distant origins: Schematic Art figurative paintings spread along the Mediterranean whereas the abstract-geometric style is more typical of the so-called Atlantic façade bio-geographical area of Europe (Figure 13.1). Apart from their wide span in time and space, they also enclose two entirely different ways of dealing with rocks and visual imagery (Figure 13.2).

Atlantic Art is materialised as carvings cut into the smooth surfaces of open air outcrops, dominating extensive views across the open country. In north-west Portugal and Galicia, they are usually found in platforms half-way up slope in a hilly landscape, usually away from valley bottoms or the top of upland plateaux. Conversely, the Schematic Art style is typically painted in the inner or hidden recesses of rocky outcrops. They are usually placed in rock shelters, small caves or cliff walls. Schematic Art sites tend to occur at liminal places, on the highest and lowest parts of the landscape concealed either on quartzite crests running down from the top of conspicuous mountains or in rocky sections of river valleys. Atlantic Art features mainly abstract and curvilinear motifs like cup-marks, cup-and-rings, wavy lines, at times, creating monumental compositions. Although the range of the basic visual forms is rather limited and repetitive, it is clear that artistic creativity was fundamental in the creation of abstract compositions. Every single arrangement is unique, as it is unique the morphology of each carved rock outcrop and the natural shapes of the land where it sits. Apart from the geometric designs, Iberian Atlantic Art is associated with sub-naturalistic depictions of animals (mainly deer and horses and, occasionally, cattle and goats) and with the representation of prehistoric weapons (particularly, daggers and halberds). This range

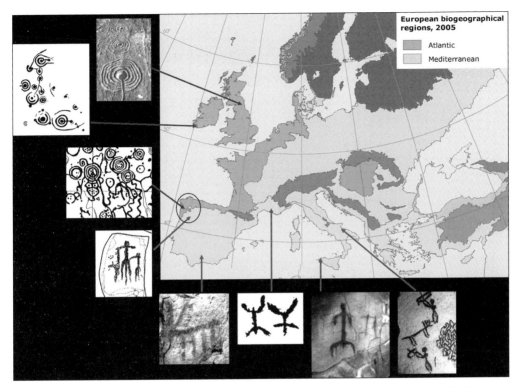

Figure 13.1: The broader distribution of Atlantic Art and Schematic Art across the Atlantic and Mediterranean biogeographical regions of Europe. The ellipse indicates the location of the study area (the cartographic section of this fig. was adapted from the Indicative map of the European biogeographical regions/Centre for nature conservation URL: http://www.ecnc.org/, accessed in October 2010).

of figurative motifs appears either associated with abstract designs or in isolation as the single theme on one rock. The human figure does not occur very frequently and tends to be associated with the depiction of scenes featuring herds of wild animals.

On the contrary, in the Schematic Art tradition, the human figure is recurrent. It is represented in a rather stereotyped manner and its shape can occasionally be reduced to its most elementary shape: the cross. These motifs tend to occur alongside geometric and abstract signs similarly composed of lines set at right angles: squares, rectangles and trapezoidal shapes internally segmented. Arrangements of dots and straight lines are frequent. Depictions of the sun and quadrupeds also occur and are represented in a linear and schematic manner. There is little formal variation within each class of motifs. They seem to work more as ideograms since the depiction of narrative scenes exists but is relatively rare. To a great extent, motifs seem to have been placed as individual images over the rocky walls. A selection of Schematic Art designs, particularly human figures, also appears as carvings on open air outcrops.

As many authors have emphasised, Atlantic Art interacts closely with the natural landscape (e.g., Bradley 1997). At many sites, the placement of the carvings themselves

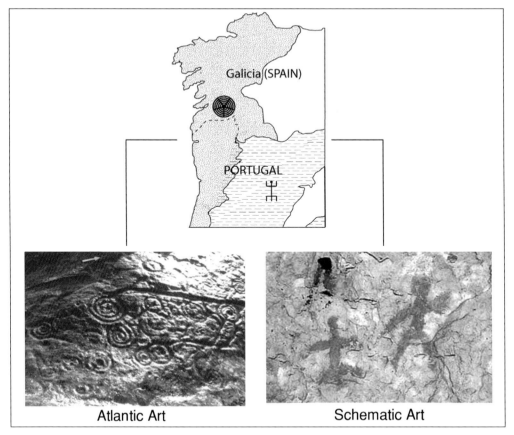

Atlantic Art Schematic Art

Figure 13.2: Two contrasting systems of visual communication occur at complementary regions of Western Iberia in Late Prehistory.

constrain physical movement around the rock and guide the observer's sight in the direction of particular points in the surroundings. Iberian Atlantic Art sites are usually highly visible in the landscape and easily accessible. In fact, carved outcrops tend to scatter across hills and hillsides not far from areas suitable for permanent settlement and, in this sense, they occur in areas which are likely to have been used in the scope of daily activities, like herding, hunting and gathering. In parts of Galicia, where the landscape is well preserved, there are outstanding concentrations of carved rocks on particular geo-morphological features and they were certainly meant to be perceived as a whole. It is as if we are dealing with a 'tattooed' landscape composed of hundred of indelible images fixed upon the skin of the land.

In the act of carving, the rock surface is physically altered, cut into, moulded and sculpted. As rocks provide texture to the land, carvings add texture to rocks. It is a rather tactile art but is also visually impressive, particularly when the sunlight strikes obliquely on the rocks emphasising the motifs' sculptural relief. Yet, the creation of Atlantic Art

compositions certainly implied, in many cases, drawing a previous sketch of the artwork intended to be placed on a particular rock surface as it is attested that many compositions were produced in a single moment and were not the result of a cumulative process of addition of motifs. Thus, not only it was necessary to have in-depth knowledge of the codes behind the symbolic language applied but also artistic and technical skills were involved in the conception of these places. Producing a complex composition of abstract designs on granite was a long-term enterprise, which encompassed enduring and rhythmic hammering on the rock surface, whose sound resonated across the land (Alves 2009, 178).

In opposition, Schematic Art sites are usually found at remote locations, sometimes at dangerous places and were probably not visited on a daily basis. There are a number of examples though where painted rock shelters sit on the periphery of settlements but they are usually concealed on rocky slopes or cliffs (e.g., Sanches 1997). Painted rock shelters do not usually display a large number of motifs and even if they do, it seems as if figures were added on over time, in successive moments. Indeed, the confinement experienced in many of these places suggests that paintings were produced by few, occasionally, and in intimate ceremonies. Moreover, the preparation of pigments and the act of painting itself was swift, silent and did not involve fine technical expertise. Rocks were not physically altered but painted motifs often interact with peculiar features in the rock face, like shimmering surfaces, lumps of quartz, mineral intrusions, natural crevices, and there is also one case in the Côa valley (Portugal) where they interact with Palaeolithic art (Baptista 1999).

Following this description, we seem to observe two systems of visual communication which are quite distinct in terms of the techniques of execution employed, the *loci* and the ways people experience them, the landscape setting, the range of designs, the manner in which motifs interact with the natural backdrop. They occur in neighbouring regions of northern Portugal which are traditionally very different on cultural grounds (e.g., Ribeiro 1963) and converge along the biogeographical transition between the Iberian Atlantic and sub-Mediterranean areas. We may therefore raise the question of whether each of these systems might correspond to specific social, cultural and ideological backgrounds. However, against the idea that we may be before two independent systems of visual culture, some may argue that the most typical designs of Atlantic and Schematic Art appear as individual motifs in other rock art contexts across Iberia.

It can be just a matter of how we put things into perspective, but it has important implications for our understanding of late prehistory at a regional and supra regional scales. There are a large number of issues that need to be discussed in the face of this evidence. First, we need to address the question of style: how is style conceptualised and identified? What are the implications of adhering to a particular notion style for the way rock art research is carried out? Second, the question of time: are we able to trace the origins of either style? What might have been the chronological relationship between them? How did rock art developed in both regions in the long-term? Is open air art related in any way to megalithic art? Could this tell us anything about the social and cultural identity of the people who created these places? Thirdly, questions may be raised regarding the dichotomy between figuration and abstraction. Neither Iberian Atlantic Art nor Schematic Art is exclusively abstract or figurative if we attend to the wider picture, but could it be that any of them was at some point exclusively abstract or figurative? Could abstract designs have had a specialised role? How does abstraction and figuration relate to each style?

THE QUESTION OF STYLE

Nancy Olsen stated that: '*rock art is that portion of a culture's visual communication system which is painted and incised onto rock surfaces. The system will consist of a "lexicon" of elements particular to the culture, it will have affinities for certain contexts, and will show organisational principles at work indicating cognitive structure.*' (1989, 427). Olsen's definition of rock art, based on the connection of several elements, leads us obliquely to the notion of style.

Style is a controversial concept but it has been used in rock art studies since its early inception because it provides a structural background for investigation. Archaeologists and rock art researchers in particular, talk about style in terms of what is commonly defined as *general style*, i.e. *historical or period style*, which means that style is thought of as belonging to a specific chronological period, region, culture or people (Meskin, 2005, 493). As opposed to *individual style*, the production of art is governed by socially legitimised rules, meaning that artists work in shared practices or traditions (*ibid.*).

Some may argue that style needs to be separated from function, others privilege function and others still look at style as a mere aesthetic device, emphasising the role of form. The idea that style is synonymous with form may however be misleading. In rock art studies, overemphasising form in stylistic analysis is characteristic of an agenda of research that privileges technical, typological and morphological analysis. In the past, this lead to the use of technique as an element of stylistic differentiation or to associate individual designs with a specific period or cultural context. Across Iberia, simple circles and sets of concentric circles sporadically occur in association with Levantine Art or even with Schematic Art paintings. They are a recurrent feature in both the Iberian Atlantic Art and the Tagus valley rock art, in central Portugal, which is carved on open air rocks along the river banks. But to what extent does the presence of images which are formally alike mean that all these rock art assemblages relate stylistically to each other, or are stylistically influenced by each other? Can a specific type of motif be associated with a particular chronology or cultural group? This does not seem likely. There is more to style that the formal properties of one specific element of a work of art. Although it plays an important role in interpretation, style also requires interpretation (Meskin 2005, 492) and determining the style of a particular figure in rock art requires some knowledge of its wider context of production.

Style has more to do with 'the way things are done' (cited in Meskin 2005, 497) and this implies the connection of several elements which are visible in a work of art. Robert Layton argues that style relates to the formal properties of the works of art as a whole and conveys three basic factors. First, the range of motifs depicted, secondly, the regularity of shapes, and finally, the manner in which components are organised into a composition (Layton 1991, 150). As far as rock art is concerned, we could add other relevant factors like the interaction between the motifs and the natural backdrop or the relationship between the site and the wider landscape. This means that, independently of the use of particular techniques, there is style. Moreover, it may not be the presence of a particular motif that allows us to identify the style of a composition but the range of motifs in articulation with the remaining factors pointed out by Layton. But is also true that two compositions may originate from the same general style but differ in terms of contents, meaning and subject matter (Meskin 2005, 496).

Style requires, above all, some sort of recurrence and time depth. Howard Morphy rightly considers that style mediates between past and present production (1994). As style

is created with the aim of consciously maintaining formal resemblance, it enhances the continuity of past forms. It works as a means of communication among members of a particular society or among communities which are culturally and/or ideologically related. As the maintenance of a style helps the prevalence of symbolic meaning across generations, not unlike oral traditions, it works as a means of social cohesion. The maintenance of a style may contribute to the creation of an artistic tradition. Denis Dutton stresses the idea that artistic manifestations that are associated with religious practices are constrained by tradition, while other art objects or performances originating in the same cultural background may be opened to more free, creative and individual variation (2005, 287). Tradition may encompass its own rhythms in terms of stylistic evolution. Because style is consciously produced, it has a dynamic of its own, developing or declining as part of processes of socio-cultural change. It may involve sudden or slow alterations depending on the internal dynamics of the social context in which it is use.

Therefore, if style is deeply attached to social and cultural contexts, rock art studies must be firmly linked to mainstream Archaeology (Bradley 1997, 8). They should also attend to the relationship between different art forms – rock art, megalithic art, sculpture and portable art – that occur at regional or supra regional scales and at different time scales. For instance, anthropologists are able to demonstrate that different styles can co-exist in a particular region and may be common to a specific culture (Layton 2001). Ethnographic evidence demonstrates that audiences understand, through the recognition of the style of a composition, that the images convey specific messages of religious or secular meaning (*ibid.*). In the study area, the two major traditions of post-glacial rock art may be contemporary of the practice of painting or carving the slabs of megalithic tombs. However, whilst in some areas there is a clear stylistic convergence between both phenomena, in others, the styles employed in the open air and within tombs only tenuously overlap. This issue that has been traditionally addressed in terms of the presence/absence of individual motifs, should therefore be considered in the light of the wider contexts of Iberian Neolithic rock art.

WIDER CONTEXTS

If Schematic Art paintings and Atlantic Art merge in the north-western corner of Iberia, it means that they encompassed processes of transmission, adoption or rejection. The motivations for adopting or rejecting a particular system of visual communication attached to an artistic style were certainly bounded to the social, cultural and cosmological backgrounds of prehistoric communities. As suggested, after its initial adoption, both styles were certainly permeable to change, they may have came out of fashion at some point and their graphic conventions could even have been re-appropriated many centuries later. But there is an elementary question that only in recent years was firmly put at the outset of investigation: why does the geographical distribution of Schematic Art paintings and Atlantic Art carvings largely complement each other?

Although this seems to be a very straightforward question, there are many reasons why it has not been given emphasis to in the course of the history of research. It has to do not only with the priorities and character of rock art studies on both sides of the administrative border between Galicia (Spain) and Portugal, but also with the unbalanced degree of

research carried out in either country (discussed in Alves 2003, chapter 3). Throughout its centenary history of rock art research, Galician scholars tended to focus on the evidence within the province where the assemblage is consistent and relatively homogeneous. It was considered a unitary group under the term 'Galician petroglyphs' (e.g., Sobrino 1935; de la Peña and Rey 1993, 2001) or 'Galician-Atlantic rock art' (Lorenzo-Ruza, 1953). The Portuguese collection of rock art with similar attributes was understood as an extension of this group on the southern outskirts of the border. Yet, in truth, it runs down about 150km along the north-western coast of Portugal (e.g., Souto 1932; Alves 2003) (Figure 13.2). The fact that this group scatters across the Atlantic façade whereas Schematic Art paintings are confined to the north-east of Portugal has long been acknowledged by Portuguese researchers yet the latter was understood as being subsequent in time. Atlantic Art was generally dated to the Bronze Age (Baptista, 1983/84; Bettencourt and Sanches, 1998) and the chronological boundaries of Schematic Art span from the Neolithic (5th–4th millennium BC) to the Copper Age (3rd millennium BC). Although we cannot address here the question of the presence of open air carvings inspired by the Schematic Art style in areas that overlap with Atlantic Art distribution, this too was crucial to the establishment of the Portuguese diachronic sequence for post-glacial art (e.g., Alves 2003, 400–417). Moreover, research in northern Portugal was not as exhaustive as in Galicia. The fact is that only in the last 15 years, the interest on their shared life-history was renewed, particularly after Richard Bradley and Ramon Fábregas carried out studies across the two sides of the border (1996). More recently, research started to widen the temporal and spatial scale of analysis, introducing a dialectical perspective, and focusing on the social and cultural contexts of prehistoric art as a whole, therefore avoiding compartmentalising the evidence in rigid classification schemes.

As far as the origins of the imagery typical of both traditions and the role that rock art sites might have played in the past are concerned, the study of the wider contexts in which the imagery was used and associated archaeological evidence allow us to have a better glimpse of the role of rock art in the *modus vivendi* of prehistoric communities (Bradley 2009). It seems to be consensual at present that the significance of Schematic Art relates in many ways with the funerary sphere (e.g., Bueno and Balbin 1992; 2002). This relationship becomes apparent when we realise that within the distribution area of Schematic Art, passage graves were decorated with a range of figurative designs that include human figures, animals and grids, which are stylistically comparable to Schematic Art paintings on natural rock formations (e.g., Baptista 1986). But there is more evidence to be considered. Sima de Curra (Málaga, Spain) is a natural cave whose internal space is reminiscent of a passage grave. Its circular innermost space, was used as a funerary chamber and on its walls was painted in red a schematic human figure (Sanchidrian 1984–85). Moreover, amongst the grave goods of a pit burial, dated to the Copper Age, at Lorca, Murcia (Spain) was an animal bone painted with Schematic Art imagery (Martínez Sanchez *et al.* 2006).

However, in the Atlantic façade of northern Iberia, a comparative study between rock art and megalithic art shows that, in opposition to the evidence in north-east Portugal, megalithic art is mostly abstract showing a strong emphasis on curvilinear designs (Bello 1994) and its distribution is consistent with that of Atlantic Art (e.g., Alves 2009, 174, fig. 16:1). Yet, in megaliths, only a few individual motifs recall open air carvings – wavy lines, simple and concentric circles – and the way curvilinear designs are arranged into

compositions inside funerary chambers differs from the open air assemblage. Yet, we may raise the question: if Atlantic Art is a 'geographical art' as Richard Bradley puts it (1997) and it only makes sense if it is perceived in relation to the open landscape, why should exactly the same conventions be used inside tombs? Could we be dealing with a wider system of representation of abstract character with two contemporary styles fulfilling different roles within one tradition, one meant to be exhibited in the open-landscape and another conceived for the dead?

Therefore, if we accept the scenario where two contemporary megalithic art traditions, one mostly figurative, the other mostly abstract, as suggested by Bello (1994), overlap, in space, with two rock art traditions with similar characteristics, could the origins of Iberian Atlantic Art's abstract imagery be assigned to the 4th millennium BC? This hypothesis has hardly been seriously considered or tested but if it is to be in the future, we need to understand on what grounds the current chronology was established.

THE QUESTION OF TIME

If the Neolithic chronology of Schematic art paintings is widely accepted, the origins of Atlantic Art in time and space are difficult to determine. It is possible nonetheless that at a specific moment of the sequence, perhaps the earliest, this style spread widely across different areas of Atlantic Europe. The selection of its basic designs arranged in simple or complex compositions is common to the prehistoric art of Galicia, NW Portugal, Ireland, northern England and Scotland. Yet, the style developed regionally and, in north-western Iberia, this might have implied the selective incorporation of new designs through time. Over the last two decades, Galician scholars have been considering the stylistic assemblage composed of abstract designs, animals and weapons, as an homogeneous group dated to the late 3rd–beginning of the 2nd millennium BC, which corresponds to the Iberian Copper Age/Early Bronze Age transition (e.g., de la Peña and Rey 1993; 2001). This proposal is partly based on the chronology of daggers and halberds represented in rock art. In reality, weapon carvings are virtually absent from northern Portugal and comprise a small percentage of the overall Galician rock art. Although weapon carvings provide a good relative dating element, should they be generalised for the whole rock art assemblage? Or could they have been introduced at a specific phase in the sequence?

It is interesting to note that daggers and halberds are the most common depictions of metal objects in Mont Bego and Valcamonica (e.g., De Lumley 1995; Anati 1994) and are assigned to a period when contacts between the western Mediterranean and northern Iberia seem to have increased (Jorge 1991). The deposition of metalwork on rocks as visual imagery and also the relationship between the landscape setting of both metal hoards and rock art in Galicia have been, in recent years, object of research projects with very interesting results and stimulating interpretative proposals (e.g., Bradley 1998; Comendador 2010). In Galicia and northern Portugal, there are a number of cases of metal objects found in rock fissures, and the close spatial relationship between Foxa Vella weapon carvings and the location of the Monte Lioira metal hoard is a remarkable example of the relationship between the two phenomena (Calo and González 1980; Bradley 1998; Comendador 2010). However, we should also draw attention to two important references by Sobrino (1935)

about the discovery of metal objects at rock art sites in Galicia. In Pedra do Lombo da Costa (San Jorge de Sacos, Cotobade), a carved outcrop displaying a complex composition of cup-and-rings surrounded by animal figures, was exhumed, from a fissure in the rock, a flat copper axe, dated to the Copper Age/Early Bronze Age (e.g., Sobrino 1935, 29; Lorenzo-Ruza 1952, 199; Bradley 1998; Alves and Comendador 2009, 43) (Figure 13.3).

Similarly, in Laxe das Coutadas (Viascón, Cotobade), another profusely decorated outcrop with the typical Iberian Atlantic Art imagery, was found another flat copper axe typologically similar to that at Pedra do Lombo da Costa (Sobrino 1935, 29; Alves and Comendador 2009, 43). At these two sites there is no evidence of weapon carvings (and, in fact, the depiction of axes is exceptional in Galician rock art) but the actual objects were deposited in natural crevices of carved outcrops. Clearly, these two cases are, for now, exceptional, yet they raise interesting questions about the specialised nature of these rock art sites and also alert us to the diversity of solutions as far as metal hoards are concerned. We do not know

Figure 13.3: Partial view of the rock carvings on Pedra do Lombo da Costa (after Sobrino 1935: Ill. XXIX, fig. 59). From one fissure in this rock was exhumed a flat copper axe, which currently belongs to the collection of the Pontevedra Museum (photo: Bea Comendador).

whether these hoards were contemporary with the creation of the carved compositions or if the carved rock worked as a physical and symbolic marker for the deposition of metal objects. We certainly cannot establish from this evidence if metalwork and the carving of weapons were contemporary with the earliest abstract compositions. But will we ever be able to define a chronological sequence for abstract designs?

The employment of abstract imagery prevailed for a long time in the Atlantic façade of Iberia. Yet, if we take a closer look at the sites that show exclusively curvilinear and geometric designs, subtle differences and similarities become apparent. Drawing exclusively on the record of Portuguese rock art, if we considered the presence/absence of the interaction between 1) the way in which motifs are organised on the rock, 2) the natural shape of the carved outcrop and 3) the layout of the wider landscape, we find a group of sites where these features interact and others where they do not.

This interaction becomes apparent in many ways. In Fornos dos Mouros (Aveiro), the shape of the outcrop seems to replicate the landform where it sits. Also the composition of circular motifs and wandering lines describe a north–south movement, following the morphology of the rock surface, the axis of the mountain itself and the valleys that visually dominates (Alves 2009, 176) (Figure 13.4). This site was recorded and excavations carried out in the year 2000, although unfortunately no diagnostic evidence was found that would

Fornos dos Mouros (Sever do Vouga, Aveiro, Portugal) Campelo (Mondim de Basto, Vila Real, Portugal)

Figure 13.4: Fornos dos Mouros is located on the western slopes of the Arestal Mountain, overlooking the Atlantic coast. A North-South section of the mountain is shown above the perspective of the carved section of the rock seen from the East. The carved rock of Campelo sits on the bottom slopes of Monte da Sra da Graça. Here, a conic lump of the rock, reminding the shape of the hill, was carved with a large set of cup-and-rings.

allow us to establish an accurate chronology for the creation of the rock art (Alves 2003). In other cases, the motifs selected for carving seem to relate to particular features visible in the landscape. In Monte dos Fortes (Valença), two sets of concentric circles over 1m in diameter (e.g., Baptista 1986, 46) are carved on a convex section of the rock and in sight of conspicuous hills. Campelo (Vila Real) rock carvings sit on the bottom slopes of a highly prominent conic hill and displays a monumental set of concentric circles sculpted on a conic lump of the rock (Dinis 2009) (Figure 13.4). There are cases in which rocks seem to have been treated as sculptures. This is the case of Tapada do Ozão where a profusion of motifs adhere to flat surfaces and bends of the rock (Figure 13.5). Likewise, the carved rocks at Lampaça (Vila Real), studied by Teixeira (2010), show circular motifs following the curvature and upright faces of rocks. Here, rock edges were decorated with sets of lines that, at some extent, seem to replicate the natural fissures of the backdrop (Figure 13.5). Further examples could be pointed out, but what is relevant is that, apart from Campelo which shows a few 'palettes', all these sites exclusively displaying cup-and-rings, cup-marks and motifs are linked together with wandering lines. Could these correspond to a particular stage in the Iberian Atlantic Art sequence?

Abstract designs do prevail for a long time in the north-west of Iberia. In fact, Iron Age art along the Atlantic façade of Galicia and northern Portugal actually remains largely abstract. This is apparent not only in the decoration of architectonic structures, pottery and metal objects, and also open air rock carvings. These later compositions show spirals, swastikas and other abstract motifs separated from each other as ideograms, as it is the case of Laje dos Sinais (Braga), located at the foothill of an Iron Age hillfort decorated with both cup-and-rings and a swastika. Also, the interaction between motifs, outcrop and the landscape does not seem significant. On the recently discovered Pedra da Póvoa stone pillar there is a set of concentric circles next to a typical Iron Age double SS motif and the representation of a stag, another long-lived image in rock art (Fonte *et al.* 2009) (Figure 13.6).

Throughout the Bronze Age and Iron Age, new carvings were certainly created or added to previously decorated outcrops, perhaps as a process of renewal or re-appropriation of the Past. It is somehow tempting to think of a revival of abstract art, probably not that different to the origins of Celtic Art in the British Isles. Curiously enough, inland, in north-east Portugal, Iron Age rock art is mostly figurative, as it can be attested by the Iron Age engravings in Côa valley (Baptista 1999) (Figure 13.7).

CONCLUDING REMARKS

I used the circle and the cross, eternal and universal signs, as symbols of the duality between two ancient forms of visual culture. Images based on lines set at right angles, like squares or grids, can be regarded as symbolising matter and the body whereas the circle incorporates the relation between humans and nature. Schematic Art puts a major emphasis upon figurative designs, it tends to be sheltered in rock formations and was used in funerary contexts. Atlantic Art is predominantly abstract, sits in the open landscape, interacting with natural features, and might have been stylistically influenced by, or may have influenced, megalithic art in its distribution area.

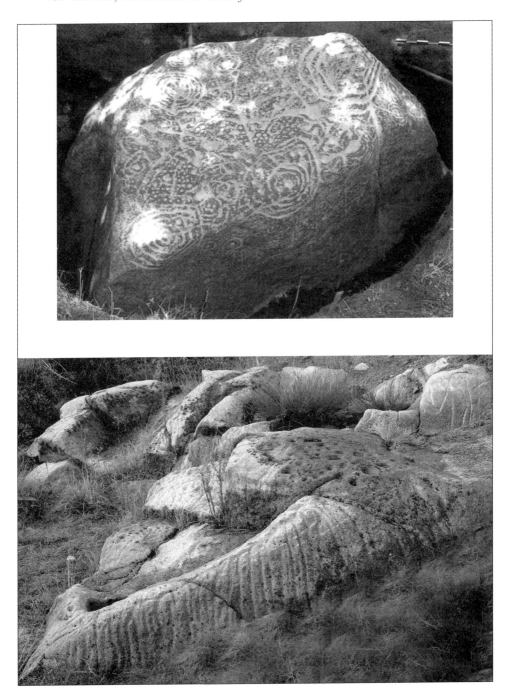

Figure 13.5: The sculptural effect of the carved rock at Tapada do Ozão (Valença, Viana do Castelo, Portugal) (after Baptista, 1986) (above) and Lampaça (Valpaços, Vila Real, Portugal) (below).

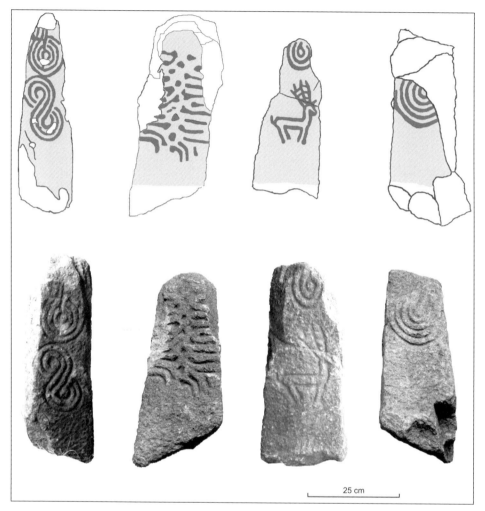

Figure 13.6: The Iron Age carvings of Pedra da Póvoa (Ribeira de Pena, Vila Real) (after Fonte, et al. *2009, fig. 2).*

We know that in the Atlantic façade of north-west Iberia, abstraction was present in Neolithic art inside megalithic tombs, but also alongside Copper Age and Early Bronze Age carvings of halberds and daggers and in Iron Age art along the north-western coast, yet we are still far from being able to set up a comprehensive diachronic sequence (Figure 13.7). Perhaps the methodological renewal in the way we approach prehistoric rock art and visual culture as a whole, using wider and dialectical scales of analysis, giving a greater emphasis upon social and cultural contexts and a more pervading use of archaeological methods like excavations at rock art sites, may bring some new light on many of the most elementary questions that are still at the frontline of investigation today, after one hundred years of research in the region.

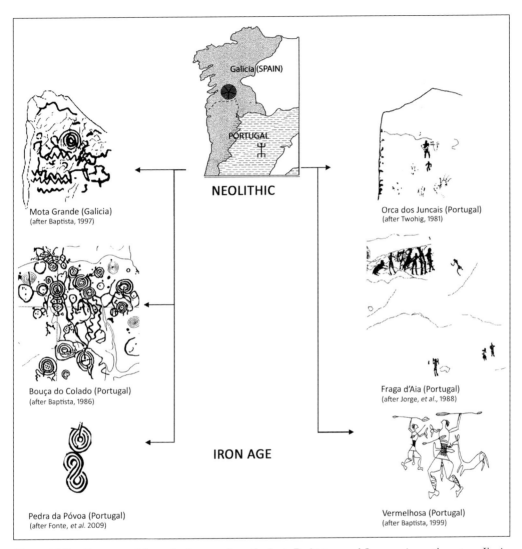

Mota Grande (Galicia)
(after Baptista, 1997)

Bouça do Colado (Portugal)
(after Baptista, 1986)

Pedra da Póvoa (Portugal)
(after Fonte, *et al.* 2009)

NEOLITHIC

IRON AGE

Orca dos Juncais (Portugal)
(after Twohig, 1981)

Fraga d'Aia (Portugal)
(after Jorge, *et al.*, 1988)

Vermelhosa (Portugal)
(after Baptista, 1999)

Figure 13.7: Abstract and figurative imagery from the Late Prehistory and Iron age in north-western Iberia.

ACKNOWLEDGEMENTS

I am greatly indebted to Andy Jones and Andrew Cochrane for the invitation to contribute to this volume and particularly for their enormous patience in the delay in the production of this paper. I would like to acknowledge the superb way they have putted together the 'Neolithic visual culture: abstraction and figuration' conference which was extremely coherent in its contents and stimulating in debate. The Portuguese Foundation for Science and Tecnology (FCT) – QREN/POPH funding programme, and the Centre of Archaeological Studies of the Universities of Coimbra and Porto (CEAUCP) have supported my recent research

as a Post-Doctorate Fellow. Sincere thanks to Richard Bradley, Susana O. Jorge, Aaron Watson, Andy Jones, Andrew Cochrane, Bea Comendador, Elisabeth Shee Twohig and to Blaze O'Connor† for inspiring debate over the years and for keeping me feeling that the spirit of art dwells on the mountains...

REFERENCES

Alves, L. B. 2003. The Movement of Signs. Post-glacial rock art in north-western Iberia. Unpublished PHD thesis, Department of Archaeology, University of Reading.
Alves, L. B. 2009. Signs on a rock veil: work on rocks, 'prehistoric art' and identity in north-west Iberia. In B. O'Connor, G. Cooney and J. Chapman (eds), *Materialitas: working stone, carving identity*. Prehistoric Society Research Papers 3, 169–180. Oxford: Prehistoric Society/Oxbow Books.
Alves, L. B. and Comendador Rey, B. 2009. Rochas e Metais na Pré-História para além da Físico-Química. In A. M. S. Bettencourt and L. Bacelar Alves (eds), *Dos Montes, das Pedras e das Águas. Formas de Interacção com o Espaço Natural da Pré-história à Actualidade*, 37–54. Braga: Centro de Investigação Transdisciplinar 'Cultura, Espaço e Memória' – CITCEM/Associação Portuguesa para o Estudo do Quaternário – APEQ.
Anati, E. 1994. *Valcamonica Rock Art – A New History for Europe*. Capo di Ponte: Edizioni del Centro.
Baptista, A. M. 1983–84. Arte Rupestre do Norte de Portugal: uma perspectiva, *Actas do Colóquio Inter-Universitário do Noroeste, Porto 1983, Portugália* IV–V, 71–82.
Baptista, A. M. 1986. Arte rupestre pós-glaciária. Esquematismo e abstracção, *História da Arte em Portugal*, vol.1, 31–55. Lisbon: Alfa.
Baptista, A. M. 1997. Arte megalítica no planalto de Castro Laboreiro, *Brigantium*, 10, 191–216.
Baptista, A. M. 1999. *No tempo sem tempo. A arte dos caçadores paleolíticos do Vale do Côa*. Parque Arqueológico Vale do Côa. Lisbon: Ministry of Culture.
Bell, C. 1914. Art. London: Chatto & Windus.
Bello Diéguez, J. M. 1994. Grabados, pinturas e ídolos en Dombate (Cabanas, A Coruña). Grupo de Viseu o Grupo Noroccidental? Aspectos taxonómico y cronológicos. In D. Cruz (ed.) *O Megalitismo no Centro de Portugal. Actas do Seminário*, 287–304. Viseu: Estudos Pré-históricos II.
Bettencourt, A. M. S. and Sanches, M. J. 1998. Algumas questões sobre a Idade do Bronze do Norte de Portugal. In R. Fábregas Valcarce (ed.), *A Idade do Bronze en Galicia. Novas perspectivas*. Cadernos do Seminário de Sargadelos 77, 13–45. A Coruña: Edicios do Castro
Bradley, R. 1997. *Rock Art and the Prehistory of Atlantic Europe. Signing the Land*. London: Routledge.
Bradley, R. 1998. Daggers drawn: depictions of Bronze Age weapons in Atlantic Europe. In C. Chippindale and P. Taçon (eds), *The Archaeology of Rock Art*, 130–145. Cambridge: Cambridge University Press.
Bradley, R. 2009. *Image and Audience. Rethinking Prehistoric Art*. Oxford: Oxford University Press.
Bradley, R. and Fábregas Valcarce, R. 1996. Petroglifos Gallegos y arte esquemático: una proposta de trabajo, *Complutum Extra* 6(II), 103–110.
Bueno Ramírez, P. and Balbín Behrmann, R. de 1992. L' árt mégalithique dans la Península Ibérique: une veu d'ensemble. *L' Anthropologie,* 96 (2–3), 499–572.
Bueno Ramírez, P. and Balbín Behrmann, R. de 2002. L'Art mégalithique péninsulaire et l'art mégalithique de la façade atlantique: un modèle de capilarité appliqué à 'art post-paléolitique européen, *L'Anthropologie* 106, 603–646.
Calo, F. and González, X. M. 1980. Estación de arte rupestre de Leiro (Rianxo, A Coruña). *Gallaecia*. 6, 207–216.

Comendador Rey, B. 2010. Space and memory at the mouth of the river Ulla (Galicia, Spain). In A. M. S. Bettencourt, M. J. Sanches, L. Bacelar Alves and R. Fábregas Valcarce (eds), *Conceptualising Space and Place. On the role of agency, memory and identity in the construction of space from the Upper Palaeolithic to the Iron Age in Europe*, Proceedings of the 15th Congress of the International Union for Prehistoric and Protohistoric Sciences. Sessions nº 41 and 72 (Lisbon, September 2006), 99–109. Oxford: British Archaeological Report S2058.

de la Peña Santos, A. and Rey García, J. M. 1993. El espacio de la representación. El arte rupestre galaico desde una perspectiva territorial, *Revista de Estudios Provinciais* 10, 11–50.

de la Peña Santos, A. and Rey García, J. M. 2001. *Petroglifos de Galicia*. A Coruña: Via Láctea

De Lumley, H. 1995. *Le Grandiose et le Sacré*, Édisude: Centre National du Livre.

Dinis, A. 2009. O Monte Farinha ou da Senhora da Graça, Mondim de Basto: interpretações para a biografia de um "lugar". In A. M. S. Bettencourt and L. Bacelar Alves (eds), *Dos Montes, das Pedras e das Águas. Formas de Interacção com o Espaço Natural da Pré-história à Actualidade*, 77–94. Braga: Centro de Investigação Transdisciplinar 'Cultura, Espaço e Memória' – CITCEM/Associação Portuguesa para o Estudo do Quaternário – APEQ.

Dutton, D. 2005. Aesthetic universals. In Berys Gaut and Dominic M. Lopes (eds), *The Routledge Companion to Aesthetics*, 279–291. 2nd edition. London: Routledge.

Fonte, J., Santos Estévez, M., Alves, L. B. and López Noia, R. 2009. La Pedra da Póvoa (Trás-os-Montes, Portugal). Una pieza escultórica de la Edad del Hierro, *Trabajos de Prehistoria*, 66(2), 161–170.

Jorge, S. O. 1991 A ocupação do espaço no Norte de Portugal durante o IIIº – inícios do IIº milénio A. C. In V. O. Jorge and S. O. Jorge (eds), *Incursões na Pré-história*, 299–380. Porto: Fundação Eng. António de Almeida.

Jorge, V. O., Baptista, A. M. and Sanches, M. J. 1988. A Fraga d'Aia (Paredes da Beira, S. João da Pesqueira) – Arte rupestre e ocupação Pré-histórica, *Trabalhos de Antropologia e Etnografia*, 28(1–2), 201–233.

Layton, R. 1991. *The Anthropology of Art*, Cambridge: Cambridge University Press.

Layton, R. 2001. Ethnographic study and Symbolic Analysis. In Whitley, D. S. (ed.), *Handbook of Rock Art Research*, 311–331. Walnut Creek and Oxford: Altamira Press.

Lorenzo-Ruza, R. S. 1952. Inventario Nacional de Folios Arqueológicos: Hierro céltico, *Noticiario Arqueológico Hispánico I*, 162, Cuadernos 1–3, 198–199

Lorenzo-Ruza, R. S. 1953. Los motivos de laberintos y su influencia en los petroglifos gallegos-atlanticos, *Revista de Guimarães*, 63(1–2), 56–82.

Martínez Sánchez, C., Nicolás del Toro, M., García Blánquez, L. A. and Ponce García, J. 2006. Figuraciones esquemáticas pintadas procedentes de una sepultura de finales del III milenio en Lorca (Murcia). In J. Martínez García and M. S. Hernández Pérez (eds), *Arte Rupestre Esquemático en la Península Ibérica*, 513–520. Comarca de Los Vélez.

Meskin, A. 2005. In Berys Gaut and Dominic M. Lopes (eds), *The Routledge Companion to Aesthetics*, 279–291. 2nd edition. London: Routledge.

Morphy, H. 1994. The Anthropology of Art. In T. Ingold (ed.), *Companion Encyclopedia of Anthropology*, 648–685. London: Routledge.

Olsen N. 1989. Social roles of animal iconography: implications for archaeology from Hopi and Zuni ethnographic sources. In H. Morphy, *Animals into Art*, 417–439. London: Unwin Hyman.

Ribeiro, O. (1963). *Portugal, o Mediterrâneo e o Atlântico. Esboço de relações geográficas,* Lisbon: Livraria Sá da Costa Ed.

Sanches, M. J. 1997. *Pré-história Recente de Trás-os-Montes e Alto Douro*, Porto: Sociedade Portuguesa de Arqueologia e Etnologia.

Sanchidrían Torti, J. L. 1984–85. Algunas bases para el estudio de los actos funerarios eneolíticos: Sima de Curra (Carratraca, Málaga), *Zephyrus* XXXVII–XXXVIII, 227–248.

Sobrino, R. 1935. *Corpus Petrogliforum Gallaecia*. Seminario de Estudos Galegos.

Souto, A. 1932. Arte Rupestre em Portugal (Entre Douro e Vouga). As insculturas da Serra de Cambra e de Sever e a expansão das combinações circulares e espiraladas no noroeste peninsular, *Trabalhos de Antropologia e Etnologia* 5(4), 285–300.

Teixeira, J. 2010. Between the engraving and the sculpture. A phenomenological approach to the prehistoric rock art place of Lampaça (Valpaços, Northwest region of Iberia). In A. M. S. Bettencourt, M. J. Sanches, L. Bacelar Alves and R. Fábregas Valcarce (eds), *Conceptualising Space and Place. On the role of agency, memory and identity in the construction of space from the Upper Palaeolithic to the Iron Age in Europe*, Proceedings of the XV World Congress of the International Union for Prehistoric and Protohistoric Sciences, Lisbon, September 2006. Oxford: British Archaeological Report S2058.

Twohig, E. S. 1981. *The Megalithic Art of Western Europe*. Oxford: Clarendon Press.

The Grimes Graves Goddess: an inscrutable smile

Gillian Varndell

'The Mona Lisa is the only beauty who went through history and retained her reputation'.
Will Rogers

The Grimes Graves Goddess (Figure 14.1) was found during the excavations carried out by A. L. Armstrong during his last season at the site in July 1939. His site notebook reads *'A most exciting finish to a rather dull day in which little was found'*. Armstrong's joy was, however, to be short-lived. The story behind this has been published (Varndell 1991), using Armstrong's archive and Kevin Leahy's invaluable verbal account of his conversation with the late Ethel Rudkin, Armstrong's erstwhile fiancée. To cut it brutally short: he had been involved with survey and excavation at the Neolithic flint extraction site of Grimes Graves

Figure 14.1: The Grimes Graves Goddess, front and side views: Armstrong's own photographs.

at an early stage during the programme of excavations undertaken by the Prehistoric Society of East Anglia which began in 1914 (Figure 14.2). His closely held belief that the so-called 'Primitive Pits' at least were Palaeolithic had already been relinquished when he embarked on the excavation of Pit 15 in 1937.

The 19ft (5.8m) deep shaft was emptied, and nine galleries radiating from the base were recorded and partially explored (Longworth and Varndell 1996, 51). The crowning moment for Armstrong was the discovery of a 'ritual group' of objects placed at the mouth of one of the galleries: the chalk goddess, set on a pedestal of chalk slabs, a carved chalk phallus and a phallic arrangement of three natural flint nodules. Opposite, on the shaft base, was an ogival platform of mined flint blocks with seven antler picks on it and next to the base was a carved chalk vessel with a broken handle. The details have had to be gleaned from archive material as the findings were never published; Armstrong did however prepare a plan of the base of the pit (Figure 14.3). There is no entry in Armstrong's site notebook after the fragment quoted above; Mrs Rudkin's own diary also stops at that point.

Figure 14.2: Armstrong and colleagues on site.

Ethel Rudkin was a sculptress, and a known example of her handiwork resides in the British Museum: a sphinx head carved from chalk, its eyes outlined with black (Figure 14.4). The story goes that on the day of the big discovery, Mrs Rudkin had not been

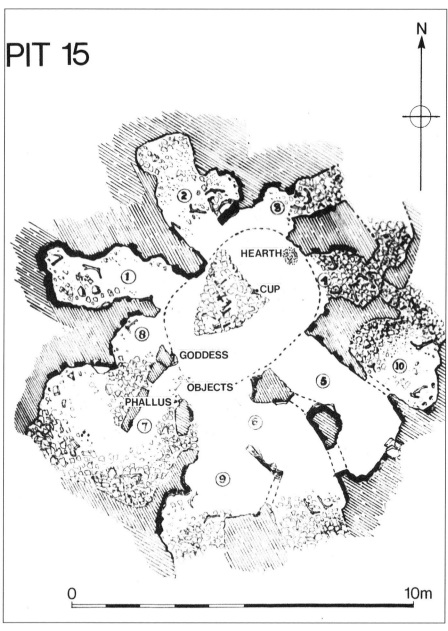

Figure 14.3: Armstrong's plan of the base of Pit 15.

allowed down the shaft, regardless of the fact that she was the only one on site that day with excavating experience. She sat in her car, bored, until the afternoon break when the Goddess and cup were placed in her hands to look after. When Armstrong emerged at the end of the working day she had carved a replica Goddess and cup. This caused some hilarity but Armstrong was so furious that he broke their engagement. Years later, when Mrs Rudkin was an elderly lady, Kevin Leahy visited her and was shown the offending item. She did not wish it to go to the British Museum and would rather it were destroyed, which presumably happened upon her death in 1984 aged 92. She had maintained, however, that Armstrong's figurine was genuine.

Leaving aside the circumstantial evidence for the moment, there are strong reasons to doubt the authenticity of the find. First among these is the lack of a flourishing tradition of creating human figurines in the more northerly and westerly parts of Europe. This is in marked contrast to regions like the Balkans, where this tradition is rich and stretches to the depiction of houses/cult buildings, deities and animal figures. Until very recently the only figurines from Neolithic contexts in Britain were the wooden 'god-dolly' from the Somerset levels (Coles and Hibbert 1968, pl. XII, figs 9a, b) and the blocky, rudimentary chalk carvings from Maiden Castle and Windmill Hill (Wheeler 1943, fig. 49, pl. XXV; Smith 1965, fig. 57 C11, 12). There has been nothing at all resembling the Goddess. As Frances Healy pointed out in conversation, nothing seems to stay unique. Surely something akin to her should have turned up by now. The Grimes Graves flint mines were opened by users of Grooved Ware pottery and to them belongs the period of greatest activity. What might a figurine of this period look like? Grooved Ware pottery is often decorated in a distinctive, unmistakeable style. The motifs are strong, often geometric. Stylistically comparable designs occur on objects like the chalk plaques from King Barrow Wood (Vatcher 1969, pl. XL VI a, b) and the redeposited example from Hanging Cliff, Kilham, North Yorkshire (Varndell 1999) (Figure 14.5). At Grimes Graves itself, though many chalk blocks bear scratched lines which appear intentional, 'art' is rare. One piece from a secure context beneath the upcast from a mine shaft does have deeply grooved lines forming a tongue-like motif with criss-cross grooves (Varndell 1991, 118 and fig. 77, C328). (Figure 14.6). The Folkton Drums,

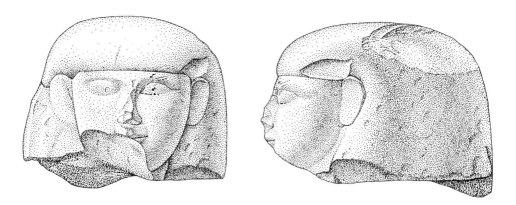

Figure 14.4: The carved chalk sphinx (max. width 11.5cm).

though disappointingly lacking in any clinching association, must fit within this cultural tradition. While remaining aware of the dangers of tracking particular motifs across space and time, the resemblance between the spiral-and-lozenge motif on the middle-sized drum (Kinnes and Longworth 1985 245, drum 2) and that on the famous Grooved Ware sherd from Skara Brae embossed on the cover of Piggott's *Neolithic Cultures of the British Isles* is noteworthy (Piggott 1954, pl. XII and cover).

More recent finds of engraved stone plaques have added significantly to the corpus. The Grooved Ware site at Rothley, Leicestershire yielded an incomplete sandstone plaque engraved with what looks like a stylised face comprising lozenges and circles (Cooper and

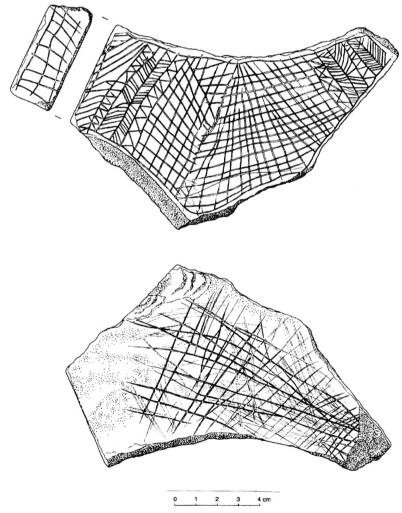

0 1 2 3 4 cm

Figure 14.5: Engraved chalk plaque from Hanging Cliff, Kilham.

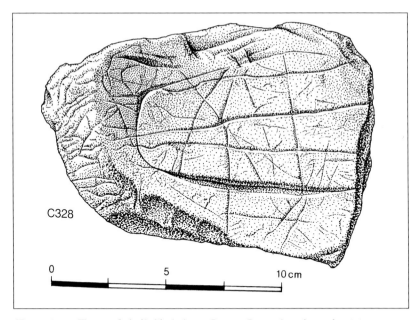

Figure 14.6: Engraved chalk block from Grimes Graves from beneath mining upcast.

Hunt 2005). The authors note similarity to the Folkton Drums. A limestone fragment from Poulton, Cheshire has engraved intersecting lines forming a lozenge pattern. It was placed among fragments of human cremated bone and faunal remains on the base of a ring ditch but the associated pottery was Bronze Age. The find was reported in British Archaeology (105, 2009) where it is stated that the plaque could be redeposited; an earlier post ring was discovered at the site which was thought to be Late Neolithic in style. Reported in *Past* by David Evans (2006, 4) was a small limestone plaque engraved with blocks of lines set radially. It was found in examining clay from the bottom fill of a pit which also contained sherds from Mortlake and Grooved Ware vessels; hazelnut shell fragments gave a radiocarbon date of 2470–2200 cal BC. A rock revealed by the 2003 fire which raged over a large tract of heather moorland at Fylingdales had zigzag motifs and opposed triangles covering one surface (Smith and Walker 2008). An entire archaeological landscape was revealed by the blaze, including other carved stones, cup and ring marked examples among them. It was remarked at the time that the geometrically-carved rock recalled Beaker pottery, which indeed it does, but Grooved Ware affiliations must remain a possibility. (However Alison Sheridan has recently drawn attention to a small number of carvings which may be of Early Bronze Age date (pers. comm.), and to which the non- cup and ring marked stones from Fylingdales may belong).

This is I believe sufficient to establish some limits of expectation, outside of Orkney at least. It is to Orkney that we must now turn, as once again Orkney seems to be holding all the aces. In 2009, the 'Orkney Venus' (Figure 14.7) was discovered during excavations at the Links of Noltland, Westray. A second, fragmentary figure turned up in the following year (Figure 14.8). The 'Venus' is only 4cm tall and made from sandstone. It is flat, with a

rounded head clearly divided from a trapezoidal torso, the sides and shoulders of which are squared off. The incised facial features include an eye and eyebrow motif; the torso has incised breasts and intersecting lines. The back has a lattice pattern. The figure was found in midden material within a building and thus probably post-dates its use. Bone from the midden gave a radiocarbon date of around 2600BC. The second find was made from fired clay; the torso is incomplete and the head lacking, otherwise it is the same size and shape as Venus I. The front bears a deeply incised square divided into triangles. It was discovered outside the walls of a building. Richard Strachan (pers. comm.) has noted that the shape of the clay figure mirrors the stone one in its straight edge and rounded edges, and that among a number of small clay balls (heads for clay figurines?) is one with a possible eyebrow motif. The figures are still undergoing study and may have more to reveal. However, the Late Neolithic context is secure and stylistically the figures appear to be very much at home.[1]

Without labouring the point too much, the bodies of Venuses I and II are quite plaque-like. As human figures they clearly have a front and back and this is reflected in the treatment of the torsos. The chalk plaques from Stonehenge Bottom do too, as does the more irregularly-shaped and larger chalk plaque from Kilham as well as the Poulton

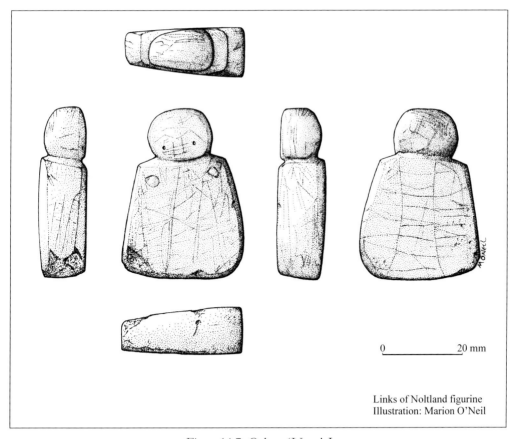

0 20 mm

Links of Noltland figurine
Illustration: Marion O'Neil

Figure 14.7: Orkney 'Venus' I.

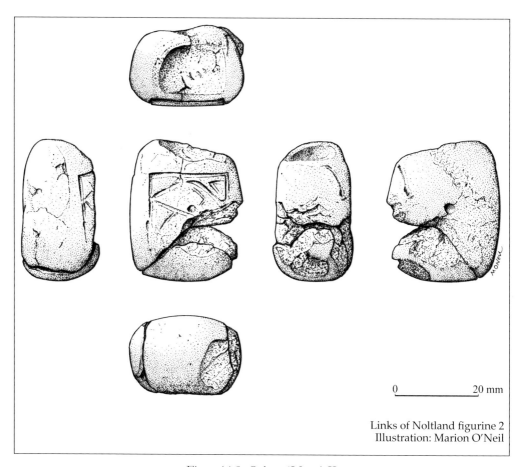

0 20 mm

Links of Noltland figurine 2
Illustration: Marion O'Neil

Figure 14.8: Orkney 'Venus' II.

example in limestone. These observations are offered merely to suggest some kind of community of intent.

The Grimes Graves Goddess also has a front and back in so far as she is flat-backed, but here the resemblance ends. She is crudely made and lumpish; there is an absence of symmetry which does not chime with what we know about the decorative endeavours of the users of Grooved Ware. The emphasis of arms, breasts and belly gives a barely perceptible nod in the direction of Upper Palaeolithic 'Venus' figurines, as if whoever carved her had heard of these, seen pictures of them, but was not at all familiar with the material. The clearly visible striations on the surface suggest carving with a flint blade; her manufacture was not a matter of a few minutes but might not have taken long starting with a suitable piece of chalk. The phallus however (Figure 14.9) is in a completely different class, extremely competently carved, symmetrical, and having a fresh, white surface, unlike the figurine. The carved chalk cup from the ritual group also has a fresh appearance. The difference in surface appearance could be due to the vigorous cleaning of the phallus and cup (for

which we have no other evidence) and the repeated handling and/or field treatment of the figurine. Of the three natural nodules supposedly arranged to resemble a phallus, two are fresh in appearance and one is weathered. If the ritual deposits are indeed an artefact of the Neolithic miners, then some time was spent in making the figurine, cup and phallus, in constructing the platform and uniting a range of differently-patinated objects to make a unique offering. Armstrong's theory was that the floorstone in Pit 15 was so poor that the miners left offerings to ensure a better result next time.

If engraved plaques are to be considered a part of the Grooved Ware repertoire, then their absence at Grimes Graves must be considered. Aside from C328 nothing comparable was found during the British Museum excavations of 1972–6. A chalk plaque engraved with criss-cross lines was recovered during excavation of Mercer's 1971 shaft (Mercer 1981, 16 and pl. VII) but this appears to be associated with an Iron Age burial, unless an heirloom or redeposited. It hardly needs stating that there was no shortage of suitable chalk blocks had engraved plaques been appropriate to the context. Chalk cups are relatively abundant and some of these have been carved with care and an eye to appearance. As ever, more sites and more associations will be needed before firmer conclusions can be drawn, but it may be that the extraction site was not appropriate for the making and disposal/deposition of engraved plaques. Sherds of major portions of two internally decorated Grooved Ware bowls form a likely placed deposit at the bottom of Mercer's 1971 shaft (Longworth 1981, 41–2).

The evidence against the Grimes Graves Goddess (and perhaps the entire ritual group) as genuinely Late Neolithic is circumstantial but compelling. It was well known that Armstrong had gone through a stage of wanting some of the mines to be Palaeolithic. The production by someone of a spoof 'Venus' as a joke is plausible, especially if the intent had not been to seriously deceive. If Ethel Rudkin was not the culprit, but then produced a copy of the spoof thereby provoking what sounds as if it must have been a very unpleasant scene,

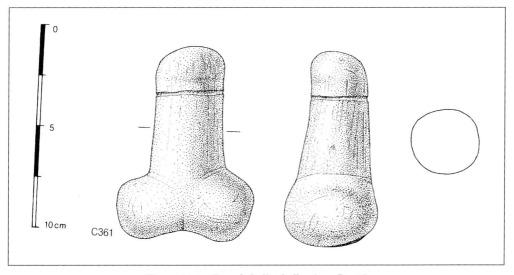

Figure 14.9: Carved chalk phallus from Pit 15.

one might imagine the responsible person too embarrassed or frightened to confess. This leaves the rest of the ritual assemblage, which might be genuine, but the phallus must remain suspect unless or until something closely comparable turns up in an unimpeachable context. Perhaps more than one pair of hands was involved. The view that Armstrong was susceptible to wishful thinking may be reinforced by his enthusiasm for the series of flint crust engravings which did not stand up to scrutiny (Varndell 2005).

For the present author, the ultimate giveaway is the smile. This and other details of the manner of execution are simply not on-message for a Late Neolithic cultural context. The smile would make sense if the figurine had been made by a prankster who probably did not intend to be taken seriously. Like La Giaconda, the Grimes Graves Goddess has so far kept her secrets, but her reputation must be a little tarnished.

ACKNOWLEDGEMENTS

Figs 14.1–6, 14.9: © The Trustees of the British Museum. Figs 14.7–8: © Crown Copyright Reproduced Courtesy of Historic Scotland. www.historicscotlandimages.gov.uk. Line drawings (Figs 14.4–6 and 14.9) by the late Phil Dean.

NOTE

1 The recent discovery of the 'Brodgar Boy' in the rubble of Structure Fourteen during excavations at Ness of Brodgar appears to add another dimension. This small (30mm high) clay figure is modelled in the round, and has a head defined by a groove and two eyes. The lower edge is broken. Shortly afterwards the joining piece was found close by and extends the 'body'; it has a groove half way along its length giving it a segmented appearance. While judging solely from images on the Internet it has a phallic look, and although it is clearly something different from the other two Orkney figures it is stylistically much more in keeping with these than is the chalk phallus from Grimes Graves which was claimed as Neolithic by A. L. Armstrong.

REFERENCES

Coles, J. M. and Hibbert, F. A. 1968. Prehistoric roads and tracks in Somerset, England: I. Neolithic. *Proceedings of the Prehistoric Society* 34, 238–258.
Cooper, L. and Hunt, L. 2005. An engraved Neolithic plaque with Grooved Ware associations. *Past* 50, 9–10.
Evans, D. 2006. An engraved Neolithic plaque and associated finds from King's Stanley, Gloucestershire. *Past* 52, 3–4.
Kinnes, I. A. and Longworth, I. H. 1985. *Catalogue of the Excavated Prehistoric and Romano-British Material in the Greenwell Collection.* London: British Museum Press.
Longworth, I. H. 1981. Neolithic and Bronze Age pottery. In R. J. Mercer, *Grimes Graves, Norfolk. Excavations 1971–72: Volume I.* Department of the Environment Archaeological Report 11. London: HMSO.
Longworth I. and Varndell, G. 1996. *Excavations at Grimes Graves, Norfolk 1972–1976. Fascicule 5: Mining in the deeper mines.* London: British Museum Press.

Mercer, R. J. 1981. *Grimes Graves, Norfolk. Excavations 1971–72: Volume I.* Department of the Environment Archaeological Reports 11. London: HMSO.

Piggott, S. 1954. *The Neolithic Cultures of the British Isles.* Cambridge: Cambridge University Press.

Pitts, M. 2009. Engraved stone found at ancient ritual site in Cheshire. *British Archaeology* 105, 209.

Smith, I. F. 1965. *Windmill Hill and Avebury: excavations by Alexander Keiller 1926–39.* Oxford: Oxford University Press.

Varndell, G. 1991. The worked chalk. In I. Longworth, A. Herne, G. Varndell and S. Needham, *Excavations at Grimes Graves, Norfolk 1972–1976. Fascicule 3: Shaft X: Bronze Age flint, chalk and metal working.* London: British Museum Press.

Varndell, G. 1999. An engraved chalk plaque from Hanging Cliff, Kilham. *Oxford Journal of Archaeology* 18(4), 351–355.

Varndell, G. 2005. Seeing Things: Flint crust engravings from Grimes Graves. In P. Topping and M. Lynott (eds), *The Cultural Landscape of Prehistoric Mines*, 51–62. Oxford: Oxbow Books.

Vatcher, F. De M. 1969. Two incised plaques near Stonehenge Bottom. *Antiquity* 43, 310–11.

Wheeler, R. E. M. 1943. *Maiden Castle, Dorset.* London Resport of the Research Committiee of the Society of Antiquaries 12.

The life and death of Linearbandkeramik figurines

Daniela Hofmann

INTRODUCTION: FIGURINES AND CONTEXT

The last five years have been crucial for prehistoric figurine studies, bringing a critique of long current anecdotal explanations which saw figurines as depictions of mother goddesses, animal demons, substitutes for human sacrifices, or clan ancestors (e.g., Lüning 2005a; Höckmann 1985; Lenneis 1995). New work (e.g., Bailey 2005; Bailey *et al.* 2010) instead focused on the material qualities of figurines to understand how they acted on their human makers and users. Abstraction, miniaturisation and the tactile, three-dimensional nature of figurines combine to charge these pieces with tensions, for example between alienation – produced by abstraction and size reduction – and the intimacy generated through touch; or between the power one wields over such a small object and its capacity to unsettle through a dislocation from normal frames of reference (e.g., Bailey 2005, 32–41, 292f). Most provocatively, this work encourages the explicit cross-cultural juxtaposition of miniature anthropomorphs from disparate cultural contexts, including the modern West.

The variety of responses to a recent figurine exhibition (summarised in Bailey *et al.* 2010) show the appeal of this approach. The much-needed influx of fresh ideas has undoubtedly moved figurine studies closer to the concerns of mainstream British archaeology: figurines are accorded the potential to develop certain kinds of agency connected to body image, power relations and strategies of representation.

However, to make full use of these new insights, they must also be taken back to the level of their respective archaeological context. Do they influence how we see a particular past society? In Bailey's (2005, 63) landmark publication, 'context' is reduced to a list of contemporary kinds of site lacking further interpretation, and rather summarily dismissed as providing little relevant information. Similarly, 'meaning' is equated with discursive meaning (e.g., 'mother goddess') and regarded as unknowable. Using these definitions, one cannot but agree. What remains to be investigated are context and meaning in the sense of the figures' role in wider social trends and transformations. In this sense, meaning and context remain central if we want to accord figurines any explanatory power in a particular case study. Miniaturisation, abstraction, or aesthetic and sensory impact are important as vehicles for how figures can work, but function at a high level of generality – they apply to all figurines made any time, any place. They cannot tell us about the motivation to produce miniature anthropomorphs or to stop doing so. Yet figurines, even just across Neolithic Europe, are diverse in frequency and appearance, a diversity we still need to acknowledge in our narratives.

This short contribution presents anthropomorphs from early Neolithic central Europe. A brief description is followed by possible connections to another arena of body representation, burial. The main themes are admixture and fragmentation – both human bodies and figurines can be described as temporary, unstable entities constituted from a variety of materials. The view of the human body as fragmentable gains currency throughout the Neolithic sequence, while figurines are absent from these later contexts. Human representations may have been increasingly subsumed in artefacts such as pottery and houses. This could chart a trajectory away from representing the human body – in a grave or as a clay miniature – and towards emphasising its capacity for action and change – for instance through fragmentation and equation with items of material culture, such as containers.

THE APPEARANCE OF LINEARBANDKERAMIK ANTHROPOMORPHS

From western Hungary to the Paris Basin and from south of the Danube into the northern European plain, the early Neolithic is characterised by the Linearbandkeramik culture (LBK, *c.* 5600–4900 cal BC; Whittle 1996; Gronenborn 1999; Figure 15.1). Beginning probably in Hungarian Transdanubia (Bánffy 2004), two waves of expansion, still controversially discussed (see e.g., Gronenborn 2007; Robb and Miracle 2007), carry a distinct and increasingly regionalised material culture across the continent. LBK people are known as the builders of monumental timber longhouses, as able farmers and inventive potters, and not least as settlers and pioneers (e.g., Bogucki 1988; 1995; Whittle 2003). They are not particularly famous for their figurative material.

There are two main reasons for this: the relative scarcity of anthropomorphs and their – to modern observers – dubious artistic merit. Both assessments are ultimately based on comparisons – necessarily unfavourable – with the much richer south-east European corpus. Recent overviews estimate the total number of LBK figurines at between 150–250, compared to about 1300 from the single tell of Vinča in Serbia (Hansen 2007, 293, 509; Becker 2010, 28). Moreover, they are most abundant in areas closest to the Balkans, in Hungary, Lower Austria, Slovakia and the Czech Republic. With very few exceptions (e.g., Schade-Lindig 2002), the further west one goes the rarer figures become, a partly geographical and partly chronological trend.

There are also some formal similarities with south-east European figures. In both areas, the range of body postures is limited and partly overlaps, so that for instance seated figures holding vessels exist in both traditions. Although much of the Bandkeramik material lacks an emphasis on large hips, buttocks or breasts, most interpretations have used this overall similarity to argue that LBK figures, albeit artistically inferior (e.g., Maurer 1981, 70), imitated south-eastern fertility goddesses (e.g., Höckmann 1985; Wunn 2001). A certain tendency to abstraction is indeed evident. Legs and arms are often quite summarily rendered, to the extent that their fragments could be zoomorphic as well as anthropomorphic (e.g., Uenze 1999, 24). Rather than incompetence, however, this may reflect a *'willed abstraction'* (Reinecke 1977, 207), as great attention can instead be devoted to decorating the figurine or to body parts such as the head.

One characteristic that distinguishes LBK figures from their south-eastern counterparts is the emphasis on modelling the head, most particularly the eyes and hair. Prominent, round

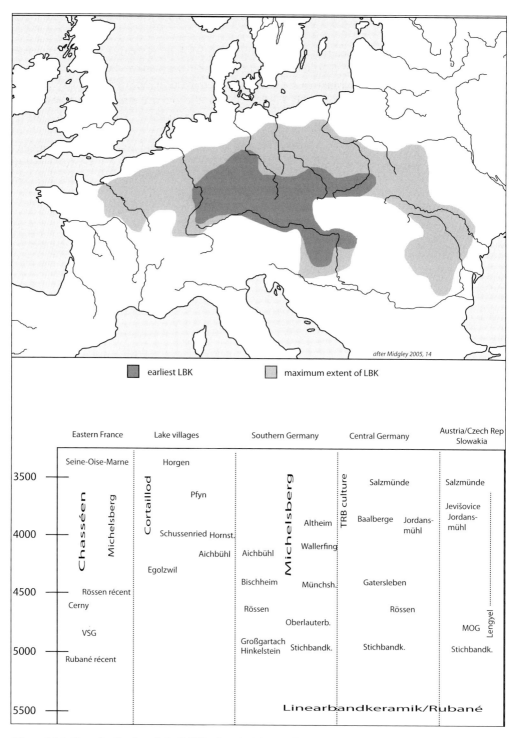

Figure 15.1: Top: distribution of the LBK culture in Europe. Bottom: chronological framework of the cultural groupings mentioned in the text.

eyes can take up a large part of the face, and traces of birch tar on some examples suggest they may once have been inlaid (Hansen and Gallay 2006), perhaps creating white shell eyes with birch tar centres, similar to the bone idol recovered from the Alsatian cemetery of Ensisheim '*Les Octrois*' (Jeunesse 1997, 86f). If so, the overall effect would have been striking, a powerful gaze directed straight at the viewer from eyes which clearly stood out from the brown or black clay of the figure's body.

Attention to hairstyles is a second LBK-specific trait (Gallay and Hansen 2006). Hair can be modelled as tresses or curls, or as elaborately wound around the head. Clearly delimited gaps, mostly on the forehead, could be interpreted as tonsures (Hansen 2007, 296). To further heighten its impact, the hair is sometimes coloured with ochre, as on the Nieder-Eschbach figure (Hampel 1989) whose smooth black clay body provides a vivid contrast to the bright red curls. Albeit abstract, depicting only selected parts of the face and body, these figurines form part of a coherent canon.

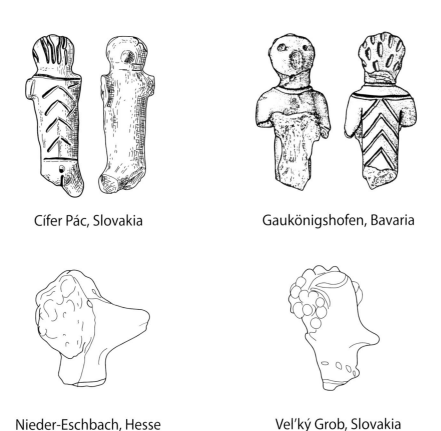

Cífer Pác, Slovakia Gaukönigshofen, Bavaria

Nieder-Eschbach, Hesse Vel'ký Grob, Slovakia

Figure 15.2: Recognisable characters. Cífer Pác (original height: c. 10cm) and Gaukönigshofen (original height: c. 8.5cm) after Hansen 2007, plates 504 and 505; Nieder-Eschbach (original height c. 4cm) after Hampel 1989, 151; Vel'ký Grob (original height c. 5cm) after Lüning 2005b, 224.

Alongside these broad similarities, however, there is considerable variability in detail. The importance of eyes varies regionally, being generally less frequent in Slovakia or Hungary, while further west only some figures also show a mouth or nose. Intriguingly, the LBK corpus contains pieces with strikingly similar counterparts hundreds of miles away, items which conform to the broad trends described above, and very individualistic figures. Among the first category is the Nieder-Eschbach figurine from Hesse, which finds a very close parallel in the heads from Vel'ky Grob, Slovakia and Aba, Hungary (Hansen 2007, 296). Similarly, the figure from Gaukönigshofen in Bavaria has the same hairstyle, nose and 'herringbone' decoration as that from Cífer Pác, Slovakia (Becker 2010; Kolník 1980; Figure 15.2). Apparently, specific, recognisable characters – whether divinities, ancestors (Lüning 2005a), culture heroes or something entirely different – existed and enjoyed widespread currency.

These are counterbalanced by one-off pieces with – as yet – no known parallels. Perhaps the most famous is the torso of the 'Adonis of Zschernitz' from Saxony, showing line decoration and an erect phallus modelled in some detail (Nebelsick *et al.* 2004). Similarly, the Meindling head (Uenze 1971) with quite naturalistic eyebrows, nose and facial decoration has no immediately obvious counterparts. Even more idiosyncrasy is evident in the small faces applied to the sides of pots – the triangular, almost fox-like face from Zauschwitz, for instance, radically differs from the rounded head with broad mouth from Oberpiebing (Reinecke 1977; Probst 1999, 258). Items like the four-fingered Sallach hand (Reinecke 1977) suggest that further, hitherto unrecognised avenues of variability may have existed. While this contrast between recognisable characters and one-offs remains underexplored, for now it seems most fruitful to concentrate on characteristics shared by LBK figurines as a whole and what they say about attitudes to depicting the human body.

THE MATERIAL CHARACTERISTICS OF LINEARBANDKERAMIK ANTHROPOMORPHS: INSTABILITY AND ADMIXTURE

Part of the difficulty in identifying far-flung parallels or types lies in the fragmentary nature of the material; virtually no LBK figurines have been found complete, replicating a pattern current across south-eastern Europe. Breakage did not only occur along weak points, but appears deliberate (Becker 2010, 34). For the Balkan material, Chapman (2000, chapter 2, see also Chapman and Gaydarska 2007) suggests that pieces of the figure were removed as material tokens of social relationships. In addition, breakage could convert androgynous figurines into separate male and female fragments (Chapman 2000, 75–79). For the LBK material, these arguments are hard to apply. Most figurines do not show clear male or female elements (although some do), and erosion on most sites is so severe that the deliberate removal of fragments cannot be backed up. What can be suggested is that figures were seen as unstable, rather than durable, entities and that fragmentation formed an integral part of their use life.

Their notional instability may have come from their character as admixtures – both in terms of materials employed and categories represented. Figurines are made from clay, a mixture of earth, water and tempers. The latter could include plant material, ochre, sand, crushed stone and bone (e.g., Böhm and Hagn 1988; Franklin 1998; Rauba-Bukowska 2009),

although only the first three are attested for figurines. These materials were mixed together to create an entirely new substance, potting clay, which was shaped and fired. At this point, the constituent elements could no longer be separated, but the figure itself remained a work in progress. Further materials could be added throughout its life: hair was coloured and occasionally some sections were coated in birch tar, either to temporarily repair the figure (Kaufmann 1976) or to attach organic materials (Sauter *et al.* 2002). Rather than a piece of artwork to be admired, these figures were continuously interacted with, treated and enhanced, before their final destruction.

In terms of categories, too, there are admixtures. LBK figures are part of a wider field of citations (Figure 15.3). This comprises pottery containers – coarse or fine, and sometimes decorated – the figures we would now recognise as anthropomorphic representations, and finally zoomorphs, mostly depicting cattle or pigs (Becker 2007). However, between these categories, perhaps only ever clearly separate in modern sensibilities, exist items which cannot be assigned to any one group. Between vessels and anthropomorphs, for instance, we can place anthropomorphs holding vessels, hollow figurines functioning as containers, vessels with arms holding smaller pots, and face-pots with eyes and a nose modelled close

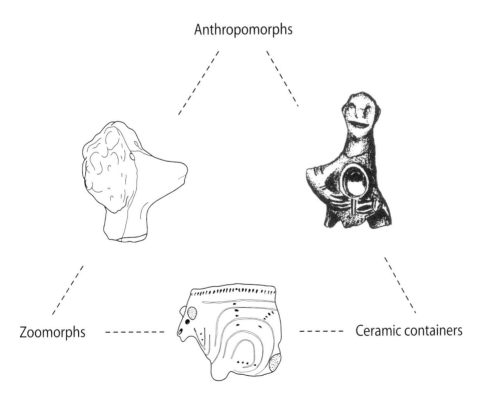

Figure 15.3: Figurines in their field of citations. Nieder-Eschbach and Immenhausen: see captions for Figures 15.2 and 15.4. Cattle pot: after Modderman 1977, 57.

to the rim of the vessel (see below). These instances make it hard to pinpoint where the antropomorph ends and the vessel begins. Indeed, this does not seem to have been a concern at all. More than just hybrids, i.e. superimposed but visually separable categories, these are true admixtures, thoroughly fusing materials to create a new category altogether.

Similarly, zoomorphs and vessels are fused in the so-called 'cattle pots' (e.g., Modderman 1977), which add a cattle head and four legs to a standard bowl type. Many more vessels with applied cattle or goat horns or heads exist (e.g., Lenneis 1995). Perhaps most interesting are the figures apparently mixing human and animal traits, such as the Nieder-Eschbach figure with its sheep-like snout, but human hairdo and anthropomorphic position of the eyes. In addition, the mouthless and round-eyed expressions of many other examples, such as the Eilsleben figure, transcend straightforward depictions of a human face and incorporate alien, animal-like elements (e.g., Hofmann 2005; 2007; cf. Bánffy 2001).

We will never be able to identify the exact species, if any, these figures evoked, let alone to decipher their possible symbolic meaning in the Neolithic. For instance, instead of humans or animals, these may be intended as supernatural beings, or as incorporating aspects of them. What I want to draw out here is how seemingly straightforward categories, such as human, animal and vessel, are transcended. This suggests a way of thinking about bodies, including human bodies, in which their boundaries may not have been obvious or stable, as also indicated by breakage. While it remains questionable to deduce a specific model of personhood from the fact that anthropomorphic representations were broken (see Brittain and Harris 2010), for the LBK there are interesting parallels between the treatment of figurines and of the human body in death, which deserve to be briefly drawn out here.

THE MORTUARY EVIDENCE

LBK mortuary evidence echoes several themes developed in relation to figurines, namely the admixture of categories, the controlled fragmentation of the human body, and special attention to the head. These remain relatively muted in cemetery burial, generally treated as the normative rite for the LBK (see, for instance, Hofmann 2009). Although here, too, an idealised image of the deceased is created through the combination of body and material culture (imported shell, stone tools, etc.), these remain visually separate. In recent years, however, alternatives to inhumation burial, which instead foreground fragmentation, have received increasing attention.

Fragmentation can take several forms, allowing more or less tight control and involving varied lengths of time. Least controversially discussed is cremation, attested from several cemetery sites (Trautmann 2007). During cremation, the recognised, individual body of the deceased is rapidly broken down. Cremation can only partly be controlled, as weather, wind and the reactions of the body to the heat all interact (e.g., Williams 2004). During this process, the body is also mixed with fragments of goods on the pyre, in the LBK mostly pottery and stone tools, although the presence of animal bone, or occasionally of more than one person, has been suggested (e.g., Schmotz 1992; Nieszery 1995). The result is a new kind of composite material, comprising burnt bone, burnt fragments of objects, charcoal and ash, which visually bears no relation to the human body. This material was then buried, probably in an organic container.

Other strategies of fragmenting the body, such as defleshing and secondary burial, are mostly relegated to the sphere of a marginal treatment for low status individuals (e.g., Gronenborn 2006). Yet on closer inspection, these rites exhibit many of the characteristics of cremation. At the Jungfernhöhle in northern Bavaria (Kunkel 1955), most likely of late LBK date, the fragmented remains of 41 adults and children were uncovered. Recent re-analysis (Orschiedt 1999, 165–78) suggests that their bodies decayed elsewhere, as small skeletal elements are under-represented in spite of good preservation and meticulous excavation. After initial decay, the larger bones were gathered and deposited in the cave alongside fragmented animal bone, sherds and flint tools. While slower and less tightly controlled than cremation, this kind of secondary burial also involved the creation of a new composite material, partly consisting of human bone but unrecognisable as particular individuals.

Evidence for similar practices comes from the pit enclosure at Herxheim in the Rhineland Palatinate (Zeeb-Lanz *et al.* 2009). Here, the mostly extremely fragmented remains of at least 450 individuals were deposited in several episodes, overall probably lasting a generation or so. The human remains, some perhaps cannibalised (Boulestin *et al.* 2009), were associated with deliberately selected material culture. For instance, the animal bone recovered with them shows an extraordinarily high percentage of cattle, dog, fur-bearing animals and bird wings when compared to the nearby settlement assemblage (Arbogast 2009), and at least some pottery was apparently imported from several hundreds of kilometres away (Zeeb-Lanz *et al.* 2009). Regardless of the controversy surrounding the consumption of human flesh at the site, there is again a focus on deliberate fragmentation, in Herxheim taken to a new extreme: many bone splinters are extremely small, especially longbones are heavily fragmented, and some heads at least were scalped (Orschiedt and Haidle 2009). The dead were de-individualised, broken up and assembled into a new composite material, no longer straightforwardly recognisable as human, before being deposited.

While unique in the scale of activity and quality of excavation and analysis, Herxheim is perhaps less anomalous in terms of LBK practice. Interest in the fragmentation of the human body is evident in cemeteries. For example, burial 13 at Sondershausen in Thuringia was disturbed whilst still partly articulated, and the legs were removed and reburied at a higher level in the grave fill (Kahlke 2004, 55). A similar example of dividing a body in half comes from Mezőkövesd in Hungary (Kalicz and Koós 2002), and exhumation of some individuals is suggested for other sites (Nieszery 1995, 23–25; Gerling 2009). There is corresponding evidence from settlements, especially from the Paris Basin. There, a special type of grave pit has been recognised, with a niche for the body cut into its side. In some cases, this allowed the body to decay in a hollow space, with the niche probably protected by a covering, and some corpses were deliberately interfered with as they decayed (Thevenet 2004, 822). Finally, other enclosure sites such as Menneville or Eilsleben show a Herxheim-style combination of partial human bodies with animal bone and other objects, albeit at a much reduced scale (Farruggia *et al.* 1996; Kaufmann 1978).

If fragmentation parallels figurine treatment, then so does the attention lavished on the head. The head and upper body more generally are a focus for grave good deposition and ochre colouring in cemetery and settlement burials (e.g., Dohrn-Ihmig 1983, 85; Nieszery 1995, 106–10), and the shell ornaments and bone combs sometimes recovered from around the head may have created elaborate hairdos (Engelbrecht *et al.* 2003). Skulls were also

removed and redeposited. At Quedlinburg in Saxony-Anhalt, the skull of a five-year old child was placed in a bowl, covered with a storage container and reburied (Rienäcker 1978), and most instances of partial human burials in the LBK concern parts of the skull. Heads were also deliberately fashioned into '*calottes*', or skull caps. Eighteen such calottes were recovered from near Draßburg in Austria, but their authenticity and date remain disputed (Mossler 1949; Hahnel 1994). Similar skull caps are now known from secure contexts at Herxheim, where their production was routinised, involving a repeated sequence of blows once the heads had been scalped and the flesh removed. Most of the cut and scrape marks on human bone at this site come from cranial remains, suggesting a special focus (Orschiedt and Haidle 2009, 47). Under the circumstances, it is perhaps not surprising that much of the lethal violence meted out to the 34 individuals from the Talheim mass grave in south-west Germany was also focused on the head, with a virtual absence of post-cranial injuries (Wahl and König 1987). A similar pattern may apply to remains from the enclosure at Asparn in Austria (Teschler-Nicola *et al.* 1996), but studies are still ongoing. The head, it appears, was of particular importance and singled out for special treatment and violence. It is tempting to link this to the notion of the head as a container for the person's vital energy, soul, or similar.

Fragmentation, admixture and focus on the head hence apply to the treatment of both figurines and burials, but their respective prevalence varied chronologically. Numerically, cemetery burial dominates in the LBK, but it seems that alternative treatments increased in importance over time. Herxheim, Menneville and the Jungfernhöhle date to late LBK phases, and cremation becomes more frequent later on (Jeunesse 1997, 60). This is merely a general pattern – some early examples of fragmentation exist, such as at Sondershausen. Yet in the central western areas of the LBK, the development gains momentum in the long term within a context of general cultural diversification. Some post-LBK cultural groupings, most notably the Hinkelstein-Großgartach-Rössen tradition of central and western Germany and the Stichbandkeramik of Bohemia, continued to establish cemeteries (e.g., Spatz 1999; Zápotocká 1998), but in regions such as Bavaria this practice disappears quite quickly. By the late Neolithic Michelsberg culture of eastern France and western Germany, orderly burial is rare, with most remains fragmented and recovered from contexts such as enclosure ditches (Nickel 1997, but see Colas *et al.* 2007). This also applies to contemporary cultures such as the Bavarian Altheim (Nickel 1997, 126), although by contrast in France, the tradition of collective burial in monuments begins (see Chambon and Leclerc 2008). Over time, then, and over some parts of central Europe, the creation of idealised images of the deceased in the grave lost its importance to fragmentation, a process more or less rapid in different sub-regions. This went hand in hand with a reduced importance and eventual disappearance of clay anthropomorphs.

THE DISAPPEARANCE OF FIGURINES

The disappearance of figurines does not exactly parallel that of cemetery burial, but over the long term the two trends coincide. LBK figurines cluster in areas with an early presence of cemeteries or on isolated sites with early roots (e.g., Nieder-Mörlen, Hesse; Schade-Lindig 2002), but become rarer further north and west (see above). In eastern Europe, as far west

as Lower Austria, figurine making continued as a post-LBK tradition (Hansen 2007), but in Germany and further west examples become ever rarer. There are isolated Stichbandkeramik pieces as far west as Bavaria, but numbers then drop dramatically, and this trend continues into the later Neolithic (Hansen 2007, 309). The late fifth millennium figurines from the Paris Basin (Scarre 2007, 20f) already belong to a different tradition and are quite dissimilar to LBK examples. Central European cultural phenomena such as the Michelsberg or Altheim have not produced any evidence for figurines (Hansen 2007, 310). Thus, while not entirely coinciding either spatially or chronologically, increasing fragmentation of human bodies and the disappearance of figurines are parallel developments, both essentially complete by the Michelsberg culture. How could this have worked?

One potential avenue is to re-think the boundaries of the category of 'anthropomorphic figurine'. By defining these items less statically, we can track their progressive transformation, rather than thinking on a presence/absence basis. Figurines are generally treated as a straightforward grouping – mostly, they are easily identifiable. But since they are part of a wider field of relations and citations which also includes ceramic vessels and zoomorphs, their boundaries may in fact be less stable. Whilst further research is needed to strengthen the following suggestions, they provide a starting point for investigating a neglected problem. For the purposes of this discussion, I focus on the relationship between human representations and containers.

LBK pots with human representations comprise vessels with anthropomorphic handles or other applications, for instance the miniature humans peering over the rim of the Obervolkach and Vedrovice vessels (Jockenhövel 1971; Becker 2010, 30). Other pots bear incised or painted human forms, such as the piece from Sondershausen grave 17, interpreted as figures with raised arms (Kahlke 2004, pl. 7), or the vessel from Gneiding in Bavaria showing a white painted figure with segmented body and raised arms complemented by small incisions for the eyes, mouth and fingers (Probst 1999, 2). Mainly on the basis of isolated parallels from disparate cultural contexts, Stöckl (2002) has even argued that all spirals and zigzags on LBK pottery are highly abstract anthropomorphic designs, an argument also extended to Stichbandkeramik and Hinkelstein pottery (e.g., Spatz 2003), but this is not always convincing. Nevertheless, it is interesting that the joined arms of the Vedrovice figures replicate the zigzag lines on the remainder of the pot, while motifs broadly in line with the overall decorative repertoire of pottery are found on many other figurines.

More fruitful than these superficial decorative linkages are the human features modelled onto pottery. Pots with faces (e.g., Pechtl 2008) provide one obvious example. Other pots have feet, sometimes explicitly anthropomorphic ones with clearly modelled toes (e.g., Weiner 2009). A large storage vessel on display at the National Museum in Prague arranges perforated lugs and a coarse horizontal incision in the clay in such a way as to suggest a mouth between lug-eyes, but the vessel is not otherwise elaborated or remarkable. Possibly, many pots, or even most containers, were seen as human-like, most clearly those vessels made to act in a way similar to people. The Mohelnice vessel is one of several pots given small hands, occasionally with clearly modelled fingers, and holding a miniature pot. The large and small vessel can be connected by a hole, so that liquids could be poured from one into the other (e.g., Höckmann 1965; Wamser 1999, 21). Such pots acted as humans in the sense that they could consume or regurgitate. They find their more obviously

anthropomorphic parallels in hollow figurines such as that from Immenhausen in Hesse, whose hands surround a rimmed hole in the chest, again to pour liquids in and out (Kneipp 2001; Figure 15.4). Categorical distinctions between pot and human become harder to maintain.

In the later Neolithic, when figurines have disappeared, there are still hints to the continued relevance of such ideas. Almost life-sized clay breasts, probably from the interior walls of a building, have for instance been recovered from a Michelsberg enclosure at Heilbronn-Klingenberg (Schlichtherle 1992; Hansen 2007, 310). A similar, but better provenanced example of broadly the same date comes from an Alpine lake village, the Pfyn culture site of Ludwigshafen-Seehalde on Lake Constance (Schlichtherle 1992). Here, the breasts came from the only building with painted wall decorations and themselves sport white dots. A gynaecomorphic vessel, reminiscent of parallels in the central German Baalberge culture, was also found nearby (Schlichtherle 1992). Interestingly, in the lake villages along the northern edge of the Alps other kinds of human representation are absent, and there are only isolated burials (Moinat and Stöckli 1995). Again, then, there is a parallel between a relative lack of interest in funerary customs focused on the presentation of the body in the grave, the lack of figurines, and the link between the few anthropomorphic decorative elements and containers (pottery, houses).

One could suggest a long-term process, from the LBK to the late Neolithic, during which certain attributes of humanity became progressively distributed outwards into not obviously anthropomorphic categories of material. Rather than *representing* humanity, the new emphasis was on how human bodies *acted* in ways similar to other items, for instance as containers. Seen in this light, human representations may still be everywhere in the later Neolithic, but no longer visible to the untrained eye.

The change of emphasis in the body parts represented, away from eyes and hair in the LBK to breasts in the later Neolithic, is interesting and deserves to be studied further. There are potential parallels with the Atlantic seaboard tradition, such as the 'disembodied' breasts inside chambered tombs in north-west France and the Channel Islands (e.g., Scarre 2010) or the statue menhirs of the fourth and third millennia (Scarre 2007; Wüthrich 2007). The lake village horizon could provide a crucial link here. Burials are rare in eastern Switzerland and south-west Germany, but the Chamblandes tradition of cist burials is well documented in western Switzerland, and at Sion-Petit Chasseur a stone cist covered by a long trapezoidal mound was fronted with anthropomorphic

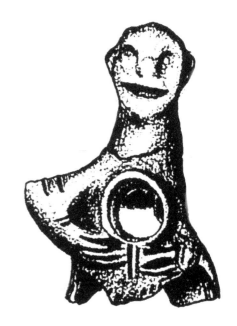

Figure 15.4: The Immenhausen figurine; original height of fragment c. 6cm. After Kneipp 2001, 37.

stone stelae (Moinat and Stöckli 1995). This interest in human representation seems once again connected to a greater emphasis on the dead, even though multiple burials and the secondary rearrangement of fragmented remains are quite different to the cemeteries familiar from the LBK. This is evidently an entirely new tradition, which itself encompasses regionally varied emphases on human representation, but may not be wholly disconnected from trends in central Europe.

CONCLUSION

Although relatively rare, LBK figurines tie in with concerns in contemporary mortuary rites, emphasising the instability of the human body through fragmentation and an admixture of different elements and categories, such as human, animal and object. Over time, in western central Europe at least, figurines disappear. It is possible that some of their roles were now taken on by other kinds of material culture, most notably containers (pots, houses), with a new focus on how bodies and materials acted in similar ways. In short, this is no longer about how people look, but about what they do, a dynamism also evident in the funerary domain with its now near-exclusive emphasis on dissolution. This is quite a different historical trajectory to adjacent regions, such as Atlantic Europe or the Balkans, where human representations were involved in different trajectories.

Thus, figurine production in central Europe seems linked to wider developments in mortuary practice, reflecting changes in what the appropriate treatment of human bodies should be. Figures are important as vehicles for such trends because they are powerful artefacts – unsettling, abstract and highly sensory. Yet, if we want to investigate how this power can be mobilized in different settings and lead to different outcomes, we must contextualize them. Only then can we approach the variety of past perceptions of humanity and the body, of which figurines are but one set of evidence.

ACKNOWLEDGEMENTS

Many thanks to Andy and Andrew for inviting me to contribute to the meeting and to this publication, as well as for critical comments on an earlier draft of this paper. Also, I could not have written this piece without the inspiration drawn from the *unearthed* exhibition and from discussions with many people at the workshops surrounding it. Finally, I am indebted to the Leverhulme Trust, whose generous financial assistance has funded my research for this paper.

REFERENCES

Arbogast, R.-M. 2009. Les vestiges de faune associés au site et structures d'enceinte du site rubanée de Herxheim (Rhénanie-Palatinat, Allemagne). In A. Zeeb-Lanz (ed.), *Krisen-Kulturwandel-Kontinuitäten. Zum Ende der Bandkeramik in Mitteleuropa. Beiträge der internationalen Tagung in Herxheim bei Landau (Pfalz) from 14.-17.06.2007*, 53–60. Rahden: Marie Leidorf.
Bailey, D. 2005. *Prehistoric Figurines: representation and corporeality in the Neolithic*. London: Routledge.

Bailey, D., Cochrane, A. and Zambelli, J. 2010. *Unearthed: a comparartive study of Jōmon dogū and Neolithic figurines*. Norwich: Sainsbury Institute for the Study of Japanese Arts and Cultures.

Bánffy, E. 2001. Notes on the connection between human and zoomorphic representations in the Neolithic. In P. Biehl and F. Bertemes, with H. Meller (eds), *The Archaeology of Cult and Religion*, 53–71. Budapest: Archaeolingua.

Bánffy, E. 2004. *The 6th Millennium BC Boundary in Western Transdanubia and its Role in the Central European Neolithic Transition. (The Szentgyörgyvölgy-Pityerdomb Settlement)*. Budapest: Archaeological Institute of the Hungarian Academy of Sciences.

Becker, V. 2007. Rinder, Schweine, Mischwesen. Zoomorphe Funde der westlichen Linearbandkeramik. In R. Gleser (ed.), *Zwischen Mosel und Morava. Neue Grabungen und Forschungen zur Vor- und Frühgeschichte Mitteleuropas*, 9–95. Bonn: Habelt.

Becker, V. 2010. Figürliche Darstellungen der Linearbandkeramik. In K. Schmotz (ed.), *Vorträge des 28. Niederbayerischen Archäologentages*, 27–46. Rahden: Marie Leidorf.

Bogucki, P. 1988. *Forest Farmers and Stockherders: early agriculture and its consequences in north-central Europe*. Cambridge: Cambridge University Press.

Bogucki, P. 1995. The largest buildings in the world 7,000 years ago. *Archaeology* 48, 57–59.

Böhm, K. and Hagn, H. 1988. Archäometrische Untersuchungen an jungsteinzeitlicher Keramik Südbayerns – eine Zwischenbilanz. In K. Schmotz (ed.), *Vorträge des 6. Niederbayerischen Archäologentages*, 15–33. Buch am Erlbach: Marie Leidorf.

Boulestin, B., Zeeb-Lanz, A., Jeunesse, C., Haack, F., Arbogast, R.-M. and Denaire, A. 2009. Mass cannibalism in the Linear Pottery Culture at Herxheim (Palatinate, Germany). *Antiquity* 83, 968–982.

Brittain, M. and Harris, O. 2010. Enchaining arguments and fragmenting assumptions: reconsidering the fragmentation debate in archaeology. *World Archaeology* 42, 581–594.

Chambon, P. and Leclerc, J. 2008. Les pratiques funéraires. In J. Tarrête and C.-J. Le Roux (eds), *Archéologie de la France. Le Néolithique*, 308–325. Paris: Editions Picard.

Chapman, J. 2000. *Fragmentation in Archaeology. People, Places and Broken Objects in the Prehistory of South Eastern Europe*. London: Routledge.

Chapman, J. and Gaydarska, B. 2007. *Parts and Wholes. Fragmentation in Prehistoric Context*. Oxford: Oxbow Books.

Colas, C., Manolakakis, L., Thevenet, C., Baillieu, M., Bonnardin, S., Dubouloz, J., Farruggia, J.-P., Maigrot, Y., Nadze, Y. and Robert, B. 2007. Le monument funéraire Michelsberg ancien de Beaurieux 'la Plaine' (Aisne, France). In M. Besse (ed.), *Sociétés néolithiques. Des faits archéologiques aux fonctionnements socio-économiques. Actes du 27e colloque interrégional sur le Néolithique (Neuchâtel, 1 et 2 Octobre 2005)*, 329–334. Lausanne: Cahiers d'Archéologie Romande.

Dohrn-Ihmig, M. 1983. Das bandkeramische Gräberfeld von Aldenhoven-Niedermerz, Kreis Düren. In G. Bauchhenß (ed.), *Archäologie in den rheinischen Lössbörden. Beiträge zur Siedlungsgeschichte im Rheinland*, 47–190. Köln: Rheinland-Verlag.

Engelbrecht, T., Kühltrunk, P. and Ramminger, B. 2003. Neolithische Haartracht – alte Zöpfe? Rekonstruktionsversuch einer ältestbandkeramischen Frauenfrisur. *Archäologisches Korrespondenzblatt* 33, 317–323.

Farruggia, J.-P., Guichard, Y. and Hachem, L. 1996. Les ensembles funéraires rubanés de Menneville 'derrière le village' (Aisne). In P. Duhamel (ed.), *La Bourgogne entre les Bassins rhénan, rhodanien et parisien: carrefour ou frontière? Actes du 18e Colloque interrégional sur le Néolithique, Dijon 25–27 Octobre 1991*, 119–174. Dijon: Ministère de la Culture.

Franklin, J. 1998. Linear and Stichbandkeramik pottery technology from the Neolithic site of Bylany (Czech Republic). In I. Pavlů (ed.), *Bylany. Varia 1*, 3–16. Prague: Studio Press.

Gallay, G. and Hansen, S. 2006. Ein bandkeramischer Statuettenkopf aus Nidderau-Ostheim, Main-Kinzig-Kreis, Hessen. *Germania* 84, 245–272.

Gerling, C. 2009. Schwetzingen, ein 'reguläres' Gräberfeld der jüngeren Linearbandkeramik. In A. Zeeb-Lanz (ed.), *Krisen-Kulturwandel-Kontinuitäten. Zum Ende der Bandkeramik in Mitteleuropa. Beiträge der internationalen Tagung in Herxheim bei Landau (Pfalz) vom 14.-17.06.2007*, 103–110. Rahden: Marie Leidorf.

Gronenborn, D. 1999. A variation on a basic theme: the transition to farming in southern central Europe. *Journal of World Prehistory* 13, 123–210.

Gronenborn, D. 2006. Climate change and socio-political crises: some cases from Neolithic central Europe. *Journal of Conflict Archaeology* 2, 13–32.

Gronenborn, D. 2007. Beyond the models: 'Neolithisation' in central Europe. In A. Whittle and V. Cummings (eds), *Going Over: the Mesolithic–Neolithic transition in north-west Europe*, 73–98. Oxford: Proceedings of the British Academy 144.

Hahnel, B. 1994. Frühneolithische Gräber in Österreich. *Fundberichte aus Österreich* 32, 107–128.

Hampel, A. 1989. Bemerkenswerte Fundstücke aus der linienbandkeramischen Siedlung in Frankfurt a. M. – Niedereschbach. *Germania* 67, 149–157.

Hansen, S. 2007. *Bilder vom Menschen der Steinzeit. Untersuchungen zur anthropomorphen Plastik der Jungsteinzeit und Kupferzeit in Südosteuropa.* Mainz: Philipp von Zabern.

Höckmann, O. 1965. Menschliche Darstellungen in der bandkeramischen Kultur. *Jahrbuch des Römisch-Germanischen Zentralmuseums Mainz* 12, 1–34.

Höckmann, O. 1985. Ein ungewöhnlicher neolithischer Statuettenkopf aus Rockenberg, Wetteraukreis. *Jahrbuch des Römisch-Germanischen Zentralmuseums Mainz* 32, 92–107.

Hofmann, D. 2005. Fragments of power: LBK figurines and the mortuary record. In D. Hofmann, J. Mills and A. Cochrane (eds), *Elements of Being: Mentalities, Identities and Movements*, 58–70. Oxford: British Archaeological Report S1437.

Hofmann, D. 2007. The conceptual animal: technologies of body representation in the Lower Bavarian Neolithic. *Journal of Iberian Archaeology* 9/10, 169–185.

Hofmann, D. 2009. Cemetery and settlement burial in the Lower Bavarian LBK. In D. Hofmann and P. Bickle (eds), *Creating Communities. New advances in central European Neolithic research*, 220–234. Oxford: Oxbow Books.

Jeunesse, C. 1997. *Pratiques funéraires au Néolithique ancien. Sépultures et nécropoles danubiennes 5500–4900 av. J.-C.* Paris: Editions Errance.

Jockenhövel, A. 1971. Ein neuer Figuralgefäßtyp der bandkeramischen Kultur. *Germania* 49, 179–187.

Kahlke, D. 2004. *Sondershausen und Bruchstedt. Zwei Gräberfelder mit älterer Linienbandkeramik in Thüringen.* Weimar: Thüringisches Landesamt für Archäologische Denkmalpflege.

Kalicz, N. and Koós, J. 2002. Eine Siedlung mit ältestneolithischen Gräbern in Nordostungarn. *Preistoria Alpina* 37, 45–79.

Kaufmann, D. 1976. Linienbandkeramische Kultgegenstände aus dem Elbe-Saale Gebiet. *Jahresschrift für Mitteldeutsche Vorgeschichte* 60, 61–96.

Kaufmann, D. 1978. Ergebnisse der Ausgrabungen bei Eilsleben, Kr. Wanzleben, in den Jahren 1974 bis 1976. 2. Vorbericht. *Zeitschrift für Archäologie* 12, 1–8.

Kolník, T. 1980. Výskum v Cíferi-Páci v Roku 1978. *Archeologické Výskumy a Nálezy na Slovensku v Roku 1978*, 142–155.

Kneipp, J. 2001. Bandkeramische Zentralplätze und ihre kultisch-religiöse Funktion. In S. Hansen and V. Pingel (eds), *Archäologie in Hessen. Neue Funde und Befunde. Festschrift für Fritz-Rudolf Herrmann zum 65. Geburtstag*, 33–41. Rahden: Marie Leidorf.

Kunkel, O. 1955. Die Jungfernhöhle bei Tiefenellern. Eine neolithische Kultstätte auf dem fränkischen Jura bei Bamberg. *Münchner Beiträge zur Ur- und Frühgeschichte* 5, 1–138.

Lenneis, E. 1995. Beschreibung der Kulturgruppen. In E. Lenneis, C. Neugebauer-Maresch and E. Ruttkay (eds), *Jungsteinzeit im Osten Österreichs*, 11–56. St Pölten: Verlag Niederösterreichisches Pressehaus.

Lüning, J. 2005a. Die Macht der Ahnen und ihrer Abbilder. Wer hatte das Sagen in der Gesellschaft? In J. Lüning (ed.) *Die Bandkeramiker. Erste Steinzeitbauern in Deutschland. Bilder einer Ausstellung beim Hessentag in Heppenheim/Bergstraße im Juni 2004*, 272–284. Rahden: Marie Leidorf.

Lüning, J. 2005b. Frisuren: Ihr Hauptschmuck ist ihr Hauptschmuck. In J. Lüning (ed.) *Die Bandkeramiker. Erste Steinzeitbauern in Deutschland. Bilder einer Ausstellung beim Hessentag in Heppenheim/Bergstraße im Juni 2004*, 221–231. Rahden: Marie Leidorf.

Maurer, H. 1981. Linearkeramische Kultobjekte aus Niederösterreich. *Fundberichte aus Österreich* 20, 57–94.

Midgley, M. 2005. *The Monumental Cemeteries of Prehistoric Europe*. Stroud: Tempus.

Modderman, P. 1977. *Die neolithische Besiedlung bei Hienheim, Ldkr. Kelheim I: Die Ausgrabungen am Weinberg 1965 bis 1970. Materialhefte zur Bayerischen Vorgeschichte 33*. Kallmünz: Verlag Michael Lassleben.

Moinat, P. and Stöckli, W. 1995. Glaube und Grabriten. In W. Stöckli, U. Niffeler and E. Gross-Klee (eds), *Die Schweiz vom Paläolithikum bis zum frühen Mittelalter. Vom Neandertaler bis zu Karl dem Großen. Band II Neolithikum*, 231–257. Basel: Verlag Schweizerische Gesellschaft für Ur- und Frühgeschichte.

Mossler, G. 1949. Die jungsteinzeitlichen Schädelbecher vom Taborac bei Draßburg, Burgenland. *Mitteilungen der Geographischen Gesellschaft Wien* 91, 123–133.

Nebelsick, L., Schulze-Forster, J. and Stäuble, H. 2004. *Adonis von Zschernitz. Die Kunst der ersten Bauern. Archaeonaut 4*. Dresden: Landesamt für Archäologie.

Nickel, C. 1997. Menschliche Skelettreste aus Michelsberger Fundzusammenhängen. *Bericht der Römisch-Germanischen Kommission* 78, 29–195.

Nieszery, N. 1995. *Linearbandkeramische Gräberfelder in Bayern*. Espelkamp: Marie Leidorf.

Orschiedt, J. 1999. *Manipulationen an menschlichen Skelettresten. Taphonomische Prozesse, Sekundärbestattungen oder Kannibalismus?* Tübingen: Mo Vince Verlag.

Orschiedt, J. and Haidle, M. N. 2009. Hinweise auf eine Krise? Die menschlichen Skelettreste von Herxheim. In A. Zeeb-Lanz (ed.), *Krisen-Kulturwandel-Kontinuitäten. Zum Ende der Bandkeramik in Mitteleuropa. Beiträge der internationalen Tagung in Herxheim bei Landau (Pfalz) from 14.-17.06.2007*, 41–52. Rahden: Marie Leidorf.

Pechtl, J. 2008. Eine Idee am Rande – Überlegungen zu einem linienbandkeramischen Gesichtsgefäß aus Stephansposching, Lkr. Deggendorf. In F. Falkenstein, S. Schade-Lindig and A. Zeeb-Lanz (eds), *Kumpf, Kalotte, Pfeilschaftglätter. Zwei Leben für die Archäologie. Gedenkschrift für Annemarie Häusser und Helmut Spatz*, 203–215. Rahden: Marie Leidorf.

Probst, E. 1999. *Deutschland in der Steinzeit. Jäger, Fischer und Bauern zwischen Nordseeküste und Alpenraum*. Munich: Orbis.

Rauba-Bukowska, A. 2009. Bone temper in early Neolithic vessels from southern Poland. Examinations using Scanning Microscopy. In D. Hofmann and P. Bickle (eds), *Creating Communities. New advances in central European Neolithic research*, 235–248. Oxford: Oxbow Books.

Reinecke, K. 1977. Neue Funde der Linearbandkeramik aus Niederbayern. *Archäologisches Korrespondenzblatt* 7, 201–210.

Rienäcker, C. 1978. Die neolithische Besiedlung Quedlinburgs. *Jahresschrift für Mitteldeutsche Vorgeschichte* 62, 109–133.

Robb, J. and Miracle, P. 2007. Beyond 'migration' versus 'acculturation': new models for the spread of agriculture. In A. Whittle and V. Cummings (eds), *Going Over: the Mesolithic–Neolithic transition in north-west Europe*, 99–115. Oxford: Proceedings of the British Academy 144.

Sauter, F., Varmuza, K., Werther, W. and Stadler, P. 2002. Studies in organic archaeometry V: chemical analysis of organic material found in traces on a Neolithic terracotta idol statuette excavated in Lower Austria. *ARKIVOC* 2002, 54–60.

Scarre, C. 2007. Monuments and miniatures: representing humans in Neolithic Europe 5000–2000 BC. In C. Renfrew and I. Morley (eds), *Image and imagination. A global Prehistory of figurative representation*, 17–29. Cambridge: McDonald Institute Monographs.

Scarre, C. 2010. Stone people: monuments and identities in the Channel Islands. www.jungsteinsite. de, article from 23.08.10, accessed 09.02.11.

Schade-Lindig, S. 2002. Idol- und Sonderfunde der bandkeramischen Siedlung von Bad Nauheim – Nieder-Mörlen 'Auf dem Hempler' (Wetteraukreis). *Germania* 80, 47–114.

Schlichtherle, H. 1992. Taucharchäologische Untersuchungen in der Ufersiedlung Ludwigshafen-Seehalde, Gemeinde Bodman-Ludwigshafen, Kreis Konstanz. *Archäologische Ausgrabungen in Baden-Württemberg 1991*, 65–69.

Schmotz, K. 1992. *Das bandkeramische Gräberfeld von Stephansposching. Archäologische Denkmäler im Landkreis Deggendorf, Heft 7*. Deggendorf: Ebner.

Spatz, H. 1999. *Das mittelneolithische Gräberfeld von Trebur, Kreis Groß Gerau. I Textteil*. Wiesbaden: Selbstverlag des Landesamtes für Denkmalpflege Hessen.

Spatz, H. 2003. Hinkelstein: eine Sekte als Initiator des Mittelneolithikums? In J. Eckert, U. Eisenhauer and A. Zimmermann (eds), *Archäologische Perspektiven. Analysen und Interpretationen im Wandel. Festschrift für Jens Lüning zum 65. Geburtstag*, 575–587. Rahden: Marie Leidorf.

Stöckl, H. 2002. Hatten bandkeramische Gefäßverzierungen eine symbolische Bedeutung im Bereich des Kultes? In H.-J. Beier (ed.), *Varia Neolithica II. Beiträge zur Ur- und Frühgeschichte Mitteleuropas* 32, 63–97. Weissbach: Beier & Beran.

Teschler-Nicola, M., Gerold, F., Kranz, F., Lindenbauer, K. and Spannagl, M. 1996. Anthropologische Spurensicherung: Die traumatischen und postmortalen Veränderungen an den linearbandkeramischen Skelettresten von Asparn/Schletz. In *Rätsel um Gewalt und Tod vor 7000 Jahren, eine Spurensicherung*. Catalogue of the Niederösterreichisches Landesmuseum N.F. 393, 47–64. Asparn an der Zaya: Niederösterreichisches Landesmuseum.

Thevenet, C. 2004. Une relecture des pratiques funéraires du Rubané récent et final du Bassin parisien: l'exemple des fosses sépulcrales dans la vallée de l'Aisne. *Bulletin de la Société Préhistorique Française* 101, 815–826.

Trautmann, I. 2007. *The significance of cremations in the early Neolithic communities in central Europe*. Accessed 7th of September 2009 at http://tobias-lib.ub.uni-tuebingen.de/volltexte/2007/3005/pdf/ Dissertation_TrautmannIris_2007.pdf.

Uenze, H. P. 1971. Eine bandkeramische Kultfigur von Meindling. *Jahresbericht Historischer Verein Straubing* 73, 10–14.

Uenze, H. P. 1999. Anthropomorphe Darstellungen des bayerischen Neolithikums. Ein Rückblick. In L. Wamser (ed.), *Dedicatio. Hermann Dannheimer zum 70. Geburtstag*, 21–34. Kallmünz: Michael Lassleben.

Wahl, J. and König, H. 1987. Traumatologische Untersuchung der menschlichen Skelettreste aus dem bandkeramischen Massengrab bei Talheim, Kreis Heilbronn. *Fundberichte aus Baden-Württemberg* 12, 67–193.

Weiner, J. 2009. Ein Bruchstück einer bandkeramischen Ahnenfigur aus Hoeningen. *Archäologie im Rheinland 2008*, 51–53.

Whittle, A. 1996. *Europe in the Neolithic. The Creation of New Worlds*. Cambridge: Cambridge University Press.

Whittle, A. 2003. *The Archaeology of People. Dimensions of Neolithic life*. London: Routledge.

Williams, H. 2004. Death warmed up. The agency of bodies and bones in early Anglo-Saxon cremation rites. *Journal of Material Culture* 9, 263–291.

Wunn, I. 2001. *Götter, Mütter, Ahnenkult. Religionsentwicklung in der Jungsteinzeit*. Rahden: Marie Leidorf.

Wüthrich, S. 2007. L'émergence du mégalithisme au 5e millénaire sur la rive nord du lac de Neuchâtel (Suisse): un phénomène lié à l'organisation socio-économique des premières communautés

agricoles? In M. Besse (ed.), *Sociétés néolithiques. Des faits archéologiques aux fonctionnements socio-économiques. Actes du 27e colloque interrégional sur le Néolithique (Neuchâtel, 1 et 2 Octobre 2005)*, 295–301. Lausanne: Cahiers d'Archéologie Romande.

Zápotocká, M. 1998. *Bestattungsritus des böhmischen Neolithikums (5500–4200 BC)*. Prague: Archäologisches Institut der Akademie der Wissenschaften der Tschechischen Republik.

Zeeb-Lanz, A., Arbogast, R.-M., Haack, F., Haidle, M., Jeunesse, C., Orschiedt, J., Schimmelpfennig, D., Schmidt, K. and von Willingen, S. 2009. The LBK settlement with pit enclosure at Herxheim near Landau (Palatinate). First results. In D. Hofmann and P. Bickle (eds), *Creating Communities. New Advances in Central European Neolithic Research*, 202–219. Oxford: Oxbow Books.

'The 'no's' to the left have it!': sidedness and materiality of prehistoric artefacts

Bisserka Gaydarska

'Almost every dichotomy the human mind has been able to generate seems to have been linked at some time to the dichotomy of left and right' (Annett 1985, 153).

INTRODUCTION

The bread and butter of archaeological studies are the stuff we all try to make sense of – the material culture of past society. Artefacts, as prominent parts of past material culture, have enjoyed refreshing new perspectives in recent years in terms of visual culture (e.g., Skeates 2005) or materiality (e.g., Meskell 2005); although never explicitly dissociated, they are rarely discussed in conjunction (but see Bailey 2005). Even eminent intellectual debates about materiality (*Archaeological Dialogues* 14/1, 2007) miss the visual aspects of the debate; if anything, it is more plausible to bond materiality with touch and sound (Knappett 2007). More traditional approaches to artefacts include discussions of their natural and acquired properties in terms of raw material procurement (Arnold 1993; Biró 1998), style (Boast 1997) or artefact production (Lemonnier 1993, Gaydarska *et al.* 2007). Two parallel, widely discussed issues in archaeology are symmetry – e.g., the symmetry of tools (Kohn and Mithen 1999) or the symmetry of decoration (Washburn and Crowe 1988) – and cognitive processes (Washburn 1983; Renfrew and Zubrow 1994; Gamble 2005). It is therefore a surprise that sidedness and materiality have suffered from such limited attention in artefact studies – in particular, artefact studies in Balkan archaeology. Notable exceptions are the publication of figurines from Franchthi Cave (Talalay 1993), the innovative view on how waist/hip ratio of Jomon figurines can be informative (Hudson and Aoyama 2007), the rare attempts to recognize handedness (White 1998; Steele 2000), and the recent discussion on facial images of selected prehistoric figurines and altars (Kamarev 2005). A valuable but still insufficient discussion of left and right sides in terms of archaeological deposition and their possible interpretations is included in one of the many papers about the Varna cemetery (Marazov 1994). The inclusion of concepts of left and right as part of a much broader research strategy concerning materiality remains more common in ethnographic than in archaeological studies (Needham 1973).

There can be no doubt that materiality resonates with all human senses, whether the sound of brass instrument, the smell of blue cheese, or the taste of liquorice. The present article discusses only the visual aspects of materiality as prompted by some prehistoric evidence from Bulgaria, while hoping to raise awareness of the importance of sidedness in archaeological studies. It also acknowledges the significance for both creators and spectators (perhaps different people?) of visual culture by the making, breaking and discarding of prehistoric figurines.

THE MATERIALITY OF ARTEFACTS

I do not find the debate about the relationship between materials and materiality in archaeology particularly helpful, not least because it implies the supremacy of concepts defined in the English language. In some languages, materiality makes more sense when contrasted with spirituality, rather than as deriving from the word 'material'. For example, the much under-researched combination of a long Christian tradition and an ill-founded Marxist ideology has resulted in the formulation of an almost antagonistic dichotomy of material and spiritual culture in Slavic languages. Thus, it is difficult to translate the notion of materiality not only linguistically but also conceptually. A single common concept of materiality is difficult to argue for past and present societies alike. I sympathise with the views that materiality makes sense only with a human actor (Tilley 2007, Knappett 2007), but in order to avoid cross-cultural and essentialist claims, it is only fair if anyone is tempted in this topic to give his/her understanding of materiality. For me, materiality is the complex combination of the material itself, with its own inherent physical and symbolic properties, and the chosen form and qualities of the result of a transformed material and a created object.

The most common approach worldwide to materiality in artefact studies is the identification of the material from which a certain artefact is made – e.g., stone, bone, clay and so on. Such an approach should explore how and why a particular property of a specific raw material is utilised to achieve the desired effect of the finished object. In parallel with inherent characteristics such as hardness, brittleness and resilience that have determined the selection of raw materials, there is a growing body of evidence suggesting that colour, shine and brilliance constituted major preferences in the creation of material culture (Jones and MacGregor 2002; Saunders 1999; Chapman 2002; 2007). This relatively new trend in artefact studies complements the lengthy discussions of technological characteristics of various archaeological objects by providing valuable insights into less functional but yet significant factors in raw material consumption and artefact production. Thus, for example, the value of obsidian may be related not only to its sharpness but also to its lustrous black surface colour. Likewise, Vinča black burnished ware may have been preferred to painted wares on the grounds of its colour and brilliance (Chapman 2006).

A logical next step would be to establish the physical (material) characteristics of an object – is it large or small, does it possess an upper and lower part, a left and right part, a front and back side, is it symmetrical, is it proportional, and so on. While most archaeological studies are preoccupied with measurements and often tedious descriptions of shape, very little research is done on sidedness and up-down-ness. Various raw materials can produce

various artefacts. Stone and clay that initially do not have obvious sidedness can produce artefacts that have (figurines), or do not have (vessels), left and right dimensions. On the contrary, material that clearly has a left or right side, such as cervid antler, can produce an object neutral to left-rightness. Similarly, some raw materials neutral to up-down-ness can produce artefacts with either a clear upper/lower division (e.g., bone figurines made on ribs) or without a prominent upper/lower division (e.g., the nephrite frog from Kurdzali, South-east Bulgaria – see Nikolov 2006, 71).

It is clear, therefore, that there is a dynamic link between the raw material and the sidedness and up-down-ness of the final product. In their daily practices, people are faced with multiple choices, with the final choice made perforce having particular meanings. The location of assemblages in different times and places highlights the contrasts in choice and meaning of different materials and their sidedness. A temporal example concerns the preferences of left-valve *Spondylus* rings in Durankulak (north-east Bulgaria) in the Varna I–III period, in contrast to the right-valve *Spondylus* rings in the earlier Hamangia I–II period. A spatial case contrasts the emphasis on up-down-ness of the Hamangia figurines, with their phallic necks and female torsos, with the left-right oriented figurines of contemporary Karanovo III–IV figurines (Chapman and Gaydarska 2006).

In addition, it is possible that the residual sidedness of some raw materials (e.g., the left-valve of *Spondulus* or a right tibia) was incorporated into the physical characteristics of the ready object that are not visible now but that may have embodied a major principle for the distribution and redistribution of things. This is to say that materiality and sidedness are not simply quantifiable properties but that they are deeply embedded in the quotidian and sacred social practices of past communities. Thus, materiality can be seen as one of the underlying principles of hoarding (e.g., sets of different objects can be assembled because of the different symbolic meanings that enhance different materials; Gaydarska *et al.* 2004) or as the justification of some people's preference for certain type of exotica (e.g., Bulgarian sites are abundant in shiny white *Spondylus* but NOT in shiny black obsidian). The importance of materiality is probably best illustrated by the necklace with the fake red deer canines – carved from animal bone, not real teeth – from the Late Neolithic settlement of Polgár-Csőszhalom (Choyke 1997), in which the visuality of an ornament made from what appeared to be a highly prized material was probably crucial for processes of social reproduction.

WHY SIDEDNESS?

For many decades, archaeology has been preoccupied with debates over form and function and it is only after the discovery of intriguing artefacts like the anthropomorphic pot of a man frozen during urination (from Gabarevo, Bulgaria: Nikolov 2006, 120) or technically astounding flint superblades that some archaeologists are prompted to look for alternative explanations of both form and function. The analysis of front and back side, left and right part and upper and lower parts may provide valuable insights on the production, meaning and deposition of artefacts.

Sidedness is not a natural property of most of the materials and objects that people use in their everyday life. That is why the narrow range of artefacts with built-in left and

right sides evokes particular interest. Anthropomorphic clay figurines are probably the most prominent examples of a carefully designed sidedness, with their close approximation to a human body. They are also one of the best examples of the *visual* relationship *pars per toto* – even if only one part (left or right) is present, it is implicit that there is a matching part to be discovered somewhere. Therefore, metaphorical wholeness is most readily achievable by the use of sidedness. Moreover, the bilateral symmetry of left and right favours the notion that any pair of left and right parts stands for wholeness, even if the parts belong to different figurines.

BODY SYMBOLISM

A mainstream current of anthropological studies initiated by Mary Douglas (1966) has provided valuable insights into societies symbolised by the human body, as a result of which rules and taboos within a community, at least for non-western/non-industrial societies, are mapped onto bodies (for the semiotics of the body, see Ellen 1977). One example of treating the human body as a metaphor for social coherence and disorder is the Rom gypsies of North America, for whom the upper body part is connected to purity, hence representing the entire related range of pure activities and substances, while the lower body part, with its own, opposed set of activities and substances, is considered as polluted (Sutherland 1977). There are a set of rules pertaining to body care that seek to balance degrees of purity and pollution. The same categorization principles are applied to house organization, food preparation, social relationships between Gypsies and non-Gypsies and between different groups of Gypsies, or to gender/age-based relationships within the Rom themselves. Their social experience as a minority whose principles are challenged on an everyday basis forced them to:

> '*choose a metaphor which approximates this experience, that they would divide the body in such a way that the boundary (the waist) is an equally difficult one to maintain. The physical experience of their bodies is similar to the widest social experience in an awareness of crossing boundaries. When these boundaries are crossed, the controls are most manifested*' (Sutherland 1977, 389).

There can be no doubt that some people have conceptualized their world view through their primordial structural tool – their body. They maintain social order through various appropriate practices and by keeping taboos on improper behaviour. One of the great challenges in modern archaeology is to identify and interpret the visuality of human body symbolism in terms of its related practices and social meaning.

LEFT AND RIGHT SYMBOLISM

Another related trend in anthropological studies is based on Durkheim's (1915; 1973) concept of contradictory dualism (see also Durkheim and Mauss 1963) and Hertz's (1960) elaboration of this argument by association with the human body, bestowing preferment on the right side, notably through the pre-eminence of the right hand. The variety of cultural codes based upon concepts for left and right in human societies has been compiled by

Needham (1973). The studies covered an enormous territory (mainly Africa but also South and North America and Asia), with two examples that discussed left and right back in time – one concerning the concept of sidedness in Greek philosophy (Lloyd 1973), the other the roots of the pre-eminence of the right in Arabic documents (Chelhod 1973). Following the structuralist-oriented research agenda of its time, almost every case study identified the significance of left and right in the society in question, enabling the compilation of long lists of categories associated with either left or right. An example for the Mapuche society in Chile is that right is life, day, health, etc, while left is death, night, sickness, etc. (Faron 1962). It would be unwise to oversimplify the results of these studies and to reduce them to a universal principle of binary opposition based on the social order of moieties. Although certain similarities cannot be denied – e.g., right is connected to male and good, left is connected to female and bad, the concepts for left and right are not always straightforward but interwoven in the worldview of moiety-based societies, for example the North American Osage (Flesche 1973) or not, such as the Temne of Sierra Leone (Littlejohn 1973), or the Indians from South India (Beck 1973). Just as the perception of left and right is culturally specific, with variation in the range of associated items/insights, it is also relational. For example, in some Chinese etiquette, the sidedness of a fish served on a plate depends on the season and whether the fish is dry or fresh (Granet 1973). In addition, there are multiple examples of reverse associations: while some African tribes relate left to South or East, other African tribes and the Mapuche of Chile relate it to West and North; while right is usually associated with male, it is exactly the opposite with the Chinese yin, standing for right and female. Last but not least, the pre-eminence of right is not universal, as proven by the preferences given to the left by some societies. Thus, the left hand is lucky according to the Wageia-Kavirondo (Weiss 1910) and sacred for the Mugwe (Needham 1973), while the primary association of the left side is with death among the Toradja of the Central Celebes (Kruyt 1973). We should also not ignore the contextual relativity of the left–right interrelation (e.g., some birds bring good luck if they cross the road right to left and misfortune if they fly in the other direction: Wieschhoff 1973, 66).

After the gradual decline of Durkheimian dualism, there has been no fresh interest in the notion of complementary opposition either in contemporary anthropological studies, or indeed, anthropologically-inspired archaeological interpretations. However, provided that complementary opposition is not reduced to essentialism, it can prove to be a valuable interpretative approach to societies with different levels of complexity. Thus, fine and coarse ware, decorated and undecorated pottery, local and imported tools, utilitarian and exotic things are connected relationally. They are equally constituted by people's worldviews and, at the same time, they frame and perpetuate this worldview. Ultimately, left and right side, upper and lower part and front and back can also be viewed as complementary oppositions that permeated some people's life and, therefore, were symbolically engaged in the maintenance or negotiation of social order. Far from being universal and unique, the dualistic principle has proven its value for interpretation and can be identified in sidedness.

Anthropomorphic imagery in traditional societies
Among the very few examples of the anthropological use of figurines in terms of such dualistic principles are the Fang society of Gabon (Fernandez 1966) and the Nzema

society of Ghana (Grottanelli 1961). In both cases, figurines are believed to embody social categories such as age and gender.

Fang ancestor figures are designed to look infantile and it is believed that this is one of the contradictory pairs with which their world is permeated. The figurines are both children and ancestors, not portraits but portrayals of living persons. It is very important to underline that the dualistic nature of the Fang lifestyle visible in their imagery and social structure does not aim '... *to resolve opposition and to create identity but to preserve a balanced opposition*' (Fernandez 1966, 63).

Although Nzema society is not discussed explicitly in terms of complementary oppositions, their imagery is characterized by dualistic meaning. Their figurines are unsexed and regarded as personal beings containing both male and female elements. They are also 'charms' and 'gods' at the same time. Apart from gender ambiguity, the dual meaning of the figurines is difficult to detect only from their design and places of deposition in small cage-like shrines. This fact poses serious constraints on the interpretation of figurines from archaeological contexts if based upon a straightforward reflectionist point of view. Therefore, archaeologists have to be cautious when gendering figurines with sexual traits, not to mention when such traits are absent. In addition, any hint of a dualistic nature, such as sidedness, in the archaeological record requires further exploration in terms not just of straightforward function but also of metaphorical significance.

The important corollary of these two examples is that it would be unwise to consider figurines as a constant category that can be interpreted through a single mode of meaning throughout their life-time. Changes in the meaning of figurines through their life-time have been discussed elsewhere (Chapman and Gaydarska 2006). What is important to underline here is that whatever changes may have happened to a figurine, or whatever the changes in the perception of a figurine, they do not necessarily affect the integrity of the figurine. Thus, for example, the making and the breaking of figurines do not contradict its integrity but rather complement it. Moreover, the residual parts – left or right, upper or lower, have their own specific meanings – meanings that may differ from the initial intention of the figurine-maker but which stays within the cognitive *habitus* of figurine consumption.

THE DOLNOSLAV FIGURINE ASSEMBLAGE

Fired clay figurines comprised the third most common artefact type on the 5th millennium BC Dolnoslav tell, in Southern Bulgaria (Raduncheva 1996), after the antler tools and the pottery (Koleva 2002). The present dataset includes 500 anthropomorphic figurines, not counting more than 200 clay zoomorphic, bone and marble figurines. The assemblage as a whole is typical for the Balkan Late Copper Age, including widespread anthropomorphs, such as seated or standing figurines, as well as some less common types designed as single body parts, such as ears, busts or arms.

One of the main principles underlying the deposition of figurines in Dolnoslav proved to be the left – right opposition. Complete figurines form 4% of the assemblage. From the remaining fragments, the percentage of body parts that have no clear indication for sidedness is relatively high (37%). These are fragments that are either entirely neutral to sidedness, such as heads or body parts that have both left and right side – e.g., both legs.

However, more than half of the figurines (59%) have some information about sidedness; their relative distribution proved to be very similar – 30% left parts and 29% right parts, both overall (Figure 16.1a) and in Phase C (the last period of deposition) (Figure 16.1b).

All categories – left, right and neutral – are present in each context – middens (D1 to D4), buildings and open areas. Together, the left and the right parts are dominant in both the middens and in the open areas with relatively equal distributions (Figure 16.2a–b). A different pattern is observed in the buildings, where the left and the right part hardly exceed 50%, and there is a slight dominance of left over right parts (Figure 16.2c).

The distribution of left, right and neutral parts in each of the middens is proportional to the total number of figurines in D1, D2, D3 and D4. The pattern of deposition shows a prevalence of right parts in D1 and D2, but left parts in D3 and D4, which resulted in an overall balanced distribution of left and right parts in these contexts (Figure 16.2a).

The preference for deposition of neutral parts in the built area (Figure 16.3) is more obvious in the detailed distribution of body parts in the buildings, where neutral parts dominate in 15 buildings. The pattern of deposition is very complex. The overall pattern of distribution in the built area suggests that the left/right opposition was not the main depositional principle there. Or, more precisely, it was in conjunction with another depositional principle that finally produced the complex cumulative result.

Apart from the symmetries in the spatial distribution of the different body parts, there is a no less striking symmetry in left and right fragments as types. Similarities occurred not only in the deposited left and right types but also in their number. As a major source of contrast on the human body, the left–right symmetry has been used to symbolize many aspects of cultural oppositions; we shall turn to the possible significance of these oppositions in the overall interpretation of the Dolnoslav figurine assemblage.

The regularity of the deposition of left and right body parts suggested an analysis of the other possible fragmentation pattern, in which the figurine body was divided into lower and

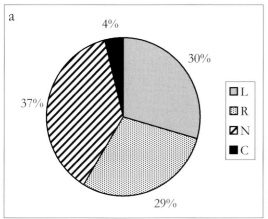 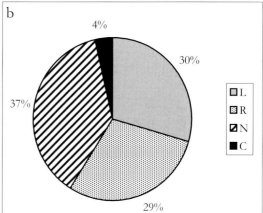

Figure 16.1: Sidedness by phase (a) all phases; (b) phase C. Key: L – left, R – right, N – neutral, C – complete.

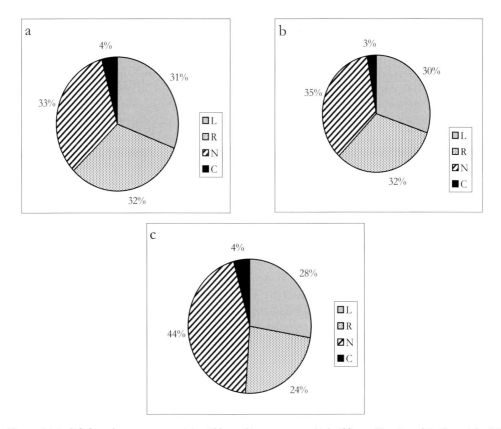

Figure 16.2: Sidedness by context type (a) middens; (b) open areas; (c) buildings. Key: L – left, R – right, N – neutral, C – complete.

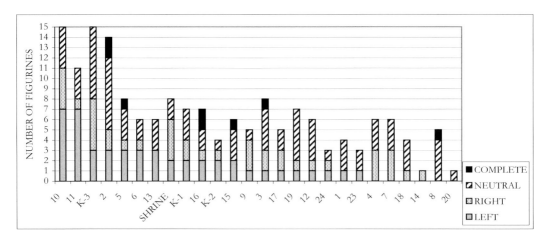

Figure 16.3: Distribution of left, right and neutral fragments, in each building.

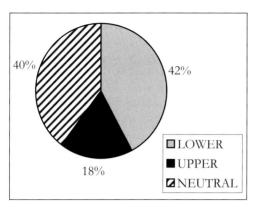

Figure 16.4: Distribution of lower and upper parts.

upper parts. The star-shaped figurines and the complete examples were excluded from the analyses. The division line was accepted to be somewhere between the waist and the buttocks. Figurines that were broken around the waist or above that line but which also have a complete or fragmented lower part (buttocks, legs) are considered as neutral in respect of this opposition.

In contrast to the attempt to maintain a balance between left and right parts, there was a deliberate preference for lower over upper body parts (Figure 16.4), although fragments neutral to the lower/upper axis also had a relatively high distribution. The distribution pattern of lower and upper parts was very similar in the middens and in the open areas – a clear dominance of lower parts, a high frequency of neutral parts (more than 1/3) and upper parts up to three times less common than the lower parts (Figure 16.5a–b). The distribution in the buildings, however, showed a very different pattern. The dominant body part

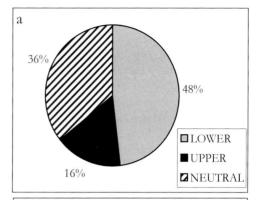

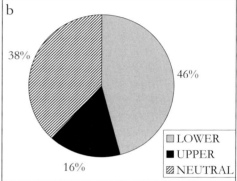

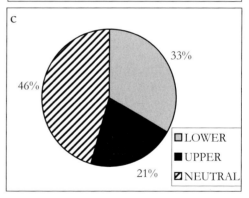

Figure 16.5: Distribution of lower and upper parts, (a) middens; (b) open areas; (c) buildings.

here was the neutral category and the distribution of lower and upper parts was much more balanced than in the middens and the open areas (Figure 16.5c).

Almost half of all lower parts were deposited in the middens (Figure 16.6a). In contrast, most of the upper parts derived from the buildings (Figure 16.6b), which may manifest a major structuring principle, in which symbolism related to the upper body parts (heads,

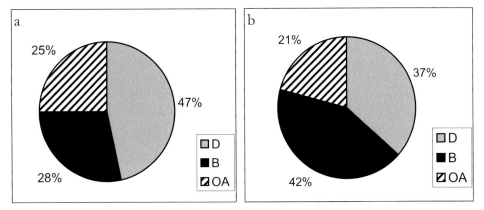

Figure 16.6: (a) Distribution of lower parts; (b) distribution of upper parts. key: D – depots (= middens); B – buildings; OA – open areas

arms, chests/breast) should prevail in the built area, while symbolism related to the lower body parts (buttocks, legs, feet) should be dominant in the non-built up areas. Such a principle is probably in constant re-negotiation, since there are both upper and lower parts in all types of context, if in differing proportions. An example of the symbolism of vertical differentiation comes from the African Oromo group (Megerssa and Kassam 1987), who define three ways of thinking: head thinking is patriarchal and hierarchical, emphasizing divisions and distinctions; heart thinking is prophetic, poetic, inspirational and oracular, with a female orientation to home and heritage; while abdominal thinking is concerned with the dissolution of boundaries, with unifying and harmonizing. These three ways of thinking exemplify the varying and alternating ways in which experience is lived (Jackson and Karp 1990, 16–17). The higher percentage of upper parts in the built area, often associated with figurines with female traits, could be interpreted in this light.

The deposition of upper rather than lower parts seems to be the leading practice in the built area, in contrast to the deposition of left and right parts rather than neutral fragments that characterize the non-built area. The combination of these two basic principles has contributed to the overall complexity of the depositional pattern at Dolnoslav.

Is such a pattern really intentional?

To answer this question, we have to start with the notion of deliberate fragmentation – there would be no left or right, upper or lower parts without purposeful breakage. To the growing number of reasons for intentional breaking, we can now add another – the enchainment of upper/lower or left – right fragments to contrive the re-integration of whole objects. Their use as tokens in enchained relations makes their final deposition in such a balanced fashion very intriguing and emphasises their potent sensual, but especially *visual*, impact.

The vast majority of Dolnoslav figurines was discarded in two contexts, both of which showed the tendency to associate diverse types of material culture in a massive statement of accumulation – the burnt buildings and the middens (Koleva 2002). Such

accumulations may well be considered as the equivalent of the missing cemeteries of the Late Chalcolithic of Thrace. These contexts of accumulation gained meaning in three ways – by the associations of their material remains, by the personal biographies that are attached to the things and by the presencing of associations and physical parts. The inclusion of a left TOLE (torso and leg) of a figurine in one midden whose right parts were placed in a building 30m away links not only the parts of the figurines but their associated objects and their biographies in a complex network of significance – the enchained network that provided at once the structure of social practices in the site and the material means for the practices themselves.

The sidedness question can now be re-phrased: are there many people who were aware not only of the general principle of the balance of sidedness but also of the importance of achieving a numerical balance of right and left parts in the different contexts of deposition and at the site overall? For example, individuals from each household who negotiate the location and type of figurines for deposition with those with the right (not a random use of the term!) to deposit material culture? These household ritual heads would have required meetings to co-ordinate such strategies and decide upon the nature of the next act of deposition. Or were there persons (? a person) who directed such operations at the level of the entire community and maintained counts of how many right-sided fragments had already been placed on such and such a depot? It is worth reflecting upon the existence of simple tallying methods that could readily have been used to achieve these varying balances. As the reader may imagine, it is problematic to pursue this line of reasoning too far, but anyone left unsatisfied by the 'random dumping of rubbish' alternative will need to confront these difficult issues.

In either case, the re-integration of previously fragmented bodies could have been achieved in two ways: through the deposition of left and right fragments from different figurines, which stood for the completion of the bodies placed in houses-to-be-burned or middens, or by *synecdoche* – the symbolic completion of the body represented by only one side in the house or midden. These strategies are comparable to the preferential mortuary deposition of complete Hamangia figurines rather than figurine fragments in sites (Chapman and Gaydarska 2006).

The visual impact of figurines

A comparison with specific Balkan Neolithic and Copper Age sites reveals that the Dolnoslav assemblage is not a unique example of figurine treatment (Table 16.1). Only an approach more sensitive to sidedness in future studies will help us to evaluate whether the depositional patterns at Dolnoslav demonstrated an everyday practice, a long-term accumulation practice or an exuberant one-off spectacle.

Here we are faced with the provocative question regarding where the objects were stored prior to their final deposition in graves, hoards and other less structured deposits? Were they proudly displayed on a shelf in the house, tucked away in a pocket or were they hidden in a wooden box? Liberated from the narrow understanding of material culture (Knappett 2005; Chapman and Gaydarska 2006), we now can say that objects rarely had a single static meaning in their lifetime. So most probably some objects were more mobile and have experienced dark moments in murky house corners or in someone's pocket; together with bright daylight in public ceremonies. While other objects would have been more confined

to a single space/s, their re-conceptualisation was enhanced more mentally than visually. Some objects were more readily worn – like ornaments and tools, than displayed and curated but never trapped in a single function. Thus, there were three possible conjoint scenarios for the use and deposition of fragments of prehistoric figurines in Dolnoslav tell. At each of these three stages of figurine consumption, the visual reference to either left of right, upper or lower was of crucial importance:

1) in daily life, the symbolism of upper and lower body parts was prioritised over left and right, with examples of the former actively displayed and instances of the latter stored for further use;
2) in cyclic events such as community gatherings, trading or feasting, characterized by the proclamation of new enchained relations and the consolidation of old relations, left and right body parts were given particular attention from among the abundant tokens, since they were not mere fragments but symbols of widely shared identity;
3) in unique or special inter-community events, such as mourning the death of a prominent elder or celebrating the foundation of a new village, when the successful social reproduction required strong visual statements from all the participants, the balanced deposition of left and right figurine fragments ensured, at least visually, that social equilibrium was re-negotiated.

Creating, keeping and displaying of left and right fragments may have been one of the structuring principles of enchainment. As evident from the anthropological data, the left/right opposition can be explained in various ways. The structuralist approach was to attribute different categories to left and right and this was most often the gender/sex division. If we accept this approach, then left and right parts represented males and females and their final balanced deposition challenged the initial strategy of the production of more female figurines than male images. In the end, the man and woman were re-united in one complementary androgynous person on a social level, again a parallel to the Hamangia example. The weakness of this approach is that it does not yet explain the production of unsexed figurines or the possibilities for more than two genders. Left/right contrasts have nothing or very little to do with gender difference, since all sexual organs are symmetrically placed. What relates to gender difference in a fragmentation chain is vertical differentiation: Hamangia figurines have a more complex up/down chain than do Late Copper Age figurines, where femaleness tends to be associated with the upper body part.

Another way to view the left and right contrast is via the South Indian caste system, in which right-side castes are related to landowners and important social actors, and left-side castes are related to artisans and people making things with their own labour (Beck 1973). The introduction of metal (Renfrew 1969), changes in settlement planning (Chapman 1990), the appearance of extra-mural cemeteries and especially the Varna cemetery (Chapman 1983; 1991) leaves us in little doubt that Final Copper Age society was a classic example of a complex society. Cross-cutting social divisions and diversification may have been the result in communities in which some people were predominantly, if not entirely, involved with cultivation, herding and food production, while other people were skilled in pottery production, flint knapping, figurine-making/breaking and so on. This was not a rigid division of labour but, rather, a practical response to the increasing individualisation of

Table 16.1: Sidedness of prehistoric figurines from selected Balkan sites.

SITE	NO OF PUBLISHED FIGURINES	COMPLETE	ALMOST COMPLETE (HEAD MISSING)	LEGS	HEADS	LEFT	RIGHT	UPPER TORSO	LOWER TORSO	NEUTRAL TORSO	% OF FIGURINES WITH KNOWN SIDEDNESS
Ovcharovo NE Bulgaria	30 (after Todorova *et al.* 1983)	6	7	10	4	N/A	N/A			3 fragments (not clear)	N/A
Vinitsa NE Bulgaria	23 (after Raduncheva 1976)	1			6	6 with sidedness but poor illustrations		4	2	4	26%
Goliamo Delchevo NE Bulgaria	85 (after Todorova *et al.* 1975)	3	6		21	18 with sidedness; secure 3 left and one right legs		12	11	14	21%
Usoe NE Bulgaria	228 (127 illustrated) (after Vajsov 1990)					24	20				19%
Omurtag NE Bulgaria	27 (found and published) (after Gaydarska *et al.* 2005)	1			3	6	6	4	3	4	44%
Sedlare SE Bulgaria	75 (personal observation on museum collection)					37 with sidedness					49%
Selevac Central Serbia	334/9 (not all illustrated) (after Milojković 1990)					62 may have some information for sidedness					19%
Gumelnitsa S–SE Romania (general, not the site)	249 (after Andreescu 2002)					54 with sidedness					22%
Răucești NE Romania	108 (after Dumitroaia 1987; p.c., John Chapman					51 with sidedness					47%

productive relations (Chapman and Gaydarska 2011). Both groups were equally important for social and biological reproduction and such a division did not interfere with any other potential group membership. This division was symbolically materialised by the left and right parts of the figurines. Akin to the left and right forming parts of an entity, the land-related group and the artisans were parts of dialectic whole. There is no constraint on people to belong to either of the groups. More and less successful households could both have been members of one group (either left or right) and some members of one family could have been occupied with arable cultivation, while others developed craft production. The symbolic social division into left and right would have been valid for the members of a small community but it also has an inter-regional significance, since the Late Copper Age was characterized by a well-developed exchange network based on production, consumption and distribution of objects, foods and exotica. Therefore, one may view the deposition of left and right parts of figurines on the Dolnoslav tell as a metaphor for the contrast between two widely shared identities: groups of farmers and groups of craftsmen, artisans and ritual specialists.

CONCLUSION

Body symbolism is an inseparable part of the life of human beings. The concept of left and right, first experienced through our body, retains its symbolic value even in modern Western societies by the use of 'left' and 'right' to define political affiliation (cf. the title of this chapter, drawn from UK House of Commons voting procedure). The inalienable relation between people and objects in the past (Chapman 2000) were asserted by a *material*, and hence *visual* expression of an embodied concept. Once prehistoric figurines fulfilled their purpose as a complete object, they were broken into upper and lower and/or left- and right-sided fragments that were used to enchain people in *(in) visible* social networks. Enchainment was not an erratic and opportunistic event but rather a careful process of social negotiation, in which left and right, upper and lower parts were used as powerful visual tokens. The balance of left and right and the dominance of lower over upper present two operational principles of enchainment for the prehistoric community living on the Dolnoslav tell in Bulgaria. The final depositional pattern of fragments of prehistoric figurines on that tell suggests symmetrical roles of artisans and craftsmen associated with the left, and farmers and herders linked to the right. The visual emphasis of social practices through left and right, as much as higher and lower, figurine parts confirmed the significance of material means of communication in the Balkan Chalcolithic.

ACKNOWLEDGMENTS

With very special thanks to the excavators of Dolnoslav, Ana Raduncheva and Bistra Koleva, and to my collaborator John Chapman.

REFERENCE

Andreescu, R-R. 2002. *Plastica antropomorfă Gumelnițeană, Muzeul National de istorie a României.* București.

Annett, M. 1985. *Left, Right, Hand and Brain: the right shift theory.* London: Erlbaum.

Arnold, D. 1993. *Ecology and Ceramic Production in an Andean Community.* Cambridge: Cambridge University Press.

Bailey, D. 2005. *Prehistoric Figurines: representation and corporeality in the Neolithic.* London: Routledge.

Beck, B. 1973. The right-left division of South Indian Society. In R. Needham (ed.), *Right and Left: essays on dual symbolic classification.* 391–426. Chicago: University of Chicago Press.

Biró, K. 1998. *Lithic Implements and the Circulation of Raw Materials in the Great Hungarian Plain During the Late Neolithic Period.* Hungarian National Museum.

Boast, R. 1997. A small company of actors. *Journal of Material Culture* 2(2), 173–198.

Chapman, J. 1983. Meaning and illusion in the study of burial in Balkan prehistory. In A. Poulter (ed.), *Ancient Bulgaria Volume 1*, 1–45. Nottingham: University of Nottingham Press.

Chapman, J. 1990. Social inequality on Bulgarian tells and the Varna problem. In R. Samson (ed.), *The Social Archaeology of Houses*, 49–98. Edinburgh: Edinburgh University Press.

Chapman, J. 1991. The creation of social arenas in the Neolithic and Copper Age of South East Europe: the case of Varna. In P. Garwood, P. Jennings, R. Skeates and J. Toms (eds.), *Sacred and Profane*, 152–71. Oxford: Oxford Committee for Archaeology Monograph. 32.

Chapman, J. 2000. *Fragmentation in Archaeology: people, places and broken objects in the prehistory of South Eastern Europe.* London: Routledge.

Chapman, J. 2002. Colourful prehistories: the problem with the Berlin and Kay colour paradigm. In A. Jones and G. MacGregor (eds), *Colouring the Past. The significance of colour in archaeological research*, 45–72. Oxford: Berg.

Chapman, J. 2006. Dark burnished ware as sign: ethnicity, aesthetics and categories in the Later Neolithic of the Central Balkans. In N. Tasic and C. Grozdanov (eds.), *Homage to Milutin Garasanin*, 295–308. Belgrade: Serbian Academy of Sciences and Macedonian Academy of Sciences and Arts.

Chapman, J. 2007. The elaboration of an aesthetic of brilliance and colour in the Climax Copper Age. In F. Lang, C. Reinholdt. and J. Weilhartner (eds.), *Stephanos Aristeios. Archäologische Forschungen zwischen Nil und Istros*, 65–74. Wien: Phoibos Verlag.

Chapman, J. and Gaydarska, B. 2006. *Parts and Wholes. Object categorization and fragmentation in prehistoric context.* Oxbow: Oxbow Books.

Chapman, J. and Gaydarska, B. 2011. Can we reconcile individualization with relational personhood? A case study from the Early Neolithic. *Documenta Praehistorica*, XXXVIII, 21–43.

Chelhod, J. 1973. A contribution to the problem of the pre-eminence of the Right, based upon Arabic evidence. In R. Needham (ed.), *Right and Left: essays on dual symbolic classification.* 239–262. Chicago: University of Chicago Press.

Choyke, A. 1997. Investigation of bone, antler and tusk objects from the site of Polgár-Csőszhalom-dűlő. In P. Raczky, T. Kovács and A. Anders (eds), *Utak a múltba.* 157–159. Budapest.

Douglas, M. 1966. *Purity and Danger: an analysis of concepts of pollution and taboo.* London: Routledge and Kegan Paul.

Dumitroaia, G. 1987. Plastica antropomorfă din așezarea cucteniană de la Răucești – 'Munteni', jud. Neamț. *Memoria Antiquitatis* XV–XVII, 21–42.

Durkheim, E. 1915. *The Elementary Forms of Religious Life.* London: Allen and Unwin.

Durkheim, E. 1973. The dualism of human nature and its social conditions. In E. Durkheim, *On Morality and Society.* 149–167. Chicago and London: University of Chicago Press.

Durkheim, E. and Mauss, M. 1963. *Primitive Classification.* London: Cohen & West.

Ellen, R. 1977. Anatomical classification and the semiotics of the body. In J. Blacking (ed.), *The Anthropology of the Body*, 343–373. London and New York: Academic Press.

Faron, L. 1962. Symbolic values and the integration of society among the Mapuche of Chile. *American Anthropologist, New Series*, 64/6, 1151–1164.

Fernandez, J. 1966. Principles of opposition and vitality in Fang aesthetics. *Journal of Aesthetics and Art Criticism* 25, 53–64.

Flesche, F. 1973. Right and left in Osage ceremonies. In R. Needham (ed.), *Right and Left: essays on dual symbolic classification*, 32–42. Chicago: University of Chicago Press.

Gamble, C. 2005. Materiality and symbolic force: a Palaeolithic view of sedentism. In E. DeMarrais, C. Gosden and C. Renfrew (eds), *Rethinking Materiality: the engagement of mind with the material world*, 85–95. Cambridge: McDonald Institute for Archaeological Research.

Gaydarska, B., Chapman, J., Angelova, I., Gurova, M. and Yanev, S. 2004. Breaking, making and trading: the Omurtag Eneolithic *Spondylus* hoard. *Archaeologia Bulgarica* 2, 11–34.

Gaydarska, B., Chapman, J. and Angelova, I. 2005. On the tell and off the tell: the fired clay figurines from Omurtag. In V. Spinei, C.-M. Lazarovici and D. Monah (eds), *Scripta praehistorica. Miscellanea in honorem nonagenari magistri Mircea Petrescu-Dîmboviţa*, 341–385. Iaşi: Trinitas.

Gaydarska, B., Chapman, J., Raduntcheva, A. and Koleva, B. 2007. The châine opératoire approach to prehistoric figurines: an example from Dolnoslav, Bulgaria. In C. Renfrew and I. Morley (eds), *Image and Imagination*, 177–190. Cambridge: McDonald Institute for Archaeological Research.

Granet, M. 1973. Right and Left in China. In R. Needham (ed.), *Right and Left: essays on dual symbolic classification*, 43–58. Chicago: University of Chicago Press.

Grottanelli, V. 1961. Asoŋu worship among the Nzema: A study in Akan art and religion. *Africa* 31, 46–60.

Hertz, R. 1960. *Death and The Right Hand*. Aberdeen: Cohen and West.

Hudson, M. and Aoyama, M. 2007. Waist-to-hip ratios of Jomon figurines. *Antiquity* 81, 961–971.

Jackson, M. and Karp, I. 1990. Introduction. Personhood and agency. The experience of Self and other in African cultures. In M. Jackson and I. Karp (eds), *Uppsala Studies in Cultural Anthropology* 14, 1–14.

Jones, A. and MacGregor, G. (eds) 2002. *Colouring the Past. The significance of colour in archaeological research*. Oxford: Berg.

Kamarev, M. 2005. Lyavoto i dyasnoto v glinenata plastika – idei za nyakoi duhovni predstavi ot epohata na kusnia halkolit. In T. Stoyanov, S. Angelova and I. Lozanov (eds), *Stephanos Archaeologicos in honorem Professoris Ludmilli Getov*. Sofia: Sofia University Press.

Knappett, C. 2005. *Thinking through Material Culture: an interdisciplinary perspective*. Philadelphia, Pa: University of Pennsylvania Press.

Knappett, C. 2007. Materials with materiality? *Archaeological Dialogues* 14, 20–23.

Kohn, M. and Mithen, S. 1999. Handaxes: products of sexual selection? *Antiquity*, 73, 518–526.

Koleva, B. 2002. Prostranstven model na inventara ot purvi stroitelen horizont na kusnoeneolitnia obekt pri Dolnoslav. *Godishnik na arheologicheskiya muzei Plovdiv* IX/1, 120–130.

Kruyt, A. 1973. Right and left in central Celebes. In R. Needham (ed.), *Right and Left: essays on dual symbolic classification*,74–91. Chicago: University of Chicago Press.

Lemonnier, P. (ed.) 1993. *Technological Choices: transformations in material culture since the Neolithic*. London: Routledge.

Littlejohn, J. 1973. Temne right and left: an essay on the choreography of everyday life. In R. Needham (ed.), *Right and Left: essays on dual symbolic classification*, 288–298. Chicago: University of Chicago Press.

Lloyd, G. 1973. Right and left in Greek philosophy. In R. Needham (ed.), *Right and Left: essays on dual symbolic classification*, 167–186. Chicago: University of Chicago Press.

Marazov, I. 1994. *Mitologya na zlatoto*. Sofia: IK Hristo Botev.

Megerssa, G. and Kassam, A. 1987. Oromo thinking: towards a folk model of cultural interpretation with particular references to trees. Paper presented at the Symposium on African folk models and their application. Uppsala University.

Meskell, L. (ed.) 2005. *Archaeologies of Materiality*. Malden, MA: Blackwell.

Milojković, J. 1990. The anthropomorphic and zoomophic figurines. In R. Tringham, D. Krstić (eds), *Selevac: a Neolithic village in Yugoslavia*. Los Angeles: UCLA Institute of archaeology.

Needham, R. 1973. The left hand of the Mugwe: an analytical note on the structure of Meru symbolism. In R. Needham (ed.), *Right and Left: essays on dual symbolic classification*, 109–27. Chicago: University of Chicago Press.

Nikolov, V. 2006. *Culture and Art of Prehistoric Thrace*. Sofia: Letera.

Raduncheva, A. 1976. *Vinitsa. Eneolitno selishte i nekropol*. Razkopki i Prouchvania (VI). Sofia: Izdatelstvo na BAN.

Raduncheva, A. 1996. Hramoviyat centar do s. Dolnoslav, Plovdivsko i nyakoi aspekti na ritualnostta v kraya na kamenno-mednata epoha. *Godishnik na Departament Arheologya, Nov Bulgarski Univestitet* II/III, 168–181.

Renfrew, C. 1969. The autonomy of the South East European Copper Age. *Proceedings of the Prehistoric Society* 35, 12–47.

Renfrew, C. and Zubrow, E. B. W. 1994. *The Ancient Mind: elements of cognitive archaeology*. Cambridge: Cambridge University Press.

Saunders, N. 1999. Biographies of brilliance: Pearls, transformations of matter and being, *c.* AD 1492. *World Archaeology* 31(2), 243–257.

Skeates, R. 2005. *Visual Culture and Archaeology: art and social life in prehistoric south-east Italy*. London: Duckworth.

Steele, J. 2000. Skeletal indicators of handedness. In M. Cox and S. Mays (eds), *Human Osteology in Archaeology and Forensic Science,* 307–324. London: Greenwich Medical Media.

Sutherland, A. 1977. The body as a social symbol among the Rom. In J. Blacking (ed.), *The Anthropology of the Body*. 375–390. London, New York: Academic Press.

Talalay, L. 1993. *Deities, Dolls and Devices. Neolithic figurines from Franchthi Cave*. Excavations at Franchthic Cave Fascicule 9. Bloomington IN: University of Indiana Press.

Tilley, C. 2007. Materiality in materials. *Archaeological Dialogues* 14, 16–20.

Todorova, H., Ivanov, S., Vasilev, V., Hopf, M., Quitta, H. and Kohl, G. 1975. *Selishtanata mogila pri Goliamo Delchevo*. Razkopki i Prouchvania V. Sofia: Izdatelstvo na BAN.

Todorova, H., Vasilev, V., Yanushevich, Z., Kovacheva, M. and Valev, P. 1983. *Ovcharovo*. Razkopki i Prouchvania (IX) Sofia: Izdatelstvo na BAN.

Vajsov, I. 1990. La sculpture anthropomorphe du site néolitique d'Oussoé près du village d'Asparoukhovo, départment de Varna. *Studia Praehistorica* 10, 103–141.

Washburn, D. (ed.) 1983. *Structure and Cognition in Art*. Cambridge: Cambridge University Press.

Washburn, D. K. and Crowe, D. W. (eds) 1988. *Symmetries of Culture: theory and practice of plane pattern analysis*. Seattle: University of Washington Press.

Weiss, M. 1910. *Die Volkerstamme im Norden Deutsch-Ostafrikas*. Berlin.

White, M. 1998. Twisted ovate bifaces in the British Lower Paleolithic: some observations and implication. In N. Ashton, F. Healy and P. Pettitt (eds), *Stone Age Archaeology*. Essays in honour of John Wymer. 98–104. Oxford: Oxbow Monograph 102.

Wieschhoff, H. 1973. Right and left in African cultures. In R. Needham (ed.), *Right and Left: essays on dual symbolic classification*. 59–73. Chicago: University of Chicago Press.

The shell, the pin and the earring: Balkan Copper Age mortuary costumes in context

John Chapman

INTRODUCTION: SETTING THE EAST BALKAN COPPER AGE IN CONTEXT

One of the visually most striking periods in European prehistory is the Copper Age of the East Balkans. This period covers the 5th millennium BC, possibly starting in the last century of the 6th millennium BC (Higham *et al.* 2007). The relevant cultural units are distributed in South Romania (Gumelniţa), North Bulgaria (Kodzadermen) and South Bulgaria (Karanovo V–VI), as well as Black Sea coastal zone developments (the Hamangia, Sava and Varna groups) (Figure 17.1) (Todorova 1978; Comşa 1987; Lichardus 1991; 1991a; Bailey and Panayotov 1995; Popovici 2010). All general accounts of the Copper Age emphasise the artifactual wealth of the principal sites, including not only famous tells such as Karanovo, Gumelniţa and Pietrele, but also important coastal cemeteries at Durankulak and Varna. The grave goods of the Varna cemetery are a byword for elite magnificence, which must have created stunning visual spectacles before and at the time of burial (Ivanov 1988; 1991; Slavchev 2010). The Copper Age has been described as a 'climax' development, in technological, economic and social terms (Nandris 1978; Chapman 2000), meaning that such a diversity and quantity of material culture would not be found again in Europe for many generations. An example of this climax phenomenon is the vast range of object colours identified at the Varna cemetery, in itself providing empirical refutation for Berlin and Kay's (1969) universalising, evolutionary hypothesis of colour development (Chapman 2002). Bailey (2000) has recognised the appropriateness of visually expressive materials to public mortuary cemeteries as a 5th millennium BC innovation.

It is not the purpose of this article to focus again on the Varna cemetery (Higham *et al.* 2007; Chapman and Gaydarska 2006; Chapman *et al.* 2006; cf. the report on the shell ornaments in the Varna cemetery: Chapman and Gaydarska in prep.) but, rather, to investigate the mortuary costumes used in a wide range of other Late Copper Age cemeteries in the East Balkans, with the aim of defining and understanding the visual palette of the period and its varied use in different burying communities.

I have recently discussed the importance of costume in the context of the body and in relation to the skin (Chapman 2010, 5–7). Once costumes become directly associated with one person, there opens up a series of discourses showing the tensions between the values of the group and the identity of the person wearing that ornament. These discourses concerned age-sex classes, kinship categorisation, status and scales of value, rites of passage, about distance and the exotic, inter-tribal communication, about personhood and the boundaries

of the body (Newell *et al.* 1990; Sørensen 1997). If artifacts are the material templates of a *scale* of values (Powers 2006), then ornaments encode not only the quality of human-ness but also differential degrees of human-ness registered along this scale of values. This socially created scale of values is expressed through style – the visual expression of cultural priorities. In this way, mortuary ornaments, just like any other artifact class, are the locus for potential conflict since cultural priorities are not necessarily accepted by everyone in the community. Style is inherently political, at the personal as much as the communal level. Since prehistoric politics related to the relationship between persons and exotic origins and distance, ornaments made of local clay were fundamentally different from those made of exotic marine shells brought from several hundred kilometres. The act of wearing personal decorations has been seen by Fowler (2004,103) as changing the very nature of the person, by providing them with a new identity, by offering them new perspectives and by affording them a different sense of self. This point is especially valuable at times such as funerals, which provide the whole community with an opportunity for social re-negotiation (Binford 1971). One aspect of such a negotiation is the notion that the skin of the body is a boundary between self and society, a place where boundary negotiations take place (Bethien 2002; cf. Sørensen 1997). Bethien (2002) takes the physical skin itself to be the '*corporeal* dress *of human beings*' – their performative and visible surface, treating the cultural elements of clothing and ornamentation as a second layer – indeed part of the performance played out on the physical skin. If the skin is interpreted as the stage on which the cultural performance is played out, the ornaments in the performances are central to these practices. These ideas help us to see how the mortuary costumes of the newly-dead buried in Balkan Copper Age cemeteries can inform us about a picture of social relations that is, *contra* Binford (1971), not necessarily normative, but the result of the varying and sometimes opposing wishes of the living to present and re-present the deceased in a particular, fitting way to the world of mourners at the funeral and to the wider world through cultural memory. The grave can be a locus of political contestation, in which claims for the future, but based upon the past, are materialised in persuasive ways.

METHODOLOGY FOR THE IDENTIFICATION OF COSTUME SETS

The data for this analysis have been drawn from excavations at eight Late Copper Age cemeteries (Figure 17.1; Table 17.1). The eight Late Copper Age cemeteries are located between 27km and 130km, as the crow flies, from Varna. These sites provide a representative sample of mortuary data from the Late Copper Age of the East Balkans. All sites but two (Devnja and Smjadovo) have been completely excavated. The publications have been studied to assess the reliability of identifications of mortuary costume in these sites in the following way.

The effectiveness of any comparative analysis of costume sets depends on a high enough level of recording of the location of ornaments and ornament sets in graves to permit differentiation between ornaments as costume elements and ornaments as grave goods. Costume elements are those that were attached to the body during pre-burial ceremonies and carried as part of the body to the grave. Ornaments as grave goods were deposited in the grave before or during burial, with other ornaments thrown into the grave during re-filling.

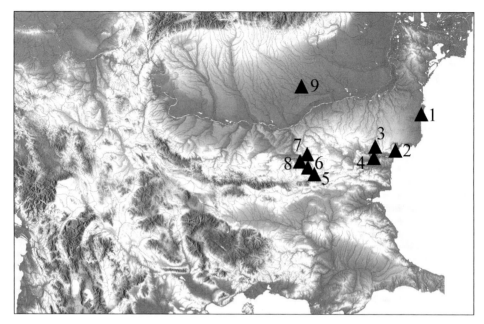

Figure 17.1: 1) Durankulak; 2) Varna; 3) Devnja; 4) Goljamo Delchevo; 5) Smjadovo; 6) Vinitsa; 7) Targovishte; 8) Omurtag; 9) Vărăşti.

Table 17.1: Late Copper Age cemeteries.

SITE	REGION	DATE/CULTURE	REFERENCE
Durankulak	West Pontic	Mid–Late 5th MBC: Hamangia IVb – Varna I–III	Todorova 2002
Devnja	West Pontic	5th MBC: Late Copper Age	Todorova 1971
Vinitsa	N E Bulgaria	5th MBC: Late Copper Age	Raduntcheva 1976
Goljamo Delchevo	N E Bulgaria	5th MBC: Late Copper Age	Todorova 1975
Smjadovo	N E Bulgaria	5th MBC: Late Copper Age	Chokadhziev and Venelinova 2006: 2007: 2008: 2009
Vărăşti	South Romania	5th MBC: Gumelniţa	Comşa 1995; Chapman, in press
Targovishte	N E Bulgaria	5th MBC: Late Copper Age	Angelova 1986; Cholakov and Boev 1986
Omurtag	N E Bulgaria	5th MBC: Late Copper Age	Yordanov *et al.* 2006

It is inevitable that ambiguous cases exist, such as the unspecified number of *Spondylus* beads in Grave 8 at the Goljamo Delchevo cemetery (Todorova 1975, 60). Here, the excavator interprets the beads as being attached to the lower hem of a funerary garment, perhaps a shroud. An obvious alternative is that they were placed in the grave as grave goods rather than representing a costume set. When beads are found under the skull or the elbows of the deceased, it is often hard to interpret them as part of a diadem or a bead

bracelet rather than as beads placed in the grave before the burial (e.g., the two *Spondylus* beads found near the elbows of the body in Grave 38 at the Vinitsa cemetery: Raduntcheva 1976, 87–88). A third uncertainty concerns the discovery of fragmentary shell rings, which were clearly not worn on the arm of the deceased but could have been placed in the grave as grave goods or sewn onto a garment (e.g., Durankulak Grave 413: Todorova *et al.* 2002, 49; and table 61/11). It is therefore fair to concede that there is an element of interpretation underpining the comparison of costume sets but we believe that this uncertainty should not seriously affect the wider picture.

THE CEMETERIES

The Devnja cemetery (27km from Varna) was excavated under rescue conditions; originally, it was probably much larger than the 26 graves published by Todorova (1971). The excavator claimed the existence of a coeval lake-side settlement some 500m from the cemetery (1971, 17) but this has not been explored. The first four graves were found by workmen, with only 22 graves excavated by Todorova (1971). Six graves, including one grave found by workmen, contained ornaments. However, since three of these graves (Graves 4, 14 and 22) had been destroyed or disturbed, only three certain graves remain (Table 17.2 and Figure 17.2).

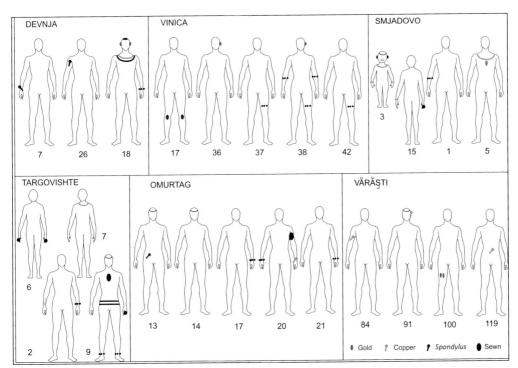

Figure 17.2: Mortuary costumes, small Late Copper Age cemeteries. East Balkans: 1–3: Devnja; 4–8: Vinica; 9–12: Smjadovo; 13–16: Targovishte; 17–21: Omurtag; 22–25: Vărăşti.

The Goljamo Delchevo cemetery (30km from Varna) was completely excavated at the same time as the adjoining Late Copper Age tell (Todorova 1975, 59–64). Todorova (1975, 61) claims ornament sets in two of the graves. In Grave 8, there is an unspecified number of *Spondylus* beads which the excavator interprets as the edging on the lower hem of a garment of an *Infans II* skeleton, but the beads could equally be placed in the grave unattached to the body or its shroud. Similarly, the sheet gold bead found under the skull of an adult male in Grave 25 may or may not have been a hair-decoration. The surprising conclusion is that none of the 31 burials contained a mortuary costume, although copper tools and weapons have been frequently deposited.

The Smjadovo cemetery (75km from Varna) was recently discovered, in 2005, during a renewed investigation of the tell. At time of going to press, the excavation of the cemetery is ongoing, with 22 Late Copper Age graves published so far, one of which was destroyed (Chokadzhiev and Venelinova 2006; 2007; 2008; 2009). Four of the graves contained costume elements, all of which were familiar to students of Varna costumes, with an unconfirmed ratio of one costume grave per five graves (Table 17.3 and Figure 17.2).

Table 17.2: Costume graves, Devnja cemetery.

GRAVE NO.	AGE/SEX CATEGORY	ORNAMENT (SET)
7	? male	Copper dress-pin in (?) right hand
18	20–25 male	*Spondylus* hair-ornament; 2 gold ear-rings; *Spondylus* necklace and black mineral bead necklace; *Spondylus* bead-bracelet on left wrist
26	? male	Copper dress-pin near right shoulder

Table 17.3: Costume graves, Smjadovo cemetery.

GRAVE NO.	AGE/SEX CATEGORY	ORNAMENT (SET)	COMMENTS
1	Adult male	Snail shell bead-bracelet on right wrist	
3	Infant I	Serpentinite bead diadem; serpentinite tooth-decoration; snail-shells at temples (?ear-rings); necklace of *Spondylus* and bone beads; sheet copper bracelets on right and left wrists	Fired clay grain skeuomorph in mouth
5	?	Necklace of polished stone beads with one gold applique	
15	juvenile	Copper bracelet on right wrist	Grain skeuomorphs in left hand

The Vinitsa cemetery (90km from Varna) is another completely excavated cemetery next to a tell occupied in the Earlier and the Late Copper Age (Raduntcheva 1976; 69–98). A total of 51 graves was investigated, one of which was destroyed. Costumes have been found in five graves – a proportion of one in ten graves (Table 17.4 and Figure 17.2). In a costume sense, Grave 46 is problematic: a child was either adorned with a copper tooth-ring or had a copper ring in the mouth – probably the latter.

Table 17.4: Costume graves, Vinica cemetery

GRAVE NO.	AGE/SEX CATEGORY	ORNAMENT (SET)
17	Adult male	*Spondylus* applique near knees
36	Adult male	Gold ear-ring on left; *Spondylus* bead necklace; *Spondylus* bead-bracelet round left knee;
37	Adult female	*Spondylus* bead-bracelet near knees
38	Senile male	Gold ear-ring on left; *Spondylus* bead-bracelet at elbows;

Table 17.5: Costume graves, Targovishte cemetery.

GRAVE NO.	AGE/SEX CATEGORY	ORNAMENT (SET)	COMMENTS
2	45yr male	*Spondylus* bead-bracelet on left wrist	
6	Infant I	Bone rings on right and left hands	
7	Infant I	*Spondylus* bead necklace	OR two beads sewn onto garment
9	18–20 female	*Spondylus* bead diadem; necklace of *Glycymeris* pendant and fired clay amulet; *Spondylus* bracelet on left wrist; bone ring on left hand; *Spondylus* bead belt; *Spondylus* bead-anklet on right and left ankles	

The Targoviste cemetery (110km from Varna) is a small, completely excavated cemetery of 11 graves located adjacent to the Late Copper Age tell (Angelova 1986). Costumes adorned four of the graves – a high proportion (36%) in a small number of graves (Table 17.5 and Figure 17.2).

The Omurtag cemetery (130km from Varna) lies some 20km from the Targovishte site and therefore may be expected to share close analogies in mortuary costume. The cemetery lies close to a Late Copper Age tell which has substantial off-tell discard (Chapman *et al.* 2005) and an important hoard within the tell (Gaydarska *et al.* 2004). We base this analysis on the physical anthropological report on the 31 graves (Yordanov and Dimitrova 2006) with details on the graves from the excavation diary (p.c., I. Angelova) and the Omurtag Museum inventory book (thanks to Miroslav Toshev). The cemetery is unique in East Balkan Copper Age burial deposits in the overwhelmingly high proportion of mature – senile (40+ years) skeletons, with very few adults, no juveniles and only three children. Only five burials are adorned with costumes – all but one mature or senile individuals – providing data that are heavily biased in favour of costumes of older persons (Table 17.6 and Figure 17.2). However, each of these 'costumes' are problematic in terms of the small number of *Spondylus* beads representing a minimal ornament set. If the beads near the skull are interpreted as parts of diadems and the beads held in the hands are considered

as bead-bracelets, the range of costume increases in quantity and diversity from minimal to moderate. However, the discovery of an utilised pumice-stone containing fragments of marine shell in the Omurtag hoard reminds us that the community was connected to a vast inter-regional network stretching to either the Cyclades (Santorini) or to Southern Italy (Lipari) (Gaydarska *et al.* 2004).

The inclusion of the Vărăşti cemetery (130km from Varna, North of the Danube) within the wider Karanovo VI-Gumelniţa-Kodjadermen (KGK) complex (Comşa 1987; Todorova 1978; Price 1993) implies that it is legitimate to make comparisons with Varna and other Late Copper Age cemeteries. It was excavated by Eugen Comşa in 1957 – 1965 as part of the project to investigate prehistoric settlement around the Lake Boian (Comşa 1995). Two prehistoric tells were established close to the cemetery: the Boian A tell, dating mostly to the Boian period, and the Boian B tell, dating to the Gumelniţa period. The Vărăşti cemetery comprises a total of 126 Neolithic/Copper Age burials – four from the Boian–Gumelniţa transition, or Spanţov, phase (Graves 10, 22, 61 and 121) and 122 from various phases of the Gumelniţa period. However, some 20 Gumelniţa graves have been seriously disturbed, not to mention the destruction of an unknown number of graves by fluvial erosion (Comşa 1995, 190). This left 106 graves for comparative analysis, of which only four contained costumes (Table 17.7 and Figure 17.2).

In Grave 84, a copper pin was sewn onto the right sleeve. In Grave 91, a copper hair-pin was found with a diadem of *Dentalium* and polished stone beads. In Grave 100, a gold tube and gold pendant were sewn onto a garment covering the right leg. Finally, in Grave 119, a

Table 17.6: Costume graves, Omurtag cemetery.

GRAVE NO.	AGE/SEX CATEGORY	ORNAMENT (SET)	COMMENTS
13	Senile female	*Spondylus* bead near head; copper dress-pin at waist	? minimal *Spondylus* diadem
14	Mature male	*Spondylus* bead near head	? minimal *Spondylus* diadem
17	Adult female	*Spondylus* bead held in hand	? minimal *Spondylus* bead-bracelet
20	Mature female	*Spondylus* applique sewn onto upper arm garment; copper dress-pin held in hand, with *Spondylus* beads	? bead-bracelet
21	Mature female	*Spondylus* beads held in hand	? minimal bead-bracelet

Table 17.7: Costume graves, Varaşti cemetery.

GRAVE NO.	AGE/SEX CATEGORY	ORNAMENT (SET)
84	?	Copper dress-pin attached to right arm
91	?	Copper hair-pin; diadem of *Dentalium* and polished stone beads
100	?	Gold tube and pendant sewn onto right leg
119	?	Copper dress-pin attached to torso

copper pin was sewn onto a garment covering the torso. The scanty costume remains from Vărăşti show an emphasis on ornaments sewn onto garments (?shrouds) and a preference for copper pins. There are at least three other graves where gold pins appear to have been placed in graves rather than attached to a garment but the latter must remain a possibility (Graves 5 and 54; the latter also contains a placed amber ornament).

Finally, the Late Copper Age (Varna group) part of the Durankulak cemetery contains 440 graves, with 137 costume graves (or 31%) (Avramova 2002). It thus constitutes the largest grave group of the eight cemeteries, with a total of 46 costumes sets distributed across four age-sex categories: children (4 unique costumes), juveniles (n=3), adult females (n=20) and adult males (n=10), with a further nine costumes found in two or more age-sex categories (Figures 17.3–4). Children's costume elements were concentrated exclusively on the upper body, with a predominance of bracelets over rings, diadems, earrings or belts. There was a maximum of three elements in children's costume (Figure 17.3). Juvenile costumes were focussed not only on the upper body but predominantly on the head, with diadems in each of the juvenile-only costumes as well as a number of bracelets. A single juvenile costume comprised five elements – D/K 558 (Costume Type 20) (Figure 17.3). The adult male costumes were not vastly more complex than those of the children, with a maximum of three elements (Figure 17.3). The commonest element was the bracelet, often paired singly or multiply, with necklaces more frequent than

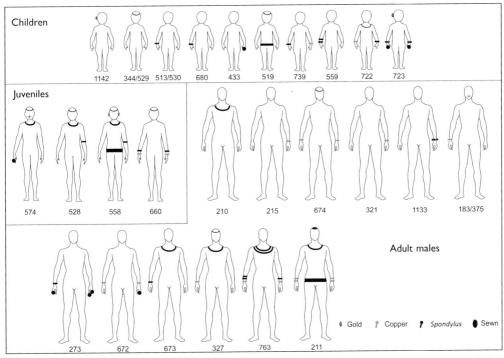

Figure 17.3: Mortuary costumes. Late Copper Age Durankulak: 1–10: children; 11–14: juveniles; 15–26: adult males.

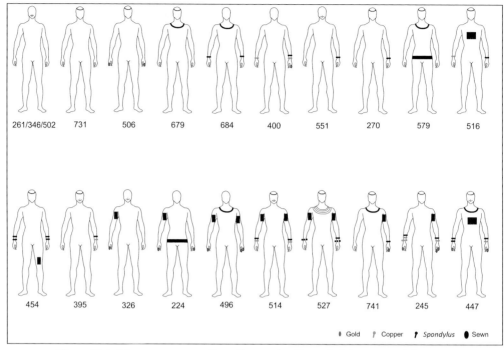

Figure 17.4: Mortuary costumes. Late Copper Age Durankulak: 1–20: adult females.

diadems. The widest range of costumes was associated with adult female burials (Figure 17.4). Sixteen of the 20 costumes incldued head decoration, mostly diadems but also copper tooth-rings, while 12 corpses were adorned with bracelets and eight with copper finger-rings. A single lower-body element was found – *Spondylus* appliques sewn onto the right leg. The most complex costume – D/K 446 (Costume Type 70) – contained six *elements*, with others containing four and five elements; another sign of complexity was the placing of as many as four necklaces on D/K 527 (Costume Type 67). Thus adult female costumes were distinctive and generally more complex than most of the adult male and children's costumes and all of the juvenile costumes except D/K 558.

INTER-CEMETERY COMPARISONS

A consideration of costume sets in Late Copper Age cemeteries indicates an apparently contradictory finding. With the exception of Durankulak, mortuary costumes do not appear to be a *frequent* means to portray personal or group identities in these communities, although several cemeteries develop these discourses with the help of other grave goods, such as the copper tools at Devnja. However, at the same time, there are few similarities in mortuary costumes between the different cemeteries, showing the importance of costume on the few occasions in which they were used.

The basis for the first analysis is the presence of costume elements in the costume graves in our eight cemeteries. This analysis also accepts as a limitation the discrepancy in sample size between different cemeteries, with only a handful of costume graves in six of the cemeteries and a total of 137 costume graves at Durankulak. However, there are some interesting patterns that can be identified despite this sampling issue. Thus, in a comparison of the number of costume sets represented in the various cemeteries (Figure 17.5a), the peaks in elements are usually associated with a large sample of costume graves (e.g., Durankulak) but the four graves at Targovishte produced more costume elements than expected. A comparison of the five body zones available for costume display, *pace* Todorova and Vajsov (2001), shows that cemeteries with smaller samples do not always utilize smaller numbers of body zones (Figure 17.5b). A simple division of the body into two parts – upper (containing head, torso and arms) and lower (containing midriff and legs) – indicates that there is a strong preference for upper-part costume elaboration in all sites (Figure 17.6a). There is a tendency for emphasis on both body parts in the Black Sea coastal cemeteries, with exclusive emphasis on the upper body at inland cemeteries, but with exceptions in both zones: the near-coastal cemetery of Devnja has no lower-part ornaments, while the inland cemetery of Vinica displayed a mixture of upper- and lower-part elements.

A more complex picture emerges from the comparison of costume elements of all five body zones by cemetery (Figure 17.6b), although the variance in sample size must be noted with caution. There is only one cemetery (Omurtag) where only two body zones were emphasised. Three body zones were emphasised at three cemeteries, four at one cemetery, while all five body zones were elaborated at Durankulak and, surprisingly for its size, Targovishte. Three body zones were prominent in various proportions at all but one cemetery (Omurtag) – the head, the torso and the arms. Head elaboration was more prominent than torso or arm decoration at only two sites (the juveniles and adult females at Durankulak and Vărăşti), of equal significance as arm decoration at three others but less important than torso decoration at only Targovishte. For the lower part of the body, midriff decoration was more frequent than leg decoration at two sites and of equal importance at three others. These comments show the amount of inter-site variation within one overall, long-lasting cemetery tradition.

This point is also underlined through a consideration of the distribution of individual costume elements (Figure 17.7a). There are six unique costume elements found at only one cemetery – perhaps showing a social identity specific to that place. There are nine costume elements which are distributed narrowly, on only two or three East Balkan sites, some showing spatial patterning, such as the inland trait of ornaments sewn onto trousers at Vinica, Targovishte and Vărăşti. Diadems and necklaces were widespread in both the coastal and inland zones, while the bead-bracelet was the most widespread costume element, also found on the ankle and the knee on two other sites. It is possible that one reasons for the popularity of the bead bracelet was as a substitute for the more prestigious solid *Spondylus* bracelet.

In this analysis, which often takes the costume elements out of the context of their costume sets, there is a strong sense of an overall regional tradition of mortuary practices, offset against the moderate to high variability found between the different cemeteries. However, if we turn to a comparison of the mortuary costumes at the seven cemeteries with the costumes at the Varna cemetery (Figure 17.7b), there is an extraordinary lack of shared

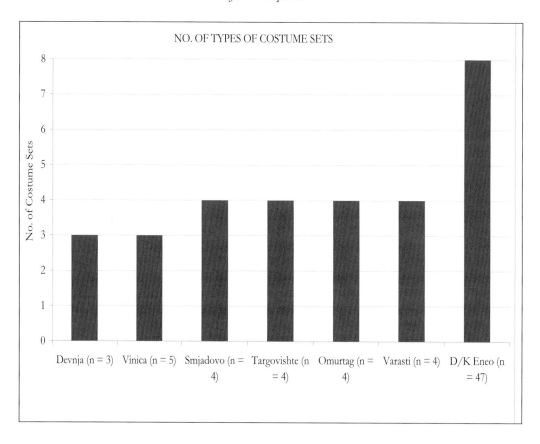

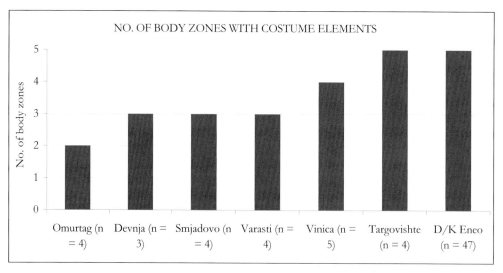

Figure 17.5: (a) No. of types of costume set; (b) number of body zones utilised.

costume sets in these East Balkans communities. Each site's costume sets are relatively distinctive, with the exception of four exact parallels: the single diadem costume, found at Durankulak 731 (Costume Type 50) and Omurtag 14; the single necklace costume, found at Durankulak 210 (Costume Type 3) and Targovishte 7; the copper dress pin attached to the right sleeve, found at Devnja 26 and Vărăşti 84; and the single bead-bracelet bracelet, found at Targovishte 2, Omurtag 21 and 17 and Durankulak 1133 (Costume Type 36). It is worth noting that each costume found at two or more sites is a simple, single-element costume. There is not a single exact parallel between the eight cemeteries for a complex costume – only analogies for individual elements (e.g., three elements in the complex Smjadovo 3 costume – the necklace and two bracelets – can be matched at Durankulak 684 (Costume Type 54)).

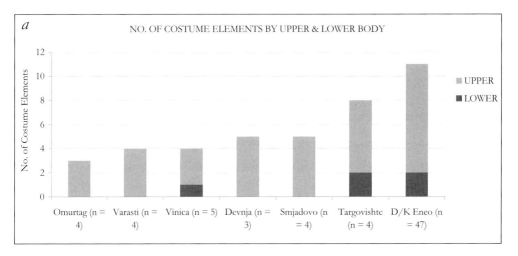

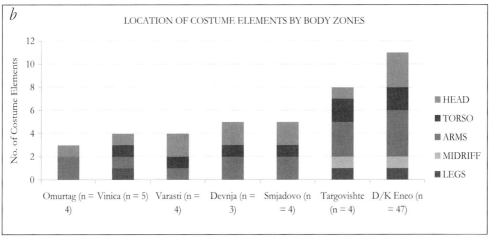

Figure 17.6: (a) Upper-body vs. lower-body location of costumes; (b) location of costume elements by body zone.

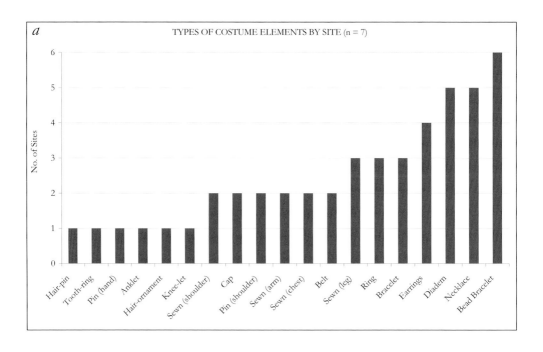

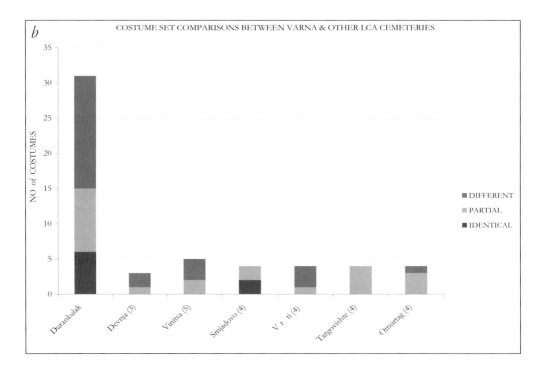

Figure 17.7: (a) Types of costume element; (b) costume set comparisons between Varna and other cemeteries; (c) number of elements in costume sets.

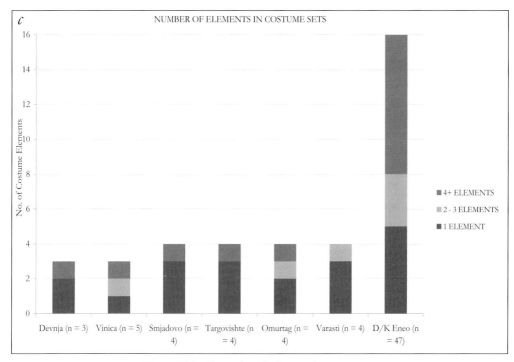

Figure 17.7: (c) number of elements in costume sets.

The small size of these cemeteries must contribute to this result but cannot explain all of the patterning, which flies in the face of the spatial proximity of some of the cemeteries, which were located within 15 km of each other. One interesting pattern in the small north-east Bulgarian cemeteries is the presence of one burial adorned with a highly complex costume set (viz., with 4 or more elements) in each site (Figure 17.7c). This pattern contrasts strongly with the dominance of minimally complex costumes over medium-complexity costumes at several cemeteries which include no complex costumes at all. It is only at the Durankulak cemetery that there is a preponderance of complex costumes over simpler varieties.

DISCUSSION AND CONCLUSIONS

There are several patterns in the variability in mortuary costumes, including the obvious dimensions of space and time. We can identify different social practices in different areas of the same overall 'cultural distribution' (KGK VI) and perhaps even in different villages. One may also expect variations in social practices through time – a variable which is hard to control for in the continued absence of AMS dates for cemeteries other than Varna and Durankulak – and therefore not discussed further here. But identifying variations through time and space does not explain these changes – it merely foregrounds them. Three factors may help us to understand such variability: (1) materialisation of variations

in the social structures of the communities burying their dead in their local cemeteries; (2) varying identities among local burying communities; and (3) the materialisation of tensions between dividuals and individuals at death.

There are powerful reasons for attributing part of the mortuary costume variability to inter-community differences in social structure. These differences may well have created different potential access to raw materials and finished objects in the intensive and wide-ranging exchange networks of the East Balkan Copper Age; higher-status persons would have derived part of that status from their wider socio-political contacts than other, less significant persons.

Over 30 years ago, Todorova (1975a; 1978) made a case for this scenario in her comparison between coastal and inland Copper Age cemeteries. Although the statistical basis of the comparison may be challenged, Todorova correctly observed the steep decline in grave goods frequency and variety with the move inland. Our analysis of mortuary costumes has shown that there is a greater diversity of costumes in the coastal cemeteries than in inland sites but the far larger size of the coastal cemeteries must have played an important role here. Differential size and longevity is a good indicator here of the relative success and integration of their burying communities. What is missing from the inland cemeteries is the upper range of the most complex costumes found at Durankulak and Varna. This result is akin to the late Jan Lichardus' analysis of grave good complexity (Lichardus 1988), in which only the Varna cemetery contained the upper two grave good complexes (Gruppe A and B) out of the total range of five. Thus, overall social status varied between coastal and inland communities. In this sense, it is significant that there are close similarities between Varna and the Late Copper Age graves at Durankulak, even in terms of the presence of identical costumes with five or six elements.

The notion of a 'regional mortuary tradition' merits further comment. This tradition has been defined in a culture-historical manner, through the classic means of the presence of shared artifacts. While the East Bulgarian cemeteries do indeed share a range of ornament types and sub-types, it is interesting that, in agreement with the third explanation, each burying community makes contrasting *uses* of the same material culture. A comparison of all of the eight cemeteries shows a striking *lack* of shared mortuary costumes. One of the main sources of variability is the preferences for different body zones with which to elaborate the cultural skin of decoration at each cemetery; another is the combinations of individual ornaments in a set. A similar result derived from the detailed analysis of grave goods from three of the Late Copper Age cemeteries, which shared almost identical object categories (copper axes, bone pins, carinated bowls) but in which different associations with age-sex categories of the deceased were found for almost every object category in each cemetery (Chapman 1996). The conclusion that different communities created their own identities through making contrasting uses of the same material culture surely applies to the wider sample of seven cemeteries. However, the small number of graves in most of these cemeteries prevents us from making a secure conclusion in this respect.

With dividual–individual tensions, there is no doubt that the 'normal' practice of burying separate bodies was, for the most part, a strong statement about their individuality. However, three kinds of 'deviant' burial have been found in the Late Copper Age of the East Balkans, as compared to the five forms of 'deviant' burial found in the rest of the Balkans and the Carpathian Basin (Chapman 2010a): (1) parts of extra bodies have been

added to complete bodies (e.g., Varna Grave 43; Vinica Grave 3; Devnja Grave 6); (2) parts of bodies have been removed (e.g., Devnja Grave 17; Vinica Grave 10); and (3) bones from different individuals have been combined to form a new, hybrid person (e.g., Vinica Grave 3). Thus even in the cemetery, the *locus classicus* for the expression of corporate identity, enchained dividuality is an important, if rare, social practice.

The visual impact of the mortuary costumes of the East Balkan Late Copper Age was extraordinarily varied – partly a result of the much wider range of objects and raw materials in use in comparison with earlier periods. It was this variation that allowed another way of expression of the tension between dividuals and individuals (LiPuma 1999). The costumes ranged from the simplest one-element – a single necklace, bead-bracelet, dress-pin, diadem or sewn appliqué – to dramatic, highly contrastive six-element costumes which embodied the characteristic Chalcolithic aesthetic of brightness, colour and exoticity (Chapman 2007).

While, on one level, costume sets represent the integration of a visual statement about the newly-dead, on another level, even in a single necklace, messages about a wide range of enchained relationships could be made alongside materialisations of the importance of heirlooms and curated beads and their implied kinship relations. The biographical complexities of six-element mortuary costumes provided generalised maps of individual connections as well as genealogical links betokening dividual relations in exchange networks across the Balkans, densely packed with information that insiders could have used to formulate interpretations of the new body created in the mortuary domain. Thus, the popularity of the bead-bracelet, with the related anklet and knee-bracelet, may well be related not only to alternatives to a solid one-piece shell bracelet but also to its potential for dividual enchainment through the combination and re-combination of single beads from different necklaces belonging to varied persons.

Thus, all of three factors which we have discussed – social structure, local identities and the tensions between dividuals and individuals – can be related to different aspects of the variability in the mortuary costumes found in the seven Late Copper Age cemeteries of the Eastern Balkans under analysis. However, and finally, we should not forget that mortuary costumes were absent from the majority of Late Copper Age burials. For example, there was one cemetery – next to the Goljamo Delchevo tell – with not a single case of a mortuary costume! Even if ornaments associated with others' mortuary costumes were deposited in these graves, the bodies lacked a fundamental way of expressing their new transitional personalities. Their social skins lacked the dramatic performative energy of a complex mortuary costume – their bodies were less interesting, less communicative and, above all, less social. Unless we can find ways of understanding the vast range of mortuary practices that we can see in the East Balkan Late Copper Age, we shall not be able to articulate the domains of the dead and the living in order to reach a full interpretation of that vibrant period in the Balkan past.

ACKNOWLEDGEMENTS

I am very grateful to the two Andys – Cochrane and Jones – for their kind invitation to make a contribution to this volume, despite being absent from the meeting that generated it. I am

also happy to thank Simon Kaner, Andy C. and Doug Bailey for the superb exhibition in the Sainsbury Centre, UEA, which led to our meeting and discussions on material culture and Balkan visuality (followed up in Varna later in the summer of 2010). This chapter is a summary of part of the research which Bisserka and I have been conducting on the shell ornament assemblage of the Varna cemetery and it is our pleasure to pay tribute to the Director, Dr. Valentin Pletnyov, and the staff, Dr. Vladimir Slavchev and Mrs. Olga Pelevina, of the Archaeological Museum Varna, for their invitation to study the shell ornaments. I am also indebted to Miroslav Toshev, the Director of the Omurtag Historical Museum, for allowing Bisserka and me access to museum documents and to the Omurtag Chalcolithic finds. In addition, I'd like to thank Alexandra Comşa for her invitation to write a chapter on the Cernica and Vărăşti cemeteries in what started as Eugen Comşa's *Festschrift* but, most regrettably, became his memorial volume after his death in late 2008. I dedicate this chapter to Eugen Comşa. I am obliged to Yvonne Beadnell for making the 'dancing figures' come to life with her usual skill. My final thanks, as ever, go to Bisserka, who has made her usual positively critical comments on this essay.

REFERENCES

Angelova, I. 1986. Praistoricheski nekropol pri grad Targovishte. *Interdistsiplinarni Izsledvaniya* 14A, 49–66.
Avramova, M. 2002. Der Schmuck aus den Gräbern von Durankulak. In H. Todorova (ed.), *Durankulak Band I. Die prähistorischen Gräberfelder. Teil II*, 191–206. DAI, Berlin–Sofia, Anubis.
Bailey, D. W. and Panayotov, I. (eds.) 1995. *Prehistoric Bulgaria*. Madison, Wisconsin: Prehistory Press.
Berlin, B. and Kay, P. 1969. *Basic Color Terms: their universality and evolution*. Berkeley: University of California Press.
Bethien, C. 2002. *Skin. On the cultural border between self and the world*. New York: Columbia University Press.
Binford, L. R. 1971. Mortuary practices: their study and their potential. In J. Brown (ed.), *Approaches to the Social Dimensions of Mortuary Practices*, 6–29. Washington, D.C.: Memoir of the Society for American Archaeology 25.
Chapman, J. 1996. Enchainment, commodification and gender in the Balkan Neolithic and Copper Age, *Journal of European Archaeology* 4, 203–42.
Chapman, J. 2000. *Fragmentation in Archaeology. People, places and broken objects in the prehistory of South Eastern Europe*. London: Routledge.
Chapman, J. 2002. Colourful prehistories: the problem with the Berlin and Kay colour paradigm. In A. Jones and G. MacGregor (eds), *Colouring the Past. The significance of colour in archaeological research*, 45–72. Oxford: Berg.
Chapman, J. 2007. The elaboration of an aesthetic of brilliance and colour in the Climax Copper Age. In F. Lang, Reinholdt and J. Weilhartner (eds), *Stephanos Aristeios. Archäologische Forschungen zwischen Nil und Istros*, 65–74. Wien: Phoibos Verlag.
Chapman, J. (ed.) 2010. *From Surface Collection to Prehistoric Lifeways: making sense of the multi-period site of Orlovo, South-East Bulgaria*. Oxford: Oxbow Books.
Chapman, J. 2010a. 'Deviant' burials in the Neolithic and Chalcolithic of Central and South Eastern Europe. In K. Rebay-Salisbury, M. L. S. Sørensen and J. Hughes (eds), *Body Parts and Bodies Whole* 30–45. Oxford: Oxbow Books.

Chapman, J. in press. A tale of two cemeteries. Cernica and Vărăşti. (To appear in Eugen Comşa Memorial Volume, Bucureşti).

Chapman, J., Higham, T., Slavchev, V., Gaydarska, B. and Honch, N. 2006. The social context of the emergence, development and abandonment of the Varna cemetery, Bulgaria. *European Journal of Archaeology* 9/2–3, 159–183.

Chapman, J. and Gaydarska, B. 2006. *Parts and Wholes. Fragmentation in prehistoric context*. Oxford: Oxbow Books.

Chapman, J. and Gaydarska, B. in prep. The shell ornaments. (To appear in Slavchev, V. (ed.) *The Varna Eneolithic Cemetery Final Report*. Vol. 2. Berlin and Varna: DAI and Archaeological Museum Varna).

Chapman, J., Gaydarska, B. and Angelova, I. 2005. On the tell and off the tell: the fired clay figurines from Omurtag. In V. Spinei, C-M. Lazarovici and D. Monah (eds) *Scripta praehistorica. M. Petrescu-Dîmboviţa Festschrift*, 341–385. Iaşi: Trinitas.

Chokadhziev, S. and Venelinova, S. 2006. Arheologicheski prouchvaniya na halkoliten nekropol v m. Gorlomova Koriya kraj gr. Smjadovo. *Arheologicheski Otkritia i Razkopki za 2004*, 62–63.

Chokadhziev, S. and Venelinova, S. 2007. Arheologicheski prouchvaniya na halkolitniya nekropol v m. Gorlomova Koriya kraj gr. Smjadovo. *Arheologicheski Otkritia i Razkopki za 2005*, 65–67.

Chokadhziev, S. and Venelinova, S. 2008. Arheologichesko prouchvane na praistoricheski nekropol v m. Gorlomova Koriya kraj gr. Smjadovo. *Arheologicheski Otkritia i Razkopki za 2006*, 100–101.

Chokadhziev, S. and Venelinova, S. 2009. Arheologichesko prouchvane na praistoricheski nekropol v m. Gorlomova Koriya kraj gr. Smjadovo. *Arheologicheski Otkritia i Razkopki za 2007*, 116–18.

Cholakov, S. and Boev, P. 1986. Antropologichno i paleopatologichno prouchvane na eneoliten nekropol v grad Targovishte. *Interdistsiplinarni Izsledvaniya* 14A, 67–86.

Comşa, E. 1987. *Neoliticul pe teritoriul României*. Bucureşti: Editura Academiei Române.

Comşa, E. 1995. Necropola gumelniţeană de la Vărăşti. *Analele Banatului, Serie Nouă, Arheologie-Istorie* IV/1, 55–193.

Fowler, C. 2004. *The Archaeology of Personhood. An anthropological approach*. London: Routledge.

Gaydarska, B., Chapman, J., Angelova, I., Gurova, M. and Yanev, S. 2004. Breaking, making and trading: the Omurtag Eneolithic *Spondylus* hoard. *Archaeologia Bulgarica* 2, 11–34.

Higham, T., Chapman, J., Slavchev., V., Gaydarska, B., Honch, N., Yordanov, Y. and Dimitrova, B. 2007. New perspectives on the Varna cemetery (Bulgaria) – AMS dates and social implications. *Antiquity* 81, 640–654.

Ivanov, I. 1988. Die Ausgrabungen des Gräberfeldes von Varna. In Fol, A. and Lichardus, J. (eds), *Macht, Herrschaft und Gold*, 49–66. Saarbrücken, Moderne Galerie des Saarland-Museums.

Ivanov, I. 1991. Der Bestattungsritus in der chalkolitischen Nekropole von Varna (mit einem Katalog des wichstigsten Gräber). In Lichardus, J. (ed.), *Die Kupferzeit als historische Epoche*. Saarbrücker Beiträge zum Altertumskunde 55, 125–150. Saabrücken, Saarland Museum.

Lichardus, J. 1988. Der westpontische Raum und die Anfänge der kupferzeitlichen Zivilisation. In Fol, A. and Lichardus, J. (eds), *Macht, Herrschaft und Gold*, 79–130. Saarbrücken: Moderne Galerie des Saarland-Museums.

Lichardus, J. 1991. Das Gräberfeld in Varna und das Totenritual des Kodžadermen-Gumelniţa-Karanovo VI-Verbandes. In Lichardus, J. (ed.), *Die Kupferzeit als historische Epoche*. Saarbrücker Beiträge zum Altertumskunde 55, 167–94. Saabrücken: Saarland Museum.

Lichardus, J. 1991a. Kupferzeit als historische Epoche. Versuch einer Deutung. In Lichardus, J. (ed.), *Die Kupferzeit als historische Epoche*. Saarbrücker Beiträge zum Altertumskunde 55, 763–800. Saabrücken: Saarland Museum.

Nandris, J. 1978. Some features of climax Neolithic societies. *Studia Praehistorica* 1–2, 198–211.

Newell, R. R., Kielman, D., Constandse-Westermann, T. S., Van Der Sanden, W. A. B. and Van Gijn, A. 1990. *An Inquiry into the Ethnic Resolution of Mesolithic Regional Groups: the study of their decorative ornaments in time and space.* Leiden: Brill.

Popovici, D. 2010. Copper Age traditions north of the Danube River. In D. W. Anthony and J. Y. Chi (eds), *The Lost World of Old Europe. The Danube Valley, 5000–3500 BC*, 90–111. New York: Institute for the Study of the Ancient World.

Powers, M. J. 2006. *Pattern and Person. Ornament, society and self in Classical China.* Cambridge, MA: Harvard University Press.

Price, R. P. S. 1993. The west Pontic 'maritime interaction sphere': a long-term structure in Balkan prehistory? *Oxford Journal of Archaeology* 12/2, 175–96.

Raduntcheva, A. 1976. Vinitsa. Eneolitno selishte i nekropol. *Razkopki i Prouchvania* VI. Sofia, Izdatelstvo na BAN.

Slavchev, V. 2010. The Varna Eneolithic cemetery in the context of the the Late Copper Age in the East Balkans. In D. W. Anthony and J. Y. Chi (eds), *The Lost World of Old Europe. The Danube Valley, 5000–3500 BC*, 192–210. New York: Institute for the Study of the Ancient World..

Sørensen, M. L. S. 1997. Reading dress: the construction of social categories and identities in Bronze Age Europe. *Journal of European Archaeology* 5(1), 93–114.

Todorova, H. 1971. Kusnoeneolitniat nekropol kraj gr. Devnja. *Izvestia Naroden Muzei Varna* VII, 3–40.

Todorova, H. 1975. Arheologichesko prouchvane na selishnata mogila i nekropola pri Goliamo Delchevo, Varnensko. In: Todorova, H., Ivanov, S., Vasilev, V., Hopf, M., Quitta, H. and Kohl, G., Selishtanata mogila pri Goliamo Delchevo. *Razkopki i Prouchvania* V, 5–243. Sofia, Izdatelstvo na BAN.

Todorova, H. 1975a. *Eneolit Bolgarii.* Sofia: Sofia Press.

Todorova, H. 1978. *The Eneolithic Period in Bulgaria in the Fifth Millennium B.C.* Oxford: British Archaeological Report S49.

Todorova, H. and Vajsov, I. 2001. *Der kupferzeitliche Schmuck Bulgariens.* PBF XX/6, Stuttgart: F. Steiner Verlag.

Todorova, H., Dimov, T., Bojadžiev, J., Vajsov, I., Dimitrov, K. and Avramova, M. 2002. Katalog der prähistorischen Gräbern von Durankulak. In Todorova, H. (ed.), *Durankulak Band II. Die prähistorischen Gräberfelder*, 31–88. DAI, Berlin – Sofia: Anubis.

Yordanov, Y., Dimitrova, B. and Cholakov, S. 2006. Rezultati ot antropoligichnoto izledvanie na kostnite ostanki ot halkolitniya nekropol 'Pchelina' v grad Omurtag. *Grad Omurtag i Omurtagskiat Kraj. Istoria i kultura* 4, 143–202.

Trapped in postures[1]

Stratos Nanoglou

'*Les traits de notre visage ne sont guère que des gestes devenus, par l' habitude, définitifs.*'
(Marcel Proust, *À la recherche du temps perdu*, II: *À l' ombre des jeunes filles en fleurs*)

INTRODUCTION

The focus on figuration, which I take it to be the process of giving a specific form, marks a significant advance over previous attempts to consider the representational landscapes of the past. Most importantly it marks a departure from identifying the 'final' product as the object of study par excellence and instead instantiates a concern with the practices of determining a form (Meskell 2007; Meskell *et al.* 2008), of representing something, whatever the mimesis might be (Taussig 1993). Some issues can be teased out already from these first sentences: first of all, I will speak of representation, despite a current wave of studies that argue against it (Olsen 2003; 2010; Thrift 1996; 2008), but I will invoke it as a practice that cites other practices, in an economy that presents again and again portions of its own history in order to go forth (more on this below); second, although I define figuration as some sort of specification, I do not do so in opposition to abstraction. Abstraction should be conceived as following figuration; it suggests a withdrawal from something already formed and thus speaks of a move that presupposes figuration.[2] Figuration and abstraction are not therefore the two sides of the same coin. When we use figuration and abstraction as a set of equals, we invariably adhere to the old binary of naturalistic versus abstract/schematic forms, since we inadvertently judge the things at hand against a hidden figure, which figuration attempts to capture and abstraction attempts to avoid.

Nevertheless, figures do differ and indeed no two processes can have the same results. In the case I will be exploring, two figurines[3] can invoke the human form, using a variety of features, presenting and even highlighting different traits (Figures 18.1 and 18.2). The differences are important and I will return to them presently, but for the moment what seems more important is the very recognition of these figurines as of human form. The issue is that someone can figure out that they represent humans. Through a complex web of associations and despite the varying degree of details, we can recognise in them a certain unifying attribute, or attribute them a certain unifying identity. The very process of this recognition is sustained through the citation of similar objects and similar figures, irrespectively of our success or willingness to identify them. What matters is that these

figures are judged and evaluated against an array of other figures in a constant process of association and disassociation, which eventually and at the same time always already includes ourselves too, for no recognition is unilateral (Butler 1997). We could follow Foucault (1980) and name this web of associations, this web of sociality (where social extends beyond humans), a regime of truth (despite the fact that Foucault actually used this term only once, Foucault 1980, 131, 133), one that '*offers a framework for the scene of recognition, delineating who will qualify as a subject of recognition and offering available norms for the act of recognition*' (Butler 2005, 22). This regime is constituted and sustained, among other things, through figuration and figuration emerges as one practice among others that enables and constrains a certain process of recognition; this process focuses on the figural representation of things and presents people with distinctive opportunities to situate themselves in the world.

In this vein, the specific form of the figures emerges as a more important issue than a simple binary can account for. If recognition depends on the possibility to associate something, someone or even oneself with an existing (or once existed) figure, then the particular figures that are drawn upon would allow or even elicit a particular recognition: this something, someone or oneself would be recognised as such and not other. Something, someone or oneself would have been produced as such and not other, even though the regime itself does not produce nor causes such production to happen (Butler 2005). To the extent that we are talking about bodies, this would mean the recognition and accordingly the production of a particular kind of bodies. Figures do not induce the subject, the body, someone or something, but are part of the conditions for their emergence.

Although a regime of truth does not produce entities, it is certainly in place, but still mutable itself, before any production, that is each and every production takes place with reference to a regime of truth, which posits a framework for action, while at the same time it changes in response to that production. This does not mean that any production, or even any action, is predetermined by the regime, only that the framework guides, or even governs, and provides the means for such action. Questioning or even subverting the framework is possible (I would say that to a certain degree it is inescapable), although this way one runs the risk of subverting one's own position within the world. This explains the compulsion to follow the rules (the norms) and act within the frame. It is as if the

Figure 18.1: Neolithic figurine from Prodromos, Thessaly, Greece. Broken at neck, most probably seated. Volos Museum: M5130 (photo: author).

web of sociality has set traps, eliciting certain postures, whether one falls in or avoids them. If the framework, however fluid, is there before recognition, before production, then it follows that any recognition and any production is made in conditions and through resources that are not fully mastered or even fully comprehended by the agents, or actants, involved (Barrett 2005). Thus, a final point should be that there is a certain opacity in the whole process that characterises all those involved too (Butler 2005). A figure can provide the means for a certain recognition, but that does not mean that such recognition will be unambiguous and transparent.

RE-PRESENTATION

So, figuration opens up an array of possibilities for the recognition and the production of certain entities and at the same time conditions them, providing a specific precedent (Joyce 2000; 2003; 2005) for their materialisation. Even so, certain questions arise: what is specific to figuration as opposed to other practices that govern the production of entities? How does figuration specifically open up and condition a scene for recognition/production? Furthermore, how does this relate to the practice of representation – a question prompted at least by the fact that the study of figural material has been so inextricably connected to representation. I will start with the last one and continue in reverse order with the rest, addressing specific cases and abstracting whatever points of wider relevance. Throughout the paper I focus on the regulatory aspects of figuration because of both theoretical and practical issues, namely the problems in addressing the idiosyncratic or the subversive in the past generally and in my case study in particular (Nanoglou 2005, 153, note 12; 2006: 173, note 6; 2008a: 3; Berggren and Nilsson Stutz 2010, 179).

Representation is often taken to signify a divide between reality and its image (Thrift 1996: 7), to present an appearance that leads to what lies beneath appearances. Indeed, many studies have used representations as reflections of life, as things out of place, that say something about that place (some still do, Mina 2008). This approach has developed hand-to-hand with a similar attitude towards all material culture: artefacts are often considered 'representative' of a life, but not part of that life (see Olsen 2003 for a critique). Representation is invoked then as a very particular association between the world and its images, which posits two pure entities side-by-side. One answer offered to this problem has been to deny this association and return to the *'things themselves'* (*ibid.*, 94), but I would argue that this move sustains the very ontology that it purportedly counters: matter is still a bounded exteriority with no real association to agency and socialisation (*ibid.*, 99). If the answer is to study material culture in itself (*ibid.*, 93–4), then we have already denied that any hybridisation is possible and we are aspiring again to be moderns (Latour 1993).

Contrary to that, and building on Derrida (1982), Laclau and Mouffe (2001), Latour (2005a) and others, I argue that we should not only focus on the association that is denied, but also pull representation back into the world. In short, we can redefine representation as an articulatory practice that cites other practices. This is a very general definition indeed, a definition that can virtually include everything in the world and flirt with uselessness in analysis, save we proceed with clarifications. It is important, however, to begin with such a general statement: representation is the presentation of a new entity that at the same

Figure 18.2: Neolithic figurine from Prodromos, Thessaly, Greece. Part of a double figure (the arm of the second figure survives at the back). Volos Museum: M5221 (photo: author).

time cites and re-articulates other entities and other practices. Such a description could apply both to figural and non-figural representation (images, language, delegates, fractals and so on; see Nanoglou 2009a, 187; see also Nanoglou 2008a, 2 for a more limited view) and accordingly figuration emerges as a particular kind of representation, one that cites and re-articulates the form of other entities and other practices (see Meskell *et al.* 2008, 141 for a pertinent but somewhat different view and a short discussion of problems with both terms). The difference of this view from the one aforementioned does not lie in the generalisation of the argument to include everything in the world, but rather in its insistence that every representation is an act within this world and not outside of it, bound to induce an effect on the world and the very things that it cites. It is within this world that specific representations and specific representational practices gain wider currency than others, out of particular concerns that prevail in distinct conditions and establish them as facts (Latour 2005b), a process that has also resulted in the identification of representation with reflection. It is out of such a process that figuration has emerged first and foremost as a recognisable practice in our times, i.e., as an analytical concept that helps us probe into the past, rather than as an 'authentic' practice of such a past. To the extent that figuration inhabits the conjunction of our encounter with the past, it is by definition associated heavily, although not exclusively, with visuality.

On that account, figuration is the production of a figure and at the same time the citation of another figure (of whatever matter), deploying a kind of mimesis, which is never pure and simple, but always contaminated by the touch of other associations (Taussig 1993). This kind of mimesis instigates and perpetuates a particular regime, one that depends a lot on visual and tactile associations, and for that reason one that especially conditions these senses, allowing them to be conventionalised in certain forms and attitudes. Figuration builds a

representational landscape that provides everyone and everything with the proper and improper forms of things, projecting what is a viable and preferable posture, whether this means how one looks, or stands, or acts in a certain way and under specific circumstances. Appearances, expressions, gestures, clothes, tattoos, and so on (to confine myself to the body again), are all under review, judged and evaluated against each other. Thus figuration attempts to entrap everyone and everything into certain postures, confining the available resources and paradigms, while at the same time marks a certain inescapable departure from accepted norms and a certain transformation of the available resources. It is at this paradoxical juncture that a possibility to subvert the framework lies.

POSTURES IN NEOLITHIC GREECE

Figuration is never a stand-alone practice in the world, but always articulated in conjunction with other practices and in particular conditions. Consequently my discussion will be also situated and focused on particular cases, rather than on an abstract level, with the hope that some suggestions of wider relevance will come out. In this vein, I have purposefully chosen to focus on postures as a, perhaps inadequate otherwise, term that sums up both someone's position and the way someone is dealing with anything in life, to bring forth the relevance of this discussion to my case study. That is because in earlier Neolithic northern Greece (roughly from the end of the seventh to the middle of the sixth millennium BC) figuration is all about posture (Nanoglou 2005), or I should say figuration that pertained to humans, for animals were depicted invariably as quadruped creatures with little attention to further details (Nanoglou 2009a). The representational landscape of Neolithic northern Greece during this time was populated by groups of figures made mainly of fired clay and consisting mostly of humans, while animals, houses and other things were depicted in smaller amounts. Furthermore, humans were rendered almost always with a certain posture and/or a certain gesture, that is they were depicted as being in a way active, whatever the degree of detail in the elaboration of these actions (Nanoglou 2005). Consequently, the question is, what kind of regime did these figures help instigate and perpetuate?

Contextual information is limited, especially for types of artefacts other than figurines, but there are indications that figurines were used in groups, rather than individually (Nanoglou 2008a). Furthermore, although it is widely accepted that figurines were deposited (and hence used?) only in settlement contexts (deemed 'domestic': Bailey 2005; Scarre 2007a among others), this is not strictly speaking the case, as there are no sites outside settlements to consider. When other types of sites appear, so do figurines (Nanoglou 2008a, 3–4). Accordingly, these assemblages formed scenes where bodies were represented as acting, where acting bodies were the necessary constituents of these assemblies. Recognition in these scenes was possible on the provision that one was acting and probably seen acting. Figures in this context helped mediate the necessary visual constituents. This mediation, in no way a simple conveyance of the 'message', was definitely conditioned by the peculiar materiality of the figurines: easy to handle, to hide, to break, to carry around, to assemble and disperse, and so on (Nanoglou 2009b). From this point of view, modes of recognition and identification were, at least partially, channelled through

a particular frame, one that could be assembled and disassembled on different occasions (see Marangou 1996). So, certain postures needed to be performed, no matter how many participants of the assembly this directive pertained to. In all probability, people could have taken similar postures, although I am not suggesting that they did. However, the issue is that we can confirm, and so did they, that these postures were being presented there by some participants, be they just the figurines or others as well. What is significant in relation to the frame is that the whole weight falls on the specific postures taken. The figures involved in the scene specify the postures, materialise the needed actions. Since figures are found everywhere, the occasion is not specified by its context, its spatial positioning. The only place invoked is again brought in the scene through figuration, through the construction of 'house models', although their contextual association with other figures is highly problematic. In one case where figurines and a house model were deposited together (in Platia Magoula Zarkou in Thessaly, Gallis 1985, deposited around 5300 BC and thus late in the period), figurines were also found in the nearby cemetery (Gallis 1982). It could be the case then that the association of the figurines with the model specified the particular deposition (in a house), rather than exemplifying the wider practice. On that account, the mobile character of the particular artefacts in conjunction with the specificity of the figural representation opens up and frames a rather transposable scene of recognition/identification/production that focuses on what should be performed, rather on where it should be performed.

REGULATING MOVES

It is interesting to see this in contradistinction to relevant practices in other areas, to bring out the distinctive traits of each framework and each regime of truth. Cases with different representational landscapes can prove quite useful in such an attempt and I would like to consider various practices in fifth and especially fourth millennium BC north-western Europe (Whittle 2000; Thomas 2005; Scarre 2007a; 2007b). The comparison is offered as an exercise, made for analytical reasons and should not be taken to imply that these phenomena were formed in relation to each other or that these were the only alternatives and therefore the traits presented would somehow correspond to a holistic picture of the phenomena. Another exercise would no doubt bring out a different set of features. Furthermore and for the purposes of this paper, I am going to offer a very general outline, picking out some aspects that would help me to foreground the specifics of figuration, at least as they are traced in relation to Greece.

The study of the Neolithic of north-western Europe has focused in the last decades on the monumental side of the life of its inhabitants for various reasons, not least because in certain areas other types of material remains are hard to come by (Bradley 2007 for a comparison between southern Britain and Ireland or Scotland). Monuments have received great attention in our endeavours to interpret the past, but arguably they were receiving considerable attention back in the past, not just in terms of work spent and sophistication employed in their construction, but also in terms of prominence in the landscape and the amount and variety of practices performed in and around them that have left a trace. These practices have been tied with bodies from a variety of

viewpoints, such as the burial of corpses, the deposition and re-deposition of bones (Fowler 2010), the gathering of people, the channelling of their movement and so on (Barrett 1994; Thomas 1999; Scarre 2002). These monuments then can easily be held accountable for guiding and governing postures in Neolithic north-western Europe. They were part of the framework that people had to take into account, even literally trapped by them, when moving around attending to their issues. Standing stones, earthen mounds, wooden palisades, ditches, but also inconspicuous locations of deposition, that were remembered or just presumed to be there, regulated the movement and the actions of the people, the animals and all other entities that inhabited the place. Postures might have been still acquired through some visual mimesis of the others that participated in any sort of gatherings, but the point is that these gatherings were also framed by certain material conditions that regulated the body, through regulating space.

All relevant phenomena span a vast area and an equally extended time and cannot be considered coherent. Nevertheless, my point is not that they are so, but that precisely the framework for action and the concomitant regime of truth was based on different resources than the ones in south-eastern Europe and northern Greece in particular. In addition, it is particularly significant that in the past two decades most studies focusing on Neolithic north-western Europe have relied heavily on landscape archaeology and highlighted the movement of people across and between places (the literature is too vast to recount here, but I would refer the reader to Barrett 1994; Barrett and Ko 2009; Brück 2005; Thomas 1999; Tilley 1994; Topping 1997; Bradley 2007; David and Thomas 2008). The importance of place in the deployment of practices has emerged vividly out of this work. Monuments were not only relatively fixed in place, but could also have been referring to places through imitating or indexing another part of the landscape (Scarre 2010). Although monuments were not the sole actants in the Neolithic landscape of the region, as clearly neither were figures in south-eastern Europe, they did provide a conspicuous point of reference for some people's lives and they were persistently present for long periods of time. Furthermore, even when there are figural representations (and these cases are indeed infrequent compared to south-eastern Europe), they tend to be less mobile, set in specific locations (Bradley 2002 for fourth and third millennium BC Iberia; Whittle 2000 for 5th millennium BC Brittany; Scarre 2010 for a possible anthropomorphic element of some monuments; Robb 2009 for stelae in the whole of Europe). Mobile artefacts representing humans are found in later 5th millennium BC central France (Scarre 2007a) and in 4th and 3rd millennium BC Iberia (Lillios 2008), but not in north-western France. The case of the British Isles is even more intriguing, since representation was largely non-figural throughout the fourth millennium BC (Thomas 2005; Varndell this volume). Consequently, and contrary to the situation in south-eastern Europe and particularly northern Greece I have been exploring earlier, these scenes of recognition/identification/production of bodies were more focused on where, rather on what the relevant practices should be.

SETTING TRAPS: WHAT VERSUS WHERE

In both areas I have been referring to, material culture set a framework for action, aspects of which were brought to bear upon the bodies of the people (and other beings) that

inhabited these areas. In neither area were the particular objects I have been studying the only ones that formed such a framework. In any event, bodies were regulated in Neolithic northern Greece too, as they moved through houses and other architectural features (Nanoglou 2008b), and accordingly I do not mean to imply the existence of two opposing worlds. On that respect, I cannot subscribe to a contrast between an assumed domestic character and a public display that was 'in no way intimate' (Scarre 2007a, 23). Besides the lack of evidence for an exclusive association of figurines with a domestic sphere (quite the contrary, see above and Nanoglou 2008a, 3–4), intimacy is not a property of the miniature, and monuments can become intimate. Correspondingly, although figurines, which form the largest group of figures in Neolithic south-eastern Europe, can be literally handled, it is not necessary to suggest that they were intimate (although it is a valid possibility, Bailey 2005).

Nonetheless and given the discussion so far, it is evident that in each area actants performed and sustained different frameworks for action and consequently produced different regimes of truth. Furthermore I suggest that one major difference is that, whereas in Greece guidance focused on what should be performed, in north-western Europe what mattered the most was the place where all that was relevant was performed. Again that does not mean that in north-western Europe there was no concern about what was going on in and around monuments, or that in Greece the place where figures were used was irrelevant; but the materiality of the framework that guided these other aspects was different in each case, affecting the population in distinctive ways. Although figurines can be manipulated (hiding or presenting them at will, rearranging them in desired sequences and so on), they are there as a constant reminder, or a recursive remainder on a different account, of what is accepted or not in a way that for example words cannot be. Somewhat similarly, even if a house-model was required to recreate the scene and accordingly to place it somewhere in particular, it was again mobile in a way that a menhir or an earthen mound was not. We could go a bit further and suggest that in the scenes set by monuments participants were the mobile element. On the other hand the associations evoked by the figures are sensually different than the ones produced through a visit to a monument.

Effectively figures and monuments alike can ask the same question: 'what kind of beings can and should be allowed to inhabit the world?' Still, they pose this question differently, eliciting different answers: on the one hand participation in the assemblies (perhaps 'representation'? see Latour 2005a) set and sustained by figuration was arguably dependent on who could or should perform a certain posture, whereas in the case of monuments on who could or should be there (see Barrett 1994), in whatever state.

Figuration in northern Greece then made explicit the postures, or the gestures or the actions, needed for the occasion, in a way that the monuments of north-western Europe did not. Even monuments that posed physical constrains on movement (Barrett 1994) did not explicitly dictate what course of action should be taken. We could suggest that up to a certain point figures were describing and simultaneously enforcing the proper way to do things, whereas monuments focused on a negative aspect, setting limits and boundaries. Nevertheless, description and explicitness do not mean transparency. That figures were depicting a posture or even narrating a course of action does not mean that they were easier to interpret than monuments. After all boundaries were explicit as well. The issue is what was explicit in each case; what was offered as a model and what was available as

a resource upon which actants were called to draw. On that account, figuration provided a very distinctive framework for the recognition/identification/production of anyone involved. It offered and regulated the conditions of possibility for a world focusing on the form, rather than the place, of the performance and thus requested or even compelled its inhabitants to answer back on similar grounds, normalising, or perhaps formalising their lives to these principles.

It is true that figures do not re-present just the form depicted, at least not in my usage of the term, but if figuration is to have any meaning as an object of study, then the invocation of form should be at the forefront of any relevant interpretation. Figurines cite various practices, but figuration is an analytical term that highlights the formal characteristics of citation. On that account figuration can provide insights into the way people confronted and dealt with various issues in their lives, focusing in particular on the visual aspect of their sensory experience. That does not preclude us from situating figures as objects within their contexts of use, rather than just as visual proxies for an underlying structure. Taking into account the rightful and forceful caveats offered on many occasions against the modern visual bias (Fabian 1983), figuration, being at the juncture of our engagement with the material culture of the past (as any of our analytical concepts for that matter), still maintains a link with visuality and emerges as a process that explicitly addresses the world through such a lens.

Unquestionably this process would have had many infelicitous moments and almost certainly it would have never been totally effective; I would even suggest that it could never be totally successful. Failure, misunderstanding, denial, subversion and all kinds of response are possible, especially when we consider that the process is contingent upon its performance. The point is precisely, that even such responses take account of the norms and resources available, and re-present them always in new articulations.

ACKNOWLEDGEMENTS

I would like to thank the editors for inviting me to contribute to this volume and for their comments on the text. Many thanks are also due to Chris Fowler and Oliver Harris for offering valuable comments on an earlier draft of the paper.

NOTES

1 The title of the paper is taken from Butler 2010, where referring to Alfred North Whitehead she says: '*he makes clear that grammar has trapped us into some unfortunate postures*'.
2 Thus I depart from the equation of abstraction with the absence of 'iconicity', as advocated for example by Skeates (2007, 199).
3 I use 'figurines' as a sub-category of 'figures'; thus, whereas 'human figures' invoke the human form, figurines do so as solid stand-alone three-dimensional objects and are accordingly distinct from vessels or figures attached to vessels and so on.

REFERENCES

Bailey, D. W. 2005. *Prehistoric Figurines: representation and corporeality in the Neolithic*. New York: Routledge.

Barrett, J. C. 1994. *Fragments from Antiquity: an archaeology of social life in Britain, 2900–1200 BC*. Oxford: Blackwell.

Barrett, J. C. 2005. Material culture, humanity and the beginnings of the Neolithic. In T. L. Kienlin (ed.), *Die Dinge als Zeichen: Kulturelles Wissen und materielle Kultur*, 111–124. Bonn: Rudolf Habelt.

Barrett, J. C. and Ko, I. 2009. A Phenomenology of Landscape: a Crisis in British Landscape Archaeology? *Journal of Social Archaeology* 9(3), 275–294.

Berggren, A. and Nilsson Stutz, L. 2010. From Spectator to Critic and Participant. *Journal of Social Archaeology* 10(2), 171–197.

Bradley, R. 2002. Access, style and imagery: the audience for prehistoric rock art in Atlantic Spain and Portugal, 4000–2000 BC. *Oxford Journal of Archaeology* 21(3), 231–247.

Bradley, R. 2007. *The Prehistory of Britain and Ireland*. New York: Cambridge University Press.

Brück, J. 2005. Experiencing the past? The development of a phenomenological archaeology in British prehistory. *Archaeological Dialogues* 12(1), 45–72.

Butler, J. 1997. *The Psychic Life of Power: theories in subjection*. Stanford, CA: Stanford University Press.

Butler, J. 2005. *Giving an Account of Oneself*. New York: Fordham University Press.

Butler, J., 2010. On this Occasion. Lecture given at the School of Arts and Humanities, Claremont Graduate University on February 17, 2010. Available at: http://deimos3.apple.com/WebObjects/Core.woa/Browse/cgu.edu.3369073988?i=1738629277. Accessed: 26 January 2011.

David, B. and Thomas, J. (eds). 2008. *Handbook of Landscape Archaeology*. Walnut Creek, CA: Left Coast Press.

Derrida, J. 1982. *Margins of Philosophy*. Translated by A. Bass. Chicago, IL and London: University of Chicago Press.

Fabian, J. 1983. *Time and the Other: how anthropology makes its object*. New York: Columbia University Press.

Foucault, M. 1980. *Power/Knowledge: selected interviews and other writings, 1972–1977*. Ed. by C. Gordon. New York: Harvester Wheatsheaf.

Fowler, C. 2010. Pattern and diversity in the Early Neolithic mortuary practices of Britain and Ireland: contextualising the treatment of the dead. *Documenta Praehistorica* 37, 1–22.

Gallis, K. 1982. *Καύσεις νεκρών από τη Νεολιθική εποχή στη Θεσσαλία*. Αθήνα: Ταμείο Αρχαιολογικών Πόρων και Απαλλοτριώσεων.

Gallis, K. 1985. A Late Neolithic foundation offering from Thessaly. *Antiquity* 54, 20–22.

Joyce, R. A. 2000. *Gender and Power in Prehispanic Mesoamerica*. Austin, TX: University of Texas Press.

Joyce, R. A. 2003. Making something of herself: embodiment in life and death at Playa de los Muertos, Honduras. *Cambridge Archaeological Journal* 13(2), 248–261.

Joyce, R. A. 2005. Archaeology of the body. *Annual Review of Anthropology* 34, 139–158.

Laclau, E. and Mouffe, C. 2001. *Hegemony and Socialist Strategy: towards a radical democratic politics*. 2nd ed. London: Verso.

Latour, B. 1993. *We Have Never Been Modern*. Translated by C. Porter. Cambridge, MA: Harvard University Press.

Latour, B. 2005a. From Realpolitik to Dingpolitik, or how to make things public. In B. Latour and P. Weibel (eds), *Making Things Public: atmospheres of democracy*, 14–41. Cambridge, MA: The MIT Press.

Latour, B. 2005b. *Reassembling the Social: an introduction to actor-network-theory*. Oxford: Oxford University Press.

Lillios, K. T. 2008. *Heraldry for the Dead: memory, identity, and the engraved stone plaques of Neolithic Iberia.* Austin, TX: University of Texas Press.

Marangou, C., 1996. Assembling, displaying, and dissembling Neolithic and Eneolithic figurines and models. *Journal of European Archaeology* 4, 177–202.

Meskell, L. 2007. Refiguring the corpus at Çatalhöyük. In C. Renfrew and I. Morley (eds), *Image and Imagination: a global prehistory of figurative representation,* 137–49. Cambridge: McDonald Institute for Archaeological Research.

Meskell, L., Nakamura, C., King, R. and Farid, S. 2008. Figured lifeworlds and depositional practices at Çatalhöyük. *Cambridge Archaeological Journal* 18(2), 139–161.

Mina, M. 2008. *Anthropomorphic Figurines from the Neolithic and Early Bronze Age Aegean: gender dynamics and implications for the understanding of early Aegean prehistory.* Oxford: Archaeopress.

Nanoglou, S. 2005. Subjectivity and material culture in Thessaly, Greece: the case of Neolithic anthropomorphic imagery. *Cambridge Archaeological Journal* 15(2), 141–156.

Nanoglou, S. 2006. Regional perspectives on the Neolithic anthropomorphic imagery of northern Greece. *Journal of Mediterranean Archaeology* 19(2), 155–176.

Nanoglou, S. 2008a. Representation of humans and animals in Greece and the Balkans during the earlier Neolithic. *Cambridge Archaeological Journal* 18(1), 1–13.

Nanoglou, S. 2008b. Building biographies and households. *Journal of Social Archaeology* 8(1), 139–160.

Nanoglou, S. 2009a. Animal bodies and ontological discourse in the Greek Neolithic. *Journal of Archaeological Method and Theory* 16(3), 184–204.

Nanoglou, S. 2009b. The materiality of representation: a preface. *Journal of Archaeological Method and Theory* 16(3), 157–161.

Olsen, B. 2003. Material culture after text: re-membering things. *Norwegian Archaeological Review* 36(2), 87–104.

Olsen, B. 2010. *In Defense of Things: archaeology and the ontology of objects.* Lanham, MD: AltaMira Press.

Robb, J. 2009. People of stone: stelae, personhood, and society in prehistoric Europe. *Journal of Archaeological Method and Theory* 16(3), 162–83.

Scarre, C. (ed.) 2002. *Monuments and Landscape in Atlantic Europe: perception and society during the Neolithic and early Bronze Age.* London and New York: Routledge.

Scarre, C. 2007a. Monuments and miniatures: representing humans in Neolithic Europe 5000–2000 BC. In C. Renfrew and I. Morley (eds), *Image and Imagination: a global prehistory of figurative representation,* 17–29. Cambridge: McDonald Institute for Archaeological Research.

Scarre, C. 2007b. Changing places: monuments and the Neolithic transition in western France. In A. Whittle and C. Cummings (eds), *Going Over: the Mesolithic–Neolithic transition in north-west Europe,* 243–261. Oxford: Oxford University Press.

Scarre, C. 2010. Stones with character: animism, agency and megalithic monuments. In B. O'Connor, G. Cooney and J. Chapman (eds), *Materialitas: working stone, carving identity,* 9–18. Oxford: Oxbow Books.

Skeates, R. 2007. Abstract and figurative representation and the politics of display in Neolithic southeast Italy. In C. Renfrew and I. Morley (eds), *Image and Imagination: a global prehistory of figurative representation,* 199–210. Cambridge: McDonald Institute for Archaeological Research.

Taussig, M. 1993. *Mimesis and Alterity: a particular history of the senses.* London and New York: Routledge.

Thomas, J. 1999. *Understanding the Neolithic.* 2nd ed. London and New York: Routledge.

Thomas, J., 2005. Ambiguous symbols: why there were no figurines in Neolithic Britain. *Documenta Praehistorica* 32, 167–75.

Thrift, N. 1996. *Spatial Formations.* London: Sage.

Thrift, N. 2008. *Non-representational Theory: space\politics\affect.* London and New York: Routledge.

Tilley, C. 1994. *A Phenomenology of Landscape: places, paths, and monuments*. Oxford: Berg.

Topping, P. (ed.) 1997. *Neolithic Landscapes*. Oxford: Oxbow Books.

Whittle, A. 2000. 'Very like a whale': menhirs, motifs and myths in the Mesolithic-Neolithic transition of northwest Europe. *Cambridge Archaeological Journal* 10(2), 243–259.

Discussion: personality and Neolithic visual media

David W. Robinson

Along our way to a Chumash rock-art site at an intermittent waterfall in the Californian Santa Barbara back-country we passed by a modest spring with an attendant pool of water (Figure 19.1). As we stopped to admire the discrete water body, a thin, white scum began to excrete across the clear pond, slowly spreading and obscuring the surface water. An overpowering noxious scent was emitted; this was an active sulphur spring, and it greeted us with its strangely wondrous but discomforting display. There was a real character to this place. A combination of unusual active attributes differentiated it from other surrounding locales. The behaviour of the water had a kind of personality, a phenomenon our project has been investigating in our rock-art research in California. In a semi-arid region, springs, ponds, and streams all act differently. The hydrology of different terrains combined with changing water tables due to variable rain fall lends unpredictability to above ground water flow (Robinson *et al.* 2009).

Rock-art is typically found at these places where one year they are full of water, the next year bone dry. The ethnography of South-Central California contains references to ambivalent beings inhabiting watery places; we think the personality ascribed to these beings was derived, at least in part, from the sometimes benevolent and sometimes malicious behaviour of the water itself. Rock-art is typically placed on rock found right at springs or important watery locales. But the personality of place is not limited to the attribute of water; the rock that the art was put on was often said to be animals turned to stone in deep mythical times. A sense of redolent power resides at these places. The mythology suggests a semi-sentient, dormant potentiality. Other forms of sentience dwelt or visited, attracted by the water's agency, from insects, to amphibians, to lizards, on through mammals such as gophers, coyote, and deer. Large, powerful mammals such as wolves, mountain lions, and grizzly bears also engaged with these places. Of course vegetation of myriad species clusters around these oasis-like riparian habitats. Humans likewise frequented the locales, accumulating midden material, pecking and grinding out bedrock mortars for food processing, storing items in the shelters, and sometimes making the paintings themselves. But other forms of agency can be identified: movement occurs, in wind borne dust, colluvial and alluvial action, plus changing thermal dynamics and light-and-shadow as the sun, the moon, and the stars wheel overhead. Thus, the rock-art locales of South-Central California are places full of different forms of personality. It was through archaeological approaches

to the sites and investigating the environmental and hydrological record that we began to rethink the ethnographic record and consider the implication of the diverse data we were collecting (see Robinson 2010). The visual and often vibrant paintings were placed at locations alive with character.

I bring up these concepts derived from our California research because they have strong resonance with an underlying theme presented in this volume. This theme concerns how visual media in past societies evoke different senses of personality; from the personality of place, the personality evident in things themselves, or personality expressed by people through performative action. This includes anthropomorphism, but also extends into other forms of non-human agency as it is in the relation between different elements and the ensemble of attributes that character or personality emerges. Thus, agency can be seen expressed in various guises; this line of recent research emphasizes that art can be much more, or in some instances entirely 'other' than symbolic representation. This theme is strongly related to a gathering trend seen in the archaeology of what Jones and Cochrane here term 'visual media': this includes figurines, portable works, megalithic art, and rock art. This trend is related to a number of intersecting streams, including but not restricted to concepts of material agency, animism, and embodiment. Drawing upon Bird-David's

Figure 19.1 Author at Sulphur Spring (photo: Rick Bury).

(1999) influential paper, Dowson's recent discussion on 're-animating' rock art research brought the old issue of animism back into the foreground, stating that: '*Gods, spirits, animals, plants and inorganic objects are potentially persons and can occupy a subject position in their relations with humans*' (2009, 380). I would add that some 'places' can also be potentially ascribed personality, and it is through contextual approaches that the character of those places can be better understood. As Creese (2011) has more recently put it in his analysis of Algonquian rock-art, the landscape was predicated on an intense social universe of human and 'other-than-human' persons. To move forward, theories need to take seriously other non-human agents within the environment because it is increasingly argued that some forms of visual media were entangled within relational ontologies that ascribe agentive value to different attributes of the environment.

Humans are thus seen not as individuated beings (cf. Fowler 2004), but enacted beings because of their ongoing interrelationship with the personalities that constitute their world. These ideas are in tune with anthropological notions such as those put forward by Ingold who states that:

> '*Human beings everywhere perceive their environments in the responsive mode not because of innate cognitive predisposition but because to perceive at all they must already be situated in a world and committed to the relationships this entails*' (1999, 82; see also Ingold 2006).

These ideas are also in harmony with indigenous philosophical notions of sentience, some of which have little to do with dichotomies of mind/body, culture/nature, human/non-human: as I have discussed previously (Robinson 2004, 94–95), Native American indigenous social ontology is often concerned with sentience as physical outward action, effects, and consequence rather than internal dialogue or cognition. Outward, affective action in the world can be the most important defining ontological basis of sentience, rather than cognition or brain function. Action is valued above motivation. Thus any aspect of the environment that can be perceived to have an agentive role in the world expresses a form of personality, human or otherwise.

However, most of the discourse I have so far discussed is predominately from a hunter-gatherer perspective. The papers here focus on Neolithic Europe: like any collection, the papers presented in this volume are from a particular time and place, now a decade-plus into the 21st century. In total, they represent a collective standpoint, saying much about the current state of the study of Neolithic visual media, but also pointing towards new directions and reflecting trends across anthropological and archaeological discourse. Jones and Cochrane have captained the direction of this Neolithic flotilla of papers, charting a course towards somewhat different, less explored waters. While focussing on visual media, each case study is informing wider perspectives on the European Neolithic. So what do these papers have to say about the personality of the Neolithic?

PERSONALITY OF PLACE

Visual media operates because it is constituted physically; it is a form of material culture, and as such it is often fixed in particular places for long periods of time. As Chippendale and Nash point out (2004, 7), the fixity of rock-art in place is a fundamental characteristic

of rock-art. This characteristic is explored to great advantage in many of the papers presented in this volume. In particularly, it can be seen that topography is a core attribute of the personality ascribed to places. Bradley and Watson's study of the rock art of Ben Lawers Mountain shows that the only way the rock art there can be understood is by considering its relation to the land surrounding. The reflective properties of Loch Tay was possibly related to the reflective mica in the rock itself; the circular images may mimic the eddies of the lake; the axis of the lake reflects solstitial alignments; but most importantly, the position of some of the art is intervisible with local summits while the shape of some stones 'mirrors' the summit of *Meall Griegh*. The rock art found there reflects the overall personality of the place as an upland, high mountain area characterized by relationships mostly having to do with reflective properties.

Of course, the personality of place is a scalable concept: a spring, a mountain, or even the wider scale of a region may have influences in the dialectical manner in which people ascribe personality to place. Sharpe's paper on rock art regionality in Britain and Ireland considers the advantages of comparing 'topographically distinct' regions, or 'bio-geographical zones' that reflect natural systems and processes. Here, heritage definitions of 'character areas' can be seen as a projection of a category that ascribes a type of personality to discrete geographic entities that can be quite enormous in scale. As Sharpe indicates, accumulating data on Neolithic rock art is at the point where a variety of questions concerning the topographic character of place can be asked. Certainly such questions are already being pursued; Twohig's contribution on the rock art of Loughcrew in County Meath, Ireland puts forward that a 'natural division' seen in rock art motifs is reflected in a natural division of topography, particularly elevation, where the most elaborate panels were situated in lower elevations and less elaborate on mid-level slopes.

PERSONALITY OF CONSTRUCTED SPACE

Twohig's work is important for another factor; her paper moves on to consider the passage tomb art of the Loughcrew complex, noting similarities between it and the less well known rock art located downslope. She presents the possibility that some rock art has been actively reincorporated into passage tombs, while Needham and Cowie's study of the Halberd Pillar in Kimartin similarly shows the reuse of a stone with Neolithic rock art in subsequent monumental contexts. Card and Thomas highlight the employment of scratched images within habitation contexts from the Ness of Brodgar on Orkney: the carving of stones '*formed key roles in both the construction and demolition*' of Structure 10, indicating use and reuse of visual media within architectural biographies. Of course, this kind of reuse of rock art within the fabric of buildings, especially monuments has been widely recognized across prehistoric Europe for quite some time. What is interesting here is the role that the art plays once added onto the skin of a stone, and how that influences the life trajectory of that stone. In its landscape context, the modification of stone may have the visual effect of reflecting what was already considered to be an essence within the stone, which in turn enhanced the personality of the place where it was positioned; but, modification also can dramatically transform the personality of the rock itself, effectively giving it new life as an enacted object. The transport and reuse of that transformed stone into a constructed

monument adds a new moment of being for that stone and must be seen as integral to the construction of the character of the newly formed megalithic space. The placement of those stones should be considered in greater detail as Robin's on-going careful consideration of the relationship between the form of art and its architectural context. Robin's work shows that particular forms act as 'threshold-signs', and thus convey specific meaning concerning the point in the monument where that sign is found; while Robin's work is transforming our understandings of Irish megalithic, what I'd like to draw from this is that there is a clear convergence between architecture and visual media that creates a distinct character to particular places within architectural space. The nodal points within megalithic space may have been ascribed a very different ontology than we can currently recognize. However, Robin argues that some of the geometric shapes may have been schematized representations of living beings such as trees and snakes as well as architectural structures themselves. Thus, non-human biotic agency may have been incorporated within spaces in complex ways. This point is reiterated in Hensey's paper using analogies from Australia that show how abstract designs can represent the physical world. Further, it may be that such images were not just visual metaphors, but active agents in their own relationship to their referent and the space they occupy. While we may think of such images as figurations, representations, or signs, it might be argued that within the framework of the Neolithic, pattern and form in visual media may have been ontologically ascribed a status other than mental abstraction or representational signage.

OBJECTS OF PERSONALITY

While coming to grips with an animic view of abstract images is a tricky business, it is perhaps easier to recognize a personality in objects that are in recognisably anthropogenic form. The famous New Zealand case of Pukaki is an exemplar par excellence of an object that is actively alive and extremely influential within human society. Pukaki was a historical figure known to be a famous warrior; a carving made in in the early 1800s was an embodiment of Pukaki and was placed at the entrance to a *pa* as a form of defence. In western eyes, Pukaki is a wooden carving representing a historical figure and wider cultural beliefs; for indigenous New Zealanders, Pukaki the carving was human, albeit a slightly different type of human than his flesh-and-blood counterparts. Pukaki was an agent with warrior strength that protected the *pa* and the group before later being gifted to the Crown in an 1877 land treaty deal. Pukaki has since returned to Ratorua where he now rests with his descendants. As Gosden and Knowles (2001) have argued from Pacific contexts, objects such as Pukaki have 'lives' with biographies similar to those of humans. While this is often thought of a '*metaphor of biography*' (Gosden and Marshall 1999, 177), the case of Pukaki also points out that there can be more substantial agentive effects that objects can carry because of their relational personalities, which is to say that Pukaki is more than index or metaphor, but an active participant, an agent.

However, Pukaki's personality is derived from the human form, a now deceased actual human being. When it comes to figurines and images, the human form is often a defining characteristic of personality. Gaydarska's chapter in this volume (re) explores anthropomorphic representation by considering the human body and 'sidedness.'

Gaydarska delves into the logics of symmetrical attributes that might divide an object's 'physical (material) characteristics' into sides including front-to-back or 'up-down-ness'. As Gaydarska argues, anthropomorphic clay figurines are examples of 'designed sidedness' approximating the human body. Shown in the case study of Dolnoslav figurines, this dichotomous structural trope of sidedness provides metaphors concerning completeness or incompleteness, and allows for different personalities to be constructed and expressed through the active manipulation of fragmentation and reintegration of figurines through changing contexts of their life biographies.

Hoffman's approach to the 'life and death' of Linearbandkeramik figurines is an example of ambiguity, and perhaps fluidity, between categories of being; indeed the admixture of materials and potential addition of subsequent adding-ons through a figurines 'life' suggests an accumulative or malleable identity in the figure itself. Indeed, Hoffman shows that it is difficult to know the boundary between what is anthropomorphic and what is not as time progressed through the Neolithic: *'certain attributes of humanity became progressively distributed outwards into not obviously anthropomorphic categories of material.'* This of course reiterates the notion that abstraction might equally concern character or personality but that interpreting it as so may be very difficult without the seriation advantages seen in Hoffman's work.

As I have indicated, if we are to pursue an archaeology of personality, the manner of that personality is based in part upon the constituent traits of the object of study. Nanoglou profitably focuses upon the traits of two specific figurines of Neolithic Greece, suggesting that the posture and the process of figuration regulated performance. Nanoglou posits a regional distinction: figures guided societal notions of bodily performance in Neolithic Greece, while in north-western Europe the *place* where performance occurred was more important than explicit figuration. Thus, while it should come as no surprise that there are different characteristics to Neolithic visual material culture in different regions, taking into account the personality of objects can elucidate those differences in significant ways. So, personality in an anthropomorphic sense relates to human identity. Even objects that are more closely associated with costume or dress can express personalities of the wearer, and suggest boundaries to personality. Chapman's look at Balkan Copper age mortuary ornaments explores how such material culture *'encode not only the quality of human-ness but also differential degrees of human-ness'* with neighbouring communities stressing alternate parts of body zones. Ironically, the humanity expressed by the smile of the Grimes Graves goddess calls into question its very Neolithic authenticity: in comparison with all other known 'verifiable' Neolithic figurines of the British Isles, Varndell points out the awkward dissimilarity of the figure in context of other visual media. Is the Goddess a 'one-off' agent of the quarry, or is it an agent of modern fakery?

MUTABLE PERSONALITIES

Much recent discourse on animism points out the importance of non-human agents in non-western/modern ontology, but visual media does not always recognize non-human agents in direct ways. Lahelma's study of Lake Onega stresses the overwhelming preponderance of images depicting waterfowl. Interpretation of these as 'soul-birds' highlights the use of waterfowl in the region in metaphor, but also highlights specific land-forms that 'actualized'

myths concerning the World Egg and the creation of the world. Significantly, Lahelma cites an ethnographic account that describes the affective power of the making of a petroglyph; the art opens the rock allowing access to a world of personality, in this case the adder. In this sense, the rock is redolent with potential to open up a world of action that enacts the agency of animals. As Jones states in his chapter on the Kilmartin rock-art, rocks are 'part of the animate, mutable and changing environment, and that rock art motifs are produced in response to this mutability'. Jones highlights recent work on the surfaces of Kilmartin rock-art panels, and how the art responded to the character of the geology. Just as animals are far more significant than simple 'resource', the ontology of rock can be conceived of as something entirely different than inert raw material. These accounts speak of fundamental Neolithic world-views that distribute and elide different categories of being throughout environments, architectures, and portable objects. As alluded to in some of the chapters of this volume, even death can be conceived of in fundamentally different ways. As Janik points out in her chapter on violent images and memory in the rock-art of the White Sea, bow-and-arrow overkill of human and animal figures is argued to indicate a symbolic state of transformation. The image of an arrow kill *'allows community members to transcend the categories of what we think we know as human, bird and bear.'* The location in a fixed place allows for repeated visual inspection, and thus the rock provides a 'hard memory' for people through time (see also Janik 2007).

ONTOLOGICAL PERSONALITIES

The discussion thus far has focused on the variable ways that personality can be expressed through the guises of different visual media, in these cases predominantly within Neolithic contexts. As I have brought up and as Jones pointed out in his chapter, exploring concepts of animism bring world-view and ontology into focus. While animism is typically associated with hunter-gatherers, it is increasingly being brought into discussions concerning the Neolithic. While put within multiple temporal contexts, Casella and Croucher (2011, 213–215) examine the Late Neolithic/Early Chalcolithic in Mesopotamia as *'networks of objects, places and nonhuman animals'* (Casella and Croucher 2011, 215). While focussing on meta-narratives behind creating and recreating the Neolithic of South Central India, Robinson *et al.* (2008) detail the use of rock-art to personify a local diety on Hiregudda Hill still associated with a contemporary offering place. Scarre (2010) has discussed anthropomorphic characteristics of megalithic monuments in Brittany and Jersey by delving into the relationship between agency and animism while Pollard and Gillings (2010, 37) discuss the possible *'agential power'* of the Avebury stones which may have been a contributing factor for their inclusion in monuments. Cummings (2012) likewise argues that animistic ontologies established the relational framework for Neolithic perceptions of stone and the incorporation of stone in chambered monuments. In rock-art studies, Wallis (2009) has looked at non-representational cup-and-ring rock-art from 'animic' perspectives. All of these researchers (and others) stress the agency of rock: Wallis goes as far to state that: *'Rock sites, their art, and associated non-human people, may, I argue, be viewed as intentional agents in the creation and negotiation of their own meaning'* (2009, 60). Wallis goes on to argue that through time, there was an increasing emphasis on human ancestors in

the later Neolithic indicating a *'different sort of animism from that in the earlier Neolithic'* (Wallis in press).

It should be emphasised rather then there being an emergent theory of 'new animism' (see Porr and Bell 2011 for discussion), there are in fact multiple approaches to possible interpretations of non-human forms of agency when considering visual media. From agency, to character, to personality, to personhood, there are a range of different manners of ascribing degrees of affectivity. Wallis' idea of *'a rhizomic personhood'* is useful as a term stressing the *'relationality inherent in a world which is filled with persons, only some of whom are human, which facilitates a non-hierarchical approach to agency'* (2009, 61). However, we should recognize that indigenous ontology might be adept at ascribing types of agency or even sentience that are entirely other than 'persons'. In this respect, perhaps character and sentience are alternative concepts; Scarre (2010, 16) rightly brings up Mircea Eliade's concept that stones might represent something other than persons, that their being was ontological separate from humanity and therefore sentient without being ascribed personhood.

CONCLUSION: THE *ARCHAEOLOGY* OF VISUAL MEDIA

To approach a consideration of non-human agents requires a shift which can de-centre the focus on the archaeological record onto a more wide ranging consideration of context, with various aspects of the total environment as being potentially 'in play'. As critiques of symmetrical theory and Actor Network Theory point out, this can be problematic: by decentring, the human (which is the focus of archaeology) can be forgotten (see Johnson 2010, 226). However, contextual archaeology allows for relations between the human and the non-human to be analysed in it's myriad relationships. In a methodological sense, paying attention to the human relationship to the world surrounding is the bread-and-butter of divergent archaeological approaches from phenomenology to geoarchaeology (for instance, see Evan's 2003 discussion of 'texture'). As Alves rightly points out in her chapter considering style in the north-western Iberian rock-art: *'rock art studies must be firmly linked to mainstream Archaeology'*. Thus, contrary to recent arguments against contextual approaches to rock art (for instance, see Bednarik's 2006), explicitly archaeological approaches to visual media have the greatest potential for expanding our understandings of past ontology (compare Bednarik 2006 with Pastoors and Weniger 2011 for the value of an archaeological contextual approach to cave art). Indeed, most if not all of the papers within this volume to one degree or another have implicit or explicit archaeological practices in their methodology. Forming strict disciplinary boundaries will only serve to limit the relational connections that archaeological and anthropological research fosters. The papers here, set within emergent trends, are illustrative of re-cast ideas of animism and relational approaches. From character, to personality, from agent to sentience, the relationship between the human and non-human was an ongoing physical enactment that resulted in the archaeological record. Contextual and relational approaches provide robust means to understanding that record.

Theoretical diversity is a strength of research and there are certainly other non-dichotomous approaches that aid moving closer to understanding past visual media and ontology. Embodiment theory promotes ways to put the human back in, so to speak, and to investigate that bodily engagements with sites and things (Hampson in prep). I finish here by

pointing out how Cochrane's chapter on Knockoe is a prime example of how understanding the placement of visual media in performance spaces brings the human body back: '*enacting flourishing forms.*' So ironically, anthropocentric 'decentering' serves us to better understanding the physical performance of being human by more fully understanding how people in the past engaged with places and objects as personae. As Gosden (2005) shows that asking 'what do objects want?' informs how people change, so too can we ask 'what do places want?' and look attentively at agentive influences of the non-human to inform our understandings of visual media.

ACKNOWLEDGEMENTS

I would like to thank Andy Jones and Andrew Cochrane for their invitation to the Neolithic Studies Group meeting and to write this discussion. Thanks also to Julienne Bernard, Rick Bury, Christopher Chippindale, Vicky Cummings, Jamie Hampson, Rick Peterson, Dan Reeves, Duncan Sayer, Fraser Sturt, and Robert Wallis. Special thanks to the personality of Blaze O'Connor.

REFERENCES

Bednarik, R. G. 2009. Archaeology versus rock art science. *Rock Art Research* 26(2), 156–158.
Bird-David, N. 1999. 'Animism' revisited: personhood, environment, and relational epistemology. *Current Anthropology* 40(1), 67–91
Casella, E. and Croucher, K. 2011. Beyond human: the materiality of personhood. *Feminist Theory* 12 (20), 209–217.
Chippindale, C. and Nash, G. 2004. Pictures in place: approaches to the figured landscape of rock-art. In Christopher Chippindale and George Nash (eds), *The Figured Landscapes of Rock-Art: Looking at Pictures in Place*, 1–25. Cambridge: Cambridge University Press.
Creese, J. L. 2011. Algonquian rock art and the landscape of power. *Journal of Social Archaeology* 11, 3–20.
Cummings, V. 2012. What lies beneath: thinking about the qualities and essences of stone and wood in the chambered tomb architecture of Neolithic Britain and Ireland. *Journal of Social Archaeology* 12, 29–50
Dowson, T. 2009. Re-animating hunter-gatherer rock-art research. *Cambridge Archaeological Journal* 19(3), 378–387.
Evans, J. G. 2003. *Environmental Archaeology and the Social Order.* London: Routledge.
Fowler, C. 2004. *The Archaeology of Personhood: an Anthropological Approach.* London: Routledge.
Gosden, C. 2005. What do Objects Want? *Journal of Archaeological Method and Theory* 12(3), 193–211.
Gosden, C. and Knowles, C. 2001. *Collecting Colonialism: Material Culture and Colonial Change.* Oxford: Berg.
Gosden, C. and Marshall, Y. 1999. The cultural biography of objects. *World Archaeology* 31(2), 169–178.
Hampson, J. In prep. Embodied identity: rock art of the Texas Trans-Pecos. *Time and Mind: The Journal of Archaeology, Consciousness and Culture.*
Ingold, T. 1999. Comments on Nurit Bird-David's '*Animism' Revisited: personhood, environment, and relational epistemology. Current Anthropology* 40(1), 81–82.

Ingold, T. 2006. Rethinking the animate, re-animating thought. *Ethnos* 71(1), 9–20.

Janik, L. D. 2007. Animism in the rock art and material culture of prehistoric Siberia. In D. A. Barrowclough and C. A. T. Malone (eds), *Cult in Context: Reconsidering ritual in archaeology*. Oxford: Oxbow Books.

Johnson, M. 2010. *Archaeological Theory: an Introduction*. Oxford: Blackwell.

Pastoors, A. and Weniger, G-C. 2011. Cave art in context: methods of the analysis of the spatial organization of cave sites. *Journal of Archaeological Research* DOI 10.1007/s10814-011-9050-5.

Pollard, J. and Gillings, M. 2010. The world of grey wethers. In B. O'Connor, G. Cooney and J. Chapmen (eds) *Materialitas: working stone, carving identity*, 29–41. Oxford: Prehistoric Society Research Papers 3.

Porr, M. and Bell, H. R. 2011. 'Rock-art', 'Animism' and Two-way Thinking: Towards a Complimentary Epistemology in the Understanding of Material Culture and 'Rock-art' of Hunting and Gathering People. *Journal of Archaeological Method and Theory* 1–45. DOI 10.1007/s10816-011-9105-4

Robinson, D. 2004. The Mirror of the sun: surface, mineral applications, and interface in California rock art. In Ni. Boivin and M. A. Owoc (eds) *Soils, Stones and Symbols: archaeological and anthropological perspectives on the mineral world*, 91–106. London: University College London Press.

Robinson, D. W. 2010. Resolving archaeological and ethnographic tensions: a case study from South-Central California. In D. Garrow and T. Yarrow (eds), *Archaeological Anthropology: understanding similarities, exploring differences*, 84–109. Oxford: Oxbow Books.

Robinson, D. W., Korisettar, R. and Koshey, J. 2008. Metanarratives and the (re)invention of the Neolithic: A case study in rock-art from Birappa and Hiregudda Hill, South-Central India. *Journal of Social Archaeology* 8(3), 355–379.

Robinson, D. W., Sturt, F., Bernard, J. and Tuker, G. 2009. *More than Sacred? Watery places in indigenous South-Central California*. Paper presented at the Theoretical Archaeology Group Meetings, Durham.

Scarre, C. 2010. Stones with Character: animism, agency, and megalithic monuments. In B. O'Connor, G. Cooney and J. Chapmen (eds), *Materialitas: working stone, carving identity*, 9–18. Oxford: Prehistoric Society Research Papers 3.

Wallis, R. J. 2009. Re-enchanting rock art landscapes: animic ontologies, non-human agency and rhizomic personhood. *Time and Mind: The Journal of Archaeology, Consciousness and Culture* 2(1), 47–70.

Wallis, R. J. In press. Exorcising 'Spirits': approaching 'Shamans' and rock art animically. In G. Harvey (ed.), *Handbook of Contemporary Animism*. Leiden and Boston: Brill Handbooks on Contemporary Religion.